CANALETTO

GIOVANNI ANTONIO CANAL

1697–1768

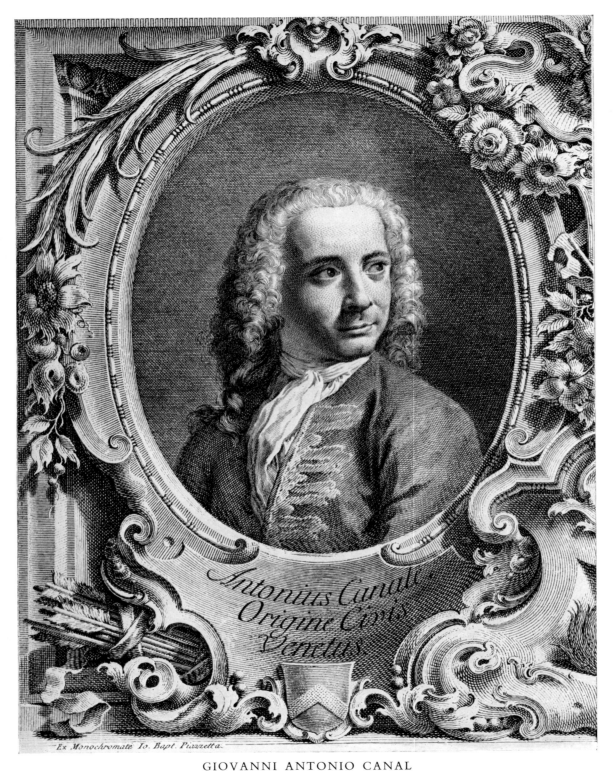

GIOVANNI ANTONIO CANAL
(Engraving by Antonio Visentini, after G. B. Piazzetta, in
Prospectus Magni Canalis Venetiarum, 1735)

CANALETTO

GIOVANNI ANTONIO CANAL

1697–1768

BY

W. G. CONSTABLE

———

VOLUME I

———

SECOND EDITION
REVISED BY J. G. LINKS

OXFORD
AT THE CLARENDON PRESS
1976

Oxford University Press, Walton Street, Oxford OX2 6DP

OXFORD LONDON GLASGOW NEW YORK
TORONTO MELBOURNE WELLINGTON CAPE TOWN
IBADAN NAIROBI DAR ES SALAAM LUSAKA ADDIS ABABA
KUALA LUMPUR SINGAPORE JAKARTA HONG KONG TOKYO
DELHI BOMBAY CALCUTTA MADRAS KARACHI

ISBN 0 19 817324 5

© *Oxford University Press 1976*

First Edition 1962
Second Edition 1976

Printed in Great Britain
at the University Press, Oxford
by Vivian Ridler
Printer to the University

PREFACE

THE text of this volume is reprinted for the present edition mainly in its original form. However, it contains a number of corrections, and changes of ownership recorded in the second edition of the *catalogue raisonné* have for the most part been reflected in this 'Life and Work'. My own comments are set between square brackets.

The plates containing the new illustrations necessarily follow Pl. 184, the final one of the first edition. They include all works not recorded in the earlier *catalogue raisonné* (but not all newly recorded versions of works already illustrated) and a number of works previously recorded but not illustrated; all the etchings and the early drawings of Rome, for example, are now illustrated as well as works of interest formerly omitted for one reason or another. For comparison of differing versions of the same subject, reference must therefore be made in some cases to the appropriate plates of both the original and the new series. The plates now end, as well as beginning, with examples of Canaletto's handwriting and signatures. The same considerations as to the size of the illustrations apply as already stated on p. ix.

The Select Bibliography has been brought up to date with an Appendix of works published since 1958 and a list of exhibitions since 1960, together with the abbreviations used to refer to them.

I join in the thanks already expressed by the late W. G. Constable to previous writers on the subject and to others who assisted in the preparation of the first edition. As far as the present edition is concerned, my work has been primarily concerned with the *catalogue raisonné* in which I acknowledge some of the help given to me. My indebtedness for assistance with this volume is to the many owners who have supplied photographs and permission to reproduce them and to these I should like to express my deep gratitude. To this I must add an apology if, through inadvertence or other cause, a reproduction has crept in without the permission of the owner.

<div align="right">J. G. L.</div>

PREFACE TO FIRST EDITION

T HE following book was originally intended to include a detailed account
not only of Canaletto and his work, but of his relations with such
younger contemporaries as Michele Marieschi, Bernardo Bellotto,
and Francesco Guardi, and to give some account of his imitators, of his
influence in northern Europe, and of the minor *vedute* painters of eighteenth-
century Venice. The amount of material involved has made this original
plan impracticable; and a separate volume is now being prepared dealing
with topics other than Canaletto himself.

Work on the book has perforce had to be spread over a considerable
period. Many of the paintings and drawings were seen and recorded in the
late twenties, and in the thirties; and owing to the war, their present
whereabouts has been impossible to discover. In such cases, either the name
of the last known owner is given, or the owner is stated to be unknown. In
some other cases, either owners have asked that their names should not be
published, or dealers have exercised a proper discretion in not giving names
of owners. Paintings and drawings are then described as in a private col-
lection.

Another result of delay in finishing the book is that material gathered
and conclusions drawn have sometimes already been published independ-
ently by others. In such cases, I have always tried to make full acknow-
ledgement; but it may be that sometimes, in presenting facts acquired by
myself or in expressing opinions of my own, I have inadvertently omitted
mention of their having been published elsewhere. If so, I apologize to all
those concerned.

The *catalogue raisonné*, which is the core of the book, aims at being
reasonably complete; but any hope of its being so has had to be abandoned,
in face of the number of hitherto unknown paintings and drawings which
are constantly coming to light, especially from English collections. No
attempt has been made to record all the school versions of any particular
painting; but where such versions have stylistic, topographical, or historic

interest of some kind or have passed as by Canaletto himself, they are as far as possible mentioned.

In the arrangement of the catalogue, paintings, drawings, and engravings are treated separately, the arrangement in each case being a compromise between topographical and alphabetical. Broadly, the Venetian paintings and drawings are grouped somewhat as in Lorenzetti's admirable guide to Venice, in that the buildings in the centre of Venice, and the Grand Canal, are treated as units. Churches, campi, palaces, &c. form a separate group arranged alphabetically. After this come sections given to the Islands, the Mainland, Rome, England, and Capricci. Indexes have been added to help a search for any particular work. For tracing Canaletto's stylistic development, readers are referred to Chapters III and IV.

For the attributions I am primarily responsible unless the contrary is stated. For the most part, paintings and drawings have been studied in originals, exceptions being noted. In making or accepting attributions, I have followed the principle that when a work is in a public gallery, has been publicly exhibited, or has been seen in the art market, opinion may be freely expressed. When, however, it is in a private collection, and has been seen only through the courtesy of its owner, the owner's attribution is followed unless permission to differ has been given, which has almost invariably been the case. Occasionally, when an attribution to Canaletto has been unacceptable and the owner did not wish the work mentioned except as by him, it has been omitted.

It should be realized that the book is not a topographical account, or history, of Venice or the other cities concerned. Topographical descriptions are given for purposes of identification; changes since the eighteenth century are noted; and occasional notes on the history or purpose of buildings are given to assist in dating a picture or drawing. Readers requiring architectural surveys must, however, seek elsewhere.

Inevitably, there is a certain amount of repetition in the book which it is hoped readers will forgive. For example, facts or theories put forward in the catalogue have had to be cited, perhaps two or three times, in other sections, though naturally with differences in emphasis and with a different purpose in view.

Some explanation concerning the illustrations is due. The aim has been to reproduce the great majority of the paintings, drawings, and etchings in the *catalogue raisonné*, with some necessary ancillary material. This aim could only be realized by reducing the size of the illustrations, and putting several on each page. Expense and lack of space forbade any other course. So the illustrations must be regarded primarily as a means of identification and not of embellishment.

Fully to express my thanks to all those who have helped me is difficult, since obligations incurred are so numerous and have been spread over such a long period.

To the late Bernard Berenson and to the late D. S. McColl I am particularly indebted. D. S. McColl first suggested my studying Canaletto, with the collections at Windsor as a starting-point; and in the early stages of research gave invaluable advice. Bernard Berenson, ever since the inception of the work, has been an unfailing source of encouragement, of enlightenment, and inspiring suggestion. Without him, I doubt whether the book could have been carried through.

To the Leverhulme Trust I am also especially grateful, for a grant which enabled me to spend the greater part of a year in Venice, thereby permitting continuous work in the archives and intensive study of the topography, past and present, of Venice.

Another kind of debt, beyond the power of specific acknowledgement, is that to previous writers on the subject, especially the late Mrs. Finberg, the late Baron von Hadeln, Sir Karl Parker, Mr. F. J. B. Watson, and Dr. Vittorio Moschini. Not only have I laid all that they have written under constant contribution; but I have never appealed to them for additional help without its being quickly and generously given.

Were I to mention all my colleagues in museums and universities who have supplied me with information, suggestions, and photographs, I should have to give a list of many such institutions throughout the world. To mention only a few: Dr. Terisio Pignatti, of the Correr Museum, has my particular gratitude for help of every kind in many fields especially in connexion with the sketch-book in the Accademia, the facsimile reproduction of which, adorned with his learned notes, he allowed me to see before

publication; Mr. Michael Levey, of the National Gallery, London, made available the proofs of his catalogue entries of the seventeenth- and eighteenth-century paintings in the Gallery, together with additional material he had collected, and discussed various problems with me; Professor E. K. Waterhouse has put at my disposal his matchless knowledge of collections and of sale catalogues; and Sir Owen Morshead, Mr. Collins Baker, Sir Anthony Blunt, and Mr. Oliver Millar have all facilitated in every way study of the collections at Windsor and Buckingham Palace, the essential foundation of all work on Canaletto. To Her Majesty the Queen I am most grateful for gracious permission to reproduce paintings and drawings in the Royal Collections.

Dealers in many countries have been more than generous in putting at my disposal their knowledge, and in supplying or obtaining photographs. To mention all is impossible; but my debt is particularly great to Mr. W. M. Martin of Christie's and Mrs. Hans Gronau of Sotheby's, to the late Captain Jack Spink, Mr. Geoffrey Agnew, Mr. J. Byam Shaw, Mr. John Mitchell, Mr. Mortimer Brandt, Mr. Dudley Tooth, Mr. Montague Bernard, Mr. Edward Speelman, and Mr. David Koetser.

To many owners of paintings and drawings I am also greatly indebted. They have allowed me to study their possessions, have searched archives on my behalf, and have given me photographs or allowed them to be made. Without their co-operation, I should often have been helpless.

In obtaining photographs and for assistance in many other ways, my warmest thanks are due to Miss Rhoda Welsford. Her knowledge, watchfulness, and tact have made available much which I might never have known and of which I could not otherwise have obtained a record. To Miss Marjorie Childs, of the Museum of Fine Arts, Boston, I also owe much for her indefatigable pursuit of books which I needed. To the Clarendon Press I am most grateful for help in getting photographs and for their patience and forbearance.

To my wife special gratitude is due. She helped greatly in my work in the Venetian archives, notably in translating many of the documents; and she has taken a large share in the ungrateful task of critical proof-reading.

W. G. C.

CONTENTS

VOLUME I

LIFE AND WORK

LIST OF ABBREVIATIONS

Full titles of works and exhibitions abbreviated in the text will be found in the Select Bibliography or the Catalogues of Exhibitions on pp. 180–6 and be identified when necessary by the dates.

B.F.A.C.	Burlington Fine Arts Club.
B.I.	British Institution.
B.M.	British Museum.
Bt.	Baronet; or Bought.
Burl. Mag.	*Burlington Magazine.*
Collins Baker	Baker, C. H. Collins, *Catalogue of the Principal Pictures in the Royal Collection at Windsor Castle*, 1937.
Costa	Costa, G. F., *Delle Delicie del Fiume Brenta*, 1750–60.
De Vesme	De Vesme, A., *Le Peintre-graveur italien*, Milan, 1906.
Gradenigo	Gradenigo, Pietro, *Notatari* (MS. in Correr Museum Library).
Kozakiewicz	Kozakiewicz, Stefan, *Bernardo Bellotto*, English edition translated by Mary Whittal, London, 1972, 2 vols.
K	(In references to works accepted by the author as by Bellotto, the name is given in full, followed by the number in the *catalogue raisonné*, vol. 2. In references to 'attributed' works, the author's name is abbreviated to 'K' followed by the letter 'Z' and catalogue number, the prefix 'Z' being the author's own method of indicating that the attribution is 'rejected or accepted with reservations'.)
Masters	*Canaletto*, The Masters series (no. 3), Purnell, London, 1965; Italian edition: I maestri del colore (no. 28), Milan, 1963.
N.G.	National Gallery, London.
P.-G.	Pallucchini-Guarnati, *Le Acqueforti del Canaletto*, Venice, 1945.
R.A., *O.M.*	Royal Academy, London, *Exhibition of Old Masters*.
Thieme-Becker	V. Thieme and F. Becker, *Künstler-Lexikon*, 1907–50.
V. and A.	Victoria and Albert Museum.
Waagen	Waagen, H., *Treasures of Art in Great Britain*, 3 vols., 1854.
Waagen, *Supp.*	Waagen, H., *Galleries and Cabinets of Art in Great Britain*, 1857.
Watson	Watson, F. J. B., *Canaletto*, 2nd ed., 1954.

FAMILY OF CANAL

(The first two names below are given only on the authority of the compilation by Toderini in the Archivio di Stato, Venice, Cittadinanze Veneziane I.) The remainder derive from official documents.

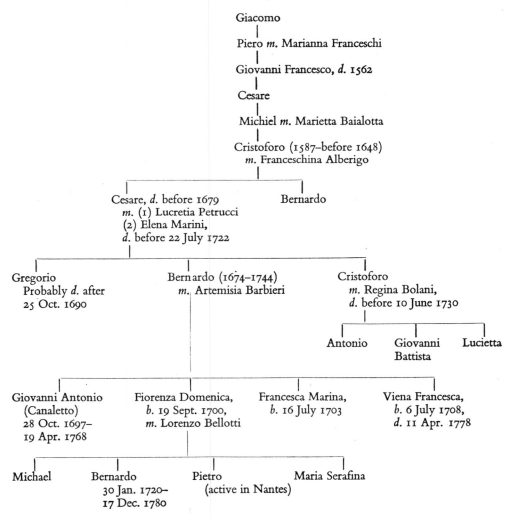

Giacomo
|
Piero *m.* Marianna Franceschi
|
Giovanni Francesco, *d.* 1562
|
Cesare
|
Michiel *m.* Marietta Baialotta
|
Cristoforo (1587–before 1648)
m. Franceschina Alberigo

Cesare, *d.* before 1679
m. (1) Lucretia Petrucci
(2) Elena Marini,
d. before 22 July 1722

Bernardo

Gregorio
Probably *d.* after
25 Oct. 1690

Bernardo (1674–1744)
m. Artemisia Barbieri

Cristoforo
m. Regina Bolani,
d. before 10 June 1730

Antonio Giovanni Lucietta
Battista

Giovanni Antonio
(Canaletto)
28 Oct. 1697–
19 Apr. 1768

Fiorenza Domenica,
b. 19 Sept. 1700,
m. Lorenzo Bellotti

Francesca Marina,
b. 16 July 1703

Viena Francesca,
b. 6 July 1708,
d. 11 Apr. 1778

Michael Bernardo
30 Jan. 1720–
17 Dec. 1780

Pietro
(active in Nantes)

Maria Serafina

NOTE ON CHAPTER I

The documents cited in Chapter I are, unless stated to be elsewhere, in the Archivio di Stato, Venice. They fall into definite groups and, for convenience, the following contractions for each group are used. Date and reference to their place in the Archivio are added in each case. I am deeply indebted to Dr. Gallo Gallia, of the Archivio, who searched for and transcribed a large number of documents which were previously unknown.

Arte dei Luganegheri. Cited as A.L.

Atti Notarili. Cited as A.N.

Avogadore di Commun. Cited as A.C.

Dieci Savi sopra le decime a Rialto. Cited as D.S.

Esaminador — Notificazioni. Cited as E.N.

Indice dei Testamenti. Cited as I.T.

Inquisitorato alle Acque. Cited as I.A.

Sopra atti del Sopragastaldo (Superior). Cited as S.A.S.

Testamenti. Cited as T.

In addition to the abbreviations noted above, the following books are usually cited by the name of the author only:

Orlandi: *Abecedario pittorico*, Florence, 1753 and 1788 eds.

Mariette: *Abécédario* (MS. in Bibliothèque Nationale), ed. Chennevières and Montaiglon, Paris, 1851–3.

Passages in documents or books referring to specific paintings or drawings are, as a rule, cited in full in the *Catalogue raisonné* or in the Appendix, and in Chapter I are usually summarized or omitted.

I

BIOGRAPHY

GIOVANNI ANTONIO CANAL was born in Venice on 28 October 1697 and baptized at S. Lio on 30 October.[1] His descent can be traced from various documents in the Archivio di Stato, Venice. One of 9 September 1602 is a declaration of descent by Christoforo da Canal which reads: 'io Christofolo suddetto son figliuolo legitimo, et naturale di domino Michiel da Canal quondam magnifico et eccellente domino Cesare che fo del nobil homo ser Zan Francesco et de domina Marietta Baialotto del quondam eccellente domino Zuanne, consorte del detto Michiel.'[2] This is endorsed with the date, and the statement that the declaration was produced in the name of Cristoforo 'pro ejus civilitate'; and with a declaration dated 22 December 1602[3] of the three Avogadori: 'approbatus fuit in civem originarium iuxta antiquam consuetudinem dominus Christophorus de Canali ser Michaelis quondam domini Cesaris quondam nobilis hominis ser Ioannis Francisci'.

Other documents in the same group, summarized by Dr. Gallia, record the marriage of Michele Canal with Marietta Baialotto, daughter of Giovanni Baiolotto, who belonged to a noble Veronese family, resident at Mestre; the recognition on 15 December 1585 of Michele as 'cittadino originario di Venezia'; and the birth of Cristoforo in 1587.

An unpublished compilation by T. Toderini in the Archivio di Stato[4] takes the line of descent traced above a stage farther back, by giving the date

[1] S. Leone, Battesimi dal 1686 al 1731, T. iv, no. 356, 30 Ottobre 1697. (The records of S. Leone, generally known as S. Lio, are now preserved in Sta Maria Formosa.) The record runs: 'Zuane Antonio fio dal Sig Bernardo [quondam] Cesare Canal pittor e della sig.na Artemisia fia del Sig. Carlo Barbieri iugali nato adi 28 detto Compare [= godfather] Sig.n Paolo quondam Vendramin Giambattista di questa contrà. Comare [= godmother] la Rucchi.'

[2] For documents cited with short titles and acknowledgements to Dr. Gallia see p. xvi.

[3] A. C. Cittadinanze originarie, busta 6, categoria C, fascicolo Canal.

[4] Toderini, Cittadinanze Veneziane, 1.

of death of Giovanni Francesco as 1562, and his father as 'Nobil homo ser Piero quondam Giacomo' who married Marianna Franceschi in 1465. Where Toderini can be checked by documents, he is accurate; and he may be presumed to be so here, though no confirmation has been found.

Later documents of 6 July 1612, 17 June 1644, 3 August 1644, and 17 August 1644, also specify the parentage and marriage of Cristoforo; and refer to charges made by Marietta, his mother, her brother, and Cristoforo on property in the villa of Taru near Mestre.[1]

A document of 7 July 1648[2] records the letting to a priest of a house in S. Lio by Franceschina Alberigo Canala [sic], who in a document of 24 September 1648[3] is called 'relita del quondam clarissimo ser Christoforo da Canal'. At the time the house was occupied by one Elena, wife of the 'fedel cavadenti'. The document of 7 July also refers to a contract of 8 May 1648 signed and sworn to by the sons of Franceschina, Cesare and Bernardin. In a series of documents acknowledging financial obligations, extending from 31 August 1648 to 28 February 1653,[4] Franceschina appears as widow of Cristoforo, and Cesare Canal as their son; and in one of 12 August 1653 Lucietta Petrucci appears as the wife of Cesare, and takes a share in these obligations.

Another group of documents dating from 6 November 1653 to 4 June 1666[5] deals with the sale of some of the Canal property by Franceschina and Cesare; and in one of them (8 May 1657) Bernardo da Canal reappears as their son and brother respectively.

In 1679 another figure appears. On 3 November a power of attorney is given to Antonio Barbaro by 'la signora Elena figliola del quondam Do. Biasio Cav. Marini et relicta del quondam Dno Cesare Canal'.[6] From this it appears that Cesare married a second time, and by 1679 was dead. There follows a series of documents dealing with Elena's financial transactions. On 27 February and 11 July 1682 she notifies financial obligations,[7] and on

[1] E.N. Reg. n. 22a, 1611–12, p. 109; A.N. a. 1644, parte 1, cartella 659, fascicolo quinto, p. 228t; E.N. Reg. n. 74a, 1644, p. 54; E.N. Reg. n. 74a, 1644, p. 62t.

[2] E.N. Reg. n. 79, dal 4 maggio 1648 al 5 marzo 1649, p. 52.

[3] E.N. Reg. n. 79, p. 102t.　　　　　　　　　　[4] All E.N. Reg. n. 79, 82, 86, 87.

[5] All E.N. Reg. n. 86, 87, 89, 96.　　　　　　　[6] A.N. a. 1679, no. 6801, c. 152.

[7] Both E.N. Reg. n. 112.

16 September she gives power of attorney to Battista Foresti, a doctor of Brescia.[1] On 15 July 1684 she receives from the delegates of the Signoria the dowry assigned to her, which includes 'in contrā di San Lio in corte di la Gradenigo una casa' which was let to one donna Seraffina. In this same house Elena sold an interest to Iseppo Butta on 6 March 1690, associated with the sale being 'Gregorio e Bernardin fratelli figlioli del quondam Cesare da Canal et della sopradetta signora Ellena'.[2] This Bernardo was to become father of Canaletto. On 25 October 1690 Elena and Gregorio, acting on their own behalf and that of Bernardin, sell two houses 'in questa città in contrā di San Leon';[3] and on 17 December 1691 Elena makes an affidavit that she is the legitimate daughter of Sig. Cavallier Marini.[4]

The affairs of a younger generation now join those of Elena in the documents. On 18 March 1695 Artemisia and Rosalba, daughters of Carlo Barbieri and Fiorenza Giugalis, give a power of attorney to 'Sig Bernardo Canal marito della suddetta Artemisia', to deal with 600 ducats which are in the Zecca.[5] Here, for the first time, the father and mother are mentioned together. On 31 March 1696, when Elena assigns the rent of a house in 'Contrā di San Lio in Corte del Perini' in payment of a debt, she is joined by another son Cristoforo.[6] More interesting is a document of 16 June in the same year, in which 'Il signor Bernardo Canal pitor quondam Cesare' acknowledges the dowry brought by his wife Artemisia, consisting of 600 ducats in the Zecca, 200 ducats in cash, and 700 in effects.[7]

In the following year, 1697, Canaletto was born. It is convenient, however, to follow the ramifications and fortunes of his family until he himself appears in the records. Canaletto had three sisters: Fiorenza Domenica,

[1] A.N. a. 1682, n. 8870, p. 14t.

[2] A.N. a. 1690, vol. n. 12690, p. 6t. The two sons are also mentioned in a document of 12 Nov. 1689 (E.N. Reg. n. 117, p. 12) as 'Gregorio e Bernardo Canal'.

[3] A.N. a. 1690–1, cartello no. 3711.

[4] A.N. a. 1691, no. 6814, c. 428.

[5] A.N. a. 1695, n. 6819, c. 24. In a document of 26 Aug. 1694 Artemisia had released her father from dowry payments after that date, he having paid 200 ducats.

[6] A.N. n. 6821, c. 49t.

[7] One ducat (current as distinct from one of silver) = 6 lire 4 soldi: 100 ducats = 60 zecchini. The zecchino (sequin) was in the eighteenth century worth slightly under 10 shillings: i.e. the ducat was worth rather less than 6 shillings.

born 19 September 1700, baptized 26 September[1]; Franceschini Marina, born 16 July 1703, baptized 24 July;[2] and Viena Francesca, born 6 July 1708, baptized 9 July.[3] Fiorenza married Lorenzo Bellotto, and among their children was Bernardo Bellotto. The other two did not marry. Elena, his grandmother, was evidently a personality. On 1 December 1707, calling herself 'moglie di un che fu cittadino originario', she petitions the Avogadore di Comun for justice against a former tenant of hers, one Giovanni Maria Pittosi, whom she had turned out, getting at the same time an injunction against him on account of acts of personal violence. Three months later she met Pittosi, 'who the moment he saw me started to maltreat me with a thousand execrations, oaths and improprieties, going to the damnable excess of attacking me with his boots'.[4] Whether Pittosi was ever punished there is no record. On 28 May 1709 Elena (with her son Cristoforo assenting) lets to Giovanni Corner 'un magazen posto in questa città in contrā di San Lio in Corte Gradenigo' which had come to her in connexion with her dowry;[5] this probably being the house which Cristoforo and his brother Bernardo, with Elena consenting, undertake to sell to Giovanni Corner on 1 September 1713 which brought in about 150 ducats.[6]

From an assessment of 5 April 1713 for the levying of the 'decima', the Venetian tax on property, a general idea can be obtained of the use to which the property of the Canal family in S. Lio was put.[7]

A shop and a storeroom were let, also two attics and three other rooms. Elena, Cristoforo, and Bernardo Canal each had an 'appartamento' for their own use, but seem to have let rooms therein. Each room was assessed separately, the total sum payable on the house amounting to 108 ducats. On 14 March 1715 Artemisia, wife of Bernardo, following the acknowledgement of her dowry of 1,500 ducats in June 1696, takes further action to secure it, giving the date of her marriage as 1695;[8] and full details of the

[1] Parr. di S. Lio. Atti di Battesimo n. 454. Adi 26 settembre 1700 (now in Sta Maria Formosa).

[2] Ibid., n. 546. Adi 24 Luglio 1703.

[3] Ibid., n. 673. Adi 9 Luglio 1708. [4] A.C. P. Busta 449, fasc. 2.

[5] A.N. a. 1709, vol. n. 3991, p. 177.

[6] A.N. a. 1713, vol. n. 3998, p. 284t.

[7] D.S. Sestiere di Castello. Catastico delle case. Registro di San Lio, vol. n. 428.

[8] S.A.S. Terminazioni, vol. a. 1713–15, terminazione 14 mar. 1715, c. 258t.

dowry are given in a document of 22 November 1715.[1] Three years later (15 July 1718) financial obligations are acknowledged by Domenico Coronato to Elena, Cristoforo, and Bernardo Canal and to Regina Bolani Canal and Antonia [sic] Barbieri Canal.[2] The name 'Antonia' raises a slight difficulty; but is probably a miswriting of Artemisia. Regina Bolani was wife of Cristoforo. The fact that Gregorio does not appear in this document, which concerns the whole family, suggests that he was dead. The last document in which he is mentioned is dated 1690, and it seems likely he died shortly after that date. On 21 October 1720 Elena made her will, which was published 22 July 1722, after her death.[3] This was written by the hand of 'Lorenzo Beloti, genero di mio figlio Bernardo'. All her property was divided between Cristoforo and Bernardo, and after their deaths, the share of each was to go to their respective wives, Regina and Artemisia; and after their deaths to their sons, and then to their daughters. In a codicil of 26 December 1720 she specifically mentions that she was living in a house in the contrado di S. Marina.

As regards Artemisia's own property there is a memorandum of 5 February 1723, concerning the tax (the 'decima') due from her on account of two houses 'poste in contrā di S. Lio . . . una affitata al signor Domenico Coronato per ducati 40 grossi, l'altra al presente da me tenuta per uso'.[4]

The preceding account of Canaletto's descent and immediate relatives is summarized in a genealogical table. Tiresome though it may be, it virtually settles the hitherto much-disputed matter of the noble origin of the Canal family. In the documents quoted, the only member of the family to whom the term 'nobilis' is applied is Giovanni Francesco. Of his son Cesare nothing is said; but his grandson Michiel was in 1585 recognized as 'cittadino originario di Venezia', and his great-grandson, Cristoforo, was in 1602 formally declared to be 'in civem originarium' in the same document that speaks of Giovanni Francesco as 'nobilis'. This meant that they belonged to a defined class in Venetian society, near to but distinct from the patrician

[1] D.S. B.I. 297, cartella n. 309, fasc. no. 1967.
[2] E.N. Reg. n. 136, a. 1717–19, p. 112t.
[3] Archivio di Stato. Testamenti, cart. n. 250, fasc. n. 197.
[4] D.S. B.I. 297, cart. n. 309, fasc. n. 1967.

nobility.[1] The position of this class was regulated by laws of 1305 and 1486; and the status could be granted by the Avogadori di Comun, on the declaration of the Magistrati sulle arti that the father and grandfather of the applicant had not engaged in an *arte meccanica*. That the Canal family maintained its claim to such status is indicated by Elena, wife of Cesare Canal, in her petition of 1707 to the Avogadori di Comun, describing herself as 'moglie di un che fu cittadino originario'.

The documents therefore justify Zanetti[2] when he writes of Canaletto 'Figliuolo egli fu di Bernardo, che traea origine dalla nobilissima famiglia da Canal'. As Parker[3] points out, it is significant that Canaletto's claim to noble descent appears never to have been challenged in his lifetime; and that Zanetti, himself a patrician, writing within a few years of Canaletto's death, should have accepted it. Mariette also had first-hand information on the matter, since he begins his account of Canaletto with the words 'Canal (Jean Antoine) ou da Canal (ainsi qu'il écrit lui-même dans un mémoire qu'il m'a envoyé, et qui contient sa généalogie)'. This genealogy has not been found among the Mariette papers in the Bibliothèque Nationale; and genealogies compiled by those seeking to prove themselves of aristocratic descent are apt to be suspect. Mariette, however, was a shrewd judge, and the documents vindicate his having taken the memoir at its face value.

The documents also explain the difference between the inscriptions on two portraits which preface the series of engravings by Visentini after Canaletto, the first group of which appeared in 1735. There, Canaletto is described as *Origine Civis Venetus*, and Visentini simply as *Venetus*.

That Canaletto was entitled to use the coat of arms of the da Canal family seems clear. This had two forms, *argent a chevron azure*, and *azure a chevron or*;[4] and Todeschini, in the work cited above, gives *argent a chevron azure* as

[1] 'Le famiglie ascritte alla cittadinanza originaria di Venezia, godevano una posizione distinta ma non nobile' (*Massime di legislazione nobiliare approvata dalla Consulta Araldica e da Real Governo italiani*, art. 42). The reference is from Dr. Gallia.

[2] P. 463. Zucchini (*Nuova Cronaca Veneta*, 1785, i. 61) repeats Zanetti's statement in almost identical words.

[3] P. 20.

[4] Coronelli, *Arme, Blasoni, o Insegne Gentilitie . . .*, Venice; Freschot, *Li pregi della nobiltà Veneta . . .*, Venice, 1682; Rietstap, *Armorial général*, gives only *d'argent au chevron d'azur*. There is another da Canal family (or a separate branch) with an entirely different coat (*d'azzurro al palo, accostato da sei*

the one used by the family from which Canaletto descended. Thus, the shield with a chevron, which appears in some of the paintings, drawings, and etchings, generally as part of an architectural ornament, may properly be regarded as a form of signature or a kind of trademark.[1]

That the Canal family at one time or another possessed a certain amount of property is also revealed by the documents. The wife of Michele brought with her some land near Mestre; and in 1648 there is reference to the wife of Cristoforo letting house property in the *contrada* of S. Lio. In 1684 Elena, the wife of Cesare, received a moderately substantial dowry including a house in S. Lio; and the dowry of Artemisia, her daughter-in-law and mother of Canaletto, consisted largely of a fair sum in cash. On the other hand, many of the transactions concerning this property consisted either of assigning it as security for debt, or selling parts of it; and the only substantial asset remaining in the family at the beginning of the eighteenth century seems to have been Artemisia's dowry and the S. Lio house, in which the Canal family maintained a precarious foothold among their various lodgers.

About Bernardo Canal, Canaletto's father, the documents say little. He is first mentioned in 1689, and thenceforward plays a part in all family affairs, though without taking the initiative. He married Artemisia Barbieri before 18 March 1695; in 1696 is first described as 'pitor'; and in the record of Canaletto's baptism appears as 'pittore'. Zanetti describes him as 'pittore da teatro', and Mariette as a painter of 'décorations de théâtre'; and he is recorded as having been associated with the production of operas by Vivaldi[2] and, in Rome, of Scarlatti (see p. 9). He was a member of the Collegio dei Pittori (see p. 26 n. below) of which he was elected Prior on 28 December 1739. He died on 12 March 1744 of apoplexy at the age of seventy, and was buried in the church of S. Lio, 'capitolo', which implies the presence of twelve priests with candles at his funeral.[3]

gigli, tre per parte, il tutto d'oro). This was one of the families included in the nobility on the closing of the Great Council in 1297 (Spreti, *Enciclopedia Storico — Nobiliario Italiano*, ii, 1929, 263).

[1] Its use in this way was apparently first recognized by H. Fritzsche in the case of the etchings (see *Graphische Künste, Mitteilungen*, 1930, 50).

[2] See V. Moschini, *Canaletto*, p. 7.

[3] The entry in S. Leone, *Atti di Morto*, 1744 (now at Sta Maria Formosa), reads: '12 Marzo 1744

The spelling of Canaletto's surname has varied between 'Canal' and
'Canale'. Among early writers 'Canal' is used by Zanetti and Mariette,
'Canale' in the 1733 reissue of Boschini and by Orlandi (1753); and the
difference has persisted in later usage. The form 'Canal' has, however,
considerably the greater authority. It is the one most frequently used by
Canaletto himself. There seems to be only one certain example, on the back
of a drawing of Padua at Windsor, of 'Canale' being used by him in a
signature; since in another, a capriccio with Roman ruins and the Colleoni
monument, an apparent 'Canale' has been tampered with. Otherwise,
Canaletto spells his name 'Canal' or 'da Canal' on signed paintings, drawings,
and etchings; and as 'Canal' he appears on contemporary engravings. More-
over, the name is so spelt in the documents in Canaletto's hand relating to
four paintings made for Stefano Conti of Lucca (see no. 194 below), and in
all official documents.

When and how the form 'Canaletto' came into use is more difficult to
decide. Suggestions such as that of Moureau that it was only adopted on the
occasion of Canaletto going to England, or that of an early edition of the
Wallace Collection catalogue that it was the name originally given to
Bellotto, and was taken over by his uncle, have nothing to be said for them.
In fact, any taking over seems to have been done by Bellotto, who once he
was out of Italy exploited his uncle's reputation by signing as 'Bernardo
Belloto. Detto Canaleto' or 'Bernard Belotto Canaletto'.[1]

Occasionally, 'Canaletto' appears as a signature or as elaboration of a
signature ('Antonio da Canal deto il Canaleto'), in at least two cases on
drawings, one of the Campanile under repair, the other of houses at Padua,
probably made before Canaletto went to England. The name was, however,
current in the early twenties, being used by Owen McSwiney in a letter of
1722 to the Duke of Richmond. Later he writes of 'Canal'; but reverts to
the use of 'Canaletto' in 1727, 1728, and 1729. In the thirties Count Tessin

SS. Gio e Paulo/Sig Bernardo Canal quondam Cesare di 70 da apoplesia in giorni sette Manco ier sera
a ore tre. Medico ecc: Giuseppe Fanni. Capitolo.'

[1] If his aim was to create doubt as to identities, he certainly has done so. Horne's belief that it was
Bellotto and not Canaletto who visited England (see p. 36 below) was in part due to the two painters
using the same name; and today in Poland, and sometimes in Germany and Austria, the countries in
which Bellotto worked, 'Canaletto' still is apt to mean Bellotto.

and the Président de Brosses use the form 'Canaletti'; and in the forties Horace Walpole and Vertue refer to him under that name, while he advertised himself in the London press as 'Signor Canaleto'. That the term was used not only by foreigners but by Venetians appears from references in the Gradenigo diary, extending from 1753 to 1768.

Evidently, therefore, 'Canaletto' was so called throughout most of his working life. How this came about is unknown. The use of an affectionate diminutive of this type is not unknown in Venice; but a more likely explanation is a desire to distinguish Antonio from his father Bernardo Canal, who was alive until 1744.

In the absence of documents concerning Canaletto's early life, the chief authorities for this are Orlandi (1753 edition), Zanetti, and Mariette.[1] All agree that his first employment was in the theatre in Venice, and that he left it as a young man, Zanetti giving the date as *c.* 1719, Mariette as 1719. Zanetti gives as a reason that he was annoyed 'dalla indiscretezza dei Poeti drammatici' and that he himself said that he had 'scomunico solennemente il teatro'. It has been suggested that this was due to dislike of innovations in Venetian theatrical design, stemming from the Bibbiena family; though this seems to stretch the meaning of Zanetti's words unduly.

According to Orlandi and Zanetti, Canaletto then went to Rome. Mariette, however, says that he had 'fait dans sa jeunesse le voyage de Rome' and that after leaving the theatre he took to painting views after nature; which might imply that Canaletto had gone to Rome before giving up the theatre. Recent research has established this as a fact. E. Croft-Murray has discovered that in the printed libretti of two operas by Alessandro Scarlatti it is stated that Bernardo and his son Antonio Canal went to Rome in 1719–20 and executed there scenes for *Tito Sempronico Greco* and *Turno Aricino* by Scarlatti, which were performed at the Teatro Catranica during the carnival of 1720.[2]

Clearly, therefore, Canaletto went to Rome in the first place to work in the theatre. In Rome, however, Orlandi says he applied himself

[1] Though Mariette seems to echo Zanetti, he knew Canaletto personally, and so may be assumed to have independent knowledge.

[2] I am most grateful to Mr. Croft-Murray for allowing me to publish this information. Mr. F. J. B. Watson tells me that it is also recorded, in less detail, in Dent's book on Scarlatti, published in 1904.

disegnare con esattezza, e con mirabil gusto dipingere le belle antiche fabbriche, in pochi anni gli venne fatto di rappresentarle su le tele con tale intendimento e maestria che da pochissimi degli antichi e da nessun de' moderni fu eguagliato nell'arte di copiare e contraffare con tanta perfezione la natura ed il vero.

Zanetti writes to the same effect, that Canaletto

tutto si diede a dipingere vedute dal naturale. Bei soggetti ei trovò quivi nel genere spezialmente dell'antichità; e belli per i pittoreschi accidenti n'ebbe dopo nella patria sua, i siti della quale non possono essere più opportuni a quel fatto; cosicchè che vedute non gli ha, crede nel mirar le pitture che siano piuttosto immaginarii pensamenti che semplici verità.

No doubt it is these accounts, repeated in various forms by later writers, which formed the basis of such fantasies as that of Uzanne, who describes in detail Canaletto's arrival in Rome, a meeting with Pannini, and their subsequent friendship.[1]

It may be noted that Orlandi writes of Canaletto painting as well as drawing, and Zanetti of his painting. This may have been justified by facts known at the time; more probably both writers, with Canaletto's later paintings of Roman subjects in mind, associated these with the early visit to Rome. In fact, the only results of this visit known to survive are a series of drawings of Roman subjects, which some authorities hold to be copies and not originals.[2] Also, search in various official records in Rome under all possible variations of Canaletto's name has failed to reveal any trace of Canaletto having been there. During the period 1714 to 1722, the only mention in the *Atta Notarile*[3] of any one of the name Canal or Canale was in 1716 (*Notarii A.C.*, 1 June and 13 December) relating to the dowry of one Candida Laezza, married to Giovanni Canal, whose father Domenico provided the money. A similar blank was drawn at the Accademia di S. Luca, where there is no mention of Canaletto in the records, nor any example of work by him among the drawings submitted annually by students for prizes. A painting by him which the Academy owns was presented to it much later in the century. The unpublished Diario di Roma of Valesio

[1] On this, see Chapter II.

[2] See no. 713 below for full description and discussion of authenticity.

[3] In the Archivio Capitolino. They record all transactions in Rome concerning marriage, property, and work which were the subject of written contracts.

(in the Archivio Capitolino) also yielded nothing; but in this case the important years 1710–24 are missing.[1]

By 1720 Canaletto was apparently back in Venice, since in the *Pittori nella Fraglia dell'anno 1687* (Elenco III) there appears the name 'Canal, Antonio, 1720'.[2] This entry might have been made during his absence; but he was certainly in Venice by 1722, since he was then working with a number of other artists on a project initiated by Owen McSwiney, who is thus not only the first known patron of Canaletto, but the first of a long series of English patrons.[3]

McSwiney (whose name is variously spelt MacSwinny or Mac Swinny) was born in Ireland, came to London in 1706, and in that year became manager of the Queen's Theatre in the Haymarket, leasing it from Sir John Vanbrugh. Here apparently he had some success. In 1711 he became an amateur member of the Academy founded in that year, with Kneller as Governor, and in the list of members was described as 'player'. An enforced move to Drury Lane, and a return to the Haymarket, brought disaster. McSwiney became bankrupt, and left England for France and Italy, remaining on the Continent for twenty years, according to the *Dictionary of National Biography*. He was back in Dublin in 1733 and in London in or before 1737, when his portrait was painted by J. B. van Loo. During these years he acted as agent in collecting works of art for Lord March, who in 1723 became the second Duke of Richmond, the chief source of knowledge of his operations being forty-eight letters written by him to the Duke between 1721 and 1729, which are now at Goodwood.[4] He was also occupied in securing Italian operas for performance in London, and in engaging singers.

[1] One potentially useful source of information which there has been no opportunity to consult are the records of the Venetian Embassy to Rome.

[2] See Nicoletti, in *Ateneo Veneto*, Nov.–Dec. 1890.

[3] Canaletto is sometimes said to have been the pupil of Luca Carlevaris. Certainly he was influenced by him (see Chapter II); but there is no evidence of any formal relation between them. Indeed, as Haskell points out (*Burl. Mag.*, Sept. 1956, 297), when the painter Alessandro Marchesini writes in a letter of July 1725 that Canaletto was now more highly estimated than Carlevaris, he could scarcely have refrained from giving this as an example of the favourite story of pupil outdistancing master, if in fact Canaletto had been a pupil.

[4] I am grateful to the late Duke of Richmond and Gordon for having allowed me to see these letters, and to make transcripts of many of them, with a view to publication.

The project on which Canaletto, with others, was employed by McSwiney
was a series of paintings in each of which the central feature was an imaginary
tomb in a setting of architecture and landscape, with various allegorical
figures, commemorating some distinguished figure in recent English history.
Twenty-four of these paintings were made; but Canaletto shared in the
production of two only, collaborating with Pittoni and Cimaroli in one
case, and with Piazzetta and Cimaroli in the other.[1] McSwiney, in a letter
of 8 March 1722, which is the first referring to the project, says that in both
cases 'the perspective and landscape' are by Canaletto and Cimaroli, and
implies that one of the paintings is ready, and says specifically that the
landscape and perspective in the other are finished. It seems probable, there-
fore, that Canaletto soon gave up working on McSwiney's project, and
turned to painting topographical pictures for other patrons. Whether the
four large paintings formerly in the Liechtenstein collection (see under no. 1
below) were ordered or bought by the Prince Liechtenstein of the day is
uncertain, though there is good evidence that they were painted in or before
1723. Complete certainty, however, comes with 1725, for in that year and
in 1726 Canaletto painted for Stefano Conti of Lucca two pairs of Venetian
views, writing for each pair two signed and dated memoranda describing
each painting in detail, certifying their genuineness, specifying their prices,
and acknowledging payment of the money.[2] The agreed price for the first
pair was 20 sequins each, it being left to the 'favourable cognizance' of
Conti to increase this to twenty-five. Later, in the documents describing
the 1725 paintings, Canaletto refers to the price as 30 sequins each; but in
the receipt for the 1726 pair, he says that the price agreed for the four was
80 sequins, with ten sequins added as a present. Since the sequin was then
worth about 10 shillings, these prices were reasonably high for a compara-
tively young man's work, seeing that at the height of his fame Sir Joshua
Reynolds charged 30 guineas for a head and shoulders, and Wilson was paid
10 to 15 guineas for a small painting.

[1] See nos. 516 and 517 below, with references to the McSwiney letters. For the project as a whole
see Watson, *Burl. Mag.*, Nov. 1953, 362 sqq. Mr. Watson has discovered some two-thirds of the
paintings and proposes to publish them shortly.

[2] Paintings and documents have never been separated throughout their history, and are now in the
Pillow collection, Montreal. See under no. 194 below; and, for the documents, Appendix I.

Stefano Conti was at one time thought to be the builder of the last Bucintoro, the state barge of the Doge, who would have had opportunity in Venice to meet Canaletto and see his work. The researches of Francis Haskell, however, have established that he was another Stefano Conti, a merchant in Lucca, and an ardent collector, especially of contemporary Venetian painters.[1] His adviser and agent was the Veronese painter, Alessandro Marchesini; and the correspondence between them makes it clear that Canaletto was by this time a tolerably busy man. In a letter to Conti of 11 August 1725 Marchesini says that the paintings ordered from Canaletto will be as large as 'il molto dell'altra prima veduta', seen through the help of a Carmelite friar by Giovanni Angelo Conti, the son of Stefano, in the house of his excellency Sagredo, perhaps the Gherardo Sagredo (d. 1738) who had modernized the interior of the Palazzo Sagredo. Another letter of 18 August in the same year tells of the Imperial Ambassador buying a view of SS. Giovanni e Paolo, 'che fece meravigliare tutti' at the public exhibition of paintings on the day of St. Roch, and another painting of a larger size.[2] Again, a letter of 3 November 1725, mentions that there is talk of Canaletto being employed by the French Ambassador;[3] and on 3 March 1726 Marchesini reports a commission to paint a view of Corfù for 'Marscial Salenbug', who is identified by Mr. Haskell as General Schulenberg, who had defended Corfù some years earlier.

The position that Canaletto had now attained is indicated by a passage in an earlier letter of July 1725, which says that Luca Carlevaris, hitherto the leading figure among Venetian topographers, was still active 'se non fosse superato di maggior stima dal Sigr Ant Canale, che fa in questo paese

[1] See *Burl. Mag.*, Sept. 1956, 296–300. An important article because of the documents it publishes and the light shed on eighteenth-century Italian painting and collecting. I am greatly indebted to this for much of the following.

[2] Mr. Haskell thinks that these were bought for Prince Liechtenstein, though there seems never to have been a SS. Giovanni e Paolo in the Liechtenstein collection. More likely, they are among the paintings at Dresden. A view of the paintings exhibited on St. Roch's day is in the background of *The Doge visiting the Scuola di S. Rocco*, in the National Gallery, London (no. 331 below).

[3] A difficulty here is that the Ambassador apparently did not present his credentials until Oct. 1726. Mr. Haskell, however, gives authority for his having been appointed in 1723, and suggests that he got into touch with Canaletto before his official entry into Venice. For the paintings concerned, see note on no. 356.

stordire universalmente ognuno che vede Le sue opere, che consiste sul ordine di Carlevari ma vi si vede Lucer entro il Sole . . .'. Apparently, Canaletto was not an easy man with whom to deal. Marchesini reports numerous delays in getting delivery of the Conti pictures, the excuses made being mainly based on pressure due to other commissions. Some of them are, however, to Canaletto's credit as an artist, and throw an interesting light on his methods of work. One reason given was that he could not get on with a painting because he needed ultramarine blue, and he did not wish to use inferior pigments; another, very surprising, that he preferred to work from nature. In Marchesini's words, speaking of the painting of the Grand Canal and the Dogana on which Canaletto was working, 'questo non lo può fare mentre esso depinge sopra il loco e non a idiea a Casa come fa il S. Lucca [Luca Carlevaris] . . .'. This accords with McSwiney's remark to the Duke of Richmond (see p. 15) that 'his [Canaletto's] Excellence lyes in painting things which fall immediately under his eye'; and makes it clear that Canaletto's practice as a young man differed from that followed in his maturity, when the available evidence points to his working from drawings.

Similar difficulties are revealed in McSwiney's letters, in connexion with paintings by Canaletto he was trying to get for the Duke of Richmond. On 28 November 1727 he writes from Venice to the Duke:

The pieces which Mr Southwell has (of Canals painting) were done for me and they cost me 70 sequins.[1] The fellow is whimsical and varys his prices, every day: and he that has a mind to have any of his work, must not seem to be too fond of it, for he'l be y^e worse treated for it, both in the price and the painting too.

He has more work than he can doe, in any reasonable time, and well: but by the assistance of a particular friend, of his, I get once in two months a piece sketched out and a little time after finished, by force of bribery.

I send yr Grace by *Captain Robinson* (Command^r of the Tokeley Gally) who sails from here tomorrow, *Two of the Finest pieces*, I think he ever painted and of the same size with M^r Southwells little ones (which is a size he excells in) and are done upon copper plates: *They cost me two and twenty sequeens* each. They'l be delivered to your

[1] Who Mr. Southwell was is unknown. Mrs. Finberg (Walpole Society, ix. 23) suggests that he was perhaps Edward Southwell (1671–1730), who was Secretary of State in 1720. One would like him to have been the Mr. Southwell described by Lady Mary Wortley Montagu, in a letter of 26 Sept. 1759 from Venice, as 'a tall, fair, well-shaped young fellow, with a good character, the reputation of a good

Grace by Mr John Smith, as soon as they arrive in London . . . I shall have a view of the Rialto Bridge, done by Canal in twenty days, and I have bespoke another view of Venice for by the by, his Excellence lyes in painting things which fall immediately under his eye.

The four pieces of Canal come to 88 sequeens. . . .

The first two paintings were in fact sent, since McSwiney writes on 5 Dec. 1727: 'The two copper plates done by *Canal* are very fine; I told you in my last lett^r that I forwarded 'em, to M^r John Smith in London'; and there is another reference to their sending in a letter of 16 January 1727 (O.S.). Travel was slow, however, for a letter of 27 February 1727 (O.S.) says: 'In a few days after you receive this, in all probability Captⁿ Robinson will be arrived—He has two pictures done for yr Grace by Canaletto.' That these arrived is indicated by a letter of 30 July 1728, inquiring how the Duke liked 'Y^e copper plates by Canaletto, w^{ch} you rec^d before'; and the two paintings are still at Goodwood (see nos. 232 and 235 below).

The history of the second pair of paintings is obscure. On 18 June 1728 McSwiney writes that 'there are five most beautiful closet pieces to be disposed of', two being by Canaletto, costing 30 zecchini. These seem to be additional to the pair already ordered, since in the letter of 30 July 1728, saying that a German Girl by Rosalba is finished, McSwiney adds, 'I wait for y^e companion [to a copper plate] which Canaletto is now about, for you: as soon as I get it, out of his hands, I'll forward 'em all to you'. There was, however, still a hitch. On 1 October 1729, over a year later, McSwiney writes: 'The remaining two copper plates of Canaletto *which two pieces* wth y^t of Rosalba's, I acknowledge to have rec^d y^e value of several months agoe. *Canaletto* promises me to let me have 'em on my return from Rome, which will be about the middle of January.' Whether McSwiney ever received them is not known, nor have the paintings been identified, though it has been suggested that two paintings at Chatsworth are they (see note on no. 115, below).

From the foregoing, it is evident that Canaletto's prices were rising, since

understanding, and in present possession of twelve thousand pounds per annum . . . he has neither visible nose nor mouth; yet he speaks with a clear audible voice'. He, unfortunately, was almost certainly too young.

he now charged at first 22 sequins, and later 30 sequins, for comparatively small paintings, as compared with the 20 paid by Stefano Conti.

McSwiney's letters refer several times to a far better known and more considerable figure in Venice than himself, who was to play a very important part in Canaletto's life. This was Joseph Smith, merchant, a banker of sorts, eventually English consul in Venice, and a mighty collector, especially of books and of contemporary Venetian paintings and drawings.[1] Smith is sometimes said to have been born in 1682; but as Parker says, if the entries in the registers of his death in 1770 are correct in stating that his age was about ninety-six, he must have been born about 1674–5, which agrees with the remark of Lady Mary Wortley Montagu in a letter of 1758 that he was eighty-two years old. He seems to have settled in Venice shortly after 1700, where he was apprenticed to one Thomas Williams. In his will (see Parker, pp. 59–61), Smith calls Williams 'my Predecessor', probably meaning as consul; and says that as the result of an 'error, neglect or mismanagement' during his apprenticeship he may have caused financial loss to Williams. Concerning his independent activities in Venice, there is some information in the letters of Owen McSwiney to the Duke of Richmond. The first reference to Smith is in a letter of 1 September 1722, when McSwiney writes that his knowledge of accounts is due to his having lived in Smith's house in Venice. This suggests a certain degree of prosperity, probably due to his marriage to Katherine Tofts, the opera singer, who about 1709 retired to Venice with a considerable fortune.[2] For a time, any connexion of Smith with the arts was apparently only indirect. On 17 December 1723 McSwiney writes that if Lord Cadogan would venture on a relief by Giuseppe Mazza, 'the thing shall be delivered into Mr Smith's hands in order to be sent to his Lordship'; and in 1725 (30 November) McSwiney reports to the Duke of Richmond that 'Mr Smith is much yr

[1] The best single account of Smith is that of Parker in *The Drawings of Canaletto at Windsor Castle*, 1948. Blunt and Croft-Murray, *Venetian Drawings at Windsor Castle*, 1957, add some valuable information. In both cases, full references to authorities are given. The account given here is chiefly concerned with the relations of Smith and Canaletto, and is based on the two publications mentioned. See also Frances Vivian, *Il Console Smith*, Vicenza, 1971.

[2] The cause of her retirement seems to have been intermittent attacks of insanity, which in time increased in severity and frequency.

Servt and longs to receive yr Grace's comands', sending a similar message on 21 December. In a letter of 3 May 1726 the Duke is asked that he 'would not forget writing a word or two to Mr Smith at Venice, or speaking to Mr Smith at London'[1] about a sum of £126 required; and goes on to say that four of the 'tomb' pictures are 'in forwardnesse. Their being so is owing to Mr Smith's regard to yr Grace, for he has (purely on that score) furnished me with money, called for at different times.' He adds in a letter of 6 August, 'I am engaged over head and ears, and if yr Grace will not write to Smith to disengage me, I shall be in a sweet pickle'; but help came reasonably soon, for on 8 November he reports: 'The credit on Mr Smith for the hundred and thirty pounds has given me fresh spirits.'

A few years later Smith was engaged in handling works of art on his own account, and his first contact with Canaletto is recorded. This appears from his correspondence with Samuel Hill, of Shenstone Park, Staffs., whose nephew, Samuel Egerton, had been apprenticed to Smith, and arrived in Venice in June or July 1729.[2] A letter of 26 November 1729, from Smith, reveals Hill as a considerable collector of miscellaneous works of art; and Smith as responsible for shipping Hill's purchases to London and paying accounts for him. Smith must have by this time become reasonably prosperous, for in 1730 Samuel Egerton writes to his uncle that he has been staying at Smith's 'new-mended' country house at Mogliano, between Venice and Treviso.[3] It is from Mogliano (which he spells Moggiano) that Smith wrote to Hill on 17 July 1730, this time in the capacity of an agent in purchasing works of art. Among other matters, he asks Hill how he likes 'the plan of Venice', adding the interesting comment that 'The author will not

[1] This is the John Smith mentioned in letters quoted earlier, who was Joseph Smith's brother, also a merchant.

[2] See W. H. Chaloner, 'The Egertons in Italy and the Netherlands, 1729–1724', in *Bulletin of the John Rylands Library*, vol. 32, Mar. 1950, Manchester. These letters were discovered by Mr. Chaloner, and first published by him.

[3] Smith rented the house and in 1730 (letter to Hill, 17 July) was engaged in repairing it thoroughly. 'An allowance from the landlord of 400 [? sequins] and a liking to the place hath hooked me in to spend near three times the summ.' He adds that the house and ground are mortgaged to him, and that he has reason to think the proprietor will never redeem it. The remodelling was in the hands of Visentini, who made drawings of the place for Smith, now at Windsor. The villa no longer exists.

sell 'em for less than 2 chequeens [sequins] a price none but strangers think the work deserves and indeed 'tis just so with everything else of worth which Italy now produces'; thus bearing out other contemporary comments on artists' prices in Venice. He then goes on:

At last Ive got Canal under articles to finish your 2 peices within a twelvemonth; he's so much follow'd and all are so ready to pay him his own price for his work (and which he vallues himself as much as anybody) that he would be thought in this to have much obliged me, nor is it the first time I have been glad to submitt to a painter's impertinence to serve myself and friends, . . . [1]

On 15 December Samuel Egerton was able to write to his uncle that Smith 'had att last prevailed with Canal to lay aside all other business till he had finished the 2 pictures you order'd when you were last here, and they'll now come home in about 15 days more'. Smith's letter makes it clear that direct dealings with artists were no new experience for him; also that Canaletto retained the characteristics of a prima donna which he had shown to Marchesini and McSwiney. The letter also suggests that Smith knew Canaletto before 1730; and this is borne out by a later passage in the letter. 'The prints of the views and pictures of Venice will now soon be finished. I've told you there is only a limited number to be drawn off, so if you want any for friends, speak in time.' This can only refer to the series of fourteen engravings by Visentini after paintings by Canaletto, published in 1735 as *Prospectus Magni Canalis Venetiarum*, of which the originals are stated on the title-page to belong to Smith, and are now at Windsor (see under Engravings); and makes it certain that some at least of the paintings date from 1730 or earlier, and that Smith was before that year already a patron of Canaletto. The connexion is, however, unlikely to have been of long standing; since in the great collection of Canaletto's work at Windsor, which came from Smith, there are no examples of work that can be assigned to the period to which the Pillow paintings (1725–6) belong.

Also in 1730 Smith was concerned in the acquisition of two paintings by Canaletto for a member of the Howard family, probably Hugh Howard, whose younger relative Ralph Howard became Earl of Wicklow. Among

[1] The plan was doubtless that compiled by Lodovico Ughi, published by Baroni in 1729. For the paintings see nos. 97 and 111.

the unpublished papers of the Wicklow family[1] is a memorandum or receipt which reads:

	£	s.	d.
Aug 22 1730 Recd two pictures of Canaletti from Venice Pd Mr Smith Mercht 35 Venn. Zecni	18	7	11
Freight	0	11	0
Custom	2	0	0
Charges		8	0
	21	6	11
Frames	1	14	0
	23	0	11

The two paintings remained in the family of the Earls of Wicklow until quite recently (see nos. 166 and 220).

That Canaletto by this time had acquired a considerable reputation is confirmed by the fact that in the 1733 *Descrizione di tutte le pubbliche pitture de la città di Venezia* (an expansion and rewriting of Boschini, *Le minere de la pittura*) Canaletto is spoken of as 'pittor di vedute, al quale e nella intelligenza e nel gusto e nella verità, pochi tra gli scorsi e nessuno tra i presenti si può trovar, che si accostino'. It is interesting, however, that Canaletto is not recorded among painters examples of whose works are in Venice, perhaps because none were owned by Venetians.

Nevertheless, the documentary references of 1730 are the only definite record known of transactions in which Smith and Canaletto were both concerned. The collection at Windsor, however, is standing witness to continuous patronage by Smith. This includes fifty paintings[2] and 142 drawings,[3] all of which formerly belonged to Smith, and covers all phases of Canaletto's activity from the late twenties until he went to England in 1746. It also includes six drawings and two paintings of English subjects.

[1] Known only in a typescript, the originals having disappeared. I am much indebted to Mr. Brinsley Ford for information about these papers.

[2] Smith's catalogue of his paintings included fifty-four, all of which came to Windsor. Four have disappeared.

[3] Parker (p. 18) gives the total as 143, made up of 139 in a list drawn up by Smith, and three removed from an album of Visentini drawings, i.e. one too many. This count was made before it was discovered that two of the drawings are in fact parts of the same drawing, so reducing the number to 142.

Smith remained in Venice at the time Canaletto was in England; but Canaletto twice made visits to Venice before his final return, and could therefore have received commissions from Smith, or have brought back the drawings on one occasion or another as a speculation, and sold them to Smith. The two paintings (nos. 428 and 429) were almost certainly made in Venice from the drawings of the same subject, with which they correspond exactly, since to make them in England and carry them to Venice would be unnecessary and inconvenient. Whether Smith acquired any work by Canaletto after the artist's return to Venice is uncertain. There are a few drawings and a painting at Windsor (see Chapter IV) which on style can be tentatively assigned to that period, but it would be rash to dogmatize. In 1762 negotiations were on foot for the sale of Smith's collections to George III; and in 1763 the drawings were handed over. The date of the transfer of the paintings is less certain, but since they were paid for in the financial year 1763–4, they presumably went to England then or shortly afterwards. Consequently, no works by Canaletto after 1763–4 are among the paintings and drawings at Windsor bought from Smith.[1] Smith continued to collect after this, and this second collection was sold at various dates after his death; but nothing by Canaletto was included in the sales. Some of his paintings, however, at some time passed into the collection of John Strange, British Resident in Venice 1773–88.[2] In a sale which has been identified as that of paintings belonging to Strange, there were two paintings, now at Windsor, which are attributed to Canaletto (see note on no. 365). But whether these came from Smith is unknown.

That Smith brought Canaletto into touch with collectors other than himself seems likely, but there is no evidence. Despite the early date on which Canaletto was first employed by McSwiney, it is possible that Smith, in whose house McSwiney had lived, mentioned Canaletto to him; and Smith certainly wrote to McSwiney on Canaletto's behalf when the latter went to England (see below). Similarly, Smith may have suggested that

[1] Parker (pp. 10–13) gives a full and lucid account of the sale and negotiations leading up to it. F. J. B. Watson (*Burl. Mag.*, July 1948, 188) adds a few details. Since this has no bearing on Canaletto or his relations with Smith, no account is given here.

[2] See Blunt and Croft-Murray, *Venetian Drawings at Winsdor Castle*, 11 n. 1.

Samuel Hill and Hugh Howard should acquire examples of the painter's work, though there is no hint that he did so. Again, when in 1754-5 Canaletto painted six pictures for Thomas Hollis,[1] the idea that he should be employed may have come from Smith. Hollis met Smith in Venice in 1750-1, and kept up a correspondence with him;[2] and in his will Smith left him copies of three books which were being printed at Smith's expense. Yet nowhere in such documents as survive is Smith mentioned in connexion with the paintings. There is less ground for the assumption, sometimes made, that Smith was the intermediary in the sale of such groups of paintings as those belonging to the Duke of Bedford, to Earl Fitzwilliam, and formerly to the Harvey Trustees and to the Earls of Carlisle. These were all acquired in the thirties; but there is no positive evidence indicating that their respective purchasers dealt through Smith.[3]

It has been suggested that Smith not only acted as intermediary, but acquired paintings by Canaletto in order to resell them; but here again, there is no substantial evidence. One argument that has been put forward is that the twenty-four paintings engraved by Visentini and published in 1742 in the second and third parts of the *Prospectus Magni Canalis* all originally belonged to Smith, as did the originals of the fourteen plates in the first part, which had been issued separately in 1735 (see under Engravings). In favour of this is the fact that the title-page of the 1742 publication is virtually the same as that of the 1735 group, and includes the words 'in Aedibus Josephi Smith Angli'. This, however, is omitted from the title-page of the 1751 reissue of the thirty-eight engravings, as though a mistake had been detected and corrected. So the evidence of the engravings is inconclusive. That one of the paintings belonged to Smith is certain, from the fact that it went with his collection to George III. Of the others, a considerable number belong to the Bedford, Fitzwilliam, and Harvey Trustees groups, acquired in the earlier thirties by the ancestors of their modern owners, conceivably from Smith. But there is nothing to indicate that they were. Nor do contemporary statements about Canaletto and Smith do much to settle whether

[1] See below, p. 40. [2] *Memoirs of Thomas Hollis*, London, 1780, 32.

[3] There is, however, a presumption that nine of the Harvey paintings belonged to Smith (see note on no. 188 below).

Smith was a seller as well as a buyer of Canaletto's work. When the Swedish Count Charles-Gustave Tessin visited Vienna and Venice in 1735–6 to find a painter to decorate the Royal Palace at Stockholm, one of his letters to Carl Hôrleman, superintendent of the building of the almost completed palace, contains a reference to Canaletto.[1] Writing on 16 June 1736, from Vienna, after having been in Venice in May, he reviews various Venetian painters, saying: 'Canaletti, Peintre de Vües, fantasque, bourru, Baptistisé, vendant un Tableau de Cabinet (:car il n'en fait point d'autres:) jusqu'à 120 sequins, et étant engagé pour 4 ans à ne travailler que pour un marchand Anglais, nommé Smitt. Cassé.' Tessin adds that he has bought several paintings in Venice, including 'une vue par Canaletti', most probably the painting now in the National Museum, Stockholm (see no. 204). He does not say, however, whether he persuaded Canaletto to disregard the alleged agreement with Smith, or whether he bought the picture from Smith or from someone else. His characterization of Canaletto up to a point agrees with that of McSwiney; but what he means by 'Baptistisé' is difficult to say. Parker (p. 8 n.) suggests that the word is a pun on *baptisé*, and may allude to somebody called Baptiste. This seems very likely, especially as the word is capitalized. Parker puts forward as a possibility Jean-Baptiste Monnoyer, the flower painter and decorator who was known as Baptiste, the reference being to his popularity or his temperament. This Baptiste, however, died in 1699, before either Tessin or Hôrleman was likely to have had any dealings with him. Popular and successful he certainly was; but we do not know that he had a reputation for being difficult, and that this was still a lively remembrance in men's minds. More possible would seem to be somebody in Swedish court or government circles, with whom both men had found it hard to deal.

The Président de Brosses[2] bears out to some extent Tessin's estimate of Canaletto's character, though there is no hint of any connexion with Smith.

Pour le Canaletto, son métier est de peindre des vues de Venise; en ce genre, il surpasse tout ce qu'il y a jamais eu. Sa manière est claire, gaie, vive, perspective et d'un détail admirable. Les Anglois ont si bien gâté cet ouvrier, en lui offrant de

[1] Siren, *Dessins et tableaux de la Renaissance italienne dans les collections de Suède*, 1902, prints the letters from the originals in the Royal Archives of Sweden.

[2] In a letter to de Neuilly, 24 Nov. 1739, when de Brosses was in Venice (Charles de Brosses, *Lettres familières écrites d'Italie en 1739 et 1740*, Paris, 1885).

ses tableaux trois fois plus qu'il n'en demande, qu'il n'est plus possible de faire marché avec lui.

Mariette (*Abécédario*, v. 190) says that Smith sold some paintings to the Elector of Saxony. Blunt (*Venetian Drawings at Windsor Castle*, 11) points out that the sale was in 1741, since Mariette mentions it in connexion with the marriage of Rosalba Carriera's pupil, Felicità Sartore, which took place in that year. Posse (*Staatliche Gemälde-Galerie zu Dresden*, 1929, xvi) says that in 1741 the Elector acquired seventy paintings in Venice, Bologna, Florence, and Rome; but which of these came from Smith is unknown; and the only Canalettos recorded by Posse as being acquired in that year came from the Wallenstein in Dux collection.

Horace Walpole has often been taken as giving decisive evidence of Smith exploiting Canaletto. He did not like Smith, to whom he refers contemptuously in a letter to Horace Mann (18 June 1744) as 'the merchant of Venice'; and writing to Richard Bentley on 3 November 1754, speaking of a Swiss painter in whom Bentley was interested, he says; 'If he improves upon our hands, do you think we [himself and John Chute] shall purchase the fee-simple of him for so many years, as Mr Smith did of Canaletti?' Miss Berry annotated and expanded this in 1798 by saying: 'Mr Smith, the English consul at Venice, had engaged Canaletti for a certain number of years to paint exclusively for him, at a fixed price, and sold his pictures at an advanced price to English travellers.' This is simply an echo of Walpole himself, since in his *Visits to Country Seats* (*Walpole Society*, xvi, 1927–8, 79), writing of the Canalettos in the Queen's House in St. James's Park (Buckingham House), he says: 'These Canaletti's are bolder, stronger, & far superior to his common Works; & either done before he engaged with Mr Smith, or particularly for him. Mr Smith engaged him to work for him for many years at a very low price & sold his works to the English at much higher rates.'

This seems to be all the evidence available.[1] Tessin in 1736 and Walpole in 1754 both say that an arrangement existed for a number of years (Tessin says four) that Canaletto should work only for Smith; Walpole alone says that Smith resold the work at much higher rates. Yet Tessin himself, and

[1] It may be noted that the Gradenigo diary, though it has references to Smith, does not mention him in connexion with Canaletto.

de Brosses, seem to imply that Canaletto was free to sell at high prices and did so. Canaletto was no simple soul, easy to exploit. He knew that his work was in demand, and he knew how to secure high prices for it. It seems very unlikely that he would enter into any restrictive arrangement with Smith, unless it was to his own advantage, which it might well have been by securing a steady customer for at least a part of his output; but that he would have allowed his paintings to be resold at a handsome profit by Smith, when other people were waiting to buy from him, seems very improbable. That he and Smith, however, had some working arrangement, by which Smith acted as intermediary or salesman, and took a commission, is quite conceivable; and may be the origin of the story told by Walpole. On such a supposition, Smith's position as patron, collector, and man with a sharp eye to business can be reconciled with Canaletto's temperament and sense of his own value.

One episode in the relations of Smith and Canaletto is apt to be forgotten. The outbreak of the War of the Austrian Succession in 1741, and the resulting military operations in Italy in 1742, caused a fall in the number of visitors to Venice, and therefore of purchasers of works of art. Canaletto, probably faced with a declining market for his paintings, at this period developed alternatives to views of Venice, in the shape of capricci, Roman subjects, views of the Brenta and of Padua, and etchings. At Windsor, all bought from Smith, were thirteen capricci intended as overdoors; six large paintings of Roman monuments and one small one; and thirty drawings of the Brenta and Padua. Also, the set of the etchings owned by Smith, also at Windsor, is the most complete one known, while there is some reason to think that they were the result of a commission from Smith (see Vol. II, Sect. D). All these productions are dated or datable in the first half of the forties; and it seems likely, therefore, that at probably a difficult time Smith gave Canaletto substantial help.

There is no need here to dwell much longer on Smith. In 1744 he was appointed British Consul in Venice.[1] Some years before this (Parker says in

[1] The date was, until recently, always given as 1740, even by Parker. F. J. B. Watson (review of Parker, *Burl. Mag.*, Aug. 1948, 241) seems to have been the first to doubt it; and these doubts have been confirmed by the discovery in the Record Office (State Papers, Foreign, Venice [S.P. 99], vol. 64) of

1740) Smith had acquired a small palace on the Grand Canal, in the contrada of SS. Apostoli, facing the Fish Market across the Canal.[1] This was reconstructed, wholly or in part, by Visentini, work on it being begun before 1743;[2] and on 22 October 1751 Pietro Gradenigo records in his diary that the palace was 'oggi scoperta [the matting removed from the scaffolding] e comendata et era ottimamente addobbata ad uso di sua nazione'. In fact, there is no record that the British Government acquired the palace. Here Smith housed most of his library and collections, which seem to have been freely open to visitors. F. J. B. Watson notes that the interior was decorated in contemporary English style, the furniture having been sent from London.[3]

Smith evidently did his best to ingratiate himself with visitors to Venice. Martin ffolkes, writing in 1733 from Venice to the Duke of Richmond, says that he has had 'the greatest civility on your Grace's account both from the Resident and Mr Smith, with whom he being known to you has set me on a very different foot from the generality of travellers'.[4] But his assiduity annoyed Lady Mary Wortley Montagu, who wrote to the Countess of Bute on 13 May 1758: 'I beg you would direct the next box [of books] to me, without passing through the hands of Smith; he makes so much merit of giving himself the trouble of asking for it, that I am quite weary of him; besides that he imposes on me in everything.'

Smith had hoped to be appointed Resident in succession to Sir James Gray,[5]

two letters from Smith in Venice to the Duke of Newcastle, dated 5 June and 19 June 1744, in the first of which he discusses the ceremonial to be observed 'in producing the commission with which I am honour'd,' and in the second reports that he had presented the commission and a memorial to the Senate, which had been accepted and approved in due form (see also Chaloner, op. cit., 1950, where this information is first published, with acknowledgement to Watson).

[1] Parker says that Smith had previously leased the palace from a member of the Balbi family. G. Lorenzetti (*Venezia*, 1926, 613) says it was on the site of the former Soranzo house. In 1784 it was acquired by Count Giuseppe Mangilli, two stories added, and the interior reconstructed. It is now known as the Palazzo Mangilli-Valmarana.

[2] In a painting by Marieschi (d. 1743) in the Fitzwilliam Museum the palace is seen in course of reconstruction.

[3] *Burl. Mag.*, July 1948, 188, quoting Madame de Boccage, *Letters concerning England, Holland and Italy*, 2 vols., London, 1770, 146–7.

[4] Earl of March, *A Duke and his Friends*, London, 1911, i. 250.

[5] See Parker, p. 14, quoting a letter of Smith's in the British Museum (Add. MS. 32,834, f. 133).

but was passed over in favour of John Murray, whose sister he married in 1758, after attempts in other directions. In the letter quoted above, Lady Mary Wortley Montagu describes her as 'a beauteous virgin of forty, who after having refused all the peers in England, because the nicety of her conscience would not permit her to give her hand when her heart was untouched, she remained without a husband till the charm of that fine gentleman, Mr Smith, who is only eighty-two, determined her to change her condition'.

In 1760 Smith retired from being consul and shortly afterwards negotiations for the purchase of his collections by George III began; and in a letter of 13 July 1762, in connexion with these, he expressed his intention of returning to London when the sale had been concluded. Whether he did so, is unknown; but the fact that he died in Venice in 1770 makes it unlikely. How much he saw of Canaletto in these later years is unknown, though he seems to have acquired drawings from him, after his return from England; but the evidence (or rather, lack of it) points to his having acquired no more examples of his work after the sale to George III.

Documentary references to Canaletto in the thirties are few. He was apparently a member of the Collegio dei Pittori,[1] which at that time used to meet in the Scuola di S. Domenico in the cloisters of SS. Giovanni e Paolo. On 15 January 1735 Antonio Canal and Domenico Claverino were candidates for election as Prior; but against the name of Antonio Canal is noted 'non può esser P[rior]. esser fig° [figliuolo] di Famiglia', and at the end of the record of the various elections is written, 'Fu dato ordine alla prima ellegione di [?] ellegger Prior in vece di Ant° Canal che non si ballotta p esser figliolo di famiglia'. This is puzzling, since 'figliuolo di famiglia' ordinarily means a son under age, which Canaletto certainly was not. Can it mean that he lived with his parents, and having no establishment

[1] This was a professional organization which in 1679 had developed out of the guild which covered a large variety of arts and crafts. Its records (consisting of *Parti* and *Capitoli*) are in the Archivio di Stato, Venice. Of the *Parti* little is preserved; the *Capitoli* chiefly record the annual election of a committee of twelve—a Prior, two consiglieri, three conservatori, three sindici, three tansadori. By 1763 the Collegio had moved its headquarters to a room in the Fonteghetto della Farina. In 1779 it was apparently dissolved. I am greatly indebted to Mr. Terence Spencer for transcribing the relevant entries.

of his own, was therefore ineligible? In any case, Bartolo Nazari was elected Prior by sixteen votes against ten for Claverino.

Official documents also have few references to Canaletto. Most of them are in connexion with payment of the *decima* (tax); and occasionally there is a risk of confusing him with other members of the family, owing to similarity of names.[1] The first time he is specifically mentioned is in a document of 11 September 1738, when as 'Domino Antonio Canal di Bernardo' he undertakes financial obligations arising out of a lawsuit with his father, Regina Bolani (the widow of his uncle Cristoforo), her children, Antonio and Giovanni Batista, and his mother Artemisia.[2]

Earlier documents (see pp. 2–3) imply that the Canal family lived in the contrada of S. Lio, where Artemisia Canal owned two houses. There is, however, a document which records that on 1 October 1738 Signor Bortolo and the brothers Lamberti let a house in the Barbaria delle Tavole (perhaps the Barbaria delle Tole of today) in the contrada of Sta. Maria Formosa, to Signor Antonio Canal, the annual rent being 55 ducats;[3] and on 23 September 1740 Giovanni Lamberti affirms this to be the rent.[4] Whether this Antonio is Canaletto or his cousin there is no means of knowing; though the lawsuit may explain Canaletto's living away from his family at this time. Another document implies, however, that perhaps he may have rejoined them; for on 27 August 1739, as 'Antonio de Bernardo Canal', he signs on behalf of his sisters and his cousins an affirmation for tax purposes concerning two houses in the contrada of S. Lio, one used by the parties to the affirmation, the other let to Domenico Coronato for 40 ducats.[5] These are presumably the two houses which belonged to Artemisia Canal (see p. 5). A further affirmation on behalf of the same people concerning the house that was let was made on 10 September 1739, but this time signed by 'Antonio Canal quondam Christofolo', i.e. by Canaletto's cousin, which perhaps implies that Canaletto was no longer concerned in the matter.[6] That Artemisia was still alive is indicated by a document of

[1] Reference to the genealogical table on p. xv may help in reading the following pages.
[2] E.N. Reg. n. 152a, 1738–9, p. 20.
[3] D.S. Estimo 1740, Registro di S. Maria Formosa, vol. n. 435.
[4] D.S. B.I. 306, cart. n. 318, fasc. n. 557.
[5] D.S. B.I. 305, cart. n. 317.

[6] Ibid.

28 September 1739, by which 'Antonio e sorelle Canal di Bernardo' and their cousins apparently made a payment to 'Temisia Barbieri consorte Bernardo Canal' on account of taxes.[1]

The property belonging to the Canal family as it was in 1740 is set out in another document.[2] This, for tax purposes, gives a numbered list of properties, with their occupiers, owners, and annual rent. The Canal properties are numbered 130–3. No. 130 was in the Calle di la Pissamano, was owned by Antonio di Bernardo, his sisters, and his cousins, and was let to Domenico Coronato for 80 ducats; no. 131, in the Corte Perina, was owned by 'Antonio Giovanni Battista e sorelle Canal', i.e. by Canaletto's cousins, who occupied it; no. 132, in the Corte Perina, was owned by the same group as no. 130, and was let to Giulio Conte Sbroja Vacca and Domenico Cima for 16 ducats; and no. 133, also in the Corte Perina, was owned by the same group as nos. 130 and 132, and was let to Niccolò Cigolato for 12 ducats. Thus Canaletto at this time lived in none of the family houses.

In 1741, apparently, Canaletto came to some arrangement with his family; but on 5 February 1741, 'Domino Zuan Antonio Canal di domino Bernardo' (the first time his full name appears in the present group of documents) notifies that he has made a settlement of all debts and credits for a sum of 100 ducats with Francesca Canal, her husband Francesco Triulcio, and with his three cousins.[3]

No further references to Canaletto and his family have been found in official documents until 1748, except for the record of his father's death in 1744 (see p. 7). These years, however, were important ones in Canaletto's working life. The War of the Austrian Succession had considerably disrupted the market for his work; and it is the period when he turned to the mainland and to Rome for subjects, and to etching as a medium, while in 1746 he went to England. Of patrons other than Smith there is little information. Probably, however, it was in the earlier forties that Canaletto painted four pictures which belonged to Sigismund Streit and were given by him in 1763 to the Gymnasium zum Grauen Kloster in Berlin (nos. 242,

[1] D.S. 1737–41. Registro 1404, p. 89.

[2] D.S. Estimo del 1740, cart. n. 435. Registro della parrocchia di S. Lio.

[3] E.N. Reg. n. 154a, 1740–2, p. 150. The Francesca in the text has not been identified. It cannot be his sister of that name, who never married (see documents relating to Canaletto's estate, below).

282, 359, and 360). One of these includes a view of the Palazzo Foscari, in which Streit lived and had his office; another represents the Campo di Rialto, which was probably the scene of many of his business operations; while the subjects of the other two are popular festivals seen by moonlight, the only known paintings of the kind by Canaletto. This, combined with the elaborate descriptions of the paintings in a catalogue of his collections compiled by Streit himself, which he also gave to the Gymnasium zum Grauen Kloster, points to the paintings being the result of a commission. Streit was a German merchant resident in Venice, who spent the later years of his life in Padua, but maintained close relations with Frederick the Great of Prussia. Except for the series formerly in the Liechtenstein collection, concerning which there is no documentary evidence, his set of paintings is the only one known to have been acquired in Venice by a foreigner, other than an Englishman.

A much disputed question is whether at this time Canaletto paid a second visit to Rome. Hermann Voss[1] was the first seriously to argue in favour of this, saying that for a large body of work Canaletto would not have relied on youthful studies or the work of other hands. Also, he sees at this point the influence of Pannini on Canaletto, which could not have occurred during Canaletto's early Roman visit. To support his argument he adduces a painting of the Spanish Steps, Rome (no. 404 below), pointing out that the Spanish Steps were built 1721–5, while the style of the picture is that of *c.* 1740, and the handling of the perspective and the slight breaks in the steps are against its being based on a design by someone else, such as the etching by Piranesi in the *Vedute di Roma*. Voss knew the painting only from a photograph, apparently made when it belonged to a Florentine dealer in 1884. In 1954, however, it appeared at Christie's, as by Bellotto; and careful scrutiny led to that attribution being accepted as unquestionably correct.[2]

In contrast, Fritsche[3] was unconvinced that Canaletto made a second journey to Rome, on the ground that he had enough material from his first visit to make his later work possible.

[1] *Rep. für Kunstwissenschaft*, xlvii, 1926, 21–22.
[2] Kozakiewicz 81 [see his opinion under no. 404]. [3] *Bernardo Bellotto*, 1936, 26.

Rodolfo Pallucchini[1] echoes the argument of Voss that the exactness and fidelity of the Roman views of the forties could result only from a second visit. He sees in them and in some etchings the influence of Pannini; and argues that the etchings fall into two groups, in one of which Roman motives are more conspicuous than in the other, which could be the result of an intervening visit to Rome. As noted in Vol. II, Sect. D, however, the distinction between the two groups is not as clear-cut as Pallucchini implies. Parker (p. 50) accepts the views of Voss and Pallucchini as plausible. F. J. B. Watson (*Canaletto*, 2nd revised edition, 1954, p. 8) appears tentatively to agree when he writes: 'That an artist, and especially one whose interest lay so entirely in natural appearances, should suddenly in the full maturity of his career take up youthful sketches entirely abandoned for so long seems improbable.' He also produces a new piece of evidence, a passage from an account of Smith and his collections at Windsor by W. H. Pyne.[2] Pyne writes: 'Canaletti was sent to Rome by this gentleman for whom he painted the views of that city which now form part of the Collection at the Queen's Palace at Buckingham House.' Watson argues that Pyne not only was 'an inveterate collector of the gossip of the art world', but seems 'to have had access to particularly reliable sources of information about Smith's career and his relations with Venetian artists', and cites an example of this. Those who have experience of Pyne's writings in other connexions will not, however, be noticeably ready to accept his reliability as a reporter.

Against the supposition of a second visit to Rome are various arguments. One is the absence, so far as is known, of any references in official documents to Canaletto's being in Rome in the early forties.[3] That a young man going there some twenty years earlier should not be mentioned is not too surprising; but that the visit of a well-known artist of high reputation should not be recorded is curious, to say the least. Again, none of the secondary authorities who were Canaletto's contemporaries—Orlandi, Zanetti, and Mariette, of whom Zanetti and Mariette knew him personally—mentions a

[1] Pallucchini–Guarnati, *Les Eaux-fortes de Canaletto*, 1945, 27, 28. Pallucchini reiterates his views in *Pittura veneziana del Settecento*, pt. ii, 1952, 119, claiming the support of Parker and Watson (see below).

[2] In *History of the Royal Residences*, London, 1819, i. 115.

[3] Sources consulted for the relevant years include those mentioned on p. 10.

second visit to Rome, though they all record his going to London.[1] So the arguments in favour of a second visit mainly rest upon the unlikelihood or the impossibility of Canaletto producing his series of Roman paintings and drawings without going to Rome again; since the evidence of the etchings is inconclusive, similarities with the work of Pannini too superficial to prove personal contact,[2] and Pyne's trustworthiness doubtful.

The close relation between the Roman drawings and paintings of the forties, and the early drawings of the twenties, is not always realized.[3] Among drawings, *The Tiber with the Ponte Rotto* (no. 728) corresponds with no. 240 in the early series; *The Forum* (no. 714) with no. 226; *The Arch of Constantine* (no. 716) with no. 222; *The Caldarium of the Baths of Caracalla* (no. 718) with no. 232; *The Temple of Venus and Rome* (no. 720) with no. 237; *SS. Domenico and Sisto* (no. 724) with no. 234; *Piazza of S. Giovanni in Laterano* (no. 727) with no. 241; *The Colosseum* (no. 721) with no. 235; *Pyramid of Cestius* (no. 722) with no. 230. Two other drawings, *The Temple of Antoninus and Faustina* (no. 715) and *The Arch of Septimius Severus* (no. 717) are related to engravings by du Pérac. Thus, a probable source of derivation for many of the Roman drawings of the forties is known. Among paintings, the proportion of identifiable sources is smaller. *The Forum looking towards the Capitol* (no. 379) is related to no. 224 in the early series; *The Forum with the Basilica of Constantine* (no. 380) to no. 226; *Temple of Antoninus and Faustina* (no. 381) to no. 225; *Arch of Constantine* (no. 382) to no. 222; *Arch of Septimius Severus* (no. 385) to no. 223; *Piazza of S. Giovanni in Laterano* (no. 400) to no. 241; *The Colosseum* (no. 388) to no. 235. In addition, *The Cordonata* (no. 397) corresponds with an engraving by Alessandro Specchi.

Thus, for a considerable proportion of his later Roman work, Canaletto had available as models drawings by himself or engravings by others; and it would be hard to say that he did not have similar help for the remainder. The next question is whether he had the ability to produce what he did from such material. Those who doubt this seem to underrate his capacity. Anyone who has seen a contemporary painter using sketches, sometimes

[1] A search in Venetian newspapers of the period has also failed to produce any evidence.
[2] See p. 67.
[3] In this connexion, it does not matter whether the early drawings are originals or copies.

made long ago, to construct a painting can scarcely doubt that Canaletto could perfectly well adapt perspective, vary light and shade, add to details, and introduce figures in any design on which he was working; all such changes or additions being of the type which for years he had been accustomed to make in his Venetian work. The Roman work, moreover, is not Canaletto at his best, tending to be somewhat hard and mechanical. Most of it was done for Smith, and there is reason to think that it may have been in the nature of a stopgap (see p. 122), rather than a deliberate launching out into a new and important field.

On the whole, therefore, the case for Canaletto making a second visit to Rome seems not proven. [Kozakiewicz, p. 69, is also convinced by the arguments against a second visit.]

Whatever the final conclusion may be, it is known that Canaletto was in Venice in the earlier part of 1745, from the drawing at Windsor representing the Campanile under repair after it had been damaged by lightning, which Canaletto notes on the drawing was on 23 April 1745 (see no. 552).

The following year he went to England. Concerning this visit, an ample and authoritative account is given by Mrs. Finberg, in the *Walpole Society Journal*.[1] In this are cited in their entirety the entries relating to Canaletto in the notebooks of George Vertue in the British Museum, the most important source of information, though Orlandi, Zanetti, and Mariette all mention the visit. Vertue was a contemporary of Canaletto whose vast collection of material relating to art and artists in England has proved remarkably accurate whenever it could be tested.[2]

In a note written in 1746, Vertue says,

Latter end of May came to London from Venice the Famous Painter of Views Cannalletti . . . of Venice. the Multitude of his works done abroad for English noblemen & Gentlemen has procured him great reputation & his great merrit & excellence in that way, he is much esteemed and no doubt but what Views and works He doth

[1] Vol. ix, 1920–1; ibid. x. 1921–2, giving additions and corrections. This pioneer article is and is likely to remain the chief authority on Canaletto in England; and the account in the text is necessarily largely a summary thereof, though some material is added which has come to light since Mrs. Finberg wrote.

[2] The notebooks, with an index, have been published at intervals by the Walpole Society, and grouped together as *Vertue*, i–v. References below are to these volumes.

here, will give the same satisfaction—though many persons already have so many of his paintings—[1]

As to why Canaletto came to England, Mrs. Finberg is probably right in saying that in general it was due to there being little business for him in Venice, owing to few English people visiting Italy on account of the War of the Austrian Succession; and Vertue, writing in October 1746 about the reasons for Canaletto's visit, suggests the same thing by adding to his entry, 'or that of late few persons travel to Italy from hence during the wars'.[2] He gives as additional reasons that

Signor Canaletti (a sober man turned of 50) . . . as he had done at Venice many nay multitudes of paintings for English Noble & Gentlemen and great numbers bought by dealers and sold here gave him a desire to come to England. being persuaded to it by Sig[nor] Amiconi History painter at his return to Venice coud best acquainted him with his success here, and also of the prospects he might make of Views of the Thames at London. of them he has begun some views. its said he has already made himself easy in his fortune and likewise that he had brought most part to putt into the Stocks here for better security. or better interest than abroad—[3]

It is also said that three noblemen, one of them the Duke of Beaufort, were responsible for bringing Canaletto over to England and for paying his expenses while he lived here.[4]

With him Canaletto brought a letter from Consul Smith to Owen McSwiney asking for an introduction to the Duke of Richmond. McSwiney apparently went to Tom Hill, former tutor to the Duke, who wrote to the Duke: 'I told him the best service I thought you could do him w[d] be to let him draw a view of the river from y[r] dining-room which would give him as much reputation as any of his Venetian prospects.'[5] The result was the two views from Richmond House (nos. 424 and 438) belonging to the present Duke of Richmond.

Canaletto soon found another important client, Sir Hugh Smithson, later

[1] Walpole Society, *Vertue*, iii. 130. [2] Ibid. 132.
[3] Jacopo Amiconi [Amigoni] arrived in England 1729 and left in 1739. There he planned to publish a set of prints after Canaletto, and had engravers in his house (Walpole Society, *Vertue*, iii. 92). The project apparently came to nothing.
[4] Osbert Sitwell, *Left Hand, Right Hand*, 1946, 73.
[5] Earl of March, *A Duke and his Friends*, 1911, ii. 602.

second Earl and first Duke of Northumberland, painting for him in 1747 *London through an arch of Westminster Bridge* (no. 412), *Westminster Bridge under construction* (no. 434), and *Windsor Castle* (no. 449); and in the same year he also painted a *Thames and Westminster on Lord Mayor's Day* (no. 435, Paul Mellon). To about this period also belong the two views of the Thames painted for Prince Lobkowicz (nos. 425 and 426), probably an unexpected client who wanted souvenirs of his stay in London. Evidently, Canaletto's expectations in coming to London were justified. Also, it must have been at about this time that the Elector of Saxony invited him to Dresden; for Mariette (*Abécédario*, i. 114) writes that 'Le Roi de Pologne, Electeur de Saxe, n'ayant pu avoir l'oncle, a fait venir à Dresde le neveu', and it was in 1747 that Bellotto arrived in Dresden.

The next reference to Canaletto is in the Venetian records. On 28 October 1748 a declaration of tax is made on the house let to Domenico Coronato (see above, p. 28) and one used by the parties to the document; the parties being described as 'Zuan Antonio Canal e sorelle quondam Bernardo, e Antonio e sorelle Canal di Bernardo, e Antonio e Zuan Battista Canal quondam Cristofolo'.[1] This raises a problem. Zuan Antonio Canal quondam Bernardo cannot be anyone but Canaletto; Antonio e Zuan Battista Canal quondam Cristofolo are his cousins; but the Antonio e sorelle Canal di Bernardo are difficult to explain. A suggestion that the document had been carelessly transcribed from earlier ones, and that an earlier description of Canaletto and his sisters, before his father's death, had been retained, together with the correct description, is unconvincing, since the two groups of names appear together in later documents. In any case, there is no need to assume that Canaletto was in Venice in 1748. His name was probably included in the document as part owner of the property concerned.

More definite and more interesting news is given by Vertue in June 1749.[2] He writes that in addition to producing views of London, Canaletto has also painted 'in the Country for the Duke of Beaufort, Views of Badmington' (see nos. 409 and 410). Vertue goes on to say:

[1] D.S. Giornali traslati. Cassier a. 1746–9, Registro n. 1407, p. 148.
[2] Walpole Society, *Vertue*, iii. 149.

on the whole of him something is obscure or strange. he dos not produce works so well done as those of Venice or other parts of Italy. which are in Collections here. and done by him there. especially his figures in his works done here, are apparently much inferior to those done abroad. which are surprizeingly well done & with great freedom & variety—his water & his skys at no time excellent or with natural freedom. & what he has done here his prospects of Trees woods or handling or pencilling of that part not various nor so skillfull as might be expected. above all he is remarkable for reservedness & shyness in being seen at work, at any time, or anywhere. which has much strengthend a conjecture that he is not the veritable Cannelleti of Venice. whose works there have been bought at great prices. or that privately there, he has some unknown assistant in makeing or filling up his . . . of works with figures—.

Only a month later, in July 1749, Vertue himself supplied information which had given colour to the rumour.[1]

at last after some time I heard how that difficulty, was spread about that this man was not the person so fam'd in Italy at Venice. it seems his name and family was Canali—so he always was called—he had a sister who had a son who having some Genius. was instructed by this his uncle Cannali. and this young stripling by degrees came on forward in his proffession being taken notice of for his improvements he was called Cannaleti—the young. but in time getting some degree of merrit. he being puffd up disobliged his uncle who turned him adrift. but well Imitating his uncles manner of painting became reputed and the name of Cannaletti was indifferently used by both uncle and nephew—from thence the uncle came to England and left the nephew at Venice so that this caused the report of two Cannelittis which was in this manner.[2]

A possible source of the rumour's origin is supplied by Edward Dayes, the water-colour painter.[3]

The picture dealing tribe carried their assurance so far, as to deny that *Cannaletti* was the person who painted his pictures at Venice, that is, on his arrival at London and

[1] Ibid. 151.

[2] Apart from anything else, this note throws an interesting sidelight on the relations of Canaletto and Bellotto, of which there seems to be no record elsewhere. Vertue does not say where he got the information, which may be mere gossip; but bearing in mind what is known of Canaletto's temperament the explanation of the breach with his nephew is quite possible. Incidentally, Mrs. Finberg says (p. 32) that when Vertue states that Canaletto came to England and left his nephew in Venice, he appears to have been misinformed, since 'competent authorities maintain that Bellotto was already in Munich in 1745, having left Venice some time before'. In fact, it seems that Bellotto was in Venice in 1745, did not go to Dresden until 1747, and was not in Munich until 1761 (cf. Fritzsche, *Bernard Belotto*, 1936, pp. 28, 107, 108, 116). He could conceivably therefore have been in England in 1746, though there is not the slightest evidence that he was; and after that year, until his death, he was in Germany and Poland. [3] E. W. Brayley, *The Works of the late Edward Dayes*, 1805, 322.

when, by the provocation, he was tempted to sit down and produce some to con-
vince the public, they still persisted that the pieces now produced were not in the
same style; an assertion-which materially injured him for a time and made him almost
frantic. By this scheme they hoped to drive him from the country, and thereby to
prevent him detecting the copies they had made from his works, which were in
great repute.

Dayes was not born until 1763, and so could have no first-hand knowledge
of what had occurred; and his telling of the story smacks of the over-
dramatization which marks anecdotes of the period. The substance of what
he says, however, may well be true.

In any case, Vertue's note had a curious repercussion at the end of the
nineteenth century. H. P. Horne,[1] writing of two paintings recently acquired
for the National Gallery (*Interior of the Rotunda at Ranelagh*, no. 420; *Eton
College*, no. 450), groups them with an *Alnwick Castle* (no. 408) as by the
same hand but not that of Canaletto, on account of their inferiority in
workmanship. In support of this, noting that the Ranelagh picture was
painted in 1754, he stated that Canaletto only stayed two years in England,
evidently relying on Horace Walpole,[2] and then quoted Vertue's first note
recording the rumour that the painter who was in England was not the
'veritable Cannelletti of Venice'; finally concluding that this man was an
impostor. Evidently he had not read Vertue's second note, and ignored
or was ignorant of other evidence as to Canaletto's coming to England.

That the story of Canaletto being an impostor 'materially injured him
for a time' is suggested by his taking steps to call attention to himself.
Vertue records in the note of July 1749, which has been already quoted:

Cannaleto the perspective painter of Venice. it may be supposed that his shyness
of showing his works doing—or done. he has been told of—and therefore probably.
he put this advertisement in the publick news papers

> Signor Canaleto hereby invites any Gentleman that will be pleased to come to
> his house to see a picture done by him being a View of St James's Park. which he
> hopes may in some manner deserve their approbation any morning or afternoon
> at his lodgings Mr Wiggan Cabinet maker in Silver street Golden Square.[3]

[1] *Magazine of Art*, 1899, 243 sqq.
[2] *Anecdotes of Painting*, 1876 ed., ii. 333. 'I think he [Canaletto] did not stay here above two years.'
[3] Mrs. Finberg reprints the advertisement as it appeared. The only substantial difference from Vertue's
version is that the times when the picture can be seen are given as 'Nine in the morning till Three in

Silver Street, in which Canaletto lodged, ran north of Golden Square, near Regent Street, and in 1883 its name was changed to Beak Street. From the rate-books, Mrs. Finberg has ascertained that Richard Wiggan's house was on the north side of the street, was later numbered 16 Silver Street, and is now 41 Beak Street. A short time before she wrote, there was still an old studio or workshop with a skylight, in the garden behind the house.[1]

The painting of St. James's Park has not been identified. It seems likely, however, to have been one of the paintings of the Old Horse Guards, pulled down in 1749 (nos. 415 and 416). This painting was apparently painted as a speculation, to attract clients; and in the same year, 1749, Canaletto apparently found a new patron, Bishop Wilcocks, Dean of Westminster and Dean of the Order of the Bath. Through him, the painting of the *Procession of Knights of the Bath at the Installation of June 26, 1749* came to Westminster Abbey, and is likely to have been commissioned by him. Meanwhile, Sir Hugh Smithson continued his patronage, for in July Canaletto was painting for him a view of Syon House (no. 440). When he made for Francis Greville, Lord Brooke, the group of paintings and drawings of Warwick Castle (nos. 445–7) is uncertain; but style indications and the proximity of Warwick to Badminton suggest the same year as the Badminton paintings.

The advertisement seems to have served its purpose well enough for Canaletto to use the same means to announce the painting of another picture. In the *Daily Advertiser* of 30 July 1751 appeared the following:

Signior Canalleto/Gives Notice that he has painted the Representation of Chelsea College, Ranelagh House, and the River Thames, which if any Gentlemen and others are pleased to favour him with seeing the same, he will attend at his Lodgings at Mr Viggan's, in Silver Street, Golden Square, for fifteen days from this Day, the

the afternoon, and from Four till Seven in the Evening for the Space of fifteen days from the publication of the Advertizement'. Despite some opinion to the contrary, Mrs. Finberg thinks the paper was the *Daily Advertiser*. This is confirmed by an entry in one of Farington's sketch-books of 1801 (Victoria and Albert Museum P. 88–1921) in which the advertisement is copied out in full, with the heading 'From the Daily Advertiser July 25 1749'.

[1] Though there is no question that Canaletto lived in Silver Street, and continued to do so for some time, it is interesting to note that Mr. J. P. Heseltine told the writer orally that he had several times heard from Lord Carlisle that Canaletto used to stay at Dover House (now the Scottish Office) facing the Horse Guards Parade, at that time occupied by Lord Clifden, an ancestor of Lord Carlisle.

31st of July, from Eight o'Clock in the morning to One in the Afternoon, and from Three in the Afternoon to Six at Night, each Day.[1]

The painting exhibited is the one now divided into two pieces, one in England, the other in Mexico (see no. 413). This is the second known case of Canaletto apparently painting a picture at a venture; a third possible case being the large view of Whitehall looking north, now belonging to the Duke of Buccleuch (no. 439). The idea, therefore, that Canaletto worked in England only on commission has to be given up.

The advertisement quoted above is duly recorded by Vertue in a note of August or early September:

Lately . . . Canaletti painter has painting a large picture a View on the River Thames of Chelsea College. Ranelagh garderns &c. an parts adjacent. with barges & boats figures—this he exposed to publick View at his Lodgings—being a work lately done to shew his skill—this valud at 60. or 70 pounds. haveing made a Tour to his own Country at Venice for some affairs there—in 8 months coming and going. it is tho^t that this View is not so well as some works of Canaletti formerly brought into England. nor does it appear to be better than some painters in England can do—[2]

The main interest of this note is that it is the earliest reference to Canaletto returning to Venice for a time during his residence in England and gives precision to the account in Orlandi (*Abecedario*, 1753 ed.) which reads:

Fece un viaggio in Londra dove fermatosi quattro anni, ebbe continuamente occasione da quei Signori di produrre nuovi parti del suo industrioso pennello. Ritornato in patria dove presentemente trattiensi. porto con se varj abbozzi delle vedute e dei siti più riguardovoli de quell' ampia Città, i quali con suo comodo è da sperare, ch'ei vorrà consignare alle tele. Ora nuovemente è ritornato in Londra.[3]

Zanetti is more vague, but agrees with Vertue and Orlandi when he says: 'Passò due volte in Londra dove dimorò e dipinse per molti anni; e acquistò

[1] Reprinted by Mrs. Finberg from Lysons's *Collectanea*, in the British Museum. Lysons gives the date of its appearance as 30 July 1751, which agrees with that given in the transcript in Farington's sketch-book of 1801 in the Victoria and Albert Museum. The advertisement, however, seems to say that the date was 31 July.

[2] Walpole Society, *Vertue*, iii. 158. Vertue's criticism of the painting is interesting, in view of the fact that until recently the left part was attributed to Samuel Scott, and exhibited as by him.

[3] As Mrs. Finberg notes (p. 37), this account was probably written a year or two before 1753, the date of publication of Orlandi's book.

gloria e danari.' Mariette writes to the same effect: 'Il a fait deux voyages à Londres, et il y a rempli ses poches de guinées.'

The fact of a temporary return to Venice may be taken as established. As regards the length of the stay there, the advertisement in the *Daily Advertiser* makes it certain he was back before the end of July 1751. An earlier date is suggested by an engraving by Nathaniel Parr after Canaletto (see Engravings, Vol. II, Sect. E) which is inscribed 'A View of the Rotondo House & Gardens at Ranelagh, with an exack representation of the Jubilee Ball as it appeared May 24th 1751 being the Birth Day of his Royal Highness George Prince of Wales'. As Mrs. Finberg says: 'This seems to show that if Canaletto drew "an exact representation" of the ball on May 24, he must have returned from his visit to Venice by that date.' Suspicion is, however, aroused by there being another engraving, also by Nathaniel Parr, published on 2 December 1751, in which the buildings and gardens are exactly the same as in the engraving of the Jubilee Ball. The Jubilee Ball engraving has no date of publication; and conceivably Canaletto's drawing for this could be a repetition of his drawing for the other engraving, the 'exact representation' of the figures being based on somebody else's notes or description.

In any case, if Vertue's statement that Canaletto was away eight months is accepted, he must have left England not later than towards the end of November 1750, and possibly towards the end of September.

The next reference to Canaletto's stay in England is in the diary of Pietro Gradenigo, who on 28 July 1753 notes: 'Antonio Canaletto Veneziano celebre Pittore da Vedute ritorna da Inghilterra in Patria.'[1]

F. J. B. Watson,[2] noting inscriptions on paintings and drawings which say that they were made in London in 1754 and 1755, argues that Canaletto must have gone back to London after his return to Venice in 1753, and remained there until his final departure. Pallucchini[3] holds, however, that he remained in Venice from 1753 onwards; and with Orlandi's statement in mind that Canaletto brought back to Venice from London various sketches

[1] References to art and artists in the diary, which previously had to be extracted from the original manuscript in the library of the Correr Museum, have been made readily available by Dr. Lina Livan in *Notizie d'arte tratte dei notatori e degli annali del N. H. Pietro Gradenigo*, Venice, 1942.

[2] *Canaletto*, 1954, 9. [3] *Pittura Veneziana del Settecento*, ii, 1952, 129.

of that city, that the canvases stated to be painted in London in 1754 were in fact painted in Venice from drawings, and then sent to England.

This thesis is, however, difficult to maintain. Among the paintings on which Watson bases his case are some of those which belonged to Thomas Hollis. The history of these is fully known until they were sold at Christie's in 1884, since when one of them has not been traced. Hollis was a man of some means, a strong radical with republican sympathies, who vigorously supported the cause of the American colonies, and was a considerable benefactor to Harvard University. He was also an ardent collector, mainly of books, engravings, and medals connected with his political enthusiasms, though he occasionally acquired paintings by contemporary artists. With his friend Thomas Brand he was in Venice from 8 December 1750 to 28 February 1751, where he met Joseph Smith, with whom he kept up a correspondence after his return to England[1] and who left him copies of certain books in his will.[2] Canaletto was not in Venice when Hollis was there, but it seems likely that he was recommended to Hollis by Smith, though there is no evidence.[3]

On the back of three of the Hollis pictures were inscriptions in Canaletto's hand, which were transcribed by a later owner (see Chapter II and nos. 396, 420 and 441).[4] The significant fact in the present connexion is that in two cases the inscription says: 'Fatto nel anno 1754 in Londra . . . ad instanza del signor cavaliere Hollis . . .', in the third case the year being apparently 1755. Hollis was in London in 1754 and 1755; and it is difficult to believe that he would have ordered paintings from Canaletto in Venice, and that Canaletto would then have written on the back that they were painted in London. Other paintings and drawings give similar evidence. A *Walton Bridge* (no. 442) is inscribed under the lining canvas, 'Fatto nell' anno 1755 in Londra . . . ad instanza del Signor Cavaliere Dickers';[5] and on a drawing of the same subject (no. 755) is written in Canaletto's hand: 'Disegnato da mi Antonio

[1] *Memoirs of Thomas Hollis*, London, 1780, 32–33. [2] Parker, p. 60.

[3] Unfortunately, the unpublished diary of Hollis in which he mentions artists with whom he came into contact begins in 1759, when Canaletto was back in Venice.

[4] There is reason to believe that two other paintings carried similar inscriptions.

[5] 'Dickers' was Samuel Dicker, M.P., who is not known to have visited Italy or to have had correspondents in Venice.

Canal . . . appresso il mio Quadro Dippinto in Londra 1755.' Supporting, though less explicit, evidence is that one of the paintings, *A Sluice on a River* (no. 475), which was among the paintings acquired by Baron King and descended in the family of the Earls of Lovelace, is dated 1754. The family tradition is that these paintings were commissioned from Canaletto; and there seems to be no record that Baron King or his relatives had any dealings with Venice.

To assume that all these paintings were among those that Orlandi hoped would result from Canaletto transferring to canvas sketches he had brought from England seems to go beyond reason. At the same time, Orlandi's remark does help to explain how the six drawings and two paintings of English subjects came into Smith's hands.

Venetian official records yield a few more facts about Canaletto at this period. On 1 October 1750 the whole family (including the unidentified Antonio and his sisters) is assessed for tax; and asks that the house in S. Lio let to Domenico Coronato should now be assessed as for their own use.[1] This transaction presumably did not need Canaletto's attendance; but he is recorded as being present at a more interesting one on 8 March 1751, where Lorenzo Pedron, Gastaldo; Marco Giorgietto, Sindico; and Francesco Pianetti, Sindico, sold 'al signor Zuanne Antonio Canal quondam Bernardo qui presente, et che per se, eredi e successori compra et acquista', a lease of the building called Scuola dei Luganegheri, situated in the contrada of San Baseggio on the Zattere.[2] For this, he paid 2,150 ducats at the rate of 6·4 lire; and the Scuola rented part of the building for 4 per cent. of the sum paid, 86 ducats per annum, also 43 ducats a month. Arrangements were made for Canaletto to be free from taxes; for cancelling the lease after five years; for meeting the claims of one Antonio Gianola on the Scuola; and, in the event of Canaletto dying without making a disposition of the property, for the 2,150 ducats to be invested on behalf of two of his sisters, Viena and Maria Angela, the name adopted by Francesca Marina, who was a tertiary in S. Francesco.

[1] D.S. 1749–52. Registro 1408, p. 82.
[2] Arte dei Luganegheri. Istrumenti a. 1751–3, cart. n. 232. The Scuola (that of the dealers in salted provisions) still exists on the Zattere.

This document not only provides one more piece of evidence that Canaletto was in Venice in the earlier part of 1751; but gives perhaps one reason for his returning there, and specifies one direction in which he invested the guineas he is reputed to have acquired in England.

In the same year, on 13 July 1751, the representatives of the Dieci Savi, assessors of taxes, report that the house in the contrada of S. Lio 'per andar al ponte di Cà Balbi', owned by 'Antonio e sorelle Canal quondam Bernardo', and formerly let to Domenico Coronato, should be assessed for tax on the basis of its being inhabited by the Canal family;[1] and on 5 October 1752 the tax is reassessed in consequence.[2]

For the remainder of Canaletto's stay in England the only source of information is his work. In addition to paintings mentioned above which were made for Thomas Hollis, Samuel Dicker, and according to tradition for Baron King, the number that can be precisely dated is small. There is satisfactory evidence, however, that paintings of Vauxhall Gardens, of the New Horse Guards, of Alnwick Castle, and of Northumberland House were made in 1752–3; and during the same years a number of drawings (see Chapter III). Of Canaletto's earlier clients, Sir Hugh Smithson, now Earl of Northumberland, remained faithful to him; but the indications are that his employment by the landed gentry was decreasing, without a corresponding increase from other quarters. Also, a considerable proportion of drawings seem to have been made for engravers (see Chapter IV), which suggests that they may have been commissioned by printsellers.[3]

That Canaletto was still in England in 1755 is witnessed by the inscription on the *Walton Bridge* painted for Samuel Dicker, and the drawing made from that picture. As to when he left, however, there is no evidence from either English or Venetian sources. Of his subsequent life in Venice, a certain amount is known. He continued to be active as an artist, since a few paintings and drawings are either dated or datable during these last years, and a number of others can, on stylistic grounds, be assigned to them (see Chapter IV). In or shortly before 1759, Canaletto painted a capriccio based on

[1] D.S. Serie delle terminazioni di sopraluogo o stima registrate, C. ii. 17. Registro n. 871, S. Lio.

[2] D.S. Giornali Traslati, Cassier dal 1752 al 1755. Registro n. 1409, p. 6.

[3] On stylistic and occasionally on other grounds a number of other paintings and drawings may be assigned to the later years of Canaletto's English stay. These are considered in Chapter IV.

Palladio's design for the Rialto Bridge and on various buildings of Vicenza, of which Algarotti wrote enthusiastically, but which has not been quite securely identified (see no. 458). A year later, in 1760, occurred a pleasant incident in which Canaletto was involved. This is related in detail in a book entitled *Barthomley*, by the Rev. Edward Hinchliffe, published in 1856, and the account is reproduced in full by Mrs. Finberg. The substance is that the writer's grandfather, John Hinchliffe (later Bishop of Peterborough), was travelling as tutor with John Crewe of Crewe Hall. In Venice the two saw a little man making a sketch of the Campanile, and Hinchliffe, recognizing a master-hand, ventured on the name 'Canaletti'; whereupon the artist replied 'mi conosce' and invited Hinchliffe to his studio, where Canaletto agreed to sell to him the painting about to be made from the sketch, and gave him the sketch itself. From Hinchliffe the sketch passed to his eldest son, from whom it was bought by Lord Crewe. Whether this sketch is the drawing which has descended in the Crewe family (see no. 528) is by no means certain; but there is no reason at all to doubt that the story is substantially authentic.

Much more important as witness to Canaletto's activity are the series of drawings representing various ceremonies and festivals in which the Doge took part, which originally numbered twelve, though only ten are known to have survived. They have been the subject of some controversy (see pp. 480–2); but all the evidence points to their being indubitably by Canaletto and to have been made in or before 1763. The last dated work by him that is known is also a drawing, an interior of S. Marco with musicians singing, now at Hamburg (no. 558). This is dated 1766, and carries an inscription in Canaletto's hand that it was made in his sixty-eighth year, 'Cenzza Ochiali', without spectacles.

To the previous year belongs his last signed and dated painting,[1] which he presented to the Venetian Academy after his election to that body in 1763 (see no. 509). Despite his reputation, both in Venice and abroad, he had failed to be elected earlier in that year.[2] The Academy had been founded early in 1756, as a centre for the regular instruction of artists, and had its

[1] Except perhaps the newly discovered no. 54★, also signed and dated 1763.

[2] Fogolari, 'L'Accademia Veneziana di Pittura e Scoltura del Settecento', *L'Arte*, Anno xvi, fasc. v, 241–72, 364–94. The present account, so far as it concerns the Academy, is entirely based on this important article.

headquarters in the Fonteghetto della Farina together with the Collegio dei Pittori. The number of members was fixed at thirty-six. Canaletto was not included among the original members, perhaps because he had been away from Venice, and because selection was heavily weighted in favour of figure-painters. In January 1763 his name was put up at an election to fill three vacant places, together with those of Zuccarelli, Pietro Gradizzi, Angelo Venturini, and Francesco Pavona; but Zuccarelli, Gradizzi, and Pavona were chosen. Fogolari suggests that the last two, mediocrities now forgotten, had an advantage over Canaletto in one being a figure-painter, the other a portrait-painter, both of whom had been employed at foreign courts. Whatever the reason, in consequence of the death of the President, Nogari, who was succeeded by Pittoni, there was another vacancy, to which Canaletto, described as 'valente e celebre professore, pittore di somma onestà e virtù', was elected by ten votes to four, in September 1763.

It is pleasant to record that in the same year he received further professional recognition in being elected Prior of the Collegio dei Pittori, while in 1764 he was among the first six members elected to the Committee of Twelve of that body. Of his duties and activities in the Collegio nothing is known; but he is recorded as being present at meetings of the Academy, and on one occasion he and a sculptor abstained from voting for a proposition that the works of old masters could only be judged by figure-painters. His last attendance was on 23 August 1767.

Canaletto died at about seven in the evening on 19 April 1768 of fever with inflammation of the bladder, which lasted about five days. He was buried in its communal tomb by the Confraternity of the Santissimo Spirito of S. Lio, as indicated by the contraction 'issimo' which heads the record of his death quoted below. He must have been a member of the Confraternity, though no specific record of this has been found. He was buried 'con Capitolo', i.e. with twelve priests and candles. In S. Lio there are three slabs inscribed ADDICTIS CULTUI S.S. SACRAMENTI, one at the west portal, two in front of the chapel south of the chancel. But there is no means of knowing beneath which his body was placed.[1]

[1] The documents which record Canaletto's death, and from which the above information is taken, are (cont. p. 45):

Canaletto died intestate. Twice, however, he deposited a will with the appropriate authority and twice it was withdrawn. The first deposit was on 1 December 1761, followed by a withdrawal on 5 February 1762 ('more Veneto') against a receipt, 'per restituirlo', by the notary Giovanni Pietro Cornoldi; the second, on 23 March 1763, was similarly removed, the same notary giving a receipt, also 'per restituirlo'.[1] In consequence, his estate was administered by the official Inquisitori all' Acque, whose actions are recorded in a series of documents, preserved in the Archivio di Stato.[2]

The first of these is dated 20 May 1768, and gives a detailed account of Canaletto's funeral and other expenses.[3] The funeral itself cost 687.10 lire; masses at S. Lio, S. Fantin, and S. Veneranda 57.12 lire; the doctor and the apothecary, 16.25 lire; while debts came to 286 lire. The total given in the account is 1,028.7 lire, but in fact amounts to 1,046.47.

On 27 May 1768 Alvise Contarini, Primo Cavalier, Associate Inquisitor, signs a report which begins, 'Manco a' vivi senza Testamento il quondam Antonio Canal, per il che succedono alla di lui Eredità tre di lui sorelle, Fiorenza vedova, Viena, e Francesca nubili Dottande'.[4] This gives a summary of the assets and liabilities of the estate. The assets, valued in ducats, included: cash, 283; furniture, 50; silver and jewellery, 105.11; capital, 2,150, totalling 2,588.11. The item of 2,150 ducats is the money invested in the Scuola on the Zattere and presumably repaid by the Scuola (see p. 41). Liabilities, in ducats, were: expenses, 166;[5] dowries to two spinster sisters, 1,200,

[1] Archivio di Stato, Indici dei Testamenti. Serie iii, vol. 22b, carta 18, a. 1762–81.
[2] The full text of these is given in Appendix III.
[3] Inquisitorato alle Acque, busta 167, calcoli intestati, fasc. 71.
[4] Inquisitorato alle Acque, busta 167, calcoli intestati, fasc. 71.
[5] In the lease made by Canaletto in 1751 (see above), the ducat is valued at 6.4 lire; and allowing for small variations, this brings the expenses to the same figure as that paid for the funeral, &c.

(1) V.S. Leone Atti Morti, vol. 5 (now at Sta Maria Formosa), 20 Aprile 1768.
issimo
Il Sig[r] Antonio del fu Bernardo Canal in eta d'anni 71 C[a] da Febre Continua Con Infiamazione nella Visica per il corso di giorni 5 c[a] fini di essere la notte scorsa alle ore 7 c[a] Visitato dall dott. Masolo. Fa sepeller li Comisari con Capitolo.

(2) Provveditori Alla Sanità: Necrologio no. 163, 1738 (at the Archivio di Stato). 20 Aprile 1768.
Antonio g[re] (= genitore) Bernardo Canal d'ani 71 di Febre et Infiamazion nella vissica gni (= giorni) 5, med[o] Musolo morto all' ore 7.
Capto (= Capitolo) S. Lio

totalling 1,366. The balance is given as 1,366 ducats, 5 per cent. of which was 73.8 ducats, which the Inquisitor accepted as the sum payable to the public credit by the estate.

In another document of 27 May 1768 Francesca Canal, as sister and co-heiress, signs a sworn statement that an inventory included in the document is a full and complete list of everything left by Antonio Canal; and this is witnessed as in accordance with the law by Alvise Contarini, Associate Inquisitor.[1] The inventory is dated 14 May 1768 and gives no indications of wealth or of luxurious living. It included twenty-eight pictures, medium and small. Canaletto's bed is described as 'a small single bed with two overlays, straw pallet, wooden boards and struts, two covers, one quilted, the other woven, all old'. His linen matched this, including four pairs of hemp sheets, eight old shirts, six pairs of old white cotton hose and five white nightcaps. His wardrobe was very modest. He owned only four coats, three of them old, one of these being dyed, two pairs of breeches (both old), two waistcoats (both old), and two old hats, while of his four cloaks, three were old and one very old. The value of his other possessions did not compensate for the small value of his household goods. His table silver, three rings, and a silver box were valued at only 105 ducats, 11 grossi. In cash, however, he had 283 ducats, 6 grossi; and capital in the Zecca of 1,666 ducats, 6 grossi.[2]

One wonders what had happened to the fortune he is reputed to have taken to England to invest, and to the guineas he is said to have brought back to Venice.

The ultimate disposition of Canaletto's property gives some additional information about his family. A document of 27 May 1768 records the decision of the Giudici del Proprio that his three sisters are entitled to succeed to their respective shares of their brother's property;[3] and on 16 June 1768 the associate inquisitor Agostino Barbarigo reports that he has fixed the sum to be paid to the State at 50 ducats, and declares the whole case duly

[1] Inquisitorato alle Acque, busta 167, calcoli intestati, fasc. 71.

[2] In a document of 12 June 1786, quoted later, 1666.6 ducats 'valuta corrente' is the equivalent of 2,150 ducats 'valuta piazza'.

[3] Giudice del Proprio, a. 1768, col. n. 85, p. 8.

settled.[1] Meanwhile, on 15 June the sisters entered into an agreement to divide the ready money, furniture, &c., in the estate into three equal parts; but that the two unmarried sisters, Viena and Francesca (who now used her secular name), were to retain equal shares in the capital of 2,150 ducats. Fiorenza in return was to get 1,000 ducats as her part of the ready money, &c.; and in the event of the other two sisters dying, was to be entitled to a third of the capital.[2] On 18 June, official notification of the agreement was given.[3]

Fiorenza, widow of Lorenzo Bellotti, was apparently not present at this transaction, and her son, Michiel Bellotti, acted for her.[4] From the agreement, and a declaration by a notary of Arezzo attached to it, it appears that Fiorenza had lived many years in Arezzo, and by reason of being more than seventy years old, could not come to Venice to do what was necessary in connexion with her brother's estate.

Lastly, a document of 12 June 1786, after reciting all the previous transactions, states that Fiorenza, at her death, left any capital she might have to her daughter Maria Serafina, that Viena is dead, and that Francesca, the survivor, asks the Provveditori of the Zecca (where the 2,150 ducats which originally belonged to Canaletto were deposited) that 1,666.6 ducats be put in her name and at her free disposition. This request was duly granted.[5]

Two early writers say that Canaletto had a son. Federici (*Memorie Trevigiani*, 1803, ii. 111), writing of the figure-painter Giovanni Battista Canal, speaks of him as the son of Antonio Canal; and Giannantonio Moschini (*Della Letteratura Veneziana*, 1806, iii. 76) says of Canaletto, 'lasciò un figliuolo di nome Giambatista, pittore storico . . .'. Federici and Moschini were, however, transcribers of gossip, frequently inaccurate; and mistook the parentage of G. B. Canal, who was in fact the son of

[1] Inquisitorato alle Acque, busta 26, Terminazioni intestate.
[2] A.N. Protocollo n. 22 del notario Giuseppe Bernardo Bellan.
[3] E.N. Reg. n. 178, a. 1767–8, p. 127.
[4] Bernardo Bellotto, a younger son, is never mentioned in these series of documents. He seems to have cut himself off from his family.
[5] Provveditori all Zecca. Ori ed argenti. Registro delle terminazioni, a. 1786, vol. n. 148, pp. 166 sqq.

Fabio Canal. It would be rash to deny the possibility of Canaletto having had an illegitimate son; but no mention has been found of a marriage or of a child born in wedlock, either in the records of the contrada of S. Lio, or in those of the Curia, at S. Marco. Possibly a marriage might have taken place in his wife's parish; but to find evidence of this, when the name of the wife, of her parents, and of her parish are all unknown, would be virtually impossible. Moreover, since no wife is ever mentioned in the many official documents quoted above, the possibility of her ever having existed is very remote.

Where Canaletto lived and worked in Venice at different times is not always certain. There is no doubt that he was born in the contrada S. Lio and that the Canal family had property there during his lifetime. Part of this was two houses owned in 1723 by his mother Artemisia, one of which was let to Domenico Coronato, the other occupied by herself; and it is reasonable to think that Canaletto lived in this second house with his parents. That he is described in the records of the Collegio dei Pittori of 1735 as 'figl° di Famiglia' (see p. 26) favours the supposition. There is, however, some evidence that he was living from 1738 to 1740 in the Barbaria delle Tavole, in the contrada of Sta Maria Formosa. Again, a document of 1740, which appears to give a complete list of Canal properties, consisting of four houses, describes three of them as belonging to Canaletto, his sisters, and his three cousins, and the fourth as belonging to the cousins alone. The last was the only one occupied by its owners, the other three being let. Of these one was that rented by Domenico Coronato, and was in the Calle di la Pissamano; the other two and the one occupied by the cousins were in the Corte Perina. In 1748 Domenico Coronato was still in the house; but in 1750 he had left, and the Canal family asked that it be assessed for tax on the basis of their using it themselves. Thus at least one of the family houses, that in the Calle di la Pissamano, was now available for Canaletto. In 1751 he took a lease of the Scuola dei Luganegheri on the Zattere. Whether this was simply an investment, or whether he made any use of the building, there is nothing to show. The only further contemporary information is given by Pietro Gradenigo, in a diary entry for 20 April 1768, saying that Canaletto died in the Contrada S. Leone. Tassini (*Curiosità Veneziane*, 1933 ed.), writing of

the Corte Perini, says: 'Presso questa Corte, al N. A. 5484 abitava e mori il celebre pittore Antonio Canal.'[1] Molmenti,[2] however, says that Canaletto died 'in his house in the Corte della Malvasia at S. Lio'. If 'Calle' is read for 'Corte', and it is assumed that the Calle Malvasia is the Calle di la Pissamano, Molmenti may have a case. Tassini, at least, proposes a place where Canal property existed; but the source of his exact identification of the house is not given.

There is only one portrait of Canaletto that can be accepted as fully authentic. This is the engraving which appears with a portrait of Visentini as the frontispiece of the *Prospectus Magni Canalis Venetiarum* of 1735, and of the enlarged editions (*Urbis Venetiarum Prospectus Celebriores*) of 1742 and 1751. Canaletto is seen head and shoulders, within an oval enclosed by a carved frame ornamented with flowers and foliage, and inscribed below the portrait *Antonius Canale/Origine Civis/Venetus*. At the bottom of the frame is a shield with a chevron, the Canal coat of arms. In the lower left margin is the inscription *Ex Monochromate Io. Bapt. Piazzetta*; and lower right, *Antonio Visentini Inv. Del. et Sculp*. From the date of first publication of the engraving, Canaletto as represented cannot be more than thirty-eight; and since there is evidence that the plates for the *Prospectus Magni Canalis* were ready in 1730, he may well be not much more than thirty. Neither of the original monochrome portraits by Piazzetta has come to light.

The engraved portrait was also published in rectangular form (engraved surface, $7\frac{1}{8} \times 6\frac{1}{8}$ in.) inscribed *Antonius Canal Pictor*, and *P. Monaco Sculp.* (copy in the Albertina). In some versions the *Antonius Canal Pictor* is omitted; in others *Appō Alessandri e Scattaglia Venᵃ* added.

A portrait in oil on panel (14 × 11 in.) in the collection of Lord Fairhaven has been published by F. J. B. Watson as a self-portrait, and dated in the second half of 1746. The portrait is inscribed on a feigned oval of stone which surrounds the figure: GIO. ANTONIO. DA CANALE. ORIGINE. CIVIS.

[1] The Corte Perini, linking the Calle Malvasia and the Calle dell'Oratorio, just to the south of the Church of La Fava, still exists. It has been widened, but on a new wall which replaced an older building, the number 5484 can be seen.

[2] *Venice*, London, 1908, pt. iii, vol. i, p. 91.

VENETUS. and IL CELEBRE CANALETO. Watson makes a very good, though not entirely convincing, case for both sitter and painter being Canaletto.[1]

Another portrait in oil attributed to Pietro Longhi, and suggested as being of Canaletto, was sold at the Parke-Bernet Galleries, New York, on 13 February 1958, no. 33, the owner unspecified. This measured $17\frac{3}{4} \times 11$ in.; and represents a young man in tricorne hat and blue coat, holding a brush, palette, and mahlstick, standing in front of an easel, on which is a painting of the north end of the Piazzetta with the Campanile on the left. The bone structure of the sitter's head is very little like that of Canaletto's in the engraved portrait, and he looks considerably younger. If he is Canaletto, this would date the portrait in the very early twenties; and if it is by Longhi, he could not have been more than twenty when he painted it. The evidence, however, points to its being a fairly mature work by Longhi, which would put Canaletto as the sitter out of the question.

For an engraved portrait reproduced by Moureau (*Antonio Canal*, Paris, 1894, 42) as of Canaletto, there is nothing to be said. The sitter is seen head and shoulders, in an oval, surrounded by an inscription which reads backward: ANTONIO CANAL NOB. VEN. ACCAD. DEGLI ARGONAUTI D. ETA D. AN. The face is quite unlike that of Canaletto in the Visentini engraving; and De Vesme (p. 445 n. 2) suggests that it represents a patrician of the same name. In fact, the portrait is part of a larger engraved design, in which the portrait with its inscription is on the front of a pedestal, on each side of which are two reclining female figures, and on top a military trophy. An example in the Library of the Correr Museum gives no artist or engraver.

[1] For detailed description and arguments see no. 519.

II

THE FORERUNNERS OF CANALETTO

THE following chapter is not intended to be a history of landscape-painting in Venice. That would need a volume to itself. The purpose here is to indicate the main traditions to which Canaletto was heir, and the form they took in the work of his immediate predecessors and older contemporaries by whose work or personality Canaletto was directly influenced.

<p align="center">★ ★ ★ ★ ★</p>

Two main traditions are traceable in Venetian landscape-painting: one, that of the topographical view, the other that of the picturesque or romantic composition, largely imaginary in content. Occasionally, the two would intermingle; but it is not until the time of Canaletto that the same practitioner not only produced both kinds of landscape, but at times fused them to produce a third and distinctive type, the capriccio.

Until the eighteenth century, topography in Venice was practised only fitfully, and rarely for its own sake. The first notable manifestation was in the series of large paintings representing various miracles of the Holy Cross, made in the late fifteenth and early sixteenth centuries by Gentile Bellini, Carpaccio, Mansueti, and Lazzaro Bastiani for the Scuola di San Giovanni Evangelista, which are now in the Accademia, Venice. In these, the backgrounds and settings are identifiable sites and buildings in Venice, including the Piazza S. Marco, the Rio S. Lorenzo, the Grand Canal with the Rialto Bridge, the Campo S. Lio, and S. Giovanni Evangelista; to which may be added the Chiesa della Carità, in a large painting of the meeting of Pope Alexander III and Doge Ziani, probably a sixteenth-century copy of a fifteenth-century work, and the Molo, in the *Lion of S. Mark* by Carpaccio, in the Ducal Palace. The use of Venetian topographical motives was not, however, limited to large-scale work, but occasionally occurs in smaller paintings, such as the introduction of a view of the Molo into the

background of a *Virgin and Child* attributed to Giorgione in the Ashmolean Museum; and the use as a setting for three figures of the arcade of the Ducal Palace with the Bacino di S. Marco in the background, in a Giorgionesque painting in the Vienna Academy. More puzzling, and less easy to explain, is why Venetian views should occasionally be found in contemporary Florentine paintings, as in the various versions of the Louvre *Virgin and Child with the Infant St. John and three Angels* by Mainardi, and in a *Virgin adoring the Child*, attributed to Jacopo del Sellaio, in the Jacquemart-André Museum. In the background of both is a view of the Molo at Venice, topographically inaccurate, but quite recognizable.

Even at their most elaborate, such pieces of topography are no more than settings for the main theme of a painting, and in other cases are purely incidental; and the only known example at this time of the city of Venice being used as the subject of a work of art seems to be the famous panoramic engraving by Jacopo de' Barbari. Nevertheless, use of topographical accessories developed considerably during the sixteenth and early seventeenth centuries, especially in Venice. There, a long series of canvases glorifying the Republic, recording its history, and depicting those who served it, gave constant opportunity for painting some aspect of the city itself. When God the Father is represented by Bonifazio protecting Venice, a bird's-eye view of the central part of the city extends beneath him; when Paolo Veronese paints the Cuccina family presented to the Virgin, he introduces into the background a view of the Grand Canal. It is, however, in the great series of historical paintings in the Ducal Palace that topographical elements become increasingly prominent. Thus, the Piazza S. Marco, looking east, is seen in Tintoretto's *Doge Pietro Loredano seeking help from the Virgin*; the Riva degli Schiavoni in *The Return of Doge Andrea Contarini* by Paolo Veronese; the Piazzetta looking north in *The Pope presenting a sword to the Doge* by Francesco Bassano; the Piazza S. Marco and the Basilica in *The Pope releasing the son of Frederick Barbarossa* by Palma Giovane; and S. Marco and the Piazzetta looking south in *Frederick Barbarossa prostrating himself before the Pope* by Federigo Zuccaro.

Drawings of the sixteenth century with topographical elements are more rare than paintings, but they exist. The Bacino di S. Marco is seen in the

background of a drawing by Schiavone, formerly in the Gathorne-Hardy Collection, of *Doge Francesco Donato kneeling at the marriage of St. Catherine*; S. Marco and the Piazzetta looking south appear in a drawing by G. Salviati in the Louvre, perhaps representing the submission of Frederick Barbarossa to the Pope; and in the Louvre also is a sixteenth-century Venetian School drawing of a barge carrying some important personage along a canal apparently in Murano, with Venice in the distance.

In the later paintings in the Ducal Palace, there is a marked tendency for the topographical setting to be the dominant element. An example is *The Arrival at the Lido of Henry III of France* by Andrea Vicentino, though the most prominent buildings are temporary erections. The same emphasis on setting is present in two other large paintings in the Correr Museum, formerly attributed to Andrea Vicentino, which represent ceremonies which centred in the coronation of the Dogaressa Grimani in 1597. In one, the Dogaressa is seen passing in procession from the Molo to S. Marco, against a background provided by the two columns on the Piazzetta, the Library, and the Campanile with the corner of the Ducal Palace on the right.[1] Particularly striking is the other, representing the Dogaressa leaving the Palazzo Grimani. In this the Palace dominates the painting, and the figures are reduced to the same subsidiary scale as in an eighteenth-century representation of a festival.

These are not isolated examples. In the Prado is a painting by Leandro Bassano of the Doge embarking in the Bucintoro at the Molo; and the predominant part played by the architecture almost justifies an official title of 'View of Venice'. At Chatsworth, a painting attributed tentatively to both Andrea Vicentino and Pietro Malombra represents the Dogaressa Grimani walking in procession and is similar in design and setting to the painting of the subject in the Correr Museum, though the architecture is somewhat less obtrusive.

Thus, by the early seventeenth century, the ground was well prepared for the emergence in Venice of topographical painting as an end in itself. Evidence of an early example is an engraved view of the Molo and the

[1] A smaller ($32\frac{1}{2} \times 60$ in.) version, more freely handled and livelier, is in the collection of Francis Stonor, London.

Piazzetta seen from the Bacino di S. Marco, which is inscribed *Ludouic: Pozoseratus flamd pinxit et dd* and dated 1585. The artist concerned was the Fleming, Lodewyk Toeput, called Pozzoserrato, who was active in Treviso, and known as a landscape-painter. Whether in fact he made a painting of the subject of the engraving is perhaps arguable; but that he produced a piece of pure topography is certain. Development was slow and spasmodic, however, and followers of Toeput's example were rare. The German-born Francis Cleyn, best known as a mural-painter and designer of tapestries in England, spent four years in Venice; and is said in 1617 to have painted for Christian IV of Denmark, in the King's Writing Closet at the Castle of Rosenborg, a series of paintings including views of Venice; but none of these seems to have survived. There is, however, what seems to be an example of early seventeenth-century Venetian topography in a painting which was in a private collection in California in 1942, representing the Molo and the Piazzetta from the Bacino di S. Marco, from a view-point slightly west of the column of S. Theodore. An attribution to Malombra may be doubted; but the date of the painting seems tolerably certain.

The times, in fact, were not very favourable to topography. The demand for records of Venetian history and Venetian achievement, with appropriate iconographic trappings, rapidly waned with the decline of Venetian political power; and though foreign visitors to Venice were increasing in number, the demand for records of her outward appearance was not yet insistent. The gap was filled by representations of what had become one of the most popular and characteristic aspects of Venetian life, the festivals and cere-monies which filled the Venetian year—a type of subject which shortly became part of the established repertoire of painters in Venice and remained so until the early years of the nineteenth century. Such paintings demanded reasonable accuracy and recognizability in the settings, and so gave ample scope to the topographer to the extent that increasingly representation of a festival became an excuse for elaboration of the setting. It is not surprising, therefore, that for a time the production of such paintings was apt to be in the hands of northerners. Toeput was the forerunner of several minor masters from the Netherlands and Germany, where topography as an

independent art was far more firmly established than in Italy. Occasionally, a more considerable painter entered the field, as when Jan Lys represented a bull-fight and acrobatic performance in the Piazza S. Marco, with S. Marco in the background; a painting signed and dated 162 . . , which belonged to the late Hans Schneider of Basel. This, however, seems to be an isolated exercise in not very accurate topography by Lys. A more regular practitioner was Joseph (Giuseppe) Heintz the younger (often called Heintzius), born probably in Augsburg *c.* 1600, who settled and worked in Venice, dying there after 1678. Examples of his work are four large paintings in the Correr Museum, representing various festivals, two signed and dated 1648, another signed and dated 1649, the fourth unsigned and undated but clearly part of the series.[1] Also signed, and in style of about the same period, is a large bird's-eye view of Venice, including the Ducal procession to the Lido on Ascension Day, formerly owned in Venice. Considerably later in date, though not conspicuously different in style, is a painting of the annual fight between the factions of the Nicolotti and the Castellani on the bridge crossing the Rio S. Barnaba (Pl. 2 *c*). This is signed and dated 1673, and passed through the London and New York art markets into a New York private collection. Occasionally, too, Heintzius produced topographical views without festival accompaniments, examples being the signed Piazza S. Marco looking east (Pl. 3 *a*), and a view of the Piazzetta, both in the Doria Pamphili collection, Rome. Neither of these conforms to the facts in spacing and proportion; but as in the settings of the festival scenes the accurate elaboration of detail is considerable.

Always, Heintzius gives the settings a major part in his design. His figures, however numerous, are relatively small; and by using a high viewpoint, he is able to weave them and his architecture into a pattern which is an interpretation of Venice in both her physical and her human aspects. Thus he set a precedent for the treatment of festival subjects, which with increasing skill and refinement was followed in Venice for a century and a half. Heintzius was highly esteemed in Italy for his fantastic inventions and his

[1] *The Canal at Murano on Ascension Day* (s. and d. 1648, Pl. 2 *a*); *Bullfight in the Campo S. Polo* (s. and d. 1648); *The Patriarch Federico Cornaro at S. Pietro di Castello* (s. and d. 1649); *The Procession to the Redentore over the bridge of boats* (Pl. 2 *b*).

figure-pieces; and there is little doubt that his prestige helped to give respectability to the idea and practice of topographical painting.

Occasionally, an Italian name occurs among seventeenth-century festival-painters. The fight between the Nicolotti and the Castellani is the subject of an engraving published in 1662, inscribed *Andrea Piazza/Eques Inuentor*; and of the same subject is an engraving, dated 1676, after Pietro Liberi. Leaving aside the group of engravings recording the festivals organized on the occasion of the visit of the Duke of Brunswick to Venice in 1685, which have no particular topographical interest, there is the group of paintings of which four were discovered in London by Francis Taylor and are now in the Museum at Worcester, Massachusetts. Two of these are signed Alessandro Piazza, one (*The Bucintoro departing for the Lido*) being dated 1700, the other (*An Operatic Performance in the Grimani (?) Theatre*), 1702.[1] Their topographical significance is not great; but they emphasize that festival-painting linked with topography had become a living art in Venice.

The festival-painters did more, however, than develop topography, even as an adjunct; they also widened its range. The Molo, the Piazzetta, and the Piazza S. Marco no longer monopolized attention; and in painting a festival, the artist also represented that part of Venice in which it took place.

Turn now to the tradition of romantic and picturesque landscape in Venice. In its beginnings, this held high promise, and was witnessed by occasional notable achievement. The luminous, serene, and sensitive landscape backgrounds of Giovanni Bellini and his followers, in the hands of Giorgione and Titian became a powerful means of expressing a mood appropriate to the subject of a painting; and, indeed, with Giorgione became an almost independent vehicle for poetic expression. This conception of landscape as more than a stage setting, and as something with character and variability of its own, became characteristic of Venetian painting, marking the work not only of the greater masters, including Paolo Veronese, notably at Maser, but of a whole range of secondary ones, such as Palma Vecchio, Paris Bordone, and Lotto. It is quite distinct from

[1] Taylor (*Worcester Art Museum News Bulletin*, Jan. 1957, 14 sqq.) suggests that Alessandro Piazza is probably identical with Andrea Piazza. But the name Piazza is not uncommon; and the fact that Andrea was at work forty years before Alessandro makes it unlikely that they are the same.

the topographical settings described above. Specific localities are rarely, if ever, represented; instead, the dominant features of the Veneto countryside are grouped and arranged according to the artist's fancy, under such conditions of light and atmosphere as suit his purpose. Occasionally Titian may introduce a Venetian reminiscence, as in the *S. Christopher* in the Ducal Palace, where on the horizon are buildings which suggest the Ducal Palace, the Piazzetta, and the Campanile; and in the *Death of Adonis* in the Uffizi, Sebastiano del Piombo, surprisingly enough, paints in the background a view of the Molo and its buildings. Tintoretto is the one great master of the sixteenth century who uses both imaginative landscape and topography; and in some of the paintings in the Scuola di S. Rocco he rivals Giorgione in using landscape as an independent means of expression.

The use of romantic and picturesque landscape as an important element in painting continued in Venice throughout the seventeenth century; but the development there of landscape as an independent art lagged behind that in other parts of Italy. This found its main centre in Rome, partly through the influence of Claude Lorrain, whose work embodied in an idealized form the character and feeling of Italian landscape, sometimes combined with nostalgic reminiscence of the glories of ancient Rome. Practically contemporary was Salvator Rosa, also mainly active in Rome, who put into dramatic and picturesque form the wilder aspects of the Italian coast and countryside. Both of them studied and were familiar with the character of specific places and particular objects; but this was for them raw material for generalized treatment, which could express and invoke romantic feeling. Around them, and following them, grew up a host of followers and imitators, reinforced by numerous artists from northern Europe who settled in Rome. For their productions there was a rapidly increasing demand throughout the seventeenth and eighteenth centuries, a considerable part of which came from foreign visitors.

A similar school of romantic and dramatic landscape also developed in the north of Italy, with Milan as an important centre; though there was a marked tendency for northern painters to find their way to Rome. A conspicuous exception was Magnasco, whose influence was widespread. He

and others, like the Roman painters, made considerable use of architectural features and especially of ruins in their work, exploiting the potentiality of these for evoking nostalgic sentiment. Since the influence of Claude in northern Italy was comparatively small, the painters there tended to stress the dramatic rather than the idyllic elements in their work. A typical figure is Giovanni Ghisolfi (1623–83), who was born and died in Milan, but worked for a time in Rome, where he came under the influence of Salvator Rosa. His dramatic ruin and architectural paintings, with strong contrasts of light and shade, may be regarded as almost a pattern for much of the landscape produced in the north during the seventeenth century.

In Venice, however, during that period painting of the kind described was rare, probably because the demand was small, potential buyers chiefly going to Rome or Milan. Occasionally an inconspicuous practitioner appears. Such seems to have been Faustino Moretti (d. 1668), who was active in Brescia and Rome; but no certain example of his work is known. A less shadowy figure is Johann Anton Eismann, referred to in a Zibaldon of 1738 in the Seminario Patriarcale, Venice (MS. 796), as Giovanni Eisman. According to this he was born in Salzburg in 1604, arrived in Venice *c.* 1644, and died there in 1698. He painted seascapes, battle pieces, and landscapes with ruins. Examples of the last named are at Dresden, Augsburg, and Schleissheim; and a particularly interesting one was in a New York private collection in 1943 (Pl. 3 *c*). This is signed GAE in monogram (= Giovanni Antonio Eisman), a form of signature which indicates that it was painted in Italy. Before the monogram appeared after cleaning, the painting had been attributed to Pannini, and even the name of Canaletto had been suggested. In fact, his ruin paintings have their closest affinity with those of Marco Ricci, of whom Eisman may be regarded as an artistic precursor.

Marco Ricci (1676–1729) is the first notable master, truly Venetian, to produce romantic and picturesque landscape as an end in itself. Born in Belluno, his main centre of work was Venice, though he was four years in Spalato, visited Florence, Milan, and perhaps Rome, and went to England in 1708, whence he finally returned to Venice in 1716. As a landscape-painter, he is in descent from Titian. At some point in his career, however, he was much influenced by Magnasco; and from that painter may have come an

impulse to paint architectural and ruin-pieces, strengthened by a possible visit to Rome (an example is at Vicenza, Pl. 4 *a*). In any case, such paintings seem to belong for the most part to the later part of his career. A notable group consists of a set of over-doors painted in 1710 for Castle Howard, when Pellegrini was employed on the decorations there.[1] Most of these have as their theme buildings and ruins, with figures, set in a landscape, all put in terms of strongly contrasted light and shade. In paintings of this kind it is sometimes said that Sebastiano Ricci was a collaborator, especially in putting in the figures; but that the Castle Howard paintings are entirely by Marco is certain, since Sebastiano did not come to England until 1711. Another important group of work by Marco Ricci, similar in character, is at Windsor, purchased by George III, with Joseph Smith's collection, consisting of forty-two paintings, some in oil, others in gouache on leather.[2] In Smith's manuscript catalogue of his collection the figures in eight paintings are specifically described as by Sebastiano; but nothing is said of this in the case of the other thirty-four. Smith was in a position to know the facts, and it may reasonably be assumed that these are by Marco alone. Confirmatory evidence that he worked to a large extent independently of his uncle is given by a pair of paintings, one of which is signed by Marco Ricci only and dated 1728.[3]

The importance of Marco Ricci from the present point of view is that during the years he was working in Venice, from 1716 until his death in 1729, Canaletto was a young and active painter, who had full opportunity of seeing Ricci's work, notably in the collection of Joseph Smith, and of meeting Ricci himself. It may reasonably be assumed, therefore, that the form which the capriccio and imaginary view took in Canaletto's hands owes much to Ricci, the most considerable practitioner of that type of landscape in Venice.[4] Moreover, in Canaletto's early work there are various resemblances to that of Ricci. Such is the use of a dark reddish-brown ground; the dramatic use of light and shade; the freely streaked-on highlights; and the construction and handling of the figures.[5]

[1] Some of the over-doors were destroyed by fire in 1940.
[2] See Cust, *Burl. Mag.*, June 1913, 153. [3] Exhib. Venice, *Paesaggio Veneziano del Settecento*, 1940.
[4] The terms 'capriccio' and 'imaginary view' are discussed in Chapter III.
[5] Cf., for example, two landscapes by Ricci at Dresden, with those in the group of paintings produced by Canaletto in the mid-1720's (Pl. 3 *b*).

Another tradition which helped to shape the work of Canaletto was that of the theatrical designers. At the time when Canaletto, as a young man, was himself employed in the theatre, the leading designers in Venice still based their work on the use of a central axis, with a central vanishing-point. In 1712–13, however, Roberto Clerici, a pupil of Ferdinando Galli Bibbiena, was employed at the S. Cassiano theatre, and brought into Venice some of the ideas of the Bibbiena family, including the fixing of vanishing-points to one side or the other of the central axis; the introduction of rows of columns or pilasters at an acute angle to the frontal plane of the stage and in sharply receding perspective, to increase the feeling of space; and the use of profuse architectural ornament.[1] Thus, though application of the new ideas was slow in coming, in addition to the many drawings made by more conservative practitioners, knowledge of drawings by members of the Bibbiena School also became current in the Venetian theatre.

Theatrical designs of the late seventeenth and earlier eighteenth centuries, with which Canaletto must have been familiar, are of two main types. They are either freehand sketches, in outline or with hatched shadows, giving the general idea of a design (Pl. 4 *b*); or elaborate drawings with carefully worked out perspective, in line and monochrome wash, sometimes used in double or treble strength (Pl. 4 *c*). In this second type, the use of guiding lines in pencil is often found, together with the use of ruler and compasses.

Canaletto's methods in drawing were very similar. There are many freehand sketches by him, both in ink and chalk, with or without hatching, either made on the ground or embodying the idea of a composition. Similarly, these would on occasion be elaborated into drawings carried out in pen and ink, with grey wash strengthened in places by double or treble use, on a basis of indications in pencil and chalk; careful regard being paid to perspective, with considerable use of ruler and compasses, and of what K. T. Parker calls 'pin-pointing'—the plotting of a design by means of minute perforations at key points. So closely, indeed, do some drawings by theatrical designers resemble in method those of Canaletto that they are not infrequently attributed to him.

[1] See Elena Povoledo, *Arte Veneta*, 1951, 126–30.

The theatre, however, gave Canaletto more than an acquaintance with technical methods. The concept of the capriccio and of the imaginary construction is basic in theatrical design; and so became familiar to Canaletto at an impressionable age. Moreover, in the construction of some of his designs, especially those of his later capricci, he used devices which can have come only from the theatre. Such is a tendency sharply to separate foreground from background, the one corresponding to a structure on the stage, the other to a backcloth, the two being linked by motives put into perspective; and in the architecture of imaginary buildings he uses the same kind of florid decoration as appears in much contemporary stage design. Noticeable also is Canaletto's use of the stage device of a proscenium, framing the view beyond. A familiar example is in the etching known as the *Portico with a Lantern*; but even more reminiscent of the theatre are such capricci as the painting of *A Triumphal Arch seen from a Portico* (Duke of Norfolk) and *A Triumphal Arch seen from a Loggia* (Academy, Rome); and among drawings *A Garden seen from a Portico* (Albertina) and *A Courtyard and a Double Triumphal Arch* (Mrs. Brackley).

Marco Ricci and the theatrical designers, however, did little towards making Canaletto a topographer. In this a considerable figure, who helped to establish topography in Venice as a recognized form of painting, was Gaspar van Wittel, better known as Gaspare Vanvitelli or dagli Occhiali (1653–1736). Born in Holland, he went to Italy in 1672, and remained there until his death in Rome. Rome was his main centre of work; but that he may have visited Venice and worked there is suggested by a view in the Prado of the Molo and the Piazzetta, seen from the Bacino di S. Marco, which is signed and dated 1697. In a private collection is recorded a view of the Grand Canal dated 1706;[1] but that these dates are not good evidence as to when Vanvitelli was in Venice appears from another view of the Molo and Piazzetta, formerly in the Henry White collection, being signed and dated ROMA 1707 (Pl. 5 *a*). But whether he painted them in Venice or elsewhere, Vanvitelli produced a considerable number of Venetian views. Evidently, the Molo and Piazzetta was a popular subject, since in addition to those mentioned, there are signed examples in the Doria Gallery, Rome;

[1] Briganti and Hoogewerff in Thieme–Becker, xxxvi.

at Dresden (no. 640; recorded in a 1722 inventory as 'von Casper de Tors', a pun on the artist's name); and the lost original of an engraving inscribed *Casparo Pinx. P. Chenu Sculp.* Other subjects include the Rialto Bridge from the north, known from a companion engraving to the one mentioned, similarly inscribed with the addition of a signature CAS. VAN WIT . . . on the engraved surface; a Bacino di S. Marco looking west with S. Maria della Salute and the Giudecca (Doria Gallery, signed; companion to the above-mentioned Molo and Piazzetta (Pl. 5 b)); the Grand Canal from the Foscari Palace to the Rialto Bridge (Earl of Radnor); the Bacino di S. Marco looking west, with the Ducal Palace right (Earl of Leicester, Holkham), described by Matthew Brettingham (*Plans etc. of Holkham,* 1773) as one of 'two perspectives, over doors', the other being a Roman subject.

In all these the emphasis is entirely topographical, and the subjects are represented with reasonable accuracy. Figures are introduced, but are quite subsidiary. Like Vanvitelli's better-known and far more numerous Roman views, they are painted in a fairly high key, with suggestions of luminosity in the shadows; the skies are blue; and local colour is emphasized. The handling is precise and tight, tending sometimes to be scratchy.

Vanvitelli was prolific as a draughtsman, on a sufficiently high level for his work sometimes to be confused with that of Claude.[1] No drawings by him of Venetian subjects are known; but many of Rome and of unidentified landscape subjects may be seen in most of the larger collections of drawings in Europe. These are for the most part in pen and brown ink, occasionally in outline, more usually with shadows hatched or put in with grey wash. Also, Vanvitelli made considerable use of water-colour, both transparent and opaque.

The probable influence of Vanvitelli on Canaletto seems to have been underestimated. In addition to providing an example of a painter primarily concerned with topography, he may also have influenced Canaletto stylistically. The high key, luminous shadows, blue skies, and emphasis on local colour, which mark Vanvitelli's paintings, are also characteristic of much of Canaletto's work in the late twenties and the thirties, though used by him in a much more masterly and subtle way. At times, even, Vanvitelli's tight, somewhat scratchy handling appears in some of Canaletto's work of the

[1] In their disentanglement the late A. M. Hind was a pioneer.

late twenties, such as the two small paintings formerly in the Ashburnham collection, and in the *Entrance to the Grand Canal* at Berlin. The technique of Vanvitelli's drawings, described above, is similar to that used by Canaletto; and F. J. B. Watson notes similarities between the group of drawings of Rome in the British Museum, which he regards as by Canaletto, and certain engravings after Vanvitelli.[1] Moreover, these drawings are similar to some of Vanvitelli's pen and wash drawings such as the *Ruins by a Lake*, in the Graphische Sammlung, Munich (Pl. 5 c). These various resemblances did not escape the sharp eye of Mariette, who says that Canaletto worked 'dans la manière de Van Vytel'.[2]

That Canaletto met Vanvitelli in Venice, or saw his work there, is unlikely, such dated works as are known having been painted when Canaletto was a child. But there is no need to assume that Vanvitelli's influence was filtered through the work of another painter, since Canaletto was in Rome at a time when he had ample opportunity to see Vanvitelli's work, and perhaps to meet him personally.

In Rome, too, Canaletto would have had opportunity to see examples of the idealized landscapes which had their descent from Claude, and of the work of the ruin-painters. That he could have seen any paintings by Ghisolfi is unlikely, since they seem to have been rare or inaccessible in Rome.[3] On the other hand, those of Viviani Codazzi (1603/11–1672), the Bergamasque who worked in Naples and Rome, were to be found in a number of Roman collections where they could have been seen by Canaletto. A more shadowy figure is Domenico Roberti (c. 1642–1707), who was born, worked, and died in Rome. Little is known of him; but two well-authenticated paintings of Roman ruins at Dresden are interesting in the light and shade being less dramatically treated, and the local colour more emphasized, than in the work of an earlier generation, thus foreshadowing eighteenth-century practice.

[1] *Burl. Mag.*, Oct. 1950, 292. Some authorities, on the other hand, regard the drawings as copies from Canaletto (see note on no. 713 below).

[2] *Abécédario*, in *Archives de l'Art Français*, 1851–3, 208.

[3] See the note on Roman collections 1687 to 1717 by Nolfo di Carpegna in *Paesisti e Vedutisti a Roma nel '600 e nel '700*, National Gallery, Rome, 1956. This gives valuable indications as to the artists whose work Canaletto might have seen. Ghisolfi is not mentioned.

Occasionally, the Roman painters turned to topography. An example is a view of St. Peter's in the Prado, by Codazzi himself; another, in the same gallery, is an interior of St. Peter's signed and dated 1640 by Filippo Gagliardi (born in Rome; died 1659). More interesting are two companion pieces in the National Gallery, Rome, one a view of the Pantheon, the other of the so-called Temple of Vesta. These have been at various times unconvincingly attributed to Pannini, Ottavio Viviani, Pieter van Bloemen, and J. F. van Bloemen, and at present remain anonymous. Competently painted, with strong light and shade and some degree of luminosity, part of their interest lies in being true capricci, as distinct from topographic or idealized views. In both, accurately represented monuments of ancient Rome are brought into arbitrary conjunction, the pyramid of Cestius being seen behind the Pantheon, while the Arch of Constantine and the Colosseum form a background to the Temple of Vesta, setting a pattern for Pannini especially, but also for Canaletto.

Topography in Rome, however, was chiefly in the hands of draughtsmen and engravers. From the time of the so-called sketch-books of Marten van Heemskeerk, in the Berlin Print Room, a continuous series of drawings and engravings records the major monuments of Rome, especially those of classical antiquity. Examples include drawings by Étienne du Pérac and his engravings in *Vestigi delle Antichità di Roma*, published in 1575;[1] and the engravings by the Flemish priest, Lievin Cruyl (*c.* 1640–*c.* 1720) which appear in three series, the *Prospectus Locorum Urbis Romae*, published by De Rossi in 1666, a group of views published in 1667, and the *Thesaurus Antiquitatum Romanarum* of Grevio, vol. iv, which appeared in 1697. A number of Cruyl's topographical drawings survive, of which eighteen, made for the 1666 publication, are in the Cleveland Museum.[2] To these may be added the engravings of Giovanni Battista Falda (d. 1678), which appear in the second part of *Palazzi di Roma*, 1655; in the first three parts of *Il Nuovo Teatro delle Fabbriche ed Edificii di Roma Moderna*, 1665 onwards; and in

[1] Cf. Ashby, *Topographical Study in Rome in 1581*, 1916; and 'Due vedute di Roma attribute a Stefano di Pérac' in *Miscellanea Fr. Ehrle*, II, 1924.

[2] Cf. Ashby, 'Lievin Cruyl e le sue vedute di Roma', in *Atti della Pontificia Accademia Romana di Archeologia*, memorie, I. i, 1923, with references; Egger, *Lievin Cruyls Römische Veduten*, 1927; Francis, *Bull. of Cleveland Museum of Art*, 1942, 152.

Giardini di Roma, 1671, and *Fontane di Roma*, 1675. A younger contemporary of Falda was Alessandro Specchi (active 1665–1710), who was responsible for the engravings in the fourth part of *Il Nuovo Teatro*, 1699, and produced a series of large plates, many of them topographical, issued separately between 1687 and 1703.[1]

Such engravings did more than help to stimulate in Canaletto a general interest in topography. They provided models for his own work. It is known, for instance, that a drawing at Windsor, *The Temple of Antoninus and Faustina*, is based upon Du Pérac's engraving of the subject; and that in the series of drawings of Rome in the British Museum, either by or copied from Canaletto, the first, a general view of the city, is copied from an engraving by Falda. Moreover, the style of these drawings is clearly influenced by the technique of engraving.[2]

More difficult to determine is the possible influence on Canaletto of some contemporary painters in Rome. One of these is Hendrik van Lint, sometimes called Studio, who was born in Antwerp 1684, came to Rome some time after 1696–7, and died there 1763.[3] Most of his known paintings are topographical, though there are exceptions such as two landscapes in the Fitzwilliam Museum, both signed and dated 1756. The subjects of the topographical works are either Roman or Venetian. In chronological order, examples include *The Aventine seen from the Tiber* and *A Convent on the Aventine* (Doria Palace, Rome), a pair signed and dated 1711; *S. Giorgio Maggiore from the Molo* and *The Bacino di S. Marco and Sta Maria Salute* (Pl. 6 a), formerly belonging to the Duke of Devonshire, both signed and dated 1723; also from the Devonshire collection and making a set with the two last-named paintings, *The Tiber with the Ponte Rotto*, and *The Tiber with S. Giovanni dei Fiorentini*, both signed and dated *Roma 1739*; and *An Italian Palace* (Fitzwilliam Museum), signed and dated 1748.

Signed *H. van Lint V. Studio*, but not dated, is *The Molo, Venice, looking*

[1] Cf. Ashby and Welsh, 'Alessandro Specchi', *Town Planning Review*, London, Dec. 1927.

[2] See no. 713 below, for discussion of the authenticity of the drawings. In the present connexion, whether they are by Canaletto or not is unimportant.

[3] He is sometimes confused, e.g. in Thieme–Becker's *Lexikon*, with Herman van Lint, an earlier painter of Utrecht.

West, with Sta Maria della Salute, which was a pair to a *Castle of S. Angelo and St. Peter's*, both in the Sir John Foley Grey sale, Christie's, 15 June 1928 (63). These are more linear and fussy in handling than the other paintings, and may be early work. Always, however, Van Lint works in a high key, with shadows a cool grey, the skies clear blue, and local colour emphasized.

Whether Van Lint was ever in Venice is very doubtful. In the two dated Venetian views, the date is preceded by *Ro.*; while the fact that the undated view of Venice is a pair to a view of Rome suggests that it may also have been painted in that city. Like Vanvitelli, Van Lint must have worked from drawings or engravings; but whether the drawings were his own, made in Venice, there is at present no means of knowing. Again, whether Canaletto met Van Lint or knew his work is also unknown. Certainly, they were in Rome at the same time; and in colour, and to some extent in handling, the work of Canaletto in the late twenties and the thirties is somewhat like that of Van Lint. But it may be that the resemblances are due to the influence on both of the better-known Vanvitelli.

A more interesting problem is the relation of Canaletto to Giovanni Paolo Pannini. It is sometimes said that Canaletto was considerably influenced by Pannini, especially in his treatment of figures; and Uzanne[1] paints an idyllic picture of the young Canaletto, just arrived in Rome, presenting himself one fine morning on the doorstep of Pannini and subsequently becoming his companion on sketching tours in Rome. The difficulty is one of dates. Pannini was born in 1691 or 1692 in Piacenza and studied architecture and perspective painting there, perhaps under Ferdinando Galli Bibiena. He went to Rome *c.* 1717, becoming a pupil of Benedetto Luti; and from 1718 to 1725 he worked on mural decorations in various Roman buildings. The only easel-painting by him that is securely dated before the early thirties represents the festival organized in the Piazza di Spagna to celebrate the birth of the Infanta of Spain, which is in the Apsley House collection, London. This is signed and dated 1727. The series of ruin-paintings and views of Rome, some of them capricci, by which Pannini is best known, came later; and the majority of the paintings of ceremonies and festivals, which include many figures, were painted in the late thirties or the forties.

[1] *Les Deux Canaletto*, 60–61.

Thus, though Pannini was in Rome when Canaletto was there, he produced nothing of a type likely to influence Canaletto, until some years after the latter had returned to Venice and had become an established artist. Moreover, before 1730 Canaletto had proved himself a skilful painter of figures in a style different from that which Pannini was later to adopt, as in the six large views in or near the Piazza S. Marco which are at Windsor;[1] while *The Doge at the Scuola di S. Rocco*, in which the figures play an important part and in certain respects resemble those of Pannini, was painted *c.* 1735 or perhaps earlier, before Pannini was giving figures a similar prominence.

Perhaps two young men in Rome, both from north Italy and both with some experience of the theatre, may have become friends and worked together. But there is no evidence of this, nor of either influencing the work of the other at the time. Yet there is something to be said for Canaletto, at a later date, having borrowed from Pannini. The series of Roman subjects he produced in the earlier forties at times so resemble, in their massing of light and shade and in their colour, paintings of similar subjects by Pannini made in the thirties and forties, that to deny a connexion would be unwise. If Canaletto went to Rome in the early forties, as is sometimes said, the resemblances are explicable. If he did not, and the weight of evidence points that way (see Chapter I), then either a knowledge of Pannini's work derived from engravings must be assumed, or that two painters of about the same age, and similarly trained as young men, arrived at similar solutions of a problem.

Of all the influences on Canaletto, however, undoubtedly the most important was that of one man, Luca Carlevaris.[2] In his work the tradition of the imaginary, idealized view found a capable exponent; while he has the distinction of being the first artist in Venice to concentrate on topography, and to gain a considerable reputation thereby.

Born in Udine in 1663, Carlevaris settled in Venice in 1679, and died there in 1730. Mauroner[3] says that he made a journey to Rome, but cites no

[1] For the date of these, see note on no. 55 in the catalogue.

[2] Fabio Mauroner's *Luca Carlevaris*, Padua, 1945, is cited as Mauroner. [See also Aldo Rizzi, *Luca Carlevarijs*, Venice, 1967.]

[3] Mauroner, 15.

authority; and no mention of this in such early authorities as Orlandi and Zanetti has been found. Some support for the statement is that in a private collection at Mestre there is a view of the Pantheon signed L. C., and one of the castle of S. Angelo;[1] while in his landscapes Carlevaris sometimes includes classic ruins. But as in the case of Vanvitelli and Van Lint, painting a view of a place did not necessarily mean a visit there, when engravings or other people's drawings were available.

The imaginary landscapes of Carlevaris vary considerably in the materials of which they are composed. Of four examples at Windsor which came from the collection of Joseph Smith, three are marine subjects, with buildings of different types, in one case a classic arch being included (Pl. 6 b). The fourth represents an estuary with classic ruins (Pl. 6 c). Another set of four including classic ruins, one of them signed with initials, was formerly in the Corsini Palace, Rome, later in the collection of Baron Ricasoli; and paintings of the same type of subject are in the Museo Civico, Udine, and at Vicenza. In all of these Carlevaris follows tradition in using strong contrasts of light and shade, massing the shadows to unify the design. Occasionally, however, Carlevaris produced a different type of landscape, of which two examples are in S. Pantaleone, Venice. The church is dark, and the paintings hang high, so that no signature is visible; but they are mentioned by Zanetti as being by Carlevaris. These are much like the landscapes of Marco Ricci, with a stream in the foreground, groups of small figures, feathery trees, and blue distances.

Dated examples of imaginary landscapes are infrequent. In the art market in Rome, in 1950, was a marine subject with medieval buildings, signed and dated 1713 (Pl. 6 d), companion to a view of Roman ruins and other buildings by a drinking-pool, signed and dated 1714; and in the Murdoch sale, Christie's, 10 July 1931, was a composition of Roman ruins, signed and dated 1715. Clearly, therefore, this type of painting was not confined, as Mauroner seems to suggest, to the earlier years of Carlevaris, but belonged also to his maturity.

But it is as a topographer that Carlevaris chiefly deserves attention, not only as a painter, but as draughtsman and etcher. His paintings include

[1] Mauroner, 61.

both festival and ceremonial subjects, and those which are primarily topo-
graphic. Signed examples are rare, and dated ones even more so, Mauroner
citing only one, *The Bucintoro at the Molo*, signed and dated 1710.[1] Other
festival-paintings can, however, be given approximate dates from those of
the events. Examples are two paintings probably made for the sixth Earl of
Manchester, ambassador from England to the Venetian Republic, both
until recently at Kimbolton Castle. One represents the landing of the Earl
on the Molo, and his entry into the Ducal Palace on 22 September 1707
(Birmingham Art Gallery, Pl. 7 *a*); the other his reception by the Doge in
the Sala del Collegio on the same date (see Nisser, *Burl. Mag.* lxx. 30). These
cannot have been painted before 22 September 1707; and since the Earl
returned to England in 1708, a date for both of 1707–8 is probable. Similarly,
a painting of the regatta on the Grand Canal organized in 1709 in honour of
Frederik IV of Denmark and Norway, now in Frederiksborg Castle,
Denmark, is likely to have been painted in or shortly after 1709 (Pl. 7 *b*).[2]
Somewhat later must have been the painting of the entry into the Ducal
Palace from the Molo of Count Colloredo, the Imperial Ambassador,
now at Dresden. Posse, in the Dresden catalogue, gives the date of the
event as 1714, though it is said that Colloredo headed a second embassy to
Venice in 1726. Yet the style of the painting is so similar to that of the
former Manchester pictures that 1714 or shortly afterward is a preferable
date.

In the topographical paintings by Carlevaris the range of subjects is small,
almost all of these being taken from the Piazza S. Marco, the Piazzetta, and
the Molo. A view of the Rialto Bridge from the north, which appeared in a
sale at Christie's on 22 February 1924, in a group with three other paintings,
is quite exceptional. The topographical views are standardized also in
handling and colour. Figures in the foreground are given prominence,
with local colour emphasized; buildings are painted in a high key, with
pale grey shadows; the skies are pale blue, often with notes of rose

[1] Mauroner (p. 57, pl. 14) gives no owner. In fact, the painting is in the Lazzaroni collection, Rome,
and was twice exhibited, in *Feste e Maschere Veneziane*, Venice, 1937, and *Paesaggio Veneziano del
Settecento*, Venice, 1940.

[2] A version, of the same size, is in the Lazzaroni collection, Rome, pendant to the *Bucintoro at the
Molo* mentioned above, dated 1710, which confirms the suggested date for the Regatta.

introduced, combining with other colours to give somewhat the effect of a pastel.[1]

This standardization makes dating difficult. The group of datable festival-paintings is of little help, since in principles of design and in colour they resemble the great majority of the topographic paintings, while there are not enough differences in the drawing of the figures and architecture to act as a guide. It is impossible to believe that Carlevaris concentrated the whole of his production within the period 1707 to 1714; and the only safe conclusion is that, having worked out a method of painting, he stuck to it.

The somewhat forced contrast between foreground figures and architectural background characteristic of Carlevaris may owe something to the example of the festival-painters, such as Heintzius; but it may equally be derived from the theatre, the figures corresponding to the actors, the architecture to the stage setting, put in a high key to give an illusion of space and atmosphere.

As an etcher, Carlevaris passed completely beyond the limited range of subject in his paintings. *Le Fabriche e Vedute Di Venetia Disegnate, Poste in Prospettiva, et Intagliate da Luca Carlevaris* was issued as a volume in 1703; and in the most complete edition included 104 plates, representing the public buildings, churches, and palaces of Venice, with many of the canals, bridges, and campi. It was the most detailed survey of Venice that had so far been produced, and set a pattern that was imitated throughout the eighteenth century.[2] Despite the reference in the title to perspective, and the fact that Luca Carlevaris had been trained as a mathematician, the relations in space and the proportions of the buildings are often not according to facts, so that sometimes the etchings are more in the nature of diagrams than a reproduction of visual appearance. But they remain an invaluable record.

[1] Typical examples that may be quoted are: *Piazza S. Marco looking West* (Wadsworth Atheneum, Hartford); *Piazza S. Marco looking South* (Earl of Crawford); *Molo looking West* (Art Gallery, Toronto); *Piazzetta looking North* (Nicholas Embiricos, Pl. 7 *d*); five paintings at Kiplin Hall, Yorks. (Pls. 7 *c* and 8 *a*).

[2] An early example was *Il gran teatro delle Pitture e Prospettive di Venezia*, published in 1721 by Domenico Lovisa, with engravings by, among others, Filippo Vasconi after Giuseppe Valeriani.

As a draughtsman Carlevaris was prolific. None of his drawings seems to have been designed as an end in itself, but for use in producing paintings and etchings. Apart from being witness to the industry of Carlevaris, the drawings indicate a new status for topography—that it demanded the same kind of observation and study as any other form of painting. The drawings fall into groups according to the purpose they were to serve.

1. Preparatory drawings for the etchings. Eighty-five of these, some in pen and ink outline, others in pen and wash, are in the British Museum (197 d. 2; cf. Watson, *Arte Veneta*, 1950, 131 sqq.).

2. Studies of figures and boats. (*a*) A volume of fifty-two pages, containing studies of fishermen, gondoliers, shopkeepers, and ladies and gentlemen, with a few sketches of boats in pen and ink outline or pen and wash (British Museum 197 N.C. 5: cf. Mauroner, 65–68, Pls. 8 *b*, 8 *c*). (*b*) Thirty-two pages from two or more sketch-books, with figure-studies in pen and ink outline, pen and wash, pencil with shading, and red chalk, pen and wash (Victoria and Albert Museum: cf. Pope-Hennessy, *Burl. Mag.*, July 1940, 27–31). (*c*) Album of fifty-three sketches in oil on paper or canvas, of figures, animals, and gondolas. Includes studies for the visit of the Earl of Manchester to the Ducal Palace, for that of Count Colloredo, and for other paintings (Victoria and Albert Museum: cf. Pope-Hennessy, *Burl. Mag.*, Sept. 1938, 126–31, Pls. 9 *a*, 9 *d*). (*d*) Twenty-four studies of boats, in wash (Correr Museum Library: cf. Mauroner, 69).

3. Miscellaneous studies. An album of twenty-nine leaves, with studies of figures and architecture, and with mathematical calculations, in chalk or pen (private collection, Venice; cf. Mauroner, 70).

This somewhat lengthy account of the work of Carlevaris is a necessary preface to considering his relation to Canaletto. Moschini,[1] followed by Mauroner, says that Canaletto was his pupil. Moschini, however, is notoriously unreliable; and no evidence has been found supporting his statement. The little there is points the other way. The early work of Canaletto, such as the four large paintings formerly in the Liechtenstein collection (see under no. 1 below) and the four paintings in the Pillow collection, Montreal (see under no. 194 below), low in tone, with dramatic

[1] *Della Letteratura Veneziana*, 1806, iii. 87.

lighting and sharply receding perspective, seem to owe little to the example of Carlevaris, and in certain respects, notably the handling of perspective, differ from his work. Conceivably, something might have been borrowed from the imaginary views of Carlevaris; but this, and the fact that three of the Pillow pictures resemble in design etchings by Carlevaris of the same standard subjects, is certainly not enough to suggest a master–pupil relation. In fact, by the time style comparison between the work of the two painters has any meaning, and might suggest such a relation, Canaletto was an independent and busy painter. As early as July 1725 he was a successful rival of Carlevaris. Writing at that time to Stefano Conti, the Lucca collector, his adviser Alessandro Marchesini compares the two painters and says that Carlevaris is in eclipse, on account of the light effects of Canaletto. Incidentally, he says nothing of their being master and pupil, which in the circumstances would have been likely.

Yet all this does not diminish Canaletto's debt to Carlevaris. The latter had demonstrated the existence of, and perhaps helped to create a market for, topography, which the sale of his paintings to English visitors to Venice, such as the Earl of Manchester, showed was more than local; he brought a new skill and subtlety to festival-painting; and he retained within his repertoire the imaginary landscape. Moreover, he extended the range of his techniques to include etching; and though there is no evidence that his drawings were meant as ends in themselves, he put topography on a new footing by his careful study of detail.

In all these respects, he set a pattern of action for Canaletto, who had only to expand and develop his own art on lines set by Carlevaris. Also, Canaletto did not hesitate to imitate. His change in style of the late twenties and early thirties to a higher key, brighter colour, more precise handling, and more literal approach, evident in such series as the one at Windsor engraved by Visentini (see under no. 161 below) and formerly in the Harvey collection (see under no. 188), was certainly, in part at least, due to the example of Carlevaris. The change brought success; and if Moschini is to be believed, Carlevaris as a result died an embittered man.

Imitation extended beyond the general to the particular. Canaletto's paintings of the receptions at the Ducal Palace of the French ambassador

(Hermitage), and of the Imperial ambassador (Dresden), are in design too much like those of similar subjects painted by Carlevaris some years before for the resemblance to be accidental. The design of Canaletto's various paintings of regattas on the Grand Canal follows closely that of the painting of the subject by Carlevaris at Frederiksborg; and a Studio of Canaletto painting of the Bucintoro at the Molo, in the Philadelphia Museum, resembles both in design and various details the Carlevaris painting in the Lazzaroni collection.

In comparing more purely topographical paintings, similarities between versions of standard subjects are almost inevitable and should not be given too much weight. But in the case of unusual subjects, resemblance may imply imitation. Thus, in Canaletto's view of the Piazza S. Marco, looking south, from near the Torre d'Orologio (Windsor), there is a suspicious resemblance to paintings of the subject by Carlevaris, one in a private collection, Milan (Mauroner, pl. 19), another formerly at Potsdam (Mauroner, pl. 25). Again, a painting by Canaletto of the Riva degli Schiavoni, looking east (Ringling Museum, Sarasota), with the column of St. Mark almost aligned with the column of St. Theodore in the near foreground, might well have been inspired by the left half of a painting by Carlevaris in the National Gallery, Rome, of which versions are at Potsdam (Mauroner, pl. 24) and Kiplin Hall (Pl. 8 a). Another possible borrowing is from one of the Carlevaris capricci at Windsor, which Canaletto could have seen in the collection of Joseph Smith. In the left part of this is a triumphal arch, which substantially reappears in a Canaletto drawing at Windsor (no. 789 below) and in a painting at Asolo (no. 482 below). Occasionally, too, Canaletto seems to have laid the Carlevaris etchings under contribution, an example being the resemblance between a Canaletto drawing of the Campo Sta Maria Formosa at Windsor (no. 605 below), from which paintings at Woburn and elsewhere were derived, and etching no. 31 in the *Fabbriche e Vedute*.

Stylistically, in addition to general resemblances noted in the case of Canaletto's paintings of the late twenties and early thirties, the main direct influence of Carlevaris seems to have been on Canaletto's figures. The use, especially in Canaletto's earlier paintings, of large figures in the foreground

which set off the view, may have come from Carlevaris; but of a connexion between the figures themselves and those of Carlevaris, there is little doubt. Few figure-drawings by Canaletto survive, even if they were made; but comparison of the few early ones that are known, such as those in the Ashmolean Museum, the Berlin Print Room, and the Boymans Museum, with the figure-drawings of Carlevaris, both in outline and in wash, reveals a notable similarity. This similarity extends to the figures in Canaletto's earlier paintings. The boldly and somewhat raggedly handled figures in the six large early paintings at Windsor of views of the Piazza S. Marco and of the Piazzetta (see under no. 55 below), though they may owe something to Marco Ricci, resemble also the figures drawn with a loosely handled pen line and wash by Carlevaris (Pl. 8 *b*); while the neat little figures in the early Windsor series (see under no. 161) and in the one at Woburn have affinities with the figures in outline of Carlevaris (Pl. 8 *c*). Even closer seems the connexion between the Carlevaris figure-studies in oil, in the Victoria and Albert Museum (Pl. 9 *a* and *b*), and the figures in the *Visit of the Doge to the Scuola di S. Rocco* (National Gallery, London; no. 331 below), which was painted in or before 1735. The free handling, lively characterization, and expressive movement of these have led to its being said that they were painted under the influence of Pannini (which it has been seen is an untenable supposition) or of Tiepolo, to the extent of their being attributed to Tiepolo himself. In fact, there is no need to look farther than Carlevaris for the source of Canaletto's inspiration.

A less important and interesting figure than Carlevaris was his contemporary Johan (Giovanni) Richter. He was born in Stockholm in 1665; and that he was in Venice by 1717 is made probable by inscriptions on the back of two paintings in the collection of Osvald Sirén.[1] He died in Venice 27 December 1745; and so was there at the time when the position of Carlevaris was as yet unchallenged, and lived to see the development of Canaletto from an unknown painter to one of European reputation.

Of the two Sirén paintings, one represents the Piazza S. Marco, looking west, from the north end of the Piazzetta; the other is a view on the Grand

[1] On the back of each is written, in an early hand which may be the artist's own: *Jean Richter Suezzese fece in Venezia l'anno 1717.*

Canal, looking south-west, with the Scalzi and S. Lucia mid-distance, right.[1] Two other well-authenticated paintings, *The Molo looking West* and its companion, a *Piazza S. Marco looking East*, are in the Gymnasium zum Grauen Kloster, Berlin. They came there as part of gifts made in 1758 and 1763 by Sigismund Streit, a German merchant resident in Venice, who in a catalogue drawn up by himself describes them as by 'the Swedish painter Richter'. Other attributions to Richter have to be made on style alone. Further examples of purely topographical paintings include two views of the Giudecca Canal, companion pieces exhibited at Tooth's, London, in 1954; and another pair, one of the Piazza S. Marco, the other of the north end of the Piazzetta, both including carnival figures, which were lent by the late Italico Brass to the *Feste e Maschere Veneziane* exhibition, Venice, 1937.

In another group of paintings, Richter appears as a painter of capricci, in that the main theme of the composition is a recognizable building put into imaginary surroundings, or several such buildings brought into arbitrary relations. Examples are two paintings in the National Museum, Stockholm, one of S. Giorgio Maggiore seen from the south with an imaginary city in the background, the other of I Carmini set on the Lagoon in imaginary surroundings (Pls. 9 c and 9 d).[2] Others are a view of Sta Lucia and the Scalzi in a fanciful setting, first published by Fiocco (loc. cit.), which appeared in the New York art market in 1951; and the Spirito Santo and the Ospedale degli Incurabili on the Zattere, also provided with a new environment in the painting in the Tziracopoulo collection (Pls. 10 a and 10 b).

As a painter, Richter is near to Carlevaris and occasionally to Vanvitelli. He works in a high key, keeps his shadows a fairly luminous grey, and uses a conventional scheme of colour, with buildings grey or brown, skies clear blue, often with rosy-tinted clouds, and costumes of bright blue, red, and yellow. He also often adopts the device of an emphatic foreground motif, to give a sense of space and luminosity to his background. So closely does his

[1] Reproduced by Fiocco, *L'Arte*, Jan. 1932, 3 sqq. This was a pioneer article on Richter, to which the present writer is much indebted.

[2] These paintings may perhaps be the 'Deux Vues par Richter' mentioned by Count Tessin in a letter of 1736 as bought by him in Venice (see Sirén, *Dessins et Tableaux Italiens . . . dans les Collections de Suède*, 1902); but proof is lacking. [The church in 9 c is more probably San Michele than I Carmini.]

work at times resemble that of Carlevaris, that the two paintings which were in the Italico Brass collection have sometimes been attributed to that painter.

What his relations were with Carlevaris is unknown. Such dates as we have suggest that Carlevaris was a formed and established painter when Richter came to Venice; which would mean that Richter was the imitator and follower. There seem no grounds for Fiocco's view that Richter, rather than Carlevaris, was the important influence on Canaletto. He does not seem to have enjoyed any particular reputation in his own day. The only known contemporary estimate of him is that of Vertue, writing in 1722, who says of Christian Richter that he has a brother in Venice, 'a painter of Views very free and Masterly as some of his works here appear to be—that have been bought a[t] Venice'.[1] Evidently he was known to and bought by English collectors; but he was not sufficiently admired to be represented in the collection of Joseph Smith, sold to George III. He seems, however, to have been one of the first painters in Venice, if not the first, to have made the capriccio proper a regular part of his production; and in this, at least, he may have shown the way to Canaletto.

[1] Walpole Society, *Vertue*, iii. 64.

III

THE WORK OF CANALETTO AND HIS ARTISTIC DEVELOPMENT TO *c.* 1740

THE usual conception of Canaletto as primarily a painter, and more particularly a topographical painter, is on the whole justified; but it needs some modification to obtain a just view of his position as an artist. Many of his drawings, among them some of his finest, were made as ends in themselves, quite independently of his paintings; and as an etcher he was highly accomplished. So, had he never put brush to canvas, he would still have been ranked as a considerable master of the graphic arts.

His earliest work was in the theatre, as a young man, and of this little is known. Moschini has found that he collaborated with his father Bernardo and one Cristoforo Canal in the setting for two operas by Antonio Vivaldi performed in 1716 at the theatre of S. Angelo;[1] and that in 1717–18 he was at work there and in the theatre of S. Cassiano. Also, in 1719–20 he worked in Rome with his father on settings for two Scarlatti operas (see p. 9). No drawings or designs for the theatre by him have been identified; for the attribution by Muraro to him of a page of sketches, perhaps for scenery, in the Horne collection, has little to justify it (see no. 851 below). Indeed, at his age it is more likely that Canaletto was an assistant to others than a designer himself.[2]

Opinion concerning his topographic work has varied widely. Once he was regarded as little more than a photographer; today, there is a tendency to accuse him of frequent inaccuracies. In most of his paintings he was

[1] *Canaletto*, p. 7. Moschini calls Cristoforo a brother. Canaletto had no brother of that name, and probably he was an uncle.

[2] It is true that Henry Angelo (*Reminiscences*, i. 9) says: 'During my father's residence at Venice he became acquainted with Canaletti, the celebrated painter; and being from his youth fond of the arts, he imbibed, through him, an acquaintance with the scenic decorations of the stage; Canaletti being the best scene-painter of the age. . . .' Angelo is notoriously inaccurate; Canaletto was a child when Angelo senior was in Venice; and the reference may be to Bernardo, Canaletto's father.

astonishingly close to the facts in detail. His concern with these is witnessed by the many diagrammatic drawings he made, notably those in the sketch-book in the Accademia (see under Sketch-books, I), in which not only are details carefully indicated, but frequent notes are added to identify buildings and to record colour. Yet he would change the relative sizes and positions of buildings by such devices as rapidly vanishing perspective lines, or the adoption of two or more viewpoints when painting an extensive view. As a rule, such distortions (if they can be so called) are used in the interest of design, to give dramatic emphasis, or to bring as many facts into a picture as possible. Sometimes they cannot be explained in this way; and equally with an occasional complete inaccuracy of detail would seem to be due to carelessness, to reliance on memory or on a defective drawing, or to mis-understanding some record by another hand.

Canaletto did not wholly confine himself to topography. In the inscrip-tion on the frontispiece to his etchings, he himself makes a distinction between *vedute prese da i luoghi* and *vedute ideate*, emphasized by occasional notes on his drawings such as *veduta esatta* and *veduta dal naturale*. In his hands, the *veduta ideata* took two main forms: the imaginary view proper, and the capriccio, a collection of identifiable motives from different build-ings or localities, arranged into a composition. The difference between the two is easy to recognize in extreme cases, such as the mountain landscapes among Canaletto's etchings on the one hand, and the group of *sopra-porte* at Windsor (see under no. 451 below) on the other. Usually, however, imaginary and identifiable elements were mixed, as in the type of composi-tion which Algarotti describes when writing to Prospero Pesci in 1759, 'un nuovo genere, quasi direi, di pittura, il qual consiste a pigliare un sito dal vero, e ornato dipoi con belli edifizi, o tolti di qua e di là, ovveramente ideali' (see note on no. 458 below). In the case of such a mixture of material, it becomes difficult to distinguish the *veduta ideata* from the capriccio; and in the following pages, when there is doubt, the term capriccio is used.

When Algarotti called the architectural capriccio 'un nuovo genere di pittura' he probably meant that it was new to him; for it had had an established place in Canaletto's work for a long time before 1759. As early as 1722 he was associated with the production of the series of *Tombeaux des*

Princes commissioned by Owen McSwiney (see note on no. 516 below). Designed to celebrate the fame of great English statesmen, soldiers, and religious leaders, these were wholly fanciful compositions, and Canaletto's share in their production was limited. Not until about 1740 does he seem to have produced a capriccio or an imaginary view, though from then onward these become a regular part of his output.

Canaletto's concept of the form and purpose of the capriccio was akin to that of Johan Richter, but differed considerably from that held by some artists of the time. For Giovanni Battista Tiepolo it implied an element of light-heartedness and humour; for Piranesi it meant the presence of macabre fantasy. In Canaletto such conceits as putting the bronze horses of S. Marco on pedestals in the Piazza are odd, rather than humorous; and only occasionally, as in some of the etchings, is he able to give his borrowings from different sources and his imagined details an emotional coherence which yield fantastic reality. Usually, he is little more than ingenious.

For him the capriccio was primarily a means to create a decoration; and it is significant that the important group of capricci he produced, the thirteen painted in 1743–4, of which nine are at Windsor, should be described by Joseph Smith as 'over-doors'. These are little more than arbitrary collocations of various Venetian monuments; but in other capricci Canaletto expanded the range of his material. The etchings dating from the earlier forties exemplify admirably the variety of motives that he brought into use, and the way he combined them to yield compositions of different types, from the capriccio proper to the imaginary view; almost as though in the etchings he was exploring all the possibilities of the capriccio.

Probably early training in the theatre had considerable influence at this point, in providing precedents and methods both for the arrangement of material and for the adaptation of existing buildings or the creation of imaginary ones. The choice of material, however, seems to have depended somewhat on the type of subject with which Canaletto was occupied at the time.

As might have been expected, Venice provided the motives most often used. These included, besides the more prominent buildings, many of the lesser-known churches; such famous objects as the Colleoni monument,

the columns on the Molo, the Pilastri Acritani, and the Pietra del Bando; and the more commonplace though equally characteristic furnishings of every campo, such as well-heads, and the posts for holding banners. With variations and embellishments, these appear and reappear, playing either a main or subsidiary part. But whatever may be the main theme of a capriccio, one motive is rarely absent: that of the Lagoon and its islands, found in the improbable company of triumphal arches, Gothic churches, Roman palaces, and even of English houses.

Renewed interest in the earlier forties in Roman subjects brought new material for capricci, notably domed buildings distantly related to the Pantheon, triumphal arches, pyramids like that of Cestius, and columns recalling those of Trajan and Marcus Aurelius. The Roman palace, also, in various strange forms, found a permanent place in Canaletto's repertoire. For a period, Padua contributed its quota, sometimes mated with Roman reminiscences. From sources more difficult to trace came Gothic elements, exemplified in the etchings and in several paintings by Gothic tombs with canopies, somewhat like those of Verona. Later, such elements are more often used, probably as a result of Canaletto's visit to England; since they include church towers and window tracery of an unmistakably English type, with occasional travesties of English buildings such as Eton College Chapel.

The imaginary view proper plays only a small part in Canaletto's work. There are admirable examples among the etchings; a number of drawings based on material from the Venetian mainland, which appear to be imaginary; and a few small paintings of island or mainland subjects, such as two at Springfield, Massachusetts (nos. 513 and 514 below). Even such near approaches to the *veduta ideata* as the two river landscapes now in Washington (nos. 473 and 474 below) contain enough recognizable borrowings from England to give them in part the character of a capriccio.

Outside the fields of topography and the capriccio, Canaletto rarely, if ever, ventured. Two examples, however, are recorded, for what the record is worth. The more remarkable is in a guide-book of 1768, *Windsor and its Environs*.[1] Describing the contents of the house of the Duke of St. Albans,

[1] Cited by F. J. B. Watson, 'A Self-Portrait by Canaletto', *Burl. Mag.*, Sept. 1956, 295 (as called to his attention by E. Croft-Murray).

after mentioning views of Rome and Venice by 'Candaleto', it refers to 'a curious Piece of Still-life by the same hand'. The book was published in the year of Canaletto's death, so the attribution has a respectable antiquity. But the infinite capacity of the eighteenth-century owner and his servants for putting wrong names on pictures has always to be remembered; and the fact that no such painting appeared in any of the four St. Albans sales (Brussels, 1786; Phillips, London, 1798; Christie's, 1801 and 1802) is not reassuring.

The second mention of an unusual type of subject by Canaletto is by Lorenzo Crico in 1833.[1] He says that in the collegiate church at Mestre (Cicogna says S. Lorenzo): 'Antonio Canal che appellasi il Canaletto, pittor veneto, paesista di molto grido, dipinse una Sacra Famiglia con piccole figure e paesaggio bellissimo.' There is no confusion here, such as sometimes occurs, of Canaletto with Fabio Canal or his son Giambattista, who regularly painted religious subjects. The present whereabouts of the painting has not been discovered, nor has any other mention of it been found; so the question of its authorship has to remain in doubt.

A third example of unexpected subject-matter is a portrait of Canaletto which F. J. B. Watson identifies as a self-portrait,[2] making a good though not completely convincing case.

An essential preliminary to studying the development of an artist is to survey in chronological sequence authentic work which can be securely dated, either exactly or approximately. Only on such a basis is dating on grounds of style likely to be valid.

In compiling the following list of dated and datable work by Canaletto, the reason for the date is noted in each case, fuller explanation being given in the relevant catalogue entry. It should be clearly understood that in this list evidence of style is not used. Consequently, many of the dates given are necessarily very imprecise, and provide only a *terminus ante quem* or a *terminus post quem*. Even so, this gives a definite starting-point for consideration of style as a means of more exact dating.

[1] *Lettere sulle Belle Arti Trevigiane*, Treviso, 1833, 297. See also, quoting Crico, Cicogna, *Delle Inscrizioni Veneziane*, 1842, v. 345. [2] Watson, loc. cit.; cf. catalogue no. 520 for discussion.

The methods of dating used are specified below, with some notes on their limitations.

1. *Inscriptions by Canaletto on the work itself, either on front or back*

In proportion to Canaletto's output, such dating is rare, especially in the case of drawings. Fortunately, dates (often combined with a signature) are generally clear and unmistakable, being either in Roman numerals, or in script easily recognizable as that of Canaletto. In at least one case a mistake in the use of Roman numerals has to be checked by style comparisons.

2. *Documents, written or printed*

With Canaletto, these range from documents in his own hand, written at about the time a picture was painted and giving dates, as in the case of the four in the Pillow collection, Montreal, to casual mention in manuscript or printed sources, which include letters, notes, diaries, periodicals, catalogues, and books. Some of these are more or less contemporary, some much later, incorporating oral tradition or material from earlier documents; and their reliability varies with the knowledge and intentions of the writer. A particular difficulty in the case of Canaletto is to connect a documentary reference with some particular work. Certain compositions were so often repeated both by Canaletto himself and by others, and so vague or misleading have been the titles given to many of his works, that it is sometimes impossible to say to what picture or drawing an indication of date applies.

3. *Representations of historical events*

If the event was unique, such as the reception of the French or Imperial Ambassadors, and the painting or drawing is known to represent it, then the date of the work may reasonably be taken to be after the date of the event. But in the case of ceremonies, festivals, &c., which recur, this is not necessarily the case. The *mise en scène*, the ritual, the costumes were more or less standardized; and a painting or drawing could have been made some time beforehand, and details appropriate to any particular occasion inserted later; and since some of these details would be known in advance, such as

the particular doge who would be present, the whole painting might even be finished before the event took place. Herein lies the risk of dating paintings of such subjects as a regatta on the Grand Canal, or the Bucintoro at the Molo, by the presence of the coat of arms of a particular doge.

4. *Engravings*

The date on an engraving is almost invariably that of publication, and is no sure guide as to the date it was made, and even less to the date of the painting or drawing from which it derives. All it gives is a *terminus ante quem*; always provided that the painting or drawing under consideration is in fact the one from which the engraving was made. For example, the first fourteen engravings by Visentini after Canaletto were published in 1735; but evidence has recently emerged (see p. 18) that they may have been finished by the middle of 1730, and that the paintings were therefore made before that date. Again, the series of engravings published by Baudin after Canaletto have been incautiously used to date the paintings as of about the same period, without its being realized that (*a*) the engravings themselves were published at different dates, (*b*) that in some cases the engravings were made from copies by Baudin which were apparently made from pictures of different dates.

5. *Paintings and drawings*

If a painting is based upon a drawing that can be dated, this only provides a *terminus post quem* for the painting. Drawings were part of Canaletto's stock-in-trade; and might be used for paintings made some years later. Similarly, a dated painting does not carry with it a drawing on which it is based, but only provides a *terminus ante quem*. Occasionally a dated or datable copy serves the same purpose for both paintings and drawings.

6. *Existence, non-existence, and condition of buildings, monuments, &c.*

When Canaletto represents a building or part of a building, or some element in a view as it is known to have been after a certain date, that date is a satisfactory *terminus post quem*, since it is highly unlikely that he could have anticipated the future to the necessary extent. Examples are the

Loggetta after Gai's gates were put in position; the campanile of S. Giorgio Maggiore after an onion-shaped steeple succeeded a straight-sided one; the Pietà after Massari began his reconstruction; and the Torre dell'Orologio after the top story was added.

But representations of views and buildings as they appeared before such changes or additions were made does not provide quite so convincing a *terminus ante quem*. It is known that in some cases Canaletto used for a painting a drawing made some time earlier; and this drawing might ante-date the changes in buildings, &c. So, through inadvertence, ignorance due to not being on the spot when the changes were made, or through intention, such as desire to please a client, the painting might represent a building or view as it used to appear before the painting was made. A case in point is Gai's gates to the Loggetta, made 1735–7; yet in a painting at Windsor dated 1744 they are omitted.[1] The drawing, also, might not represent contemporary fact. Canaletto was not always topographically accurate,[2] and many of his drawings, even quick sketches, were not made on the ground. Sometimes, therefore, a drawing may be a record of recollection, and not of direct observation. Moreover, Canaletto is known in some of his Roman views at least to have taken material from earlier engravings, which would completely frustrate any attempt at dating from appearance of the buildings.

In the following list (*a*) titles are those used in the catalogue; (*b*) drawings are marked ★; (*c*) D. = dated, S. = signed; (*d*) explanation and grounds for dating are given in the catalogue. When there are two or more means of dating, the more precise is usually alone given.

[1] [No. 37, now at Buckingham Palace. The gates are in fact shown although Mr. Michael Levey, to whom thanks are due for examining the painting, notes that they seem rather sunk under the patchy varnish and the paint itself may be faded or thin. They appear unmistakably in the related Visentini drawing and in the engraving referred to in the catalogue entry.

[2] In judging Canaletto's topographical accuracy consideration should be given to his practice of changing his viewpoint, even when making sketches on the ground. No. 548 provides one of many examples which are also to be found in the Accademia sketchbook.]

Cat. no.	Title	Owner	Date	Authority	Remarks
516	Allegorical: Tomb of Lord Somers	Earl of Plymouth	1722	Documents	
517	Allegorical: Tomb of Archbishop Tillotson	Private Coll.		Documents	
1	Piazza S. Marco, looking E.	Schloss Rohoncz	Probably in or before 1723	Pavement reconstructed 1723	
234	Rialto Bridge from N.	Pillow, Montreal	2 Aug.–25 Nov. 1725	Documents	
230	Grand Canal looking N. from Rialto Bridge	Pillow, Montreal			
194	Grand Canal from the Carità to Bacino di S. Marco	Pillow, Montreal	22 Dec. 1725–15 June 1726	Documents	
304	SS. Giovanni e Paolo *Piazzetta, looking S.	Windsor (7446) Ashmolean		Straight-sided steeple of S. Giorgio Maggiore	Very probable date; but see note 6 above (p. 83)
55	*Piazzetta, looking S.	Windsor			
124	Bacino di S. Marco from the Piazzetta	Thurkow	Before 1726–8		
125	Bacino di S. Marco from the Piazzetta	Rasini			
356	Reception of French Ambassador	Tziracopoulos	After 1726	Date of Event	
126	Bacino di S. Marco, from the Piazzetta	Mario Crespi		Onion-shaped steeple of S. Giorgio Maggiore	
127	Bacino di S. Marco, from the Piazzetta	Toronto	After 1726–8		
134	Bacino di S. Marco, looking E.	Wallace Collection			

Cat. no.	Title	Owner	Date	Authority	Remarks
299	S. Giorgio Maggiore from the entrance to the Grand Canal	Windsor			
300	S. Giorgio Maggiore from the Canale di Giudecca	Ex Liechtenstein			
301	S. Giorgio Maggiore from the Bacino di S. Marco	Private Coll.			
56	Piazzetta, looking S.	Major J. M. Mills	After 1726–8	Onion-shaped steeple of S. Giorgio Maggiore	
60	Piazzetta, looking S.E.	Private coll., U.S.A.			
58	Piazzetta, looking S.	Indianapolis			
544	*Piazzetta, looking S.	Windsor (7442)			
546	*Piazzetta, looking S.	Windsor (7441)			
575	*Riva degli Schiavoni, looking W.	Darmstadt			
612	*S. Giorgio Maggiore from the Canale di Giudecca	Windsor (7482)			
235	Rialto Bridge from the N.	Duke of Richmond	1727–9	Documents	
232	Grand Canal, looking N. from Rialto Bridge	Duke of Richmond			
371	Dolo on the Brenta	Ashmolean	Before 1729	Absence of church dedicated 1729	But cf. note 6 above and note in cat.
545	*Piazzetta, looking S.	De Burlet	1729	D.	

Cat. no.	Title	Owner	Date	Authority	Remarks
573	*Riva degli Schiavoni, looking E.	Darmstadt	Mar. 1729	D.	
355	Imperial Ambassador landing at Ducal Palace	Aldo Crespi	After 16 May 1729	Date of Event	
372	Dolo on the Brenta	Italico Brass, Jr.	In or after 1729	Date of dedication of church	
166	Grand Canal: Entrance looking W.	Houston, Texas	In or before 1730	Documents	
220	Grand Canal: looking SE. from near Rialto Bridge	Houston, Texas			
161	Fourteen views of Venice engraved Visentini (pub. 1735; Pt. I, 1942 ed.)	Windsor	1729–30	Document	The *Entrance to the Cannaregio* presents difficulties in dating (see note in catalogue)
97	Molo looking W.	Late Lord Egerton of Tatton	1730	Documents	
111	Riva degli Schiavoni, looking E.	Late Lord Egerton of Tatton			
4	Twenty-four views of Venice	Woburn	1731 or shortly after	Documents and engravings	Evidence creates a probability, supported by style
551	*Piazzetta looking N.	Darmstadt	July 1732	D.	
598	*S. Geremia and the Entrance to the Cannaregio	Windsor	Perhaps 16 July 1734	Inscription said to be on back	

Cat. no.	Title	Owner	Date	Authority	Remarks
601	*Canale Sta Chiara, looking S.E.	Windsor (7489)	16 July 1734	Inscribed on back	
36	Piazza S. Marco, looking W.	Brown, Boveri & Co.	Before 1735–7	Gates of Loggetta absent; tradition	But see note 6 above
45	Piazza S. Marco; N.E. corner	National Gallery, Canada	Before 1735–7		
35	Piazza S. Marco: looking W.	Borletti	Before 1735–7	Gates of Loggetta absent	But see note 6 above
39	Piazza S. Marco and the Loggetta	Barber Institute	Before 1735–7	Gates of Loggetta absent	But see note 6 above
761	*Capriccio: Loggetta of Sansovino as Portico of a Church	Durlacher Bros.	Before 1735–7	Gates of Loggetta absent	But see note 6 above
	Six paintings (5 untraced) engraved by Boitard including		Before 1736		See chapter on Engravings after Canaletto
153	Entrance to Grand Canal from Molo or	Windsor			
152	Entrance to Grand Canal from Molo	Kauffman			Less certainly the original of the engraving
610	*Church of the Gesuati	Formerly Italico Brass	After 1736	Consecration of church	
622	*S. Simeone Piccolo	Windsor (7467)	Shortly before 1738	Condition of church steps	

Cat. no.	Title	Owner	Date	Authority	Remarks
Under 258	Grand Canal, looking S.W. from Chiesa degli Scalzi	Buehrle	After 1738	Steps of S. Simeone Piccolo finished	
259	Grand Canal, looking S.W. from Chiesa degli Scalzi	National Gallery, London	After 1738		
43	Piazza S. Marco, looking N.	Kansas City			
167	Grand Canal, Entrance, looking W.	Rosenberg and Stiebel, N.Y.			
192	Grand Canal, looking E. from Campo di S. Vio	Earl of Leicester	Before 1739	Engraving (Fletcher)	
226	Grand Canal: Rialto Bridge from S.	Earl of Leicester			
269	Canale di Sta Chiara, looking N.W.	Mario Crespi			
787	*Capriccio: View of a City	British Museum	1741	S. & D.	
95	Molo looking W.	Albertini	Before 1742	Engraving	
7	Piazza S. Marco, looking E.	Fitzwilliam, Milton Park	Before 1742	Engravings	
23	Piazza S. Marco, looking W.		Before 1742		
244	Grand Canal, looking N.W. from the Palazzo Pesaro	Mrs. Thomas Parrington	Before 1742	Engraving	Probably before 1740

Cat. no.	Title	Owner	Date	Authority	Remarks
106	Molo from Bacino di S. Marco	Private coll., London	Before 1742	Documents	
190	Grand Canal from the Campo S. Vio	Private coll., London			
188	Twenty-one views of Venice	Harvey Trustees	Before 1742	Engravings in some cases. Tradition	
253	Entrance to Cannaregio	Private coll., England	Before 1742		
Under 251	Entrance to Cannaregio	Kleinberger, N.Y.			
251	Entrance to Cannaregio	Agnelli		Absence of Marchiori statue	But see note 6 above
Under 252	Entrance to Cannaregio	Private coll., Italy	Before 1742		
243	Grand Canal: Campo Sta Sofia to S. Marcuolo	Matthiesen		Drawings from paintings by Visentini in Correr and B.M.	
306	SS. Giovanni e Paolo	Matthiesen			
277	Campo Sta Margherita	Harvey Trustees			
274	Campo S. Angelo	Harvey Trustees			
695	*River at Padua	Morgan Library Fogg Museum	1742	S. & D.	Drawings not used for engravings
378	Forum, looking towards Capitol	Windsor	1742	S. & D.	
382	Arch of Constantine	Windsor	1742	S. & D.	
384	Arch of Septimius Severus	Windsor	1742	S. & D.	
386	Arch of Titus	Windsor	1742	S. & D.	
390	The Pantheon	Windsor	1742	S. & D.	

Cat. no.	Title	Owner	Date	Authority	Remarks
251	Entrance to Cannaregio	Windsor	In or after 1742	Presence of Marchiori statue. Engraving	Statue may be an addition to a pre-1730 painting
377	View on a River at Padua	Mark Oliver	In or after 1742	Drawing dated 1742	
331	Visit of Doge to Scuola di S. Rocco	National Gallery, London	Before 1743	Absence of Marchiori sculpture	See note 6 above
387	Colosseum and Arch of Constantine	Hampton Court	1743	S. & D.	
451	Capriccio: Horses of S. Marco in the Piazzetta	Windsor	1743	S. & D.	Date inscribed is 1753; but the style makes clear that this is due to a slip in using Roman numerals
85	Molo looking W., with Prison	Windsor	Oct. 1743	S. & D.	
68	Piazzetta, looking N.	Windsor	Oct. 1743	S. & D.	
37	Piazza S. Marco, looking W.	Windsor	1744	S. & D.	
17	Piazza S. Marco, looking S.	Windsor	1744	S. & D.	
174	Grand Canal, Entrance, looking E.	Windsor	1744	S. & D.	
455	Capriccio: Scala dei Giganti	Windsor	1744	S. & D.	
452	Capriccio: Library and other buildings	Windsor	1744	S. & D	

Cat. no.	Title	Owner	Date	Authority	Remarks
476	Capriccio: with the Colleoni Monument and Ruins	Windsor	1744	S. & D.	
460	Capriccio: with S. Francesco della Vigna	Private coll., Milan	1744	S. & D.	
228	Rialto Bridge from S.	Formerly Trotti, Paris	1744	S. & D.	
114	Riva degli Schiavoni, looking E.	Fitzwilliam, Milton Park			
112	Riva degli Schiavoni, looking E.	Wallace coll.			
113	Riva degli Schiavoni, looking E.	Albertini			
121	Riva degli Schiavoni, looking E.	Vienna	Before 1745	Reconstruction of Pietà not begun	Date probable only (see note 6 above)
173	Entrance to Grand Canal, looking E.	Arthur Tooth & Son, London Sir Henry Price			
133	Bacino di S. Marco, looking E.				
132	Bacino di S. Marco, looking E.	Fitzwilliam			
134	Bacino di S. Marco, looking E.	Wallace Coll.			
122	Riva degli Schiavoni, looking W.	Soane Museum	After 1726–8 and before 1745		Steeple of S. Giorgio Maggiore; and reconstruction of Pietà
131	Bacino di S. Marco, looking E.	Boston			
552	*Piazzetta, looking N.; Campanile under repair	Windsor (7426)	After 23 Apr. 1745		Date of damage inscribed on drawing

Cat. no.	Title	Owner	Date	Authority	Remarks
Under 552	*Piazzetta, looking N.; Campanile under repair	New York Art Market, 1939	Shortly after 23 Apr. 1745	Date of damage. S.	
139	Bacino di S. Marco, looking W.	Arthur Erlanger	After 1745	State of Pietà façade	
141	Bacino di S. Marco	Princeton University	After 1745		
615	*Sta Maria della Pietà	Late Italico Brass	After 1745	State of façade	
424	Thames and City from Richmond House	Duke of Richmond			
438	Whitehall and the Privy Gardens, from Richmond House		1746–7	Document, tradition, state of buildings	
732	*London: The City seen through an Arch of Westminster Bridge	Windsor (7561)			
Under 732	*London: The City seen through an Arch of Westminster Bridge	Buffalo	After 20 July 1746	Date of completion of bridge	
425	Thames on Lord Mayor's Day, looking towards the City	Prince Lobkowicz	Late 1746–7 to 1752	State of bridge; Documents	
426	Thames: Westminster Bridge in distance				
427	Thames, looking towards Westminster Bridge	Mrs. Charles Wood	1746–7	State of bridge	

Cat. no.	Title	Owner	Date	Authority	Remarks
412	London through an arch of Westminster Bridge	Duke of Northumberland	1746–7	Engraving; state of bridge	
434	Westminster Bridge under construction	Duke of Northumberland	Late 1746–early 1747	State of bridge	
435	Westminster Bridge on Lord Mayor's Day	Duke of Buccleuch	Late 1746–7	Engraving	
749	*Westminster Bridge from the N.	Windsor (7558)	Late 1746–early 1747	State of bridge	Very probable, but not certain
750	*Westminster Bridge from N.E. with civic procession	Windsor (7557)	1746–7	State of bridge	
747	*Thames, looking to Westminster Bridge	M. Bernard	1746–7	State of bridge	
449	Windsor Castle	Duke of Northumberland	1747	Document	
752	*Westminster Bridge, the western arches	British Museum	Early 1747	State of bridge	
409	Badminton House	Duke of Beaufort	1748–9	Document	
410	Badminton Park	Duke of Beaufort			
734	*Old Horse Guards	British Museum			
735	*Old Horse Guards,	Viggiano	Before or in 1749	Date of demolition of building	Probably for painting of subject 1749
736	*Little Walsingham House	Viggiano			
416	Old Horse Guards and Banqueting Hall	Late Sir Arthur Wilmot, Bt.	Before autumn 1749	Date of demolition of building	Probable date only; cf. note 6

Cat. no.	Title	Owner	Date	Authority	Remarks
440	Syon House	Duke of Northumberland	1749	Document	
415	Old Horse Guards	Earl of Malmesbury	1749	Document (July 1749)	
432	Westminster Abbey: Procession of Knights of the Bath	Dean and Chapter, Westminster Abbey	After 26 June 1749	Date of event; Documents	
751	*Westminster Bridge from S.W. under repair	Windsor (7562)	Early 1750	State of bridge	
746	*Thames from Somerset House, Westminster Bridge in distance	Windsor (7559)	1750	Condition of bridge, &c.	
436	Westminster Bridge from the N.	Lord Strathcona	After mid-1750	State of bridge	
Under 427	Thames, looking towards Westminster	Lady Janet Douglas-Pennant	In or after 1750	State of bridge	
731	*London from Pentonville	British Museum	Before or in 1751	Engraving	
413	Chelsea College and Ranelagh	National Trust, England, and Private Coll., Cuba	1751	Contemporary newspaper	
431	Vauxhall Gardens	Lord Trevor	c. 1751	Engraving	
439	Whitehall and the Privy Garden, looking N.	Duke of Buccleuch	1751-2	State of buildings	
408	Alnwick Castle	Duke of Northumberland	Before or in 1752	State of building; dated copy 1752	

Cat. no.	Title	Owner	Date	Authority	Remarks
740	*Northumberland House	Minneapolis	After 1752	State of house	
419	Northumberland House	Duke of Northumberland	Before or in 1753	Engraving	
417	New Horse Guards	Mrs. Robin Buxton	Nov. 1752–Nov. 1753	Engravings	
418	New Horse Guards	Formerly Drury Lowe	In or after 1753	State of building	
730	*Hampton Court Bridge	British Museum	1754	Engraving	
475	Capriccio: Sluice on a river with a church	Ex Lovelace	1754	S. & D.	
512	Capriccio: Pavilion, with arcade and colonnade, on the lagoon	Mortimer Brandt (ex Tatton)	1754	Inscription on back	Copied from original canvas on to lining canvas
420	Ranelagh: Interior of Rotunda	National Gallery, London	1754	Inscription by Canaletto on back	
422	London; St. Paul's Cathedral	Unknown (painted for Hollis)	1754	Inscription probably by Canaletto on back	See note in catalogue
Under 437	London: Westminster Bridge				
441	Old Walton Bridge	Dulwich Gallery	1754	Inscription by Canaletto on back	
65	Piazzetta, looking N.	Sir Harry Hague			
66	Piazzetta, looking N.	Formerly Earl of Lincoln	Before 1755	State of Torre dell' Orologio	Puts date before first English visit
67	Piazzetta, looking N.	National Gallery of Canada			

Cat. no.	Title	Owner	Date	Authority	Remarks
102	Molo from the Bacino di S. Marco	Uffizi			
103	Molo from the Bacino di S. Marco	Earl Cadogan			
104	Molo from the Bacino di S. Marco	Duke of Norfolk	Before 1755	State of Torre dell' Orologio	Puts date before first English visit
105	Molo from the Bacino di S. Marco	Count Matarazzo			
107	Molo from the Bacino di S. Marco	Brera			
755	*Old Walton Bridge	Unknown	1755	S. & D.	
442	Old Walton Bridge	Mrs. Skrine	1755	Inscription by Canaletto on back	
396	Rome: Cordonata and Piazza del Campidoglio	Gavito (ex Hollis)	1755	Inscription by Canaletto on back	Label recording inscription partly destroyed
528	*Piazza S. Marco looking E.	Late Lady Anna-bel Dodds-Crewe	1760 or later	Document	
242	Looking S.E. from Campo Sta Sofia to Rialto Bridge	Gymnasium zum Grauen Kloster, Berlin (ex Sigismund Streit)			
282	Campo di Rialto		Before 1763	Documents	
359	Vigilia di S. Pietro in Castello				
360	Vigilia di Sta Marta				

Cat. no.	Title	Owner	Date	Authority	Remarks
361	Bull-fight in Piazza S. Marco	Peter Jones	Before 1761	Date of entry into Cleeve Coll.	Painted with Cimaroli
630–9	*Ten drawings of Ducal Ceremonies and Festivals	Various Owners	After 1755–before 1763	Engravings	
509	Capriccio: Colonnade and Courtyard of a Palace	Accademia, Venice	1765	S. & D.	
558	*S. Marco: Interior with musicians singing	Hamburg, Kunsthalle	1766	S. & D.	

[Nos. 41, 54*, 339, and 534, showing the Torre dell'Orologio in its *post-1755* state, should be added to the above list; no. 54* is also S. & D. 1763. See also the note on dating under no. 339.]

Recent research has done much to modify earlier conceptions of Canaletto's development as an artist.[1] Especially has the view of his earlier work changed. A number of paintings, some of them previously regarded as doubtfully by him, others as mature work, can now be safely assigned to the middle twenties; another group, at one time thought to be characteristic of the thirties, can now be securely dated some years earlier; while a third group, of which many were given to Bellotto, can now be taken as painted by Canaletto in the early forties.

The earliest work associated with Canaletto of which we have definite knowledge is a series of twenty-three topographical drawings of Rome, twenty-two in the British Museum and one at Darmstadt. There is still argument as to whether these are originals or early copies, though the evidence seems slightly to favour their being originals. In any case, those who doubt their being by Canaletto do not deny that they are copies, and careful copies, of his work.[2] Even as such, they throw a considerable amount of light on his beginnings. The drawings are diagrammatic rather than pictorial, timid and tight in handling, the work of a careful and accurate observer. They are completely in the tradition of the Roman topographical engravers, and were in fact engraved by Brustoloni. Their historical importance is twofold. They are witness to the fact that Canaletto had early practice in precise record of topographical facts; and that he provided himself with a corpus of Roman material, of which he was to make extensive use later.

The next piece of work in which Canaletto took part was the series of decorative canvases commissioned by Owen McSwiney from a considerable group of artists, and ultimately engraved under the title of *Tombeaux des Princes.* Out of twenty-four paintings, Canaletto appears to have collaborated in only two. In *The Tomb of Lord Somers* he worked with Piazzetta and Cimaroli; in *The Tomb of Archbishop Tillotson,* with Pittoni and Cimaroli.[3] The dates are fixed by a letter of 8 March 1722,[4] from McSwiney to Lord March

[1] No attempt is made in this chapter to mention every work of Canaletto included in the catalogue. The intention here is to discuss the character of his work at different periods of his career, referring throughout only to selected examples. The numbers that follow titles cited are those of the catalogue.

[2] See cat. no. 713 for a full description with discussion of the arguments concerning authenticity.

[3] See Chapter I, and under nos. 516 and 517. [4] In the archives at Goodwood; see Appendix II.

(later second Duke of Richmond), which implies that the *Somers* was finished, and that Canaletto and Cimaroli had completed their work on the *Tillotson*. Who provided the designs and how the work was divided is not known; but it seems highly probable, from comparison with work known to be by them, that Piazzetta and Pittoni were responsible for the figures, Cimaroli for the trees and landscape, and Canaletto for the architecture, which is of a type for which his training in stage design would have prepared him.

Everything in the paintings smacks of the theatre, probably reflecting the inclinations and experience of McSwiney, who had been a theatre manager in London. For Canaletto they represented a complete change of artistic climate from that of the Roman topographical drawings, involving him in a project which in conception and treatment stems direct from the imaginary compositions of the seventeenth-century ruin-painters.

During or shortly after his employment by McSwiney, Canaletto returned to topography, though with a very different approach from that in his first essay. The earliest examples known are four paintings formerly in the Liechtenstein collection.[1] In one of these (*The Piazza S. Marco*) the pavement of the Piazza is represented as it was before being relaid in 1723, which dates it in or before that year; since the possibility of the painting being a reminiscence rather than a record may in this case be disregarded.[2] The four paintings form a set, and are so similar in style that they must have been made about the same time. In all of them there are distortions due to the use of abrupt foreshortening, as in theatre scenery; the proportions and relative sizes of buildings sometimes vary from the facts; the light and shade are arbitrarily massed and sharply contrasted; and the handling is broad, detail being subordinated to general effect, the figures in particular being freely painted, with a somewhat ragged touch. Here, to the treatment of topography has been applied the ideas and methods of the ruin-painters

[1] *Piazza S. Marco looking East* (no. 1) and *Grand Canal from the Campo S. Vio* (no. 182, both Thyssen-Bornemisza collection); *Grand Canal from the Palazzo Balbi to the Rialto Bridge* (no. 210) and *Rio dei Mendicanti* (no. 290, both Mario Crespi).

[2] Rodolfo Gallo has proposed for the *Interior of S. Marco* (no. 78) a date before 1722, which would make it Canaletto's earliest topographical painting of a Venetian subject. For reasons why the suggestion seems untenable, see note in the catalogue entry.

and theatre-designers, with the intent of securing pictorial unity and dramatic emphasis. The result is comparable to that attained by the painters of the Picturesque half a century later, of giving an identifiable scene certain predetermined characteristics considered proper to a picture.

One problem raised by these four paintings is the relation of Michele Marieschi to Canaletto. Only one signed painting by Michele Marieschi is at present known (in the City Art Gallery, Bristol); but with the aid of the series of etchings by him issued in 1740, a group of paintings consistent in style can be attributed to him. In these, and in the etchings, is the use of exaggerated foreshortening, dramatized light and shade, with free and occasionally ragged handling, especially in the figures. Thus, there are considerable stylistic resemblances between the work of Marieschi and the former Liechtenstein paintings, in which, also, notably in the *Piazza S. Marco*, there is a mottled treatment of surfaces much used by Marieschi. On these grounds, Canaletto's authorship of the Liechtenstein group has been doubted, and Marieschi suggested as perhaps their painter. He, however, was not born until 1710;[1] and this makes the suggestion untenable unless the Liechtenstein paintings are dated considerably later than the evidence of the pavement in the Piazza S. Marco indicates. Moreover, the style of the paintings accords very well with that of another set of four, in Montreal, established by documents to be by Canaletto (see below). It seems probable, therefore, that the young Marieschi modelled his work on that of the Canaletto of the twenties, and continued to paint substantially in that style, while Canaletto developed other ideas and methods.

To the early twenties may also be assigned a pair of paintings in the Bavarian State Paintings collection (*Piazza S. Marco looking East*, under no. 1; *Grand Canal from the Campo S. Vio*, under no. 183). These are officially called 'School of Guardi', but their close relation in style to the former Liechtenstein pictures justifies their attribution to Canaletto and the date proposed. More likely to arouse controversy are a pair of capricci (nos. 500 and 501) in the Cini collection, Venice. In treatment of the forms, use of light and shade, colour, and paint quality, these are also close to the four

[1] Mauroner, *Michiel Marieschi*, 1940. The date had previously been independently discovered from the Venetian archives by the present writer.

Liechtenstein pictures; and certain passages, notably the façade of the building on the right in no. 500, have the same mottled handling as the campanile in the *Piazza S. Marco*. There is nothing surprising in the idea of Canaletto painting capricci so early in his career. Not only was the example of the ruin-painters before him, but he had himself collaborated in two of the 'tombs' series ordered by McSwiney. In fact, it would be more surprising if he had not attempted the painting of capricci on his own initiative; and it may be that other paintings similar in type to those mentioned, but less closely related to established work, may ultimately have to be regarded as by Canaletto.[1]

With another group of early work uncertainties vanish. This consists of four paintings in the Pillow collection, Montreal, securely authenticated and dated by documents signed by Canaletto himself, which have accompanied the paintings throughout their history.[2] These establish *The Rialto Bridge* and *The Grand Canal looking North* as painted between 2 August and 25 November 1725, and the other two between 22 December 1725 and 15 June 1726. With these four may be grouped versions of *The Grand Canal looking North from the Rialto Bridge* and of *SS. Giovanni e Paolo* in the collection of I. J. Lyons, slightly larger in size, but comparable in every other respect. All are low in tone, and painted on a dark-reddish ground, visible in places. Sky and water are sombre greenish-blue, harmonizing with the darker greys and browns of the buildings. Local colour is subdued, the costumes being touched with dull reds, blues, and yellows. The figures tend to be thin, with small heads, and are very lively and expressive in action. Light and shade are sharply opposed and organized into a pattern which subdues and unites detail. The brushwork is free, with sharply streaked-on lights.

In the Pillow paintings Canaletto reveals increasing skill in reconciling the claims of design and drama with those of topographic accuracy. Foreshortening is still somewhat exaggerated; but compared with earlier work

[1] Examples are *Capriccio with Reminiscences of Venice* (no. 468); and three capricci attributed to Canaletto in the exhibition *Pittura Veneta* organized in Venice in 1947 (nos. 102, 103, and 106 in the exhibition catalogue). [Nos. 479** and 479*** should also be considered.]

[2] *The Rialto Bridge from the North* (no. 234 below); *The Grand Canal looking North from the Rialto Bridge* (no. 230 below); *The Grand Canal from the Carità to the Bacino di S. Marco* (no. 194 below); *SS. Giovanni e Paolo* (no. 304 below). See Appendix I for documents.

the relative proportions of buildings are nearer the facts, the light and shade less arbitrary in arrangement owing to the skilful use of cloud shadows, and the gradations of tone more sensitive, giving an increased feeling of light and atmosphere. In this connexion it is significant that in the correspondence relating to the Pillow pictures it is revealed that Canaletto at this time preferred to paint in front of his subject, and not in the studio.[1]

To about the same period as the Pillow paintings (1725–6) may be assigned, on grounds of close similarity in technique and style, a pair of paintings at Dresden;[2] and perhaps to a slightly later date another pair at Schloss Pillnitz, near Dresden.[3] With one of the Pillow pictures is also connected what may be the earliest known drawing by Canaletto, except for the disputed group of Roman drawings. This is *The Rialto Bridge from the North* (Ashmolean Museum: no. 593), which closely corresponds to the painting of that subject, and carries an inscription as to placing of a light in the foreground which matches what has been done in the painting. This is freely handled, with roughly hatched shadows, in marked contrast to the tight precision of the Roman drawings. On the back are figure sketches which suggest the influence of Carlevaris.

This phase of Canaletto's work culminated in the production of six large paintings, now at Windsor, all about the same size and all painted in the vicinity of the Piazza S. Marco.[4] From style, they must be of about the same date; and that date is indicated by the fact that in *The Piazzetta looking South*, the campanile of S. Giorgio Maggiore has a straight-sided steeple. This, the earlier form, was replaced by an onion-shaped one some time between June 1726 and 1728, which was in turn replaced by another straight-sided steeple in 1791. Thus, if the topography is accurate, this painting and the five

[1] See Haskell, *Burl. Mag.*, Sept. 1956, 296 sqq. 'Esso dipinge sopra il loco e non a idiea [*sic*] a Casa come fa il S. Lucca [Carlevaris].'

[2] *Entrance to the Grand Canal looking E.* (no. 168); *Grand Canal looking E. from the Campo S. Vio* (no. 183).

[3] *Grand Canal looking North from the Rialto Bridge* (no. 231); *Grand Canal from the Palazzo Balbi to the Rialto Bridge* (no. 211).

[4] *Piazza S. Marco looking East* (no. 12); *Piazza S. Marco looking West from the South-East corner* (no. 32); *Piazza S. Marco looking West from North end of the Piazzetta* (no. 33); *Piazzetta looking North* (no. 55); *Piazzetta looking South* (no. 63); *Entrance to the Grand Canal from the Piazzetta* (no. 146).

others must date from some time before 1728. Canaletto's topography, however, is not always reliable; and the use of an earlier drawing or the personal preference of himself or a patron could perhaps have caused a straight-sided steeple to have been introduced even after 1728. Fortunately, style and technique support the topographical evidence. All six paintings are on a dark ground and low in tone, with strong contrasts of light and shade, some exaggerations in foreshortening, bold, free handling, and sharply streaked-on lights. The links with the Pillow paintings are so close that to date them more than two or three years later is to disregard all probabilities. They represent, however, an advance on the Pillow pictures. The drama is less forced; the buildings are more massive in feeling and more securely related in space; the handling is better adjusted to enriching the forms, without lessening their solidity; and the tone relations are more subtly handled to give a feeling of pervasive light and air. In particular, the figures are better proportioned and weightier, without impairing variety in pose and in expressive action. In short, the paintings are masterpieces of dramatized topography, converting a record of fact into an imaginative creation.[1]

Closely connected with the Windsor paintings are six drawings at Windsor and one in the Ashmolean Museum.[2] These are drawn with a pen, freely and decisively used, on the basis of slight pencil indications, but without the use of mechanical aids. The pattern of light and shade is clearly marked, the shadows being hatched and occasionally cross-hatched. The views of the Piazza S. Marco, looking east and west, both horizontal drawings, are justly regarded by Parker as made direct from nature. The others, all uprights, he considers have 'much the appearance of being drawn from memory, simply as preliminary essays or rough indications of the projected pictures', owing to occasional capricious placing of some feature and a lack

,[1] With the Windsor paintings may be grouped several others which resemble them in technique, style, and dramatic emphasis, and may be assigned to about the same period (1727–8). These include two views of the *Bacino di S. Marco from the Piazzetta* (Thurkow collection, no. 124; Rasini collection, no. 125) and two views of the *Entrance to the Grand Canal from the Piazzetta* (Metropolitan Museum, no. 148; Grenoble, no. 151).

[2] *Piazza S. Marco looking East* (no. 524); *Piazza S. Marco looking West* (no. 530); *Piazza S. Marco looking West from the North end of the Piazzetta* (no. 532); *Piazzetta looking North* (no. 548); *Piazzetta looking South* (no. 542); *Entrance to the Grand Canal from the Piazzetta* (no. 580); *Piazzetta looking South* (no. 543).

of exactitude in detail. In fact, such characteristics often mark sketches made on the ground which are to serve not only as a record of fact but as adumbrations of a composition; while the low horizon line and the consequently restricted foreground present in all the drawings favours their being made from nature. Moreover, the recently discovered evidence that at this time Canaletto preferred to paint in front of his subject, makes it likely that his drawings would be made in the same way.

In the large paintings at Windsor and in others related to them, Canaletto appears to have been thinking primarily in pictorial rather than topographic terms, and to have concerned himself with the dramatic and picturesque possibilities of material drawn from a limited area. Yet during the very time that these were being painted, he began to produce work of very different character, in which the main emphasis was topographic. It was in November 1727 that Owen McSwiney wrote to the Duke of Richmond saying that he was sending him two paintings on copper by Canaletto of the same size as those done for Mr. Southwell. One of these was a *Rialto Bridge from the North* (no. 235), the other a *Grand Canal looking North from the Rialto Bridge* (no. 232): both still belong to the present Duke of Richmond. They are pieces of literal topography, very precisely handled, painted in a high key, with cool grey luminous shadows, grey-blue skies, green-blue water, and bright local colour on the costumes. Gone are the dark ground, low tone, subdued colour, and dramatic oppositions of light and shade; and Canaletto enters into competition with Luca Carlevaris on his own ground, with perhaps some memory of Vanvitelli in his mind.[1]

From comparison with the Richmond paintings, a number of others can be approximately dated. Among these are two formerly in the Ashburnham collection.[2] These are the same size as the Richmond pair and are also on copper, but may well be somewhat earlier, the contrasts of light and shade and the slender figures with small heads being reminiscent of those in the Pillow pictures. Another pair very close in style to the Richmond paintings, of about the same size and on copper, belong to the Earl of Leicester.[3] To this

[1] See Chapter II. [2] *Riva degli Schiavoni looking East* (no. 117); *Molo looking West* (no. 89).

[3] *Grand Canal from the Campo S. Vio* (no. 192); *Rialto Bridge from the South* (no. 226). These might well be either the missing pictures sent to the Duke of Richmond or those that belonged to Mr. Southwell. The former Ashburnham pictures also have some claims.

group also belongs an *Entrance to the Grand Canal from the Molo* (Kauffman collection: no. 152), of the same size as the others and also on copper, though somewhat more raggedly and freely painted.[1]

Increased production at this period of work in which purely topographical elements were emphasized, was almost certainly due to increasing demand from foreign visitors to Venice, whose first wish was to acquire a reasonably accurate record of some aspect of the city they admired, rather than a work of art. Thus Canaletto's range of subject widened considerably, since subject had become more important. Also, seeing that in the later twenties Canaletto was practising side by side two different modes of interpreting his material, it is not surprising that he should have produced at that time a number of paintings in which the two modes are in varying degrees combined. Examples include two of the paintings at Dresden,[2] in which the red-brown ground and emphatic contrasts of light and shade of the Pillow pictures are retained, but with cooler and higher general tone, more emphatic local colour, and somewhat more precise handling. Another group[3] is similar, but the handling is still more precise, and detail more developed. In a third group,[4] contrasts of light and shade are reduced, the key is still higher, and more play is made with local colour, though some of the characteristics of the other type of painting remain, notably in the brushwork and, in the Louvre and Hermitage paintings, the use of exaggerated foreshortening.[5]

In these paintings the two types of approach are not always very happily mated, and are a mechanical mixture rather than a fusion. In one painting of the period, however, Canaletto combines them perfectly, to create a masterpiece, the famous *Stonemason's Yard* in the National Gallery, London

[1] This is perhaps the original of one of a set of six engravings by Boitard after Canaletto, published 1736. This only gives a *terminus ante quem* for the painting, however.

[2] *Grand Canal from the Palazzo Corner Spinelli to the Rialto Bridge* (no. 208); *SS. Giovanni e Paolo* (no. 305).

[3] *Grand Canal; the Salute and Dogana* (Berlin: no. 181); *Molo looking West* (Turin: no. 86); *Grand Canal from the Palazzo Balbi to the Rialto Bridge* (Ferens Art Gallery: no. 214).

[4] *S. Giacomo di Rialto* (Dresden: no. 297); *Piazza S. Marco looking East* (Sir Robert Barlow: no. 2); *Entrance to the Grand Canal looking East* (Louvre: no. 169); *Rialto Bridge from the Fondamenta del Vin* (Hermitage: no. 229).

[5] To the period under discussion F. J. B. Watson assigns the charming *View of Dolo* (Ashmolean Museum: no. 371). Difficulties in accepting this date are noted in the catalogue entry.

(no. 199). This is topographically accurate, precise and elaborate in detail; but the factual material is transformed into an imaginative conception by virtue of large and subtly contrived design, suffusion with light and air, and masterly handling of paint. This is the picture which led Whistler, himself a painter much exercised over modulating tone to secure atmospheric envelopment, to compare Canaletto with Velasquez.

In the next phase of Canaletto's career as a painter and draughtsman, the main emphasis was on topography. Detailed and precise description became the rule; stormy skies are replaced by those of a serene blue, in which light white clouds float; mellow light suffuses everything, with its complement of shadows high in key, full of reflected light. Canaletto painted the golden Venice which tourists most liked to remember. At the same time, he continued systematically to widen the range of his subjects, to cover every aspect of the Grand Canal and to include many of the less familiar churches and campi, sometimes bringing together paintings or drawings of uniform size into a series, which could be hung as a whole in one room or on one wall. Also, it is during this period that the use of mechanical aids to production develops, including the occasional employment of the *camera ottica*, no doubt stimulated by the need for accuracy and for speed in working.

In this period, too, Canaletto developed the use of drawings as an independent means of expression, instead of as preliminary to a painting. Probably a market for these was developing, and Joseph Smith certainly provided part of the demand. Naturally, such drawings might be used later for production of a painting; but from this time onward there are a considerable number for which no equivalent in paint is known. An early example of drawings apparently intended to stand by themselves is a series of five at Windsor, all about the same size.[1] A drawing at Darmstadt (*Riva degli Schiavoni looking East*: no. 573) is so close to these in style that it might be one of the series, except that it repeats the subject of one of the five. The Darmstadt drawing is dated March 1729, which gives an approximate date for the others. All have some connexion with paintings of their respective subjects; but in only one case (*The Molo looking West*) is that connexion

[1] *Riva degli Schiavoni looking East* (no. 574); *Riva degli Schiavoni looking West* (no. 577); *Piazzetta looking South* (no. 546); *Molo looking West* (no. 565); *Molo with the Bucintoro* (no. 642).

close enough even to suggest that the drawing was made with a painting in mind. The handling is free, the shadows hatched, as in the drawings described on p. 104; though they differ from these in having ruled construction lines, sometimes in pencil, sometimes in ink. Parker (p. 30) considers them as having 'the convincing appearance of being drawn in the open'; but the construction lines and the careful working out of vanishing-points suggests that at least they were begun in the studio. Some confirmation of this is the existence of what seems to be a preliminary sketch for *The Piazzetta looking South*, which is dated 1729 (De Burlet collection: no. 545). In this the horizon line is at a level consistent with the drawing being made on the ground; in the Windsor drawing it is higher, with ruled lines converging to a vanishing-point upon it.

In the late twenties and early thirties, probably in emulation of Luca Carlevaris, Canaletto also expanded his repertoire to include paintings of festivals and ceremonial events, a type of subject which was to occupy him at intervals throughout his life. Here again, Canaletto showed himself alive to the possibilities of a new market. Venice was famous for its round of festivals and ceremonies; and both those who took part in them and visitors who had seen them would be ready to buy records of such events. Four examples belong to the period under consideration.[1] The reception of the French ambassador was in 1726, that of the Imperial Ambassador in 1729; but these dates only establish times before which the pictures could not have been painted. There is nothing in style to separate them, and to indicate that *The Reception of the French Ambassador* is earlier than the other.[2] Both are painted in a comparatively high key, the shadows translucent, and local colour emphasized, with nothing left of the strong chiaroscuro and dramatic emphasis of the Pillow pictures. In design, both are clearly modelled on the

[1] *Reception of the French Ambassador at the Ducal Palace* (ex Hermitage: no. 356), with a pendant *The Bucintoro returning to the Molo on Ascension Day* (ex Hermitage: no. 338); *Reception of the Imperial Ambassador* (Aldo Crespi: no. 355), also with a pendant in the same collection, *The Bucintoro returning to the Molo* (no. 336).

[2] A letter of Alessandro Marchesini to Stefano Conti in 1725 (see Haskell, *Burl. Mag.*, Sept. 1956, 298) refers to a commission to Canaletto from the French Ambassador. This may refer to the Hermitage pictures; but if so, it does not settle their date, in view of the difficulty at this time of getting Canaletto to fulfil orders.

pioneer painting by Luca Carlevaris, of the reception of the Earl of Manchester at the Ducal Palace (see Chapter II), though Canaletto has enriched and diversified that design. In particular, his skill in giving vitality to individual figures is extended to the treatment of a crowd, which takes on a character of its own over and above that of the individuals who compose it. The two paintings of the Bucintoro do not help to solve the problem of date, unless it was for them that Canaletto used the drawing of the subject at Windsor (no. 642 below) which can be dated 1729.[1] Thus the evidence, such as it is, suggests that all four pictures were painted *c.* 1729–30.[2]

In these years Canaletto must have produced one of his best-known series of Venetian views, the fourteen paintings now at Windsor, which belonged to Joseph Smith and were engraved by Visentini, the engravings being published in 1735.[3] At one time it was assumed that the paintings were made in the early thirties; but the publication of a letter of 17 July 1730 from Joseph Smith to Samuel Hill (see Chapter I) makes an earlier date practically certain. In this, following a reference to Canaletto, Smith writes, 'The prints of the views and pictures of Venice will now soon be finish'd', and advises Hill to speak in time if he wants any, since only a limited number are to be drawn off. The reference can only be to the Visentini engravings, in the production of which Smith was directly concerned.[4]

The dating in 1729–30 of the Windsor paintings is confirmed by their very close resemblance in style to two pairs of paintings, one of which can be securely dated in 1730, the other in the same year or perhaps a little earlier. The first of these is mentioned in the letter to Samuel Hill quoted above, and is still owned by a descendant of Hill.[5] Of these, Smith says, 'At last I've got Canal under articles to finish your 2 peices [*sic*] within a twelve month'; while on 15 December 1730 Hill's nephew writes that the two pictures are finished. The other pair until recently belonged to the

[1] The same drawing may have been used for the Bucintoro painting in the Windsor and Woburn series discussed below. [2] For other festival-paintings, see below, pp. 118–19.

[3] For a list of the paintings, their titles, and their numbers in the catalogue see under *Engravings after Canaletto: Visentini*.

[4] There is, however, a difficulty over the date of the *Entrance to the Cannaregio* (no. 251) discussed in a note in the catalogue.

[5] *Molo looking West* (no. 97); *Riva degli Schiavoni looking East* (no. 111).

Earls of Wicklow[1] and are dated by an entry in an account of 22 August 1730: 'Recd two pictures of Canaletti from Venice/Pd Mr Smith Mercht 35 Venn. Zecni [Sequins].'

Within the Windsor series some slight variations in style can be detected. Twelve of the paintings, all views of the Grand Canal, are of the same size, and the only difference is that two or three, such as *From the Rialto Bridge to the Foscari Palace* (no. 219), are softer and less decisive in handling than the others, which may indicate that they are somewhat earlier. The remaining two of the series, *The Bucintoro returning to the Molo* (no. 335) and a *Regatta on the Grand Canal* (no. 347), are larger in size, and painted with a brisker and harder touch, and a more decisive impasto in the lights. In these respects they resemble the two painted for Hill, and the two now at Houston. All six suggest an increasing dexterity of hand, and the maturing of a formula, which indicates their being somewhat later in date than the twelve of the Windsor series.

In this group of paintings, as in the group of drawings at Windsor considered above, there is evidence that Canaletto employed mechanical aids. Some of the lines, especially those running across the canvas, are so unfaltering and so precisely directed towards a vanishing-point that the use of a ruler seems certain. There is no evidence, however, that Canaletto was as yet using a *camera ottica*.

The Windsor series with its four companions gives some stylistic evidence for approximately dating three other series: (1) belonging to the Duke of Bedford, at Woburn, (2) formerly owned by the Trustees of Sir Robert Harvey, now dispersed, (3) formerly belonging to the Prince of Liechtenstein, now also dispersed. The Woburn series consists of twenty-two paintings of the same size, thirteen representing views on the Grand Canal, the remainder the Piazza S. Marco, the Piazzetta, the Arsenal, the Cannaregio, the Scuola di S. Rocco, the Campo S. Stefano, Sta Maria Formosa, and the Redentore.[2] As in the Windsor series, two larger festival-paintings have been added, a *Bucintoro at the Molo* (no. 332) and a *Regatta on the Grand Canal*

[1] *Grand Canal: Entrance looking West* (no. 166); *Grand Canal looking South-West from near the Rialto Bridge* (no. 220). Both are now in the Museum at Houston, Texas.

[2] See under no. 4 for history.

(no. 348). Nothing has been found among the Bedford papers as to the date of acquisition;[1] but Scharf, a trustworthy authority, says that the series was painted for John, fourth Duke of Bedford,[2] in which case they were probably commissioned by him when he travelled on the Continent in 1731. When they came to Bedford House, London, whence they were moved in 1800 to Woburn, there is equally nothing to show. The two festival-paintings are more mechanical and calligraphic in handling than the others, which suggests they are somewhat later in date. The others are all very similar in quality and technique, and must have been painted at about the same time. A drawing at Darmstadt (no. 551) helps to fix when this was. This is a perspective drawing in ruled outline of the Piazzetta looking north, with the edges of the shadows also outlined, dated July 1732, and inscribed *per ingiltera*. It corresponds very closely, even in the shapes of the shadows, with the painting of the same subject at Woburn. Whether it was made for that painting or whether, as Hadeln suggests, it was made from the painting for purposes of record, as was an outline drawing by Bellotto at Darmstadt, according to an inscription, is uncertain; but in either case, it favours a date for the Woburn paintings of 1731–2. This accords with the control of tone-relations in these being a little more skilful than in the Windsor series, and the drawing of the architecture and of the figures being firmer and more confident.[3]

Of the early history of the Harvey series, nothing has so far come to light; and at present their date has to be judged on style alone.[4] The series consists of twenty-one paintings, uniform in size, eleven being views of the Grand Canal, the remainder of churches and the campi in which they stand.[5] In the views on the Grand Canal, the division of light and shade and the use of

[1] Miss Gladys Scott-Thomson, formerly librarian and archivist to the Duke of Bedford, was kind enough to make a special search.

[2] *Descriptive and Historical Catalogue of the Collection of Pictures at Woburn Abbey*, 1889.

[3] Whether Joseph Smith was concerned in any way with the Woburn pictures is unknown. Only two of the paintings, however, correspond closely with engravings in the second and third parts of the engravings by Visentini after Canaletto published in 1742; while eleven of them differ considerably from engravings of the same subjects. If the Woburn pictures had passed through Smith's hands, one would have expected a larger number to be used for the Visentini engravings.

[4] Except that nine of them being engraved in the 1742 edition of Canaletto–Visentini provides a *terminus ante quem*. [5] See no. 188 for note on history.

local colour are less emphatic, and the touch more mechanical, than in the others; which suggests that the series was painted in two batches. The Grand Canal group is so similar in character and quality to the Woburn series that they must be of about the same date; while the rest of the paintings were probably produced somewhat later.[1]

In the Harvey paintings reasonably clear evidence of the use of the *camera ottica* by Canaletto appears. This is in a view on the Grand Canal, looking south-east, with the Chiesa della Carità on the right (no. 198). The viewpoint is in the centre of the Canal, some little distance from the church; and the foreground buildings, especially those on the right, are so abruptly foreshortened as to produce a distortion similar to that in a photograph taken with a very wide-angle lens.[2]

With the Woburn and Harvey series may be compared a third, composed of eight paintings of the same size and similar in style, all formerly in the Liechtenstein collection.[3] There is no reliable evidence as to when this group was acquired; but their high key, cool luminous shadows, lively figures in which local colour is emphasized, and crisply handled paint, with impasto in the lights, all point to their being painted in the early thirties.

Comparable with the Harvey paintings are three formerly in the collection of the Earl of Carlisle.[4] These seem to have been acquired in the thirties; but the date of acquisition is too uncertain to be useful in dating, so once more style is the only criterion. In the *Bacino di S. Marco* the treatment of the architecture, of the water, and of the sky and clouds is close to that in the Harvey paintings, while general tone and relation of light and shade are similar. In delicate precision of touch, in subtle gradations of tone and

[1] I regret having to disagree with Vittorio Moschini, who gives the Harvey paintings to 1741–2. I know of no paintings of the early forties that are similar in style; while the link with the Woburn paintings is clear.

[2] [See catalogue entry on no. 198 for the 'angle'. The suggested evidence is questionable.]

[3] *Entrance to the Cannaregio* (private coll.: no. 252); *S. Giorgio Maggiore from the Bacino di S. Marco* (unknown: no. 300); *Riva degli Schiavoni from the Bacino di S. Marco* (Toledo, U.S.A.: no. 118); *Dogana and Giudecca Canal* (Mario Crespi: no. 159); *Bacino di S. Marco from the Piazzetta* (Mario Crespi: no. 126); *Molo looking West* (private collection, U.S.A.: no. 91); *Piazzetta looking South* (private collection, U.S.A.: no. 60); *Grand Canal from Sta Maria della Carità to the Bacino di S. Marco* (private collection: no. 195).

[4] *Bacino di S. Marco looking East* (Boston, U.S.A.: no. 131); *Piazza S. Marco, looking South-East* (N.G., Washington: no. 50); *Entrance to the Grand Canal, from the Molo* (N.G., Washington: no. 154).

colour, and in the skilful use of light cloud shadows to help bring multifarious detail into unity, it goes beyond them, and I am inclined to date it somewhat later. It ranks as a masterpiece of one kind of painting, as does the *Stonemason's Yard* of another. The *Piazza S. Marco* and the *Entrance to the Grand Canal from the Molo* cannot be rated so highly. Colour, massing of light and shade, and treatment of the architecture and of the figures, all relate them to the Harvey pictures; but the handling is lifeless and mechanized to the extent of suggesting that it is the application of an over-matured recipe, and that the paintings perhaps date from the middle thirties.[1]

About 1735 or perhaps earlier was probably painted one of Canaletto's best-known and most-admired paintings, *The Doge visiting the Church and Scuola di S. Rocco*, in the National Gallery, London (no. 331). Occasionally this has been the centre of controversy. At a time when the character of Canaletto's work was imperfectly understood, the skill and vivacity with which the figures are painted were regarded as outside his competence, and they were said to be by G. B. Tiepolo; and Sack,[2] accepting this attribution and realizing how difficult it was to give figures and architecture to different hands, gave the whole painting to that artist. Later realization of Canaletto's ability as a painter of incidental figures has disposed of this intrusion of Tiepolo. Now, however, there is dispute over the painting's date. F. J. B. Watson in 1949 proposed 1730 to 1735, but in 1955 thought that the date should be 'four to six years earlier', i.e. 1724–9 or 1726–31. Meanwhile, Moschini had suggested the earlier thirties, and then in 1956 Michael Levey proposed '*c.* 1735 but not later' (for references see the note in the Catalogue). Evidence other than style is not helpful. The absence of the figure by Marchiori from the lunette over the church portal makes a date before 1743 practically certain, especially as G. Zanetti mentions the figure being in position when the Doge visited the church in that year; but a

[1] The figures in these paintings have some resemblance to those in *The Doge at the Scuola di S. Rocco*, discussed later, which has been dated 1735 or earlier.

Vittorio Moschini sees a connexion between the Carlisle and the Harvey paintings, but dates them, with the latter, in the early forties. Pallucchini (*Pittura Veneziana del Settecento*, ii. 127) recognizes the *Bacino di S. Marco* as earlier than the other two, but dates it in the late thirties, and the others in the early forties.

[2] In *G.B. und D. Tiepolo*, Hamburg, 1910. [Michael Levey, *Burl. Mag.*, 1962, 268, points out that Sack in fact described the painting as a 'Zusammenarbeiten . . . der beiden . . . Künstler'.]

resemblance noted by Levey of the Doge to Alvise Pisani, elected in January 1735, is too shadowy to be useful as evidence. As regards style, since the painting clearly has little in common with such early work as the Pillow pictures, or the six large paintings at Windsor, Watson's dating presumably depends mainly on comparison with the series of fourteen at Windsor, datable 1729–30. Such comparison is not, however, too reassuring. In the *Scuola di S. Rocco* there are a combination of freedom and precision in handling and a power of atmospheric suffusion which indicate a maturity not exemplified in the Windsor pictures, and more easily found in the Harvey series. Moreover, there is a plentiful use of the circular, calligraphic touch of which there seems to be no example before the thirties. On balance, therefore, a date in the early thirties is indicated.

Meanwhile, throughout the period under discussion Canaletto had been active as a draughtsman.[1] In connexion with the Woburn and Harvey series he made use of a type of preparatory drawing, of which no previous examples are known. These are freehand, diagrammatic sketches in chalk or ink outline, frequently inscribed with notes on the identity of buildings, on their relative positions, and on colour, the chief collection of which is in a sketch-book in the Accademia. Put together, these in many cases form a panorama of buildings corresponding in detail not only with a number of the Woburn and Harvey paintings, but with others.[2] To Vittorio Moschini is due the attractive suggestion that these diagrammatic sketches represent the systematic note-taking of Canaletto as he went about Venice. In any case, they indicate one method of collecting his raw material, hitherto unduly disregarded.[3]

The link between the sketch-book and the Woburn and Harvey series suggests a date for the former of *c.* 1730; and thereby helps to date some other work. One series of sketches (14*v* to 17*r*) not only served for a *Grand*

[1] Unfortunately, a drawing of the period which might have thrown some light on Canaletto's practice at the period has disappeared. This was in the Wellesley sale (Sotheby's, 25 June onwards, 1866, no. 1005): 'View of the Place of St. Mark with the Campanile, dated 1731, pen, slightly washed, 16 × 10.' If this is by Canaletto (and inclusion in the Wellesley collection is no guarantee), its large size and the combination of pen and wash would seem to mark a new development in his practice.

[2] See under Sketch-books, and appropriate entries for details.

[3] [Hadeln sees the use of the *camera ottica* in no. 540 and Giosefi in the Accademia sketch-book but in both cases evidence can equally be adduced against its use.]

Canal from the Palazzo Contarini to the Palazzo Rezzonico, at Woburn (no. 200), but for a painting of the same subject at Aynhoe (no. 201); which strengthens the case based on style for dating this picture and its pendant (*Piazza S. Marco looking East*: no. 5) at about the same period as the Woburn series.

This same series of sketches (14*v* to 17*r*) and two others (10*v* to 14*r*; 17*v* to 20*r*) were also used for four of a group of six drawings of the Grand Canal at Windsor which are of approximately the same size and closely related in style.[1] They are freely handled, with hatched shadows somewhat like the group of 1729 at Windsor (see p. 107); but the lines of the hatching are closer together and more regular, and greater care is taken to keep the hatching within the outlines of the forms, while the use of a ruler is sometimes evident. Though in some cases related to paintings in the Woburn and Harvey series, their elaboration gives the impression of drawings meant to be independent works. Parker thinks that they were probably all made from nature; though the presence of ruled lines, and the fact that diagrammatic sketches for four drawings exist, points to preliminary work, at least, in the studio. Parker regards them as 'roughly of the mid-thirties'; but their connexion with the Accademia sketch-book, their relation to some of the Woburn and Harvey paintings, and the fact that in style they are elaborations of the 1729 series suggest a somewhat earlier date.[2]

Certainty comes, however, with a drawing at Windsor of the Canale Sta Chiara, which is inscribed on the back, in Canaletto's hand, *16 luglio 1734*[3] (no. 601). With this may be coupled another Windsor drawing, *The Entrance to the Cannaregio* (no. 598), which on the mount is said to carry on

[1] *Palazzo Rezzonico to Palazzo Balbi* (no. 588); *Palazzo Corner to Palazzo Contarini*: two versions (nos. 584 and 585); *Palazzo Contarini to Palazzo Rezzonico* (no. 586); *Palazzo Corner-Spinelli to Rialto Bridge* (no. 590); *S. Croce to S. Geremia* (no. 599). The first four of these are those connected with the diagrammatic sketches.

[2] The Accademia sketch-book was, of course, a storehouse of material, and could well have been used for paintings and drawings made considerably later. A possible case is given by the outline diagrams on pp. 32*v* and 33*r* of the Convent of S. Croce and the wall of the Corpus Domini, which seem to have been used for two drawings of capricci in which these buildings are the central motive, one in the Hermitage (no. 767), the other in the Morgan Library (no. 768). In style, however, these drawings do not fit well with drawings of the earlier thirties, but seem rather to belong to the early forties.

[3] The date can be seen through the paper of the drawing, which is pasted down. As Parker (p. 32) points out, the last figure is a little obscure; but there is little doubt that it is a 4, not 7 or 9.

the back the same inscription, though *luglio* has a capital *L*.[1] Parker suggests that the proximity of the two sites might be taken as evidence that the two drawings were in fact made on the same day; though against this is the fact that the *Canale Sta Chiara* is considerably more free in handling and more luminous than the other.[2]

By 1735 Canaletto as a topographer had attained full maturity and had produced much of his best work. In this, the second phase of his career, his chief aim was to present an accurate and detailed record of a particular scene, seen in the light of a sunny day in Venice. So it was that Orlandi, writing of Canaletto's views of the Piazza S. Marco, could say, 'con tale aggiustarezza ed artifizio dipinse, che l'occhio s'inganna, e crede realmente di veder la vera, non la dipinta'. Yet more than a sharp eye and a skilful hand went to the makings of his paintings and drawings. The material of an ordinary and conventional view would be so manipulated by slight changes in proportions of buildings, by arrangement of light and shade with an occasional and unobtrusive use of cloud shadows, and by disposition of boats, market stalls, and figures, as to become a balanced and harmonious design. The extent of Canaletto's achievement in this respect can be judged from his ability to give to each of several versions of a particular scene its own character and individuality. Added to this was a remarkable power of filling a composition with light and atmosphere, due to the use of reflected lights in the shadows, and sensitive modulations of tone. Thus, within a narrow framework prescribed by the demands of clients, Canaletto managed to give the results of observation the impress of his own imagination, to create out of the Venice before his eyes a Venice of his own.

Among paintings that, on style, may be assigned to the middle thirties are two of a set of four, which were formerly owned by the Holbech family of Farnborough Hall, the family tradition being that two were bought by William Holbech when he was in Italy from 1730 to 1745 and that the other

[1] This drawing is also pasted down, but no inscription can be seen from the front. Parker justly notes that it is not impossible for the two drawings to have been confused.

[2] From the *Canale Sta Chiara* was probably developed another drawing of the subject, also at Windsor (no. 600). This is tighter and more precise in handling than any drawing yet mentioned; and it is possible that it was made considerably later than the 1734 drawing, and conceivably made with the idea of an engraving in mind.

two were painted at Farnborough to complete the decoration of the dining-room. Two of the paintings, a *Piazza S. Marco looking West* (Brown, Boveri, and Co.: no. 38) and a *Piazza S. Marco: the North-East Corner* (National Gallery of Canada: no. 45) are closely related in style, and differ from the other two in being lower in key and less mannered in handling.[1] In colour, tone, treatment of light and shade, and character of the architecture and figures, they are related to the Harvey paintings, though a more mechanical and stylized touch justifies their being regarded as some years later in date. Some confirmation of a date of *c.* 1735 is given by the absence from the *Piazza S. Marco looking West* of Gai's gates to the Loggetta, made in 1735–7.[2]

The tendency towards mechanical handling noted here is no new thing; but in the later thirties it becomes usual in Canaletto's work. It manifests itself in a harder treatment of the architecture, and in the introduction of detail by a series of repetitive gestures, such as putting in the lights by a series of dots and dashes; while the fairly large, firmly constructed, well-characterized figures which appear in many earlier pictures are replaced by smaller ones, well enough drawn and sufficiently expressive in action, but mainly types resulting from skilfully used recipes, in which dots and dashes again supply the lights. The cause, no doubt, was the need for turning out work quickly to satisfy the demands of clients; and to the same necessity is probably due the appearance in some paintings of a hand less skilful than Canaletto's own. Evidently, he had taken on assistants, one of whom may well have been Bellotto, who was born in 1720 and by 1735 would have been quite capable of helping his uncle.

These considerations help in dating a series of eight paintings of uniform size, in Earl Fitzwilliam's collection.[3] These are closely related in style, and must have been painted at about the same time, which was before 1742,

[1] The other two are a *Bacino di S. Marco from the Piazzetta* (no. 128) and an *Entrance to the Grand Canal looking East* (no. 173).

[2] [The gates were not, however, put up until 1742, according to Lorenzetti in *L'Arte*, Rome, 1910 They were thought to have been omitted by Canaletto in no. 37 but they do appear in that painting.]

[3] *Piazza S. Marco looking East* (no. 7); *Piazza S. Marco looking West* (no. 23); *Piazza S. Marco looking South-West* (no. 52); *Riva degli Schiavoni looking East* (no. 114); *Bacino di S. Marco looking East* (no. 132); *Bacino di S. Marco looking West* (no. 136); *The Molo: looking West, Library to Right* (no. 98); *Rialto Bridge from the North* (no. 237).

since two of them are engraved in the Canaletto–Visentini series published
that year. Colour, tone, and the treatment of the architecture and of the
light and shade relate them to the two earlier Holbech paintings; but the
handling is noticeably more mechanical in the way described above,
suggesting a date a few years later, perhaps 1736–7. Very similar in style to
the Fitzwilliam paintings and of about the same date are a set of four in the
National Gallery, Rome.[1] In the past these had been attributed to Bellotto,
for no very convincing reason; but recent cleaning has removed any linger-
ing doubts as to Canaletto's authorship.[2] Into the same group, on grounds
of style, also fall two views of the Piazza S. Marco, both formerly in the col-
lection of the Duke of Leeds, one now at Detroit (no. 24), the other in the
Fogg Museum (no. 14).

 To the later thirties also belong two pairs of festival-paintings, each pair
including the same subjects, *The Bucintoro at the Molo* and *A Regatta on the
Grand Canal*, which were also the subjects of two earlier pairs.[3]

 Just as the designs of his paintings of ceremonial subjects had been taken from
Luca Carlevaris, so those of all Canaletto's *Regattas* were based on the paint-
ing by Carlevaris of the regatta organized in 1709 in honour of Frederik IV
of Denmark (see Chapter II). Canaletto has enriched the design by more
skilful massing of light and shade, by elaborating some of the architecture,
and by greater liveliness in handling the boats and the figures; while into
each of his paintings he introduces some variations. But the design in every
case is basically that of Carlevaris. For the dating of these festival scenes,
Michael Levey has made the ingenious suggestion that the ducal coat of
arms which appears in some of them may be used as evidence of date.[4] One

 [1] *Piazza S. Marco looking West* (no. 29); *Piazzetta looking South* (no. 57); *Grand Canal looking
South-East from the Rialto Bridge* (no. 223); *Rialto Bridge from the South* (under no. 228).
 [2] A case in reverse is a *SS. Giovanni e Paolo* at Springfield, Mass., sold to the Museum as by Canaletto,
and long attributed to him. Cleaning revealed this as an indubitable Bellotto.
 [3] National Gallery, London (nos. 333 and 350); private collections (ex Duke of Buccleuch: nos. 341
and 351). The earlier pairs are Windsor (nos. 335 and 347), datable 1729–30; Woburn (nos. 332 and
348), datable 1731–2 (see pp. 110–11). Paintings of *The Bucintoro at the Molo* in the Hermitage (no. 338)
and in the Aldo Crespi collection (no. 336) are pendants to paintings of the arrival of foreign repre-
sentatives to the Ducal Palace (see p. 108), all four datable 1729–30 (see p. 109).
 [4] *Burl. Mag.*, Nov. 1952, 365–6; *National Gallery Catalogues: Eighteenth Century Italian Schools*, 1971,
26–27.

objection is that the evidence of the coat does not always agree with that from other sources. For example, there is some reason to believe that the *Regatta* at Windsor was painted in or before 1730; but it carries the coat of the Ruzzini family, and Carlo Ruzzini did not become doge until June 1732. Similarly, the Woburn *Regatta* is likely to have been painted in the early thirties; yet it carries the Pisani arms, though Alvise Pisani did not become doge until January 1735. The difficulty is that one cannot be certain that a particular coat was put in when the picture was painted. Since regattas were held frequently, and the festival of wedding the Adriatic (one incident in which is recorded in *The Bucintoro at the Molo*) took place annually, it would be quite possible to paint a picture for stock, and put in a coat of arms when and as required. It is interesting that the pendant to the Windsor *Regatta* (*The Bucintoro at the Molo*) has no coat on the Bucintoro, as might have been expected and as occurs in other versions of the subject. The picture, like its pendant, belonged to Joseph Smith, and presumably in this case he saw no reason for having a coat put in. Even so, the usefulness of the coats of arms in relative dating may be considerable, since a painting carrying the coat of a certain doge is prima facie likely to be later than one which carries the coat of a predecessor. For this reason, the two pairs of paintings in the National Gallery, London, and formerly in the Buccleuch collection, both of which carry the Pisani arms, may be presumed to be later than the other examples mentioned; a presumption justified by both being considerably more mannered and mechanical in handling than the others, in a way characteristic of the late thirties.

The two former Buccleuch pictures belong to a set of six until recently all in that collection.[1] They are of the same size, and so similar in style that it has even been suggested that they were painted at the same time on one long strip of canvas which was divided later. Differences in the quality of the painting suggest that assistants were employed. Details in two of them enable limits of dates to be fixed. In the *Grand Canal from the Scalzi to*

[1] The four other paintings are: *Entrance to the Grand Canal looking West* (late Sir Alexander Korda: no. 162); *Entrance to the Grand Canal looking East* (late E. Buehrle collection: no. 172); *Entrance to the Cannaregio* (Agnelli collection: under no. 251); *Grand Canal from the Scalzi to S. Croce* (late E. Buehrle collection: under no. 258).

S. Croce, the steps of S. Simeone Piccolo are seen as when they were finished in 1738; and in the *Entrance to the Cannaregio*, the statue by Marchiori on the quay adjoining the Palazzo Labia is not in position, making a date before 1742 likely. These limits are consistent with the Pisani arms being on the festival-paintings, since Alvise Pisani was doge until June 1741.

Another group of paintings that has rashly been dated in the late thirties consists of the originals of a set of six engravings by Fletcher after Canaletto, published by Baudin on 26 July 1739. This is an example of how carefully the evidence of engravings should be used. Of the originals, five have been identified,[1] to reveal that the engravings prove only that all the paintings were made before 1739. The engravings make a set uniform in size and technique, partly because they appear to have been made from copies of the originals by Baudin; but the paintings do not. The two belonging to the Earl of Leicester can be dated 1727–9 (see p. 105 above); the Mario Crespi picture, on style and form an old label on the back, 1730; [there is no evidence to date the remaining two pictures as the absence of Gai's gates to the Loggetta in no. 43 can only prove a date before 1742, when they were erected].

In drawings that may be tentatively assigned on style to the later thirties, the same tendency towards the mechanical is seen as in the paintings. This is exemplified in two groups at Windsor. In one of these,[2] a few drawings retain something of the freedom of handling which marked earlier work; but throughout outlines are more calligraphic, the hatching of the shadows more regular and lighter in tone, and the lightly hatched clouds are sometimes ringed with a line. The second group,[3] as noted by Parker, merges into the first; but in most of them the outline is still more wiry and equally calligraphic, the hatching of the shadows still more precise and thin, and the

[1] *Piazzo S. Marco looking North* (Kansas City: no. 43); *Grand Canal: Entrance looking West* (Private collection: no. 167); *Grand Canal from Campo S. Vio* (Earl of Leicester: no. 192); *Rialto Bridge from South* (Earl of Leicester: no. 226); *Canale Sta Chiara* (Mario Crespi: no. 269).

[2] Examples are *The Piazzetta looking North* (no. 549); *The Arsenal* (no. 603); *Riva degli Schiavoni looking West* (no. 576); and *Bacino di S. Marco looking West* (no. 379).

[3] Examples are *S. Simeone Piccolo* (no. 622); *S. Pietro in Castello* (no. 620); *The Redentore* (no. 621); *S. Giorgio Maggiore* (no. 612); *S. Francesco della Vigna* (no. 609); *Campo Sta Maria Formosa* (no. 605); *SS. Giovanni e Paolo* (no. 613); *Piazza S. Marco from the North-East corner* (no. 533); and *Campo S. Stefano* (no. 607).

clouds are almost all ringed with lines. Some of the drawings in the first group may have been made, at least in part, in front of the subject; but those of the second have all the marks of having been produced in the studio, even perhaps with the aid of an assistant. The technique suggests that they may have been made to be engraved, as does the fact that, though not uniform in size, many of the subjects are similar in type and could be made into a series. Apart from style, the only indication of date is in *S. Simeone Piccolo* of the second group, in which the steps of the church are unfinished, with blocks of stone waiting to be put in position. Since the steps were finished in 1738, this makes a date before that year very probable for all the drawings.

IV

THE WORK OF CANALETTO AND HIS ARTISTIC DEVELOPMENT FROM *c.* 1740 WITH NOTES ON METHODS OF WORK AND SIGNATURES

THE early forties saw a notable widening in Canaletto's range of subject, and some change in the character of his work. In 1741 the War of the Austrian Succession had involved most of northern Europe, and in 1742 the fighting extended to Italy and peace did not come until 1748. The number of visitors to Venice was much reduced, and as a result the demand fell off for the more or less standard views of Venice which he had produced during the thirties. He continued to produce a certain number of these; but he also painted and drew a number of capricci, made paintings and drawings of ancient and contemporary Rome, worked on and near the Brenta and at Padua, and, surprisingly enough, produced a remarkable series of etchings. The Roman views and the capricci represent to a limited extent a turning back to his earliest work as a painter, as do the *vedute ideate* which he etched and drew. It is as though, with the market for topography now limited, Canaletto decided to explore the possibilities of nostalgic appeal, fantasy, and decorative effect, which had served his predecessors so well. Undoubtedly Joseph Smith was his chief patron at this time, since many examples of each type of work mentioned were in his collection, and the etchings may well have been commissioned by him. Also, from now on the printsellers became more important, directly or indirectly, as a source of income or employment.

Whether Canaletto paid a second visit to Rome is an arguable matter, discussed in Chapter I. Here the main concern is with what he produced, and its character. Fortunately, a number of the Roman subjects are dated.

The earliest of them is a set of five at Windsor, dated 1742,[1] and with these, on grounds of style, may be grouped four others.[2] All nine paintings are primarily topographical, with sometimes a certain amount of manipulation of the relative position of buildings in the interest of design. Contrasts of light and shade are emphasized, partly, no doubt, under the influence of earlier ruin-painters and perhaps of Pannini, and partly, it may be, to add a dignity and weight suited to the subject. Yet there is nothing of the deliberate search for dramatic effect apparent in work of the twenties. On the contrary, the paintings are in direct descent from the Venetian views of the thirties. The shadows are luminous with reflected light; the architecture is drawn with combined feeling for mass and precision in detail; and local colour is effectively used, mainly in the figures, which are characteristically varied in type and lively in action. The handling is, however, somewhat hard and monotonous, with a resultant loss of atmosphere. The general impression is the application of a matured recipe to making a picture, especially apparent in the twirls and flourishes with which the figures are put in. These characteristics are also marked in a *Colosseum* at St. James's Palace (no. 387), signed and dated 1743, with which may be grouped an *Arch of Septimius Severus* (Cincinnati: no. 385) and perhaps an *Arch of Titus* (ex Earl of Lovelace: under no. 386). The shadows in these are heavier, and reflected light less used than in the 1742 paintings, so that the general effect is more gloomy and even less atmospheric. So it is with some of the views of contemporary Rome, such as the *Piazza di S. Giovanni Laterano* (Mrs. Clifford Curzon: no. 400).

Connected with the paintings of Roman subjects is a series of drawings, which fall into two groups, those made with the pen alone and those with wash added.[3] One subject (*The Tiber and the Ponte Rotto*), in pen alone, is

[1] *The Forum looking towards the Capitol* (no. 378); *Arch of Constantine* (no. 382); *Arch of Septimius Severus* (no. 384); *Arch of Titus* (no. 386); *The Pantheon* (no. 390).

[2] *The Forum looking towards the Capitol* (H.M. the Queen: no. 379); *Temple of Antoninus and Faustina* (idem: no. 381); *Arch of Constantine* (J. Paul Getty: no. 383); *Basilica of Constantine and Sta Francesca Romana* (Signora Campanini-Bonomi: no. 380).

[3] Characteristic examples are: (1) Pen. *Tiber with the Ponte Rotto* (Windsor: no. 728); *Forum with Basilica of Constantine* (Windsor: no. 714); *Temple of Antoninus and Faustina* (Windsor: no. 715); *Arch of Septimius Severus* (Windsor: no. 717); *Colosseum* (Berlin: no. 719); *Temple of Venus and Rome* (Windsor: no. 720). (2) Pen and Wash. *Baths of Caracalla* (?) (Windsor: no. 718); *SS. Domenico and*

repeated, with variations, in pen and wash. With these drawings may be grouped, on grounds of style, several capricci of Roman subjects.[1] Here again, one subject (*Ruined Roman Portico*) is carried out both in pen and pen and wash. These drawings, like the paintings, are direct descendants of their predecessors made in Venice in the later thirties. There is the same tendency towards using wiry outlines, fine precise hatching, ringed clouds; and there is the same evidence of mechanical aids being employed, especially a ruler and occasionally compasses. The result is usually monotony and lifelessness. This is not surprising, since there is no indication that the drawings were made on the ground, while a considerable proportion of them almost certainly derive from those made by Canaletto on his first visit to Rome, or from sixteenth-century engravings.[2] Apparently, the drawings were made for their own sake, independently of the paintings, with which only four of them have any connexion. There is no evidence of their date except that of style, which relates them to Venetian drawings of the later thirties, and somewhat more closely to a group of Venetian drawings, to be considered later, which can be tentatively dated in the early forties. There seems no reason, therefore, for not regarding them as contemporary with the paintings.

One interesting point is Canaletto's use of a monochrome wash in some of the drawings. This was apparently an innovation in technique for him.[3] In many cases the use of the wash is tentative, a reinforcement of the pen and ink, rather than the medium in which the drawing was conceived. Among exceptions is the British Museum version of *The Tiber with the Ponte Rotto*, in which pen and wash are well integrated, and the possibilities of double washing well realized. It may well be, however, that this drawing, an elaboration of the one in pen and ink, was made later. Henceforward, Canaletto used wash frequently, which, with double and sometimes triple applications in the shadows, made available a range and variation of tone

Sisto (Windsor: no. 724); *Piazza S. Giovanni in Laterano* (Windsor: no. 727); *Tiber with the Ponte Rotto* (British Museum: no. 729).

[1] Pen. *Arco dei Pantani* (Windsor: no. 783); *Ruined Roman Portico* (Windsor: no. 810); *Ruins and Houses* (Windsor: no. 816); *Classic Ruins by the Lagoon* (Windsor: no. 800). Pen and wash. *Ruined Roman Portico* (Windsor: no. 811); *Ruins of a Domed Building* (Windsor: no. 815).

[2] For this, see Chapter I, and notes on the catalogue entry relating to the early Roman drawings (no. 713). [3] Unless the drawing in the Wellesley sale was in fact by Canaletto (see p. 114 n. 1).

difficult to secure quickly by the use of the pen alone; thereby giving drawings some of the characteristics of paintings, and a completeness which helped them to stand alone as independent works.

The paintings and drawings of Roman subjects throw some additional light on the relations of Canaletto and Bellotto. That Bellotto had used some of his uncle's Venetian compositions for his own purposes is fairly clear;[1] but from the Roman work he borrowed extensively. Versions by him exist of, among paintings, *The Forum looking towards the Capitol, The Temple of Antoninus and Faustina,* and *The Arch of Titus;* and of the drawings, there is a copy by him (also a drawing) of the *Arch of Septimius Severus,* while *Ruins of a Domed Building* provided one of the motives in an etching. Bellotto also painted some Roman subjects independently, and it is sometimes difficult to distinguish his work from that of Canaletto. The main differences are that the tone of Bellotto's work is cooler, the shadows inkier, and the touch coarser.

Among capricci produced by Canaletto in the early forties, the group of drawings in which he uses Roman material has already been noted. But the most important examples of this type of composition form a group of paintings at Windsor, which were made for Joseph Smith. Originally there were thirteen of these, described in Smith's catalogue of his collection as intended for 'over-doors'; but only nine of them have so far been found at Windsor. In style they are very closely related; and four of them are dated, one 1743, and the others 1744.[2] Almost certainly one of the paintings missing from Smith's original group is a capriccio with S. Francesco della Vigna (no. 460) which is dated 1744, and is both close in style to the Windsor paintings, and of comparable size; while in Smith's list of his over-doors is a S. Francesco della Vigna, which is not at Windsor. With these ten may be grouped, on grounds of style, two other capricci, one based on the Scuola di S. Marco, of which there are two versions (no. 467 and note), the other

[1] A painting at Springfield, Massachusetts, by Bellotto of *SS. Giovanni e Paolo* is a case in point.

[2] Dated. *Horses of S. Marco in the Piazzetta,* 1743 (no. 451); *Library and other buildings,* 1744 (no. 452); *Scala dei Giganti,* 1744 (no. 455); *Colleoni Monument and Ruins,* 1744 (no. 476). Undated. *Monastery of the Lateran Canons* (no. 456); *Molo with the Flagstaffs of S. Marco* (no. 453); *Ponte della Pescaria and buildings on the Quay* (no. 454); *Palladian design for the Rialto Bridge* (no. 457); *S. Giorgio Maggiore* (no. 462).

made up of motives from Rome and Vicenza, of which there are also two versions, one of them signed (no. 479 and note). The Windsor paintings and the one based on S. Francesco della Vigna are all of them the simplest type of capriccio, consisting of a regrouping of recognizable monuments or buildings, with a minimum of imaginary elements introduced. Most of them are based on buildings by Palladio, for whose work Joseph Smith seems to have had a particular liking. In the other two, there is more freedom of invention; but they, like the others, are ingenious rather than interesting, decorative arrangements rather than imaginative creations. All of them are heavy-handed in treatment, with dark lifeless shadows, dull in colour, with details even more calligraphically handled than those of the Roman series. Everything in them suggests pictures made to order.

Venetian views of this period include a pair dated 1743, and four dated 1744, all but one at Windsor.[1] These are all versions of views which Canaletto had painted many times; and with one exception (*The Entrance to the Grand Canal*) they are in varying degrees low in tone, with dark shadows and spotted lights, and are painted with a touch that is sometimes loose but always mechanical, characteristics which also mark a *SS. Giovanni e Paolo* in the National Gallery, Washington, and suggest that it belongs to the same period as the others. In contrast, the *Entrance to the Grand Canal* is fairly high in key, with luminous shadows, though equally mechanical in handling. One characteristic which marks most of these paintings is that the view represented is more extensive than the eye would ordinarily include. In *The Piazzetta looking North* and *The Piazza S. Marco looking West*, for example, the angle subtended at the viewpoint is well over ninety degrees, and the foreshortening is very sharp. This is good evidence that at this time Canaletto was using the *camera ottica*; a supposition which gains some support from a small group of drawings at Windsor.[2] On style, these may be dated *c.* 1740; and in all of them there is the same extension of the subject and exaggerated foreshortening as in the paintings.

[1] *Piazzetta looking North*, 1743 (no. 68); *Molo looking West*, 1743 (no. 85); *Piazza S. Marco looking South*, 1744 (no. 48); *Piazza S. Marco looking West*, 1744 (no. 37); *Entrance to Grand Canal looking East*, 1744 (no. 174); *Rialto Bridge from the South*, 1744 (ex Trotti: no. 228).

[2] Including *Piazzetta looking West* (no. 547); *Piazza S. Marco looking North* (no. 538); and *Piazza S. Marco looking South* (no. 537). (But see p. 162 below.)

To the earlier forties may also be assigned four paintings from the Gymnasium zum Grauen Kloster, Berlin.[1] These belonged to Sigismund Streit, an eighteenth-century German resident in Venice, who in 1763 gave his whole collection of various objects to the Gymnasium.[2] Whether the Canaletto paintings were commissioned by him is unknown; but it seems very likely, since in one of them the palazzo in which he lived is represented, in another the place in which he worked, while in the third and fourth the subjects are popular festivals seen under moonlight, in both respects outside Canaletto's usual range.[3] Unfortunately, in an elaborate catalogue of his collection compiled by Streit and given to the Gymnasium with his collection, he gives no hint as to the date of the paintings. All that is certain is that they were painted before 1763. But in style they clearly belong to a period before Canaletto went to England in 1746; while in tone, colour, and handling, the *Grand Canal* and the *Campo di Rialto*, which carry the others with them, are closely related to paintings dated 1743 and 1744.

At one time they were attributed by Voss to G. B. Moretti,[4] partly because of the unusual character of the moonlight scenes, partly because the handling lacked vigour and freshness, and partly because the *Campo di Rialto* and the *Vigilia di S. Pietro* are the subject of engravings in a series by Brustoloni after Moretti. Quite apart, however, from the unlikelihood of Streit being deceived is that the handling is characteristic of Canaletto in the forties; while there is evidence that Moretti and his sons made drawings from work by Canaletto for the use of engravers (see note under no. 282 in the Catalogue).

Two of the paintings (the *Grand Canal* and the *Vigilia di Sta Marta*) are based on diagrammatic drawings in outline carrying inscriptions in Canaletto's hand, similar to those in the Accademia sketch-book mentioned on p. 114, but coming from another sketch-book now dismembered.[5] So

[1] *Grand Canal from Campo Sta Sofia* (no. 242); *Campo di Rialto* (no. 282); two *Vigilia* pictures (nos. 359 and 360). [However, see note on no. 242 suggesting a much later dating.]

[2] See Zimmermann, *Zeitschrift für Kunstwissenschaft*, viii, 1954.

[3] The only other moonlight scene known is the view of the façade of St. Peter's, Rome (no. 393); and the authorship of this has been challenged. There are, however, two drawings of the Lagoon by moonlight (nos. 661, 662) undoubtedly by Canaletto.

[4] *Rep. für Kinstwissenschaft*, xlvii, 1926. For a detailed criticism of this see Constable, in *Scritti di Storia dell'Arte in onore di Lionello Venturi*, Rome, 1956, 81 sqq.

[5] See under Sketch-books, and the catalogue entries relating to the paintings.

closely akin in style to these are two diagrammatic drawings of buildings in the Campo di S. Basso (nos. 540 and 541) that it seems likely that these also belong to this period. Evidently, Canaletto was still doing this kind of preparatory work in the earlier forties; and, as will be seen later, continued to do it throughout his life. Related in style to the *Grand Canal* and the *Campo di Rialto* is a third painting, a *S. Giacomo di Rialto* (National Gallery of Canada: no. 298). This has a particular interest in that, for two figures in the right foreground, two drawings in outline are known (no. 839), in which the calligraphic flourishes which had become a characteristic part of Canaletto's technique, especially in his figures, are well seen.[1]

In his work of the forties so far described, Canaletto was primarily applying to an enlarged range of subjects conceptions and technical methods matured and systematized during the thirties, with an occasional glance back at work of an earlier period. At the same time, however, he was breaking new ground, and in the field of the graphic arts produced some of his finest and most original work. Drawings, more than ever before, became independent means of expression. Working from nature was to some extent resumed; variety of subject was increased to include many capricci and *vedute ideate*; and technique became more varied and resourceful. Meanwhile, Canaletto turned to an entirely new medium, that of etching; and in subjects ranging from the topographical to the imaginary views, including both Venetian and Roman motives, revealed remarkable originality in both conception and handling of the medium.[2]

Among drawings which exemplify this new kind of activity are two groups at Windsor. The first of these consists of eleven small drawings of approximately the same size, the subjects, with one exception, all being buildings on or near the Molo, in one case composed into a capriccio. Of the eleven drawings, eight fall into pairs consisting of the same subject in pen alone and in pen and wash; the remaining three are all in pen.[3] In the

[1] Perhaps because of these drawings, Vittorio Moschini gives the painting to Canaletto's post-English period. Its relation to work of the forties seems, however, too close for this to be at all likely.

[2] For detailed consideration of the etchings, see Vol. II, sec. D.

[3] *The Molo looking West* (pen: no. 566); idem (pen and wash: no. 567). *The Molo looking West from the Bacino di S. Marco* (pen: no. 563); idem (pen and wash: no. 564). *The Fonteghetto della Farina from the Molo* (pen: no. 569); idem (pen and wash: no. 570). *Capriccio with the Fonteghetto della Farina* (pen:

pen drawings the use of the ruler suggests preparation in the studio, though completion on the ground seems likely. The penwork is precise but within limits free, outlines broken to suggest the play of light round the forms; and no enclosing lines are used for the clouds. In the hatched shadows the lines vary in thickness, and occasionally run together with a blot, where an accent is needed. Altogether, the drawings are livelier, more robust, and more atmospheric than most of those of the later thirties. The wash drawings are less accomplished. They are somewhat empty, the buildings not securely related in space, the clouds indecisively handled and accents not well placed, while wash and line are not effectively combined. The most successful (the capriccio with the Fonteghetto della Farina) is so, because line dominates wash. It may be suggested that the wash drawings were made in the studio from the others, and that they are early attempts in the use of wash, even ante-dating the Roman drawings in that medium. All the drawings appear to have been made for their own sake, and not to lead up to a painting; and since they all belonged to Joseph Smith, they may have been made for him.

The second group of drawings at Windsor is a small one, but in Parker's words, 'consists of some of the most sensitive and beautiful of Canaletto's drawings'.[1] All are in pen and wash, which are admirably combined to give substance to the forms, to establish their positions in space, and to surround them with light and air. In simplicity and directness of handling they may well be compared with some of Rembrandt's landscape drawings. This favours Parker's view that they are made direct from nature; though some work in the studio is indicated by some inconsistency in the direction of the light in the two halves of the *Islands of S. Elena and S. Pietro*, which would be unlikely to occur in a drawing made entirely on the ground. No versions or variants of any of these drawings are known, nor paintings of the subjects; and it seems clear that they were always intended to be independent works of art.

no. 764); idem (pen and wash: no. 765). *The Molo looking West from the Bacino di S. Marco* (no. 562); *Grand Canal from near the Palazzo Corner* (no. 583); *Giudecca from the Bacino di S. Marco* (no. 651).

[1] *Venice from the Punta della Motta* (no. 522); *View on the outskirts of Venice* (no. 523); *Islands of S. Elena and S. Pietro* (no. 650); *Island of S. Elena, the Lido in the distance* (no. 649).

In sharp contrast with this group is another of pen and wash drawings in which the motives are Venetian churches. This exemplifies Canaletto's increased interest in the capriccio and a development in his technical resources; they are, however, typical examples of skilfully mechanized use of a stylized and calligraphic touch, especially noticeable in the figures.[1] They would seem to have been produced mainly with the engraver in mind; for all but one (*S. Lorenzo*) appear in the series *Prospetti sei di altretanti Templi di Venezia*, engraved by Wagner or Berardi (see Vol. II, sec. E). This series is said to have been published in 1742, which would give a *terminus ante quem* for the drawings. Unfortunately, no confirmation of this date has been found; but the drawings are sufficiently near the pen and wash drawings of Roman subjects to justify dating them in the earlier forties.

From islands in the immediate vicinity of Venice, such as S. Elena and S. Pietro, Canaletto extended his search for new subjects to others, notably Murano; and from material so acquired also produced several capricci. These drawings form a fairly coherent group in style, which like the group concerned with views near the Molo (see above) includes both pen and pen and wash versions of some of the subjects.[2] In style the pen drawings are similar to those in the Molo series, though somewhat tighter and more mechanical in treatment, with such devices used as enclosing the clouds within a line. The versions in pen and wash do not, in most cases, correspond closely with those in which pen alone is used, and since in the wash drawings the handling of the medium is confident and highly competent, in contrast with that in the other group, it seems probable, in view of the character of the pen drawings, that this group is the later of the two. Two of the designs (the *S. Michele* and the *Capriccio with a House on the Lagoon*) were engraved in the Wagner–Berardi series *Sei Villaggi Campestri*, which has been said to be dated 1742, though the authority for this is unknown.

[1] *S. Giorgio Maggiore* (British Museum: no. 770); *S. Lorenzo* (Janos Scholz: no. 772); *Redentore* (Fogg Museum: no. 775); *S. Salvatore* (Lebel: no. 776); *S. Simeone Piccolo* (Detroit: no. 777).

[2] *Island of S. Michele.* Pen (Windsor: no. 653); idem, Pen (Strölin: under no. 653); idem, Pen and wash (Ashmolean: no. 654); idem, Pen and wash (Rotterdam: under no. 654). *Murano: S. Giovanni dei Battuti.* Pen (Windsor: no. 655); idem, Pen and wash (Rotterdam: under no. 655); *Pavilion on the Lagoon.* Pen (Windsor: no. 657); idem, Pen and wash (Windsor: no. 658); *Capriccio: Reminiscences of S. Donato, Murano.* Pen (Windsor: no. 778); idem, Pen and wash (Windsor: no. 779); *Capriccio: House on the Lagoon.* All in wash (British Museum, no. 795; Hermitage, under no. 795; Boston, no. 796).

From the Lagoon Canaletto extended his search for new material to the mainland, the River Brenta, and Padua. Drawings that can be securely identified as views on the Brenta are comparatively few.[1] With one exception they are uniform in style, related to the Lagoon group, but more freely handled, with the hatching in the shadows looser, and more often running into blots which provide sharp accents. The exception is *Le Porte del Dolo*, which is a preliminary design in ink outline with a certain amount of hatching over a schematic outline in red chalk, somewhat similar to the diagrammatic outline drawings previously discussed. There are no wash drawings of the subject; but two of them (*Le Porte del Dolo* and *Dolo and the Brenta*) are related to etchings. Less coherent in style than the Brenta group is one composed of mainland subjects.[2] Some of these, exemplified by those in Group I (footnote 2), are pen drawings almost identical in style with those made on the Brenta; and one of them (*Mestre*) is closely connected with an etching. Others (Group II) are more tightly handled, with more precise hatching, and sometimes with ringed clouds. Of one of these there is an elaborated version in pen and wash, similar in type to the two versions of the same subject in Group III, of which no pen versions are known. How far the views represented in the majority of this group existed in fact is difficult to say. Parker groups most of them together as *vedute ideate*. Some certainly suggest this (e.g. the *Cottage and a Distant City*); but others are at least as likely to be actual scenes.

It looks, however, as though Canaletto was working with three purposes in mind: acquiring material for etchings, providing drawings suitable for engraving, and creating works that were ends in themselves. Some indication of date is given by there being an outline copy by Bellotto of the *Church by a Roadside*; and a version by him of the *Houses on a River* at Darmstadt.

[1] Dolo (?): *Entrance to the Brenta* (Windsor: no. 667); *Le Porte del Dolo* (Matthiesen: no. 668); *Dolo and the Brenta* (Victoria and Albert Museum: no. 669); *Villa Tron* (three versions, Windsor: nos. 671, 672, and 673); *Villa on the Brenta* (Windsor: no. 674).

[2] These include: I, *Mestre* (Windsor: no. 666); *Statues in the Grounds of a Villa* (three versions, Windsor: nos. 708, 709, and 710); *Church by a Roadside* (Windsor: no. 698); *House on a River* (Windsor: no. 703). II. *Cottage and a Distant City* (Windsor: no. 700); *Cottage with arched windows* (Windsor: no. 701); *House with arched doorway by a country road*. Pen (Windsor: no. 705); ibid. Pen and wash (Windsor: no. 706). III. *Houses and Walled Garden by a Stream*. Pen and wash. Two versions (Rotterdam: no. 704; art market: under no. 704).

Bellotto is known to have used his uncle's work in connexion with some of his own etchings (see p. 133), the date of which is generally accepted as *c.* 1742, which suggests a somewhat earlier date for the Canaletto drawings.

The long series of drawings of Paduan subjects includes some of Canaletto's most accomplished work, and is marked by the same diversity as the mainland group.[1] The pen drawings fall stylistically into two groups: one freely handled with the hatching running into occasional blots, as in the Brenta group (e.g. *Padua from near the Walls* and the two versions of the *Footbridge over a River*), the other and more numerous, with lines more precise, hatching more tidy, and clouds ringed with a line. The pen and wash drawings are very fully developed, double and sometimes triple washes being used, always with much skill. Three of them (*Brenta Canal and Porta Portello*; *Padua with S. Francesco*; *Outskirts of Padua with the Tower of Ezzelino*) are versions of pen drawings, but differ considerably from these. As in the case of the Lagoon group, Canaletto's control of wash had so developed that close adherence to a pattern was unnecessary.[2]

In all three groups concerned with mainland subjects, a new element is the occasional use in the more freely handled drawings of simple construction lines, notably a horizon line often put in with red chalk. These differ from the construction lines used in the thirties, in being indications rather than a carefully worked-out plan, and may well have been put in on the ground. The Paduan group also includes other evidence as to how Canaletto worked.

[1] It includes: I. Pen. *Houses, Padua* (Grassi: no. 692); *The Brenta and the Porta Portello* (Windsor: no. 675); *Ramparts and Sta Giustina* (Windsor: no. 682); *Piazza delle Erbe* (Windsor: no. 688); *Padua, with S. Francesco* (Windsor: no. 680); *View from Ramparts with Sta Giustina* (Windsor: no. 683); *View from Ramparts with S. Antonio* (two versions, Windsor: nos. 677, 678); *Sketches of Buildings* (Viggiano: no. 679); *Ramparts and a City Gate* (Windsor: no. 693): *Padua, from near the Walls* (Windsor: no. 686); *Outskirts, with Tower of Ezzolino and S. Antonio* (Windsor: no. 684); *Panoramic View of Houses and Gardens by a River* (Morgan Library and Fogg Museum: no. 695); *Footbridge over a River* (two versions, Windsor: nos. 696, 697). II. Pen and wash. *Houses, Padua* (Berlin: no. 691); *Brenta Canal and Porta Portello* (Albertina: no. 676); *Prato della Valle, with Sta Giustina* (Windsor: no. 689); *Prato della Valle with Chiesa della Misericordia* (Windsor: no. 690); *Padua, with S. Francesco* (Knoedler: no. 681); *Outskirts, with Tower of Ezzolino and S. Antonio* (Tooth: no. 685); *Farm on the Outskirts* (Windsor: no. 694); *Capriccio: Reminiscences of Palladio and Padua* (Windsor: no. 782).

[2] The relation of the pen drawing and the wash drawing of *Houses, Padua* is obscure. The wash drawing appears to be of an actual view, the pen drawing a capriccio. Perhaps the wash drawing came first and the pen drawing was made from it.

The drawings from the Viggiano sketch-book (Vol. II, C. XIX) are rough outline sketches indicating the position of buildings in the two versions of *Padua: View from the Ramparts with S. Antonio*; while the elaborate panorama in outline of *Houses and Gardens by a River*, shared by the Fogg Museum and the Morgan Library, is similar in type to the diagrammatic sketches previously discussed, and provided material for two comparatively highly finished drawings, for an etching and a painting.

This is not the only connexion of the Paduan drawings with the etchings, since they provided material for three more of these. Also, two of the pen and wash drawings were the originals of two engravings by Berardi in *Sei Villaggi Campestri.*[1] Here again is evidence of Canaletto's diversity of purpose in his drawings, sometimes reflected in differences in their character.

The panorama of *House and Gardens by a River* has a further interest, in that the Fogg Museum section is dated on the back 1742, which raises a presumption that the whole Paduan group may be dated about this time. Support for this comes from an unexpected quarter. Bellotto made much use of the Paduan drawings. Copies by him of at least seven of these exist, two drawings being each copied twice; and in three cases he adapted Canaletto's drawings for use in his own etchings. The accepted date for these etchings is *c.* 1742, which provides a *terminus ante quem* for the drawings concerned, and reinforces the evidence of the Fogg Museum drawing.

This use by Bellotto of his uncle's work in the early forties also helps to date two small groups of capricci at Windsor. In the first of these, all the drawings are in pen and ink, handled in a very distinctive style.[2] The handling is very bold and free, the hatching of the shadows wide-spaced, frequently running to blots, the outlines broken, so that the whole composition is dominated by the masses of light and shade. The *Temple of Saturn* was copied in outline by Bellotto; and in reverse, with some modifications, appears on the right of one of his etchings. Thus, this drawing and the others must be dated before *c.* 1742.

[1] See under Etchings and Engravings after Canaletto (Vol. II, sec. E).

[2] *Temple of Saturn in imaginary surroundings* (no. 784); *Temple of Vespasian in imaginary surroundings* (no. 785); *Fountain and Ruins by the Lagoon* (no. 794); *Canopied Gothic Tomb with Roman Ruins* (no. 814).

The second group of capricci are all in pen and wash.[1] These have the same broken outlines, and the same characteristic of being composed primarily in terms of light and shade; while the washed-in shadows parallel those in the other group in the freedom of their handling and the introduction of accents by additional use of wash. So closely related are they in style to the other group that they must be of about the same date.

To some extent connected with these groups, a few other drawings may also be tentatively dated from hints provided by Bellotto. One is a capriccio with a distant view of Padua (Windsor: no. 780) in line and wash, undoubtedly by Canaletto, but unusual in its combination of sharply blocked-out forms with an emphasis on silhouette, dark shadows, and freely handled detail. Comparable with it, and probably based upon it, is a painting by Bellotto at Parma, which may be dated in the forties, suggesting a date in the earlier forties for the drawing. Another case is the capriccio *House and Tower on the Lagoon*, of which there are four versions, all in line and wash. Of one version (British Museum: no. 795) there is an outline copy by Bellotto at Darmstadt, while another (Hermitage: under no. 795) was engraved by Berardi in *Sei Villaggi Campestri*, which together suggest that this particular design also belongs to the early forties.

Yet a third group of drawings which have distinctive character consists of *vedute ideate* in pen and wash.[2] These are elaborately composed, full of detail put in with a mannered though lively touch, and are in a high key without strong contrasts of light and shade, double washes being little used. In subject they are related to some of the etchings, and in technique they resemble an etching reinforced by, say, aquatint. It seems reasonable to regard them as of the same period, the earlier forties, a suggestion supported by the *Church on a Hill* having been engraved by Berardi in an untitled series.

With the more freely handled Paduan drawings may be compared a

[1] *Classic Triumphal Arch by the Lagoon* (Windsor: no. 789); *Ruins of a Church by the Lagoon* (Windsor: no. 804); *House and Column adjoining a Ruined Arch* (Windsor: no. 817).

[2] Examples are *Ruins and a Bridge by the Lagoon* (British Museum: no. 802); *Ruined Mill and Houses by the Lagoon* (Victoria and Albert Museum: no. 803); *Church on a Hill, the Lagoon in the distance* (ibid.: no. 805).

small group made up of Venetian subjects, all in pen, at Windsor.[1] These have the same boldly hatched shadows with occasional blots, the same limited use of outlines, and at times the same ringed clouds. In all, a ruler and, when required, compasses were employed; and the use of calligraphic twirls is more developed than in the Paduan group, suggesting that the Venetian drawings may be somewhat later in date. The drawings of S. Marco appear to be the first that Canaletto made inside the church.

The foregoing description of the different groups of drawings produced by Canaletto in the earlier forties may seem unduly lengthy; but it makes clear the remarkable range and variety of his work at this period, and emphasizes how much his attention was concentrated upon the graphic arts, to some extent dwarfing his activities as a painter. There still remains, however, something to be said about these. His preoccupations being what they were, Canaletto's visit to the mainland did not give much opportunity to produce paintings. But those that he did produce have a distinct character of their own, reflecting Canaletto's absorption in the graphic arts; and they provide a useful clue to the authorship of a considerable group of paintings which are still the subject of controversy.

All the paintings of mainland subjects are connected with drawings and etchings. A *View of Mestre* (Sangster: no. 370) corresponds closely with a drawing and an etching. The painting itself is warm in tone with cool grey shadows and developed local colour. The figures are small and mechanically handled, somewhat resembling those in the drawing and etching; and the lights throughout are spotted in. Similar spotted lights and strong local colour mark a *View on a River at Padua* (ex-Mark Oliver: no. 377) which is connected with the diagrammatic panorama divided between the Morgan Library and the Fogg Museum (no. 695) of which one section is dated 1742, with two elaborated drawings at Windsor, evidently based on the panorama, and with an etching. This differs from the *Mestre* in being cooler in tone, having dark-grey shadows, and being more calligraphic in handling. Similar in tone and colour is a *Padua: the Brenta Canal* (ex-Koetser: no. 375), in which the spotting of the lights is even more notice-

[1] Examples include *Piazza S. Marco, North-East Corner* (no. 539); *Piazzetta looking South* (no. 544); *S. Marco: the Crossing and North Transept* (no. 556); *S. Marco: a Sarcophagus* (no. 557).

able. This is connected with two drawings of the subject (Windsor: no. 675; Albertina: no. 676). All three paintings are related to those of Venetian subjects dated 1743–4 discussed above (p. 126); and more closely to a painting of an evening service in S. Marco (no. 77) which is based on the drawing of the crossing and north transept of the church already mentioned. A scene by artificial light is a rarity, perhaps unique, in Canaletto's work, and as such it is not wholly convincing. For its warm deep tone, the subject is probably responsible; but the drawing of the figures, and the use of sharply flecked-in lights, is so similar to that of the Paduan paintings that it is probably of about the same period.[1] In common with them, it has the look of having been made in the studio from drawings, utilizing technical devices suggested by these.

It is not a very long step from these to two further mainland paintings. *Dolo on the Brenta* (ex-Brass: no. 372) is connected with a drawing (Victoria and Albert Museum: no. 669) and with an etching; a *Prato della Valle* (ex-Brownlow: no. 376), of which there are several versions, with a pair of drawings at Windsor and a pair of etchings, each pair forming a continuous panorama.[2] Both are low in tone, with cold dark shadows and occasional sharp notes of local colour, especially in the figures, which are small and doll-like. The handling is mechanical and calligraphic, and lights are spotted in profusely.

These two paintings form part of a considerable group, all marked by the same characteristics; and which with a few exceptions, such as four views of Venetian palaces, covers much the same range of subjects as those of the paintings, drawings, and etchings of the earlier forties already described.[3] So closely

[1] It is markedly different in style from two other paintings of the interior of S. Marco, which seem to belong to Canaletto's post-English years.

[2] Another view of Dolo, looking along the Brenta in the opposite direction, in the Ashmolean Museum (no. 371) differs completely from the Brass painting in tone, colour, treatment of the figures, and freedom of handling. Its dating presents a problem discussed in the catalogue entry.

[3] Examples are *Piazza S. Marco looking East* (ten Cate: no. 15); *Piazzetta looking South* (ibid.: no. 59); *Piazzetta looking East* (Neave: no. 74); *Piazzetta looking West* (Neave: no. 71); *Molo looking West* (Neave: no. 92); *Grand Canal, Entrance, looking East* (Neave: under no. 170); *Entrance to Cannaregio* (Kleinberger: under no. 251); *S. Salvatore* (unknown owner: no. 319); *Scuola S. Teodoro* (Ward: no. 329); *Palazzo Grimani* (N.G., London: no. 324); *Palazzo Corner della Cà Grande* (O'Neill: no. 323); *Palazzo Pesaro* (private collection: no. 325); *Palazzo Vendramin-Calergi* (Loyd: no. 326); *Monument*

related in style are the paintings in this group that they must be by the same hand; and that hand has in some cases been accepted as that of Bellotto.[1] This can only be justified on grounds of style, since such other evidence as there is points to Canaletto as author. First is the close connexion of the Brenta and Padua paintings with Canaletto's drawings and etchings. This is not certain proof, since Bellotto is known to have copied some of the drawings, though in only one case (*The Brenta Canal and the Porta Portello*) is a painting known of any of the subjects he copied. Next is the evidence of engravings. The subjects of the two capricci in the Uffizi and of the two formerly with the Hallsborough Gallery were all engraved during Canaletto's lifetime by Berardi for an untitled series published by Wagner, the engravings all being inscribed *Antᵒ Canaletto Pinx*. There is also the evidence of early attributions. The name Canaletto has been attached to the Brownlow *Prato della Valle* since the early nineteenth century and perhaps since the late eighteenth; and the group of paintings belonging to Sir Arundell Neave have been called Canaletto since they were acquired by his forebears in the early nineteenth century.[2] It is always possible that the adoption by Bellotto of the name of Canaletto may have produced confusion; but in early documents and literature there seems to be no instance of Canaletto meaning anything but Antonio Canal. Lastly, in style the one clear link with Bellotto is given by the low tone and the heavy cold shadows. These, however, are to be found also in Canaletto's work; while the treatment of the architecture and figures so closely resembles that in paintings indubitably by him that it is difficult to think of them as by Bellotto. As regards date, the links with the Paduan and Brenta drawings all suggest the earlier forties,[3] a view consistent

to *Colleoni* (Mountbatten: no. 310); *Bucintoro returning to the Molo* (Dulwich: no. 339); *Basilica of Constantine* (Borghese Gallery: under no 380); *Colosseum* (ibid.: no. 388); *Piazza Navona* (Neave: no. 401); *Quirinal* (ibid.: no. 394); *Two Capricci* (Asolo: nos. 482 and 483); *Two Capricci* (Uffizi: nos. 485 and 486); *Two Capricci* (Leipzig: nos. 461 and 480); *Two Capricci* (ex-Hallsborough Gallery: nos. 484 and 493); *Farmhouse on the Mainland* and *Village and Ruins* (Springfield: nos. 513 and 514).

[1] For example, the version of the *Prato della Valle* in the Poldi-Pezzoli Museum; the two Roman subjects in the Borghese Gallery; and the two capricci in the Uffizi.

[2] It may be noted that Cicogna describes a view of the Prato della Valle belonging to Giuseppe Pasquali as by Canaletto.

[3] [Kozakiewicz, vol. I, 67–68, agrees generally with the attribution and dating. However, see note on no. 339 below suggesting a much later date for most of the group.]

with the absence of the Marchiori statue (erected 1742) from the painting of the *Entrance to the Cannaregio*, though such evidence is not conclusive, as pointed out previously.

Another group of paintings whose attribution to Canaletto has been doubted, and which have sometimes been given to Bellotto, are marked by strong contrasts of light and shade, bold and sometimes splashy handling of paint, and summary, mechanical treatment of detail. The group includes a few actual views, but mainly consists of capricci composed of reminiscences of classic and gothic buildings, notably in Padua.[1] The designs, of which the Hamburg and Poldi-Pezzoli paintings are examples, were evidently highly popular, judging by the number of repetitions, ranging from studio replicas to school pieces. As regards attribution, the two Windsor paintings can be identified with two entries in Joseph Smith's manuscript catalogue of the paintings sold to George III, so that their authorship is certain; and they carry the other paintings with them. Date is more difficult to determine. The presence of Paduan reminiscences in some of them suggests, however, that the buildings of that city were still in Canaletto's mind, while *mutatis mutandis* they are akin to the group of boldly and freely handled drawings of capricci at Windsor mentioned above, both in type of subject and method of approach. Tentatively, therefore, the group may be given to the earlier forties.

With this group may be associated two companion capricci formerly in the collection of Lord Boston: *Island in the Lagoon with a Church and Column* (Rust: no. 487) and *An Island with a Pavilion and a church* (St. Louis: no. 488). These have the same treatment of light and shade, the same range of colour, and the same bold handling as the other paintings. It has been suggested that they were painted in England; but this does not accord with their style, nor with the tradition in Lord Boston's family that they were painted in Italy.

[1] Examples are *S. Michele and Murano from the Fondamenta Nuove* (Hermitage: no. 366); a companion, *Murano: S. Giovanni dei Battuti* (Hermitage: no. 368); *Classical Ruins with Paduan Reminiscences* (Windsor: no. 494); *Ruins with Paduan Reminiscences* (Windsor: no. 495); *Ruins with Paduan Reminiscences* (Hamburg: no. 496); *Ruins and Classic Buildings* (Poldi-Pezzoli: no. 497).

In May 1746 Canaletto arrived in England. The last work known to have been produced before his leaving Venice is a drawing at Windsor of the Piazzetta, with the Campanile under repair after it had been struck by lightning on 23 April 1745, a date recorded on the drawing (no. 552). The scaffolding is still in place, and men at work. It is carefully drawn with the pen, the shadows delicately washed in, the only signs of the calligraphic touch which was by now characteristic of Canaletto being in the figures. One curious feature is that the horizontal lines of the side of the campanile towards the spectator are made to vanish towards the right instead of to the left. Evidently, on this occasion, the *camera ottica* was not used.[1]

It is sometimes said that Canaletto's visit to England was largely responsible for the mechanical and calligraphic use of his materials. In fact, this had developed and become part of his usual practice many years earlier; and in England he only extended the use of matured formulas and devices. Skill and dexterity he never lacked; but the imaginative element that inspired his better work was almost consistently absent, and this gives some substance to the rumour which began to spread in England that he was not the famous Canaletto, but an imitator.[2] It should be remembered, however, that owing to the cessation of travel the English were not familiar with Canaletto's work of the forties; and his critics were measuring his work of the time against that produced at the height of his powers.

Fiocco[3] and following him Pallucchini[4] suggest that the deficiencies in the English work were, at least in part, due to the influence of Dutch painting, and in particular of Jan van der Heyden. Fiocco thinks that the clarity of colour in Dutch landscape-painting turned Canaletto's head, and seduced him into seeking a porcelain-like finish; while Pallucchini holds that a

[1] Another version of this drawing is in the British Museum (no. 553). Parker gives conclusive reasons, including the type of paper used, for thinking that it was made in England. [A painting of the same subject (Levantis: no. 67*) has recently appeared, also perhaps executed in England.]

[2] See Chap. I, pp. 35–36.

[3] *Venetian Painters of the Seicento and Settecento*, 1929, 62.

[4] *Pittura Veneziana del Settecento*, ii, 1952, 130.

demand for documentary precision stimulated resort to Dutch example. Canaletto's English work, in fact, has no more clarity of colour or smooth precision of handling than much of his Venetian work; and his fidelity to fact is at least as great in many of his Venetian subjects as in English ones. Moreover, there is no reason to think that in any of the houses he is likely to have visited he would have seen much Dutch painting, or many examples of Van der Heyden's work.

A simpler and more probable explanation is that Canaletto came to England as a man of forty-nine, not to seek new experience and new inspiration, but to find patrons. His reputation was established for supplying a certain kind of work, and this is what he was expected to provide; the pressure to do so being all the greater since most of his work was commissioned, while on the rare occasions when he painted at a venture it was to attract custom. From the beginning Canaletto tended to put English material into a Venetian framework. He might observe that material sharply and accurately enough; but rarely did that observation extend to the character of English light and colour. Likewise, the conventions he used were based upon Venetian experience, and the details and figures he introduced were apt to have an Italian flavour. Briefly, much of his English work was painted without conviction, in a mode established by custom and long practice.

From documents, the history of buildings represented, and from engravings, Canaletto's English work can be more precisely dated than that of any other period in his career, owing largely to the tireless and accurate work of Mrs. Finberg.[1] Among his best paintings were a pair of views from Richmond House, painted probably in the summer of 1747.[2] Connected with the paintings, and in the nature of preparatory studies, are two drawings, in pen and wash, both carefully studied, but both very calligraphically handled.[3] The paintings reveal a similar calligraphic touch, though more

[1] *Walpole Society Annual*, ix, 1920–1. In the following pages exact dates and reasons for dating are as a rule omitted, since these are given in the relevant entries in the catalogue.

[2] *The Thames and the City of London* (Duke of Richmond: no. 424); *Whitehall and the Privy Garden* (idem: no. 438). Formerly regarded as painted 1746, but 1747 seems preferable (see notes in the catalogue).

[3] *The Thames and the City of London from the Terrace of Richmond House* (Earl of Onslow: no. 744); *Whitehall and the Privy Garden looking North* (T. R. C. Blofeld: no. 754).

lively and spontaneous; and they have a luminosity and a delicacy of colour rarely seen again in Canaletto's English work. Yet they represent a London seen through Venetian eyes. The light might be that of Venice; the river the Bacino di S. Marco; the barges of the City companies those of the Venetian nobility; and the spires of the city churches, dominated by the dome of St. Paul's, those behind the Riva degli Schiavoni.

During 1746 and 1747 Canaletto found his subjects for both paintings and drawings mainly on the Thames, especially the stretch running north from Westminster, among them being a number of attempts to put paintings of Venetian festivals in terms of the processions of civic barges which used to take place on the Thames on Lord Mayor's Day and other occasions.[1] For the most part, in treatment, a skilfully applied recipe has taken the place of direct response to the material. The drawings are apt to be hard and lifeless, or given an artificial vivacity by mannered gestures; and in the paintings, the texture of the paint is often monotonous, and the handling of detail mechanical. The aim was primarily a record of facts, and as such the result was unrivalled in its day, notably in luminosity and charm of colour; but, judged by Canaletto's own standards, much of the work is second-rate. An exception is the large view of Windsor Castle painted for Sir Hugh Smithson, later Duke of Northumberland (no. 449). Perhaps getting away from London and the Thames set Canaletto's imagination to work, enabling him to produce an interesting design based on an unconventional view of the subject, and to give a liveliness to his handling, especially in the foreground figures, which rivals that of the two Richmond pictures.

London was to remain Canaletto's main centre of work, with an enlarged range of subjects; but in 1748 he began to make occasional visits to the country houses of his patrons. The only work which can be assigned with any

[1] Paintings. *Thames looking towards Westminster Bridge* (Wood: no. 427); *London through an arch of Westminster Bridge* (Duke of Northumberland: no. 412); *Westminster Bridge under construction* (Duke of Northumberland: no. 434); *Westminster Bridge on Lord Mayor's Day* (Paul Mellon: no. 435); *Thames on Lord Mayor's Day* (ex-Prince Lobkowicz: no. 425); *Thames, with Westminster Bridge in the distance* (idem: no. 426); *Windsor Castle* (Duke of Northumberland: no. 449). Drawings, in pen and wash. *City seen through an arch of Westminster Bridge* (Windsor: no. 732); idem (Buffalo: under no. 732); *Westminster Bridge from the North* (Windsor: no. 749); *Westminster Bridge from the North-East with a Civic Procession* (Windsor: no. 750); *Thames looking towards Westminster Bridge* (Bernard: no. 747); *Westminster Bridge, the western arches* (British Museum: no. 752).

probability to that year are the two views of Badminton painted for the Duke of Beaufort (nos. 409 and 410), very competent though not at all exciting. Resemblance in style and colour to the Badminton pair, however, indicate that the four views of Warwick Castle (nos. 443, 445, 446, and 447) were perhaps also painted in 1748; and these would carry with them the group of drawings of the castle and the town (nos. 756–60). In both the Badminton and Warwick paintings the trees are in full foliage, which suggests they were painted about the same time of year; and since Warwick is not too great a distance from Badminton, this may well have been the same year.[1]

In 1748 Canaletto may also have made the drawings of the *Old Horse Guards* (British Museum: no. 734) as it appeared before it began to be demolished in 1749; and this was perhaps used for a painting of the same subject which can be dated before July 1749, since it appears to have been the subject of an advertisement in a newspaper at that time. Another painting of the *Old Horse Guards* from a different viewpoint can also be dated before the autumn of 1749 (formerly Sir Arthur Wilmot: no. 416); and for this were made two drawings of houses adjacent to the Horse Guards building which are part of the series in the Viggiano collection (nos. 735 and 736).[2] These are diagrammatic outline sketches, carrying inscriptions in Canaletto's own hand, and witness the persistence of an earlier practice, even though this may have become spasmodic. How these sketches came to be injected into a series which at one time made up the whole or part of a sketch-book mainly devoted to Italian material is unknown. Possibly Canaletto had brought the book to England, to use in case he was called upon to provide an Italian subject, which in fact seems to have happened. In 1749 were also painted *Syon House* (Duke of Northumberland: no. 440), an uninspired but conscientious performance; and almost certainly *Westminster Abbey with the Procession of Knights of the Bath* (no. 432), which, though somewhat heavy-handed, makes very effective use of the crimson of the Knights' robes in contrast with the greys and browns of the buildings.

[1] A version of the view of the south front of Warwick Castle (Lord Astor: no. 444) is larger than the one at Warwick, and follows the drawing of the subject more closely. This may have been made later, entirely from the drawing.

[2] Identification of their subjects is due to the perspicacity of F. J. B. Watson.

The following year, 1750, was in production the leanest year of Canaletto's stay in England. This may have been due to his going back to Venice for some eight months; but he did not leave until the autumn, and a more likely explanation is that the demand for his work had fallen off. No paintings can be definitely assigned to 1750, though two views of the Thames, looking towards Westminster Bridge, are, from the state of the bridge, most unlikely to have been painted before that year.[1] Both are competent performances, of a type that might well have been produced some time later from drawings. There are, however, a few drawings which are datable in 1750, all in pen and wash and highly finished.[2] The three Windsor drawings are very mechanical in treatment, skilful but lifeless factual records, and only the Seilern drawing has some sensitive and lively handling, suggesting the possibility that the Windsor drawing of the same subject is derived from it. The three Windsor drawings are among the six of English subjects which belonged to Joseph Smith, all of which were presumably taken to Venice by Canaletto, and were among the drawings from which Orlandi hoped paintings would be made.[3] In fact, that hope was only gratified in the case of the two drawings at Windsor of the Thames from Somerset House; the paintings from which, now at Windsor, also belonged to Smith. These were almost certainly made in Venice, and on style may well be dated 1750-1. Both are stylized, routine performances, less alive than a smaller version of the view with Westminster Bridge in the distance (Duke of Hamilton: under no. 430), which is closer to the drawing than the Windsor painting, and may have been painted in 1750, from the drawing, before it went to Venice.

Canaletto was back in England before July 1751. His stay in Venice seems to have had a stimulating effect, for after his return he painted two of his largest and most ambitious English works, *Chelsea College and Ranelagh*

[1] *Thames looking towards Westminster from near York Water Gate* (Lady Janet Douglas-Pennant: under no. 427); *Westminster Bridge from the North, Lambeth Palace in the distance* (Earl Strathcona: no. 436).

[2] *Westminster Bridge under repair* (Windsor: no. 751); *Thames from Somerset House, the City in the distance* (Seilern: under no. 745); idem (Windsor: no. 745); *Thames from Somerset House, Westminster Bridge in the distance* (Windsor: no. 746).

[3] See Chapter I, p. 38. A painting of *The City seen through an Arch of Westminster Bridge*, the subject of one of Smith's English drawings, exists, but this was made in England (see no. 412).

seen from across the Thames (divided into two: no. 413) and *Whitehall and the Privy Garden looking North* (Duke of Buccleuch: no. 439). The *Chelsea College*, advertised on 30 July as on exhibition at Canaletto's lodgings, is known to have been painted at a venture.[1] About the *Whitehall* there is no such certainty, though from internal evidence it may be dated in the early fifties. Of the two, this is much the more impressive picture, in which the imaginative approach in earlier work has to some extent been recaptured. The subject must have been difficult to handle, with the wall of the Privy Garden splitting the composition in two. Skilful massing and disposition of shadows, however, has countered this by emphasizing horizontal elements and centring attention on the Privy Garden itself. Moreover, the handling is more varied and less mannered than in most of Canaletto's English work. In contrast, the *Chelsea College* is dull in design, and somewhat coarsely painted according to a formula. It is not wholly unreasonable that the left part, belonging to the National Trust, England, should have been attributed to Samuel Scott.

The *Whitehall*, however, was somewhat of a flash in the pan, and most of the work produced before Canaletto's second visit to Venice some time before 1753[2] is nearer in spirit and treatment to the *Chelsea College*.[3] All are slick and mechanical, even below the standard of earlier English work; and it is not surprising that the *Alnwick Castle* should have been one of the paintings cited as proof that it was not the real Canaletto who came to England.[4]

Apparently, the demand for Canaletto's work among the landed gentry was declining; and so he turned to producing more drawings, specifically for engravings.[5] Out of ten engravings nine are described as from drawings and one only (*Northumberland House*) as from a painting and a drawing.

[1] See Chapter I, pp. 37–38.　　　　　　　　　　　[2] See Chapter I, p. 39.

[3] Paintings of this period include *Vauxhall Gardens*, 1751–2 (Lord Trevor: no. 431); *Alnwick Castle*, before 1752–3 (Duke of Northumberland: no. 408); *Northumberland House*, 1753 (idem: no. 419); *New Horse Guards*, 1752–3 (Mrs. Robin Buxton: no. 417); idem, 1752–3 (Drury-Lowe: no. 418).

[4] See Chapter I.

[5] Engravings after Canaletto published in the period 1751–3 include: *Ranelagh, Rotunda and Gardens* (two views, 1751); *Ranelagh: Interior of the Rotunda* (1751); *Vauxhall Gardens* (three views, 1751); *New Horse Guards* (1752); *The Monument* (1752); *Northumberland House* (1753); *London from Pentonville* (1753). See below, Engravings after Canaletto.

Only two of these drawings have been traced; but English practice at the time, so far as it can be checked, did not confuse *delineavit* and *pinxit* in the inscriptions on engravings, so it may be assumed that drawings were made for the other eight engravings.

When Canaletto returned from his second visit to Venice is not known. That he was back in England in 1754 and that he was still there in 1755 is witnessed by the existence of paintings dated in those years made for English clients. One group of these was made for a new client, Thomas Hollis, the English radical, a friend of Joseph Smith whom he had met in Venice.[1] The five paintings of this group which have been traced are uneven in quality. *The Rotunda, Ranelagh* and the *Capriccio with the Banqueting House* are both lifeless applications of a well-worn recipe, to the extent that the *Ranelagh* was one of those quoted to prove that their painter could not be Canaletto, while the authenticity of the *Capriccio* has been doubted. The *Old Walton Bridge*, in contrast, though mechanical in touch and lacking atmosphere, is effectively designed, with dramatic contrasts of light and shade, and oppositions of bright and sombre colour. So close in style to the *Ranelagh* is *Eton College Chapel* (National Gallery, London: no. 450) that it must be of the same period. In the past it has been dated 1747, presumably because Canaletto is known to have painted at Windsor in that year (see p. 141). The style, however, is against this; and it is certain that the picture was not painted on the ground or from a drawing made on the ground, so gross are the topographical inaccuracies. It suggests something made from memory, perhaps with the help of an inadequate sketch or a poor engraving by another hand.

The *Piazza del Campidoglio and the Cordonata* almost certainly was painted in 1755. It is competent but dull, closely related to the *Ranelagh*, and is a

[1] See Chapter I. There were six paintings, bequeathed by Hollis to Thomas Brand (later Brand-Hollis), from whom they ultimately went to Edgar Disney, whose widow sold them at Christie's in 1884. Four are known to have carried inscriptions in Canaletto's hand, saying they were painted for Hollis, and dating them; another, which has not been traced, probably carried a similar inscription; about the sixth there is no information (for details see the relevant catalogue entries).

Interior of the Rotunda at Ranelagh (1754: no. 420); *Walton Bridge* (1754: no. 441); *Westminster during the building of the Bridge* (1754?: no. 437(*b*), untraced); *St. Paul's Cathedral* (1754: no. 422); *Piazza del Campidoglio and Cordonata* (1755, probably: no. 396); *Capriccio with Banqueting House, Whitehall* (n.d.: no. 472).

version of an earlier painting of the subject belonging to Sir Arundell Neave (no. 397), which seems to be based on an engraving by Alessandro Specchi. Presumably, the subject was chosen by Hollis as a reminiscence of a considerable stay he made in Rome. Conceivably, the painting could have been made in Venice, and sent to Hollis in England; but this hypothesis has become very unlikely, since it is now known that Canaletto was working in England in 1755. Evidence of this is another *Walton Bridge* from a different viewpoint (no. 442), with an inscription on the back that it was painted in London in that year for Samuel Dicker, another new client; and by a drawing of the same subject (no. 755) carrying an inscription in Canaletto's writing that it is from the picture made in 1755. In style this is very much like the earlier view of the subject, with similar exploitation of the possibilities of a stormy sky, and dramatic contrasts of light and shade. The inscription on the back is similar in form to those on the *Ranelagh* and the earlier *Walton Bridge*, including a declaration that the subject was painted 'per la prima ed ultima volta'. This guarantee of a painting being unique is another indication that customers in England were becoming few. The days of a queue waiting for a version of a well-known subject were apparently over. Incidentally, Canaletto took the declaration fairly lightheartedly, since he painted not only two Walton Bridges, but a second interior of Ranelagh from another viewpoint.

In 1754, however, he had found another client of importance, beside Hollis. This was Baron King, from whom is descended the Earl of Lovelace,[1] in whose family there remained, until dispersed in 1937, a group of six paintings which family tradition says were acquired with money brought into the family by the wife of the fifth Baron King, who with his wife commissioned some or all of the paintings.[2] All six are so similar in style that one of them, *A Sluice on a River*, being signed and dated 1754, carries

[1] Which Baron King of the day was concerned is uncertain (see under no. 367); but in the present connexion this is immaterial.

[2] Five are capricci, the sixth a view with imaginary elements in it. *Sluice on a River with reminiscences of Eton College Chapel*, dated 1754 (Coolidge: no. 475); *River Landscape with a Ruin* and *River Landscape with Column and Roman Arch* (both National Gallery, Washington, Paul Mellon collection, nos. 473 and 474); *Domed Church and the Colleoni Statue* and *Palace, Bridge and Obelisk* (both owners unknown: nos. 478 and 504: *Island of S. Michele* (?), *with imaginary elements* (Stephenson Clarke: no. 367).

the others with it. The designs are effective, the colour agreeable, and the handling somewhat coarse, but lively. Two are uprights, four horizontals; and their character and sizes suggest that they were intended as part of the decoration of a room. This is particularly the case with the two uprights, which combine reminiscences of the Surrey countryside, in which the King house was situated, with reminiscences of Rome and Venice, including a boat in which the ladies hold umbrellas, very like those seen in Canaletto's Venetian festival paintings.

To the same period as the Lovelace paintings seem to belong three variants of a capriccio, one of which, *A Pavilion with an Arcade and Colonnade by the Lagoon* (Morrison: no. 512), has on the lining canvas an inscription, probably transcribed from one on the original canvas, giving the date as 1754, the same year as the Lovelace paintings. This could have been painted in Venice; but is so close in style to the Lovelace pictures as to make England much more probable. A second variant of the composition, in part at least by Canaletto (see (*a*) under no. 511), is oval in shape, and came from Bretby Hall. There it formed part of a scheme of decoration datable 1750–60; which suggests that it was painted during Canaletto's later years in England to go into the place it formerly occupied. Yet a third variant (no. 511) also has links with England, having been owned by the same English family since the early nineteenth century and perhaps earlier. Remembering that there exists a highly finished drawing of the subject, whose history is unknown but which came to light in England (no. 823), it seems possible, at least, that Canaletto either brought this drawing to England or made it there and used it to produce these and perhaps other examples of the composition.

At this period in Canaletto's life it is sometimes difficult to say whether a painting or drawing was made in England or in Venice, and therefore to suggest a probable date. Subject alone is not enough, without additional evidence. This exists in the case of the British Museum version of the drawing representing the Campanile under repair (see above, p. 139 n.) and of the Piazza di Campidoglio which belonged to Hollis (p. 145), to show that they were produced in England. Similarly, in the case of the four paintings of Venetian subjects which belonged to the Holbech family and decorated

the dining-room at Farnborough Hall, family tradition says that two were brought from Italy in the thirties, but that two (*Bacino di S. Marco from the Piazzetta*, no. 128, and *Entrance to the Grand Canal looking East*, no. 171) were painted in England, a supposition quite consistent with their style. Examples of the reverse process already quoted are the two paintings at Windsor of the Thames from Somerset House, which were very probably painted in Venice. It has to be assumed that in whichever country he was, Canaletto had with him a certain amount of material, notably drawings from which he could work.

Difficulties in dating are particularly acute in the case of a group of capricci, both paintings and drawings, all carried out in a fully matured, mechanical style which marks them as late work but is no great help in putting them into a time sequence.[1] One test that has been suggested, to separate paintings and drawings made after the English visit from those made before it, is the inclusion of buildings in the Gothic style; but since there are plenty of these to be seen in Italy, and Canaletto put elements from them into work certainly produced before he went to England, this test is of no great value. It is only when buildings are introduced which can be connected with specific buildings in England that there is an argument in favour of a date after 1746.

This seems to be the case with the *Palace with an Obelisk and a Church Tower* (Earl Cadogan), with which goes its pendant *A Castellated Villa with Column and Church*. Not only is the subject a variant of one of the Lovelace pictures, and very close to it in style; but the church tower is like that of St. Mary, Warwick, of which Canaletto made a drawing. The subject was engraved by Berardi, with considerable differences, notably the omission of the tower. The engraving is described as from a drawing; and it is

[1] Paintings. *Palace with Obelisk and Church Tower, Castellated Villa with Column and Church* (Earl Cadogan: nos. 502 and 503); *Palace with Clock Tower and Roman Arch, Round Church with Renaissance and Gothic Buildings, Triumphal Arch seen from a Portico* (Duke of Norfolk: nos. 505, 507, and 506); *Oval Church by the Lagoon* (ex-Fonda: no. 489). Drawings. *Palace on the Lagoon* (Cleveland, Ohio: no. 819); *Round Tower on the Lagoon* (ex-Marquis of Lansdowne: no. 806); *Triumphal Arch and Gothic Building on the Lagoon* (Newberry: no. 790); *Westminster Bridge and Old Montagu House* (Frankfurt a. M.: no. 786. Versions in the Victoria and Albert Museum, British Museum, Gooden and Fox); *The Loggetta as the Portico of an Imaginary Church* (ex-Durlacher: no. 761); *Similar subject* (Victoria and Albert Museum: no. 762).

possible that this drawing was used as a basis for the painting either in England or later in Venice, though style considerations favour England.

Certainly made after Canaletto's arrival in England is the drawing at Frankfurt, with its three variants, incorporating reminiscences of Westminster Bridge and Old Montagu House. This seems to derive from a drawing in an Amsterdam collection (no. 753), carrying written notes on colour, which is itself so far from the facts as to have prompted the suggestion that it was made after Canaletto went back to Venice. The presence of colour notes probably implies that the drawing was made either on the ground or shortly after the subject had been seen, and therefore that it was made in England. The derivatives, however, may well have been made considerably later.

A third example of the use of what seems to be an English motive is the drawing of *A Triumphal Arch and Gothic Building on the Lagoon* (Newberry), which carries with it in date its pendant *A Round Tower on the Lagoon*. In this, a building appears reminiscent of King's College Chapel, Cambridge, or Eton College Chapel, as does a building in the former Lovelace painting *Sluice on a River*, which is dated 1754. A complication here is that both drawings are related to engravings by Berardi, which have been said to have been published in the forties, and are inscribed to the effect that the originals were paintings. The implication is that the drawings must date from before the English visit; yet it is difficult to believe that the building in the *Triumphal Arch on the Lagoon* could be a complete invention.

[In the case of the two drawings of *The Loggetta as the Portico of an Imaginary Church* (nos. 761 and 762), there is the evidence of the upper story of the Loggetta which has been completed by the addition of its outside wings. This was finished in March 1750 and would have been seen by Canaletto if in Venice that year or certainly in 1753.]

Turning to work in which style and other comparisons are the only means of dating, the Cleveland *Palace on the Lagoon* is in subject related to the *Palace, Bridge and Obelisk* (formerly in the Lovelace collection) and to the similar capriccio in the Cadogan collection; and it seems likely that it was used as a starting-point for either or both of them. Since the two paintings

can be dated *c.* 1754, this gives a *terminus ante quem* for the drawing; and on style it seems likely to have been made in Venice before Canaletto came to England.

Comparison with the two Cadogan capricci suggests that the three paintings belonging to the Duke of Norfolk are of about the same date as these. They are high in key, the brushwork free but mannered, with the architecture precisely and mechanically drawn. F. J. B. Watson's suggestion that they may have been designed as decorations to be set in light or white panelling[1] is supported not only by their character but by the fact that examples are known (Farnborough Hall and Bretby Hall) of paintings by Canaletto being used in this way. If the three paintings served a like purpose, the case is somewhat strengthened for their having been painted in England rather than after Canaletto's return to Venice.[2]

An Oval Church by the Lagoon presents an even more baffling problem. Superficially, the dashing breadth of the handling recalls that of the group of capricci based on reminiscences of Rome and Padua, of which examples are at Windsor, datable in the earlier forties. Yet in the treatment of light and shade, in colour, and in occasional tricks of brushwork, it is related to the Lovelace capricci. Since an isolated anticipation of methods used ten years later is unlikely, on balance the painting may be assigned to the middle fifties.

Paintings and drawings known to have been produced by Canaletto after his final return to Venice are few in number, compared with the time that elapsed before his death in 1768. There is, in fact, only one painting which without question belongs to the period, the capriccio *A Colonnade and Courtyard of a Palace* (Accademia, Venice: no. 509), which is signed and dated 1765, and was presented by Canaletto to the Accademia di Pittura e Scoltura after his election to that body. This was what Richard Wilson used to call 'a good breeder', for there are several replicas and versions, in which Canaletto seems at least to have had a hand. Essentially, it is a carefully

[1] *Arte Veneta*, ix. 256.

[2] Watson compares the figures in the three paintings with those in the 1743–4 over-doors at Windsor; but the similarities seem too remote to justify dating the paintings so early.

worked-out architectural study, with boldly massed and sharply con-
trasted light and shade which brings details together into an effective
design. The tone is cool, the shadows heavy, and the handling mechanical;
use of a ruler is evident, and details are put in with the free use of twirls
and blobs. By the painter's own standards, it is far from a masterpiece,
though perhaps a suitable monument to a newly elected academician.
With the painting is connected a drawing of the subject in pen and wash
(Albertini collection: no. 822), which *mutatis mutandis* is similar in style. This
may well have been used for the painting, and may be dated any time
between Canaletto's return to Venice and 1765.

Probably to this period belongs a capriccio about which Algarotti writes
with enthusiasm in a letter of 28 September 1759 (see under no. 458).
The subject of this was Palladio's design for the Rialto Bridge, combined
with various buildings from Vicenza; and the letter implies that it had been
commissioned by Algarotti, and recently painted. The strongest candidate
for being this painting is one in the Conti collection, Milan (no. 458),
though the identification is not complete. Like the Academy painting, this
is virtually an elaborate architectural piece, with carefully worked-out
perspective and cast shadows. As in that picture, the tone is cool, the shadows
somewhat heavy, and the brushwork lifeless, except in the mannered
treatment of the figures. These analogies suggest that even if it is not the
Algarotti picture, it belongs to the same period. The same holds for an-
other painting of a similar subject, *S. Giorgio Maggiore with the Rialto Bridge*
(N. Carolina State Art Museum: no. 463), which in style closely resembles
the Conti painting.

The only other works for which there is definite evidence other than
style that they belong to Canaletto's last years are drawings.[1] Among these
is a *Piazza S. Marco looking East from the South-West Corner* (formerly
Lady Annabel Dodds-Crewe: no. 528). This was apparently acquired by the
Rev. John Hinchliffe during a visit to Venice in 1760, when he saw Canaletto
in the Piazza S. Marco making the drawing or, more probably, the sketch on
which it was based.[2] The drawing is in pen and ink, much elaborated, is
enclosed by ruled lines, and is the application of a skilfully handled recipe.

[1] [See, however, note on catalogue entry no. 339. [2] See p. 43 and the catalogue entry.]

It would be difficult to date, but for the circumstances of its acquisition, which incidentally reveal that on occasion Canaletto still followed the practice of working from nature.

A major achievement of these later years was the set of twelve drawings of ceremonies and festivals in which the Doge took a leading part, of which ten are known.[1] These are in pen and brown ink, with grey wash, double- and treble-washed in places, each enclosed within ruled ink lines. They are as elaborate as any drawings Canaletto ever made, and justify the remark of Sasso, the Venetian dealer, writing to Sir Abraham Hume in 1789, 'che sono Belli quanto quadri'.[2] At the same time they are largely the result of an extremely dexterous use of a series of calligraphic gestures, set within skilfully contrived designs; to the extent that Hadeln regarded some of the drawings as perhaps school copies.

The whole series of twelve was engraved by Brustoloni, who occasionally introduced a freshness of touch lacking in the originals. The engravings are inscribed *Antonius Canal pinxit*; owing partly to this, some controversy has arisen over the relation of the engravings to the drawings. It is argued in some quarters that a set of paintings of the subjects must have existed, from which the engravings were made, and that the drawings were made either for or from these paintings. Another view is that a set of paintings by Guardi of the subjects is the source of the drawings, which were used for the engravings.[3] The weight of evidence, however, favours the term *pinxit* having been used loosely instead of *delineavit*, a not uncommon practice especially in the case of wash drawings; that no series of paintings by Canaletto existed; and that the engravings were made direct from the drawings. The introduction of Guardi is an irrelevance, since it can be shown that his paintings were almost certainly adapted from the engravings. The engravings can be dated 1763–6, so that the drawings were almost certainly made in or before 1763.

Preparatory to one of the drawings (*The Bucintoro leaving S. Nicolo di Lido*)

[1] For a list of subjects, history, and present owners of the surviving drawings, see nos. 630–9.

[2] The correspondence is in the library of the National Gallery, London. I am greatly obliged to Mr. Martin Davies for allowing me to consult this.

[3] These and other views are discussed in the introduction to the catalogue entries concerned with the drawings.

were two diagrammatic drawings with inscriptions by Canaletto, now in the Fogg Museum (no. 652). Together, these represent the waterfront of the Lido near S. Nicolò; and are known to have been part of a longer panorama, of which the other parts have disappeared. These were evidently made on the ground, as in the case of similar drawings; and their close connexion with one of the Ducal Ceremonies series is good evidence they were made after Canaletto's return to Venice. They indicate also that even towards the end of his career Canaletto had not given up the use of factual diagrams as preparations for other work.

The last dated work by Canaletto known is the pen and wash drawing at Hamburg of *The Interior of S. Marco with musicians singing* (no. 558). This carries an inscription giving the date as 1766, and saying that it was made in the artist's sixty-eighth year, 'Cenzza Ochiali'. The use of a ruler and, probably, compasses has given it something of the stiffness and rigidity of the *Colonnade and Courtyard of a Palace*. Yet in the skilful use of washes of varying depths to give sense of space, it is a *tour de force*, and though the drawing of the figures is highly stylized, something of the liveliness and individuality of those in earlier work has been recaptured.

On the basis of these certainties, or near certainties, a few other works may be approximately dated. A drawing in pen and wash of *The Piazza S. Marco from the South-West Corner* (formerly H. Oppenheimer collection: no. 527) is an elaborated version, with some differences in proportion and in the figures, of the former Dodds-Crewe drawing of 1760, or of the sketch from which this was made; and is so similar in technique (except for the use of wash) that it must date from about the same time. On the ex-Oppenheimer drawing, again, seems to have been based a painting in the collection of Lord Wharton (no. 19), which is not unlike the Academy picture of 1765 in its precise, hard handling, its cool tone, and the calligraphic drawing of the figures, and may reasonably be dated between 1760 and 1765.

Of a similar subject, but seen from a viewpoint nearer S. Marco, and extending to the left to include the Torre d'Orologio and part of the Procuratie Vecchie, are three almost identical drawings, all in line and wash.[1] In the precise drawing of the architecture, the stylized figures, and the

[1] Windsor (no. 525); Lehman collection (no. 526); former Reveley collection (under no. 525).

handling of the wash, these are closely related to the ex-Oppenheimer drawing, and appear to be of the same period. For the Windsor drawing there is a limiting date, since this was among those bought by George III from Joseph Smith in 1763; and this limit may well apply to the others. Evidently Smith's purchases from Canaletto continued after the latter's return from England.

Closely related in subject to these three drawings is a painting in the National Gallery, London (no. 20). This is an upright, from the same viewpoint, but excluding the buildings to the left. So close is it in detail to the Robert Lehman drawing that it may well be based upon it. This and its pendant in the same collection (*The Piazza S. Marco looking East from the North-West Corner*) are cool in tone, hard and definite in handling, with sharply streaked or dotted-on lights, and details put in with twirls and flourishes. Livelier than the Academy picture, they nevertheless have similar fundamental character. Probably they may be dated between the Lehman drawing and 1765.

The two National Gallery paintings have so many stylistic resemblances to two views of the interior of S. Marco, looking eastward along the nave (Windsor, no. 78; Montreal, no. 79), as to suggest that all four belong to the same period. The figures in the two S. Marco paintings are too small to allow of much calligraphic virtuosity, but it is nevertheless present in them and in various details. With these four may be grouped a *Bacino di S. Marco looking West* (Erlanger collection: no. 139). Confirmatory evidence of a late date for this is that the façade of the Pietà is seen in the form it took after reconstruction began in 1745.

To the last years also seem to belong a small group of drawings of capricci.[1] These are all marked by a florid though mechanical use of line, much calligraphic detail, and an elaborate use of wash which gives them something of the character of paintings. The two Windsor drawings were among those sold to George III in 1763, and must have been made before that date. The Brackley and Albertina drawings were both engraved, the

[1] This includes *Terrace and Loggia of a Palace on the Lagoon* (Windsor: no. 821); *Classical Arch in a Garden with a Statue of Hercules* (Windsor: no. 827); *Courtyard with a Portico* (Brackley: no. 826); *Garden seen from a Baroque Vestibule* (Albertina: no. 828); *Cottage with a Flight of Steps* (Berlin: no. 699).

latter apparently as part of a series; but the dates of the engravings have not been found. Perhaps consciousness of the engraver's needs helps to account for the lifelessness of both drawings. More vigorous and accomplished is the Berlin drawing. In technique, especially in the use of wash and the treatment of the figures, it is clearly related to the Hamburg Interior of S. Marco, and may with certainty be placed among Canaletto's last drawings.

<p align="center">* * * * *</p>

References to Canaletto's methods of work are made throughout the foregoing pages and in the Catalogue. It may, however, be useful to bring these references together, and to add a certain amount of further information.

Despite the vast number of paintings he produced, the drawings of Canaletto are the centre of his work. They served three purposes: (*a*) to provide material for paintings or elaborated drawings, (*b*) to be used for engravings and occasionally for Canaletto's own etchings, (*c*) to exist as independent works of art. Sometimes a drawing might be used for more than one purpose; but in most cases they differ in type according to their purpose.

Drawings preliminary to other work fall into two groups. One of these consists of diagrammatic drawings in outline, on which in most cases notes are written giving colours, identifying buildings, describing details, and marking the junction-point of drawings on two or more sheets of paper. The largest single collection of these is in a sketch-book in the Accademia, Venice (see under Sketch-books). These were generally drawn in chalk or pencil, occasionally on the basis of rough indications in the same material; but sometimes the lines were strengthened with ink. There is evidence that Canaletto used such sketches throughout his career: and they have all the marks of being made freehand. The second group of preliminary drawings covers a wide range, from those that sometimes are little more than memoranda, such as some of those in the Viggiano and Brass sketch-books, to others that are tolerably complete though freely and boldly handled. This latter kind again is divided into drawings made from nature, and those which were made from memory as a stage in the working out of a design, two types not always easy to distinguish. Pen and ink is a usual medium in all

such preliminary drawings, even for the more elaborate ones, though slight pencil and chalk indications beneath this are not uncommon.

Drawings used for engravings may be either in pen and ink, or in pen and wash. It is by no means always certain that a drawing was intended to be engraved; but where there is a reasonable chance that this is so, the drawing is apt to be precise and somewhat monotonous in treatment, with hatched or washed areas carefully defined and evenly executed. An indication that an engraving was in mind is enclosure of a drawing within a single- or double-ruled line. Usually pencil or chalk indications under the pen lines can be detected. A danger in this connexion is the existence of engraver's copies, instanced by those of Visentini for his engravings after Canaletto (see Engravings: Visentini); while there is reason to think that some of the elaborate pen and wash drawings of capricci which were in the Henderson collection, and are now in the British Museum, are engraver's copies.

Drawings intended to be independent works of art are invariably elaborately finished, either with the pen alone, or in pen and wash. Apparently it was not until the early forties that wash was used systematically; but from that time onwards, it was the usual medium for this type of drawing. It is doubtful whether these were ever made wholly direct from nature. There is almost invariably some indication of preparation in the studio, such as construction lines ruled or struck with dividers or compasses or freehand indications in pencil or chalk, usually black, but occasionally red;[1] or some hint, such as inconsistencies in lighting, that they were finished in the studio from memory. In the wash drawings gouache was sometimes used in the lights, though this seems only to have been in work of the last period, when wash was handled to give an effect approximating to that of a painting.

The materials used by Canaletto in his drawings have been excellently described by K. T. Parker.[2] He points out that his penwork is of three fairly distinct types, each of which, it is natural to assume, corresponds with a different type of pen. These he takes to be the quill, in all the variations due to the different birds from which it was taken and the way it was cut by the

[1] As K. T. Parker points out (p. 22) the use of red chalk in this way is less exceptional than it has been assumed to be, since it appears at various periods throughout Canaletto's life.

[2] *Canaletto Drawings at Windsor Castle*, 20–21.

individual; the reed pen, noting that a soft quill broadly cut could yield similar results; and some sort of metal pen, which produced the thin incisive quality of some of Canaletto's lines.

The ink used by Canaletto has not been systematically investigated. It is generally assumed that it was at first brown in colour, as it usually appears today. In a few drawings, however, the ink is black or dark grey; and this may have been the original colour in all the drawings. In the eighteenth century ink was made with galls and sulphate of iron, and in time this black ink was apt to change to brown as the result of oxidization. The only ink used that remained black was Chinese or Indian ink.

Parker was the first to note that in addition to ruler and compasses Canaletto also used what Parker calls 'pin-pointing', a device that seems to be peculiar to himself. This consists of a series of minute perforations plotting the principal points and distances in an architectural composition, and, as Parker says, does not seem to have involved anything in the nature of a transfer.

The relation of the different types of drawings to one another and to paintings is a question difficult to determine, and involves consideration of how far Canaletto worked from nature. The diagrammatic sketches appear to have been made on the ground; and likewise some of the more elaborate preliminary drawings, in which the height of the horizon and the angle of convergence of the horizontal lines is consistent with the artist standing or sitting in front of the subject. Moreover, the evidence of the Rev. John Hinchliffe that in 1760 he saw Canaletto making a sketch in the Piazza S. Marco is not to be disregarded. As regards painting, nothing definite was known until publication of the letters from Alessandro Marchesini to Stefano Conti, one of Canaletto's early patrons for whom the four paintings now in Montreal were made.[1] In a letter of 22 September 1725 Marchesini writes of Canaletto, 'sta dipingendo non con l'immaginaria mente nelle solite stanze de Pittori stessi come practica il S. Lucca [Carlevaris]. . .'. This seems decisive for the period at which Marchesini was writing; though painting from nature did not mean that preliminary drawings were not made, since for one of the Conti paintings (*The Rialto Bridge from the North*)

[1] Haskell, *Burl. Mag.*, Sept. 1956, 298.

there is such a drawing in the Ashmolean Museum. It seems very likely, too, that the six large early paintings at Windsor were made on the ground, preliminary sketches also being made.

The problem is, how far Canaletto continued to paint from nature; and all the evidence suggests that he came ultimately to relying mainly upon drawings, on engravings, or on memory. Even in the case of topographical paintings the large amount of his production, the number of versions which exist of some paintings, the mechanized and routine handling of many of them, the frequent departures from fact in the relative positions of buildings and in details, are all inconsistent with painting direct from nature; while capricci must clearly have been studio-made. This is not to say, of course, that on occasion Canaletto did not revert to earlier practice. For example, the two views from Richmond House, perhaps the first paintings made in England, suggest this, also the *Whitehall and the Privy Gardens*, despite the omission of some details in the latter.

The type of drawing or other material used for any particular painting and how it was employed have to be guessed in each case. Too little weight is usually given to the extent to which memory and long practice can enable an artist like Canaletto to construct a painting from slight indications or from a drawing or engraving by another hand. Such things as variations in treatment of perspective and the use of a predetermined series of tones and colours are easy for experienced practitioners. So it cannot be assumed that there was normally a regular sequence from the preliminary sketch through an elaborated drawing to the painting. Such sequences do, however, exist. One example is a view of the Molo, looking west, of which a sketch is in the Pennsylvania Academy of Fine Arts, a more developed drawing at Windsor, and a painting in an English private collection. Another is a view of S. Giovanni dei Battuti, Murano, seen from across the Grand Canal, of which there is a rough sketch in the Brass sketch-book, a pen drawing with hatching at Windsor, another in pen and wash at Rotterdam, and a painting in the Hermitage. But more often, whatever material was available at the time seems to have been used, which might include an elaborated drawing. That the finished type of drawing, however, was usually an end in itself and not thought of as preliminary to a painting, is

indicated by one example (*Walton Bridge*) being known, on Canaletto's own testimony, as being from and not for a painting; and it is unlikely that this is the only case.

The extent to which Canaletto relied on memory in his paintings is suggested by two facts. One is the relatively small number of drawings, other than those made for their own sake, which are closely related to paintings; even allowing for the fact that drawings are less likely to survive than paintings. Another is the large number of versions of certain views undoubtedly by Canaletto himself which are not replicas, each containing a considerable number of variations both in design and in detail.

Canaletto's methods as a painter varied considerably at different times in his career. That he was an excellent technician is evident from the good condition in which his paintings have remained; and at least a hint as to the reason for this is given by a letter of September 1725 by Marchesini (Haskell, *op. cit.*, 298), saying of Canaletto and Marco Ricci 'non è questi Pittori ordinari, e nelle Loro opere non può scansare L'Azzuro quale tutto il Suo principal colore, che adoperi, mentre deve servirsi anche né verdi per resistere alla discrezione del Tempo'. Later in the correspondence it appears that one of Canaletto's excuses for not delivering Conti's painting was difficulty in obtaining suitable colours.

In much of his work of the twenties Canaletto used the dark red-brown ground that was traditional in Venetian painting, both colour and brushstrokes of this being allowed to show through in places, particularly in the shadows. Apparently, this ground was in some form of tempera, subsequent work being in oil scumblings and glazes. This helps to account for the rich, cheese-like quality of the paint in many of these early pictures, the most notable example being *The Stonemason's Yard* in the National Gallery, London. This use of the red-brown ground continued throughout the thirties, examples being in the Earl Fitzwilliam series. But in the meantime, beginning in the later twenties, another method of painting was developed. In this the ground was white and smooth, the paint also being put on smoothly, either directly or in the form of glazes, impasto being used only in the lights. Hitherto Canaletto had used only canvas as a support. Probably as a result of the change to a technique which permitted greater

elaboration of detail, he painted a number of pictures on copper, seven examples being known, two belonging to the Duke of Richmond, two to the Earl of Leicester, two to the Duke of Devonshire, and one to the Kauffman collection, Strasbourg. The use of metal as a support was rare in Italy, though not unknown; and it seems likely that it was suggested to Canaletto by some of the northern painters he could have met in Rome, such as Vanvitelli. But shortly he seems to have given up the use of copper and thenceforward consistently used canvas. It has been argued on the strength of one painting, a *Bucintoro at the Molo*, that Canaletto used gouache on paper. The painting, however, is very doubtfully by Canaletto. On the other hand, as noted above, the use of gouache in parts of late wash drawings is not unusual.

Two unfinished paintings at Princeton and Philadelphia, if not certainly by Canaletto, at least demonstrate current methods of beginning a topographic painting. These were very much what one would expect. The main masses of the buildings and their shadows are blocked in with monochrome, over which glazes could be run, the bare canvas or a pale monochrome being used for sea and water. Evidently Canaletto sometimes varied this procedure, since paintings exist in which the sky and clouds have been put in first, the cloud forms being visible through the architecture painted over them. Especially in later work, the same method was used in putting in figures; and frequently, through paint which has become transparent with time, the fully developed details of the architectural setting can be seen. The chief importance of this way of painting is that it helps to explain the breadth and unity of Canaletto's painting, since even the most multifarious details could be brought into unity by the boldly massed system of tones beneath them.

There seems no doubt that, in his paintings as well as in his drawings, Canaletto used mechanical aids. In many cases the lines of the architecture and such details as the rigging of ships indicate the use of a ruler, so evenly and unfalteringly are they put in. There is ground for thinking that sometimes a pen was used, since occasionally two parallel lines very close together can be seen, as may happen when the supply of ink in a pen is running out. Possibly, on occasion, something resembling a rigger brush, like those used by sign-writers, may have been employed, since single hairs

close together might produce a similar result. No positive evidence has been found, in paintings, of whether compasses or dividers were ever used, such as the indented lines which usually indicate this; though segments of circles are usually struck with so much certainty and correctness as to suggest that something of the kind was employed. In drawings, however, indentations of dividers and compasses are occasionally present.

There is no doubt that Canaletto was familiar with the rules of linear perspective. Evidence of this is the drawing at Darmstadt of the Piazzetta, looking north, which is in pen outline, largely ruled, and carried out in strict conformity with the conventions of linear perspective, including the outlines of cast shadows. This makes it all the more remarkable that sometimes Canaletto makes some of the lines of his architecture vanish in directions inconsistent with the rest, an example being the drawing of the Campanile under repair at Windsor. In some masters, such as Paolo Veronese, such inconsistencies are clearly used for the purposes of design. Canaletto may have had this in mind, but not obviously so, for his inconsistencies seem to have little bearing on the construction of his compositions.

That Canaletto used some form of optical apparatus to assist him is reasonably certain. Zanetti (p. 463), a most reliable source of information, is quite specific. 'Insegnò il Canal con l'esempio il vero uso della camera ottica; e a conoscere i difetti che recar suole a una pittura, quando l'artefice interamente si fida della prospettiva che in essa camera vede, e delle tinte spezialmente delle arie e non sa levar destramente quanto può offendere il senso.'[1] Concerning the type of apparatus he used, and the extent of that use, there is a difference of opinion. As regards type, it seems clear from Zanetti's references to distortion and colour that the apparatus was more than a piece of glass, sometimes squared up, which artists use to select a composition. Evidently it included some form of lens; but how elaborate it was it is hard to say.[2] The fact that in the list of Canaletto's property at the time of his death (see Appendix III) there is no mention of any piece of

[1] G. A. Moschini, *Della Letteratura Veneziana*, Venice, 1806, iii. 76–77, says much the same as Zanetti. Probably he is only repeating Zanetti, whom he constantly cites elsewhere. Lanzi (*Storia Pittorica della Italia*, ii, 1793–6, 225, also repeats Zanetti.

[2] For the various types of device see Meder, *Die Handzeichnung*, 1919, 477, 550, and Fritzsche, *Bernardo Belotto*, 1936, 174–98.

optical apparatus, suggests that whatever he used was a comparatively simple affair. This supposition is confirmed by the recent discovery in the Correr Museum, by Dr. Terisio Pignatti, of a *camera ottica* which almost certainly belonged to Canaletto. This consists of a square wooden box, in one side of which is a lens, so mounted that it can be pushed in or pulled out for focusing. The image is thrown on to a mirror and reflected into a piece of ground glass set in the top of the box, the hinged lid of which covers the glass, and can be lifted. On the outside of this lid is the inscription *A. Canal*. Hadeln's view, tentatively supported by Parker, that the *camera ottica* was used for the diagrammatic drawings described above is untenable, since in these there is none of the distortions which are apt to mark the use of a lens, while the conventions of linear perspective are sometimes disregarded in order to make the diagram clear. By experimenting with the apparatus described above Dr. Pignatti has established the probable relation between the diagrammatic drawings and the use of the *camera ottica*. With the panorama recorded on pp. 41r to 45v in the Sketch-book (a view of the Entrance to the Grand Canal) he has compared a tracing of the same view, as seen on the screen of the *camera ottica*. The drawing differs considerably from the tracing in the proportions and spacing of the buildings, and in many details; and on the basis of this and other similar tests, Dr. Pignatti holds that the sketch-book drawings were not made with the help of the *camera ottica*, though this may sometimes have been employed to determine the extent of a view to be included in a drawing, in the same way as a masked piece of glass or a rectangular opening in a piece of cardboard.[1] [Giosefi, in his 1959 monograph, tried to demonstrate that Canaletto used the *camera ottica* for a number of his sketches in the Accademia sketchbook— unsuccessfully, in the opinion of the present editor who has found no evidence of the use of a camera and, indeed, doubts whether a painting or drawing *could* betray such use. 'Exaggerated foreshortening' or a 'wide angle appearance', sometimes quoted to establish the use of a camera in, for example, nos. 198, 537, 538, and 547, seem, by the failure of these

[1] For a detailed account of the comparisons, see Pignatti, *Il Quaderno di Disegni del Canaletto alle Gallerie di Venezia*, pp. 20–22.

pictures to record the facts, evidence in the opposite direction. However, it is reasonable to suppose that Canaletto occasionally found a camera useful for rough sketches which he no doubt destroyed.]

During the nineteenth century the view was widely held that sometimes the figures in Canaletto's paintings were put in by other hands, a favourite example quoted being *The Doge at the Scuola di S. Rocco*, the figures in which were ascribed to G. B. Tiepolo.[1] As noted elsewhere, Sack in his book on G. B. and G. D. Tiepolo carried this belief to its logical conclusion; for, recognizing that the whole of this particular picture must be by the same hand, he attributed it to G. B. Tiepolo.[2] That Tiepolo as a young man sometimes supplied the figures in other men's work is known from engravings;[3] but in the case of Canaletto's work there is no such evidence, and none of the early authorities (Orlandi, Marietti, Zanetti) refers to other painters putting in his figures. In view of the widespread practice of collaboration in the eighteenth century, it is difficult to prove a negative, Canaletto himself being concerned with Pittoni, Piazzetta, and Cimaroli in jointly producing two of the 'Tomb' paintings planned by Owen McSwiney. Yet if Canaletto's figures in his earlier paintings are studied, notably those in the six large ones at Windsor, it seems clear that the figures in *The Doge at the Scuola di S. Rocco*, which is the test case, are a direct development from earlier practice, differences being due only to painting in a higher key and to more calligraphic handling of paint, which marked all his work at the time.

A more difficult problem is the extent to which Canaletto used assistants. A prevalent idea is that he had a large workshop; but analysis of work by or attributed to him does not entirely favour this. A large proportion of work called School of Canaletto is evidently not by immediate followers but by imitators who often reflect other influences, notably those of Marieschi and Guardi. The main link between them and Canaletto is that of subject, which they could easily imitate from engravings, without access to originals,

[1] Cf. Moschini, *Della Letteratura Veneziana*, Venice, 1806, iii. 76; Bottari-Ticozzi, *Lettere Artistiche*. 1822, vii. 441 sqq.; Lanzi, *Storia Pittorica della Italia*, ii, 1793–6, 225; Zanotto, *Pinacoteca della Imp. Reg. Accademia Veneta*, Venice, 1832. [2] See p. 113, n. 2 above.

[3] Cf. the series of thirty-six etchings by Giampeccoli after Marco Ricci which are described on the title-page as having had the figures added by Tiepolo, while individual etchings are inscribed: *Io. Bapt: Theupolus Fig: addidit.*

in the form of either paintings or drawings. It may be objected that, even if
the work of these imitators is subtracted, the bulk of work attributed to
Canaletto is too great for one man to produce without a considerable
number of assistants. But it should be remembered that Canaletto's career
as an artist extended over nearly fifty years; and that much of his work
is of a type which could be produced rapidly and on mass-production
lines.[1] This is not to say, however, that assistants were not sometimes em-
ployed. In a fair number of paintings, mainly of the middle and late thirties
when Canaletto was apparently most active, it is possible to see evidence of
another hand than that of Canaletto having been at work; and F. J. B.
Watson has suggested that the notes on the diagrammatic drawings were
intended as an aid to assistants. But there is no stylistic or other evidence
to suggest whose hand was at work. The most likely candidate is Bellotto.
He would have been old enough in the middle and late thirties to work
in his uncle's studio, and his work painted in Italy has many resemblances in
style to that of Canaletto. Moreover, that he had free access to material in
his uncle's studio is shown by his copies and adaptations from Canaletto's
drawings in the early forties (see pp. 125, 133). The suggestion that Guardi
was similarly employed (see Watson, p. 12) seems much less probable.
Gradenigo (*Diary*, 25 April 1764) refers to him as 'buon Scolaro del rino-
mato Canaletto'; but whether this means he worked in Canaletto's studio
is not clear. In any case Guardi was not available as an assistant in the thirties,
since apparently he did not take up the painting of views until about 1760,
after his brother's death. Then he was undoubtedly influenced by Canaletto;
but he took as his model Canaletto's early work, and not that of the sixties,
which he would be likely to have taken if he was working in the studio.
Dates would allow Michele Marieschi to have been an assistant, and un-
doubtedly he owed much to Canaletto; but there is no sign of his charac-
teristic touch in Canaletto's work at the crucial period. Other possibilities
are G. B. Moretti and Visentini. In the few known examples of his work,

[1] Only thirty years ago the writer visited the studio of an Italian view-painter, who was working
on twenty paintings at the same time, first putting in all the skies, then the main masses of the fore-
ground, and so on, using the same colours in each case. This may well be the way Canaletto sometimes
worked. Incidentally the paintings were of considerable merit.

notably an architectural piece in the Accademia, Venice, Moretti is nearer to Canaletto in his drawing than any other painter; and he apparently copied work by Canaletto for engravers. Visentini, again, was thoroughly familiar with Canaletto's work, and in his known paintings handles his material in somewhat the same manner. There is also the mysterious Guerra (see no. 518), with whom Canaletto collaborated. Lastly, Cimaroli must be taken into account. He had worked with Canaletto on the McSwiney 'Tombs', and by tradition collaborated with him in a *Bull-fight in the Piazza S. Marco,* painted considerably later; which suggests the possibility of a continuing association over some years.[1]

<p align="center">★　★　★　★　★</p>

Of the known and indubitable works by Canaletto only twenty-five paintings and nine drawings are certainly signed, a small number compared with the amount of his production. Most of the signatures are to be found on work of the forties.

In form, they vary. The simplest are A. C. F., on the *Piazza S. Marco looking South-east* and *The Entrance to the Grand Canal,* both in the National Gallery, Washington, and both painted in the thirties (nos. 50 and 154); A. C. on *A View of a City* (no. 787: British Museum) dated 1741; and A. C. on *A Sluice on a River* (no. 475) dated 1754. *A. Canal* is used on two views of Venice dated 1743, *The Piazzetta looking North* and *The Molo looking West* (nos. 68 and 85, both at Windsor); *A. Canal* with the *A.* and *C.* in monogram on *Entrance to the Grand Canal looking East* (no. 174: Windsor); on four capricci at Windsor, belonging to the set of over-doors painted for Joseph Smith, one (no. 451) dated 1743, another (no. 452) dated 1744, the others (nos. 457 and 462) not being dated but certainly painted 1743-4; and on a *Capriccio with S. Francesco della Vigna* (no. 460: private collection, Italy) dated 1744.

The form ANT. CANAL, with FECIT added, appears on a group of Roman subjects at Windsor, *Ruins of the Forum* (no. 378), *Arch of Constantine* (no. 382), *Arch of Septimius Severus* (no. 384), the *Arch of Titus* (no. 386), and the *Pantheon* (no. 390), all dated 1742; a drawing, *Houses and Gardens on*

[1] [W. G. Constable's lack of support for the generally held view that Canaletto maintained a 'studio' of assistants is repeated in the Canada, 1964/5 catalogue, introduction.]

a River (no. 695: Fogg Art Museum), dated 1742; *The Colosseum* (no. 387: Windsor) dated 1743; and as *Ant. Canal* on *The Piazza S. Marco looking South* (no. 48: Windsor) and *The Rialto Bridge from the South* (no. 228: unknown owner) both dated 1744.

A variation of this form is ANTO. C. used on two capricci at Windsor, one based on the Scala dei Giganti, the other including the Colleoni Monument (nos. 455 and 476), both dated 1744.

The use of the full name is rare. *Antonio Canale* is written on the back of a drawing at Windsor (no. 678: *View from the Ramparts at Padua*); and is also the probable form of the signature on the *Capriccio with Roman Ruins* (no. 477: owner unknown) which reads ANTONIO CANALETO, but with the 'TO' clearly added. Judging from the spacing, *Antonio Canale* may have been the form of the signature on the *Colonnade and Courtyard* (no. 509) in the Accademia, dated 1765. Also, in the inscription on the back of *A Pavilion with a Ruined Arcade* (Morrison: no. 512), as transcribed on to the lining canvas, the form *Io Antonio Canaleto* is used.

Rare also is the use of 'Canaletto'. This appears in the form *Ant° Canaleto* on *The Arch of Constantine* (no. 383: private collection), dating from the early forties, and on the *Capriccio with Reminiscences of Rome and Vicenza* (no. 479: private collection). It also appears, combined with the full name, in the inscriptions transcribed from those on the back of two paintings which belonged to Hollis (*Ranelagh*, no. 420; *Old Walton Bridge*, no. 441), in the forms *Antonio del Canal detto il Canaletto* and *Antonio Canal detto il Canaletto*.

On drawings other than those already mentioned, the signature is incorporated in inscriptions in Canaletto's hand, mainly on late drawings, and takes different forms. *Io Zuane Antonio da Canal Ho fatto*, &c., appears on *S. Marco: the Crossing and North Transept*, a late drawing (Hamburg, no. 558) dated 1766; and is elaborated into *Io Zuane Antonio da Canal detto* (or *deto*) *il Canaletto* (or *Canaleto*) on three others (*The Campanile under Repair*, under no. 552; *Padua: Houses*, no. 691; *Capriccio with Westminster Bridge*, no. 786). This second form is simplified to *Antonio Canal il Canaleto* in the *Old Walton Bridge*, no. 755.

On a number of drawings, such as the series of Roman subjects in the

British Museum (no. 713), a capriccio belonging to Mrs. Brackley (no. 826), *S. Giacomo di Rialto* in the Seilern Collection (no. 611), and the so-called *Palazzo Gradenigo* in the British Museum (no. 628), Canaletto's name is inscribed between the lower margin of the drawing and an enclosing line, in the form *Antonio Canal del.* Whether this can be regarded as a signature is doubtful. It may have been written by Canaletto, though it is not recognizably in his handwriting; and it seems rather in the nature of an instruction to a possible engraver.

A type of signature peculiar to Canaletto is the introduction into the composition of a shield carrying a chevron, the coat of arms of the Canal family (see Chapter I).[1] Often this shield takes the form of a cartouche on some building. This appears in four etchings (P.–G. 2, 11, 13, 23; see Vol. II, sec. D) and on two paintings, the *Capriccio with the Scala dei Giganti* (Windsor: no. 455) and *A Triumphal Arch seen from the Portico of a Palace* (Norfolk: no. 506), the first-named carrying an ordinary signature also. For the most part, however, the chevron is found on drawings, eleven examples being known. Of these, one is *The Piazza delle Erbe, Padua* (Windsor: no. 688), another is *The Temple of Venus and Rome* (Windsor: no. 720), and the remainder are capricci. On one of these, *Courtyard with a Portico* (Mrs. Brackley: no. 826), the shield with a chevron appears three times. The etchings and at least one of the paintings and most of the drawings belong to the earlier forties, which seems to be the period when Canaletto most favoured the use of the device.[2]

[1] This was first noticed by Alexandre de Vesme and published in *Le Peintre-Graveur italien* in 1906 [pointed out by Michael Levey, *Burl. Mag.*, 1962, p. 268].

[2] [To the above must be added: *Ant. Canal fecit* on *Piazza S. Marco looking West* (no. 37: Windsor), also *looking East* (no. 16*, Leger Galleries); *Io Antonio Canal, detto il Canalletto, fecit. 1763* on *Piazza S. Marco looking South and West* (no. 54*: Wengraf); *Io Zua. Antonio Canal, detto il Canaleto, fecit* on *The Fondamente Nuove* (no. 321: formerly Dr Katz); *Antonio Canal fecit* said to have been on the back of *Piazza S. Marco; looking South* (no. 47: Fitzwilliam Museum, a late work). More doubtfully: *Antonio Canal Pitor/Venezia 1722* on *The Molo: looking West* (no. 85(f): Stein); *Io. Antonio Canal 1723* on *Capriccio with Ruins* (no. 479**: Milan); *A. Canale 1719* on *Temple of Antoninus and Faustina* (no. 381*: Budapest). The inscription on the *Campanile under Repair* (under no. 552: formerly New York) must now be regarded as spurious. Illustrations of a number of signatures and inscriptions will be found on Pls. 253–4.]

APPENDIXES

I. DOCUMENTS CONCERNING FOUR PAINTINGS MADE FOR STEFANO CONTI OF LUCCA

A di 2 Agosto 1725 Venetia

Ricevo Io Sotto schritto dal Sig' Alesandro Marchesini Cechini dieci Cechini a nome del Ill^{mo} Sig': Steffano Conti a Conto di due quadri di vedute che li devo fare di quarte n° 8 è alti n° 5 in Sei, e questi acordatti Col sudetto Sig' Marchesini in cechini Venti per Siascheduno Limitendo alla buna cognitione del Sud° Cava^r la diferenza dalli 20 alli 25 come era le mie pretese in fede di che

Ci mia propia Mano Io Antonio Canal

A di 25 Novembre 1725 Venetia[1]

Dichiaro con la presente mia sottoscrita e atesto aver dipinto due quadri di vedute di Venetia del Canal Grande, sopra due telle di lungezza quarte otto e Meza et per altezza quarte cinque e Meza, Nella prima il Ponte di rialto dalla parte che guarda verso il Fontico de Todeschi, che resta dimpeto la Fabrica de Magistrati de Camerlenghi; et altri piu Magistratti con altre fabriche uicine che si adimanda dell' erbaria, dove sbarca ogni sorte derbazi e frutami per dispensare alle arti per la Città, nella Mettà del Canale e dipinto una Peotta nobile con figure entro con quatro gondolieri che va scorendo et pocco vicina una gondola a livrea del Ambassiator del'Imperator, Nel secondo quadro continuando l'istesso Canale che si adimanda le Fabriche sino le pescherie, il Palazzo Pesaro e nel fondi il campanile di S. Marcola. dall'altra parte del Canalle che vicino il Palazzo di Ca' Grimani e continua altri Pallazi ciovè Rezonico e Sagredo e molti altri. Per il prezzo delli due sudetti quadri mi fu ordinatti e pagatti dal Sig': Alessandro Marchesini per ordine e comissione dell Ill^{mo} Sig': Steffano Conti di Lucca in Cechini trenta per cadanno con la riserva & & li cechini presentemente Valle lire ventidue suno per cio tengo in comissione per altri due della stessa misura et Listesso prezzo che devo farli, e tanto farò Listesso Atestatto per li due altri susseguenti. e per Segno di autentica verità, e Giuramento di mia Mano Mi Sotto Schrivo

Io Antonio Canal Venetiano

La sudd^a riserva circa il prezzo significa che ne pretende qualche cosa di piu p[?] regalo

[1] See Plate I.

APPENDIX I

A di 22 Decembre 1725 Venetia

Riceuto Io Sotto schrito Del Sig': Alesandro Marchesini per Comissione Del Il^{mo} Sig': Stefano Conti Cechini Dieci e questi li o riceputi per Capara de altri due quadri della istessa Misura e Grandeza. delli Altri due antecedenti fatti e Spediti Al Sude.^{to} Il^{mo} Sig̅ Conti in Fede di cio mi Sotto Schrivo

<div align="right">Io Antonio Canal Venetiano</div>

A di 15 Giugno 1726 Venetia

Dichiaro con la presente Io sottoscrito aver fatto altri due quadri di vedute p L'Ill^{mo} Sig: Stefano Conti di Lucca della stessa grandezza dell'altre due che feci L'anno antecedente e queste o fatto in una la Veduta della Chiesa di Sa^{to} Giovani e Paolo con il Campo e la Statua á Cavalo del General Bortolam° da Bergamo et altre figure varie cioé un Conselier in vesta rossa che in atto d'andar in chiesa altro fratte della religion Dominicana con altre figurine diverse.

Nel Secondo la Veduta della Chiesa de P.P. della Carità Rochetini con la sua Piazza dove o ripartido molte figurine fra le quali in un grupeto di tre fegurine nel mezo del campo vi Sono due padri della medema Religione, che discore con un Savio in Vesta pavonaza. Nel orizonte in fondi al canal vi e parte della Riva de Schiavoni. La Cupola che si vede sonno La principale della chiesa della Salute che continua la sua fondamenta sino alla Doana da Mar in Fede di che schrissi di Mano propia

<div align="right">Io Antonio Canal Pitor</div>

A di 15 Giugno 1726 Venetia

Oltre li quatro quadri acordati in cechini Otanta O Riceputo dal Sig' Alesandro Marchesini altri cechini dieci che L'Ill^{mo} Sig' Stefano Conti mi dona per Regalo in agiunta Delli Sopra Schriti quadri in Fede di che di mano propia mi Sotto schrivo

<div align="right">Io Antonio Canal</div>

II. LETTERS FROM OWEN McSWINEY TO LORD MARCH (LATER SECOND DUKE OF RICHMOND) CONTAINING REFERENCES TO CANALETTO[1]

Venice, 8 March 1722

GIVES information about the fifteen decorative pictures he has commissioned for Lord March, each representing an imaginary tomb of a famous English personage.

'That of L^d Sommers is a sacrifice or Religious Ceremony (at his monument) in acknowledg^mt of the service done the Church, for his pleading the cause of the Bishops, etc. The perspective and lands^cpe are painted by *Canaletto* & *Cimeroli* The figures by *Geo. Battista Piacotta*.' ★ ★ ★ ★ ★ ★ ★ ★ ★ ★ ★ ★ ★ ★

'A Bishop Tillotson's perspective and landscape (finished) by *Canaletto* and *Cimaroli*. Figures (now painting) by *Jean Battista Pittoni*.'

Venice, 4 October 1726

'The pictures to A Bishop Tillotson and Lord Stanhope are just upon the points of being finished (and excellently well too) and as soon as the Chiaro Scuros can be done I'll forward 'em to Yr Grace.'

Venice, 11 October 1726

(Postscript)

'The two pictures of L^d Stanhope and Bishop Tillotson are finished, and as soon as I can get the Chiaro Scuro's done I'll forward 'em to Y^r Grace.'

Venice, 1 November 1726

'Mr. Graham writes me word from Bologna, that The Figures in that to Lord Stanhope, are perfectly well done by Sig^nr Francesco Monti: and that to Bishop Tillotson is finely finished by Sig^nr Pittoni, who did that to Lord Dorset etc. As soon as the Chiaro Scuro's are done, I'll forward 'em to y^r Grace.'

Venice, 28 November 1727

'I shall have *the two* (dedicated to the memorys' of the Earls' Cadogan and Godolphin) next week, as they write me from Bologna etc. I shall send 'em from hence (by the first opportunity) together with that to the memory of A. Bishop Tillotson (w^ch

[1] I am greatly indebted to the late Duke of Richmond for allowing me to transcribe these letters and giving permission to publish them.

is exceedingly well done) so that you'l want but one, besides the large one to K. William etc. to compleat your apartment at Goodwood. ★ ★ ★ ★ ★ ★ ★ ★.

The pieces which Mr. Southwell has, (of Canals painting) were done for me, and they cost me *70 sequeens*. The fellow is whimsical and vary's his prices every day: and he that has a mind to have any of his work, must not seem to be too fond of it, for he'l be ye worse treated for it, both in the price and the painting too. He has more work than he can doe, in any reasonable time, and well: but by the assistance of a particular friend of his, I get once in two months a piece sketch'd out and a little time after finished, by force of bribery.

I send yr Grace by Captain Robinson (Commandr of the Tokeley Gally) who sails from hence tomorrow, *Two of the Finest pieces*, I think he ever painted and of the same size with Mr. Southwells little ones (which is a size he excells in) and are done upon copper plates: *They cost me two and twenty sequeens* each. They'l be delivered to yr Grace by Mr. John Smith, as soon as they arrive in London. ★ ★ ★ ★ ★ ★

I shall have a view of the Rialto Bridge, done by Canal in twenty days, and I have bespoke another view of Venice for by the by, his Excellence lyes in painting things which fall imediately under his eye.

The four pieces of Canal come to *88 sequeens* and the Rosalba etc. to 24 which comes to about *Fifty six Guineas sterling* and if your Grace will permit me to charge four Guineas more for the Freight, and expences in packing 'em up and sending 'em on board wth ye Customs etc. and some former expences of the same nature, the same will amount to six guineas wch I'll draw for as at twice as yr Grace desires.'

Venice, 5 December 1727

'I shall forward 'em to you, by the first ship, that sails from hence, for London, together with that, to the memory of A. B. Tillotson. ★ ★ ★ ★ ★ ★ ★ ★.

The two copper plates done by *Canal* are very fine: I told you in my last Lettr that I forwarded 'em, to Mr. John Smith, in London.'

Venice, 16 January 1727 (*O.S.*)

'That it please yr Grace

The three pictures (to the memorys' of Earls' Cadogan, Godolphin and A. Bishop Tillotson) are cased up; and lye ready to be embarqued, on board the first ship, that sails from hence, for London. That is if the news, from London, gives us any hopes of an accomodation, with Spain: for I shou'd be sorry that these pictures met with the same fate, that yr picture by Rosalba did: therefore I shall take my measures about 'em from the advices, in the following Gazettes and Canaletto has, just, finished the piece of the Rialto Bridge, and as soon as it's companion is done, I'll forward 'em to you wth that of The Country Girle, by *Rosalba*.'

Venice, 13 February 1727 (O.S.)

'Y^r three pictures (to the Memorys' of Earls' Cadogan, Godolphin and Bishop Tillotson) will be put on board Capt^n Ambrose Wade of the Chandois (who has the Hon^r to be known to y^r Grace) that is, if the news from London, next week, gives me encourage^mt to put 'em on board him. In all probability he'l be in London by the latter end of April, so that y^r pictures will be placed in y^r appart^mt at Goodwood, before you retire into the country.

I hope you'l like these pieces, as well as the small ones done by Canaletto, which I sent above two months agoe, on board Captain Robinson.

Y^r German Girle, (done by Rosalba) and the other two pieces of Canaletto, I'll send, by the first opportunity.'

Venice, 27 February 1727 (O.S.)

'May it please y^r Grace,

Two days agoe, sailed from hence, for London, Capt. Ambrose Wade, on board the Chandois Frigatter. He has promised me to take particular care of a box directed for you in which, are, Three pictures to y^e, memory's of Earls' Cadogan and Godolphin and A. Bishop Tillotson. ★ ★ ★ ★ ★ ★ ★ ★ ★ ★ ★ ★ ★ ★ ★.

In a few days after you receive this, in all probability Capt^n Robinson will be arrived. He has two pictures done for y^r Grace by Canaletto.'

Venice, 18 June 1728

'My businesse at present, is to let your Grace know that there are five most beautifull closet pieces to be disposed of

Two of Canaletto	30 Zechines
Two of Carpioni	40
and one	
of Padouanino	30'

Venice, 30 July 1728

'I long to hear how you like y^e Three pieces (to y^e memorys' of Earls' Cadogan and Godolphin and B. Tillotson) which I sent you by Capt. Wade as likewise y^e *copper plates* by Canaletto, w^ch you rec^d before.

The German Girle (by Rosalba) is finished, but I wait for y^e companion (to a copper plate) which Canaletto is now, about, for you: as soon as I get it, out of his hands, I'll forward 'em all to you.'

Venice, 1 October 1729

'The remaining two copper plates of Canaletto *which two pieces* w^th y^t of *Rosalba's,* I acknowledge to have rec^d y^e value of several months' agoe.

Canaletto promises me to let me have 'em on my return from Rome, which will be about the middle of January.'

III. DOCUMENTS RELATING TO THE FUNERAL AND ESTATE OF CANALETTO

FUNERAL EXPENSES OF CANALETTO

Adi 20 Maggio 1768—Venezia

Spese fatte per il Funeral del quondam Antonio Canal ed altre spese come da Ricepute tutte Volanti.

Spesi nel Funeral in tutto senza Messe come da ricepute . . .	L. 687: 10
Più per Messe n° 14 come da riceputa	L. 28:–
Più per Suplemento a dette del Sovegno S. Gaetano S. Fantin come riceputa	L. 25:–
Più la Messa S. Veneranda	L. 4: 12
Più per debito incontrato dal quondam sudetto di Zecchini n° 13 .	L. 286:–
Più Contati all'Eccellente Medico come riceputa . . .	L. 12: 8
Più al Spicier da Medicine come da Conto saldato in contanti .	L. 4: 17
	L.1028:–7[1]

R. Archivio di Stato—Venezia

Inquisitorato alle Acque—Busta 167

Calcoli intestati—Fascicolo 71

THE ESTATE OF CANALETTO

I

L'Illustrissimo, et Eccellentissimo Segretario

Alvise Contarini Primo Cavalier

Aggiunto Inquisitor

Manco a' vivi senza Testamento il quondam Antonio Canal, per il che succedono alla di lui Eredità tre di lui sorelle, Fiorenza vedova, Viena, e Francesca nubili Dottande.

Prodotte, e giurate le notte, ed Inventari comprensive la facoltà tutta lasciata dal

[1] The total given in the document, but incorrect.

Deffonto Antonio Canal furono dall'Eccellente Segretario Inquisitor esaminate, indi comandò l'estesa del seguente conteggio:

Facoltà			Diffalchi		
Contanti	Ducati	283:–	Spese	Ducati	166:–
Mobili	,,	50:–	Dotte alle due		
Argenti e Gioie	,,	105:11	Sorelle nubili	,,	1200:–
Capitale	,,	2150:–		Ducati	1366:–
	Ducati	2588:11			
Diffalchi	Ducati	1366:–			

Ducati 1222:11 per qualli a' 5 per cento rendite debite in valuta corrente Ducati 73:8. In Ducati settatatre grossi 8 valuta corrente viene l'Eccellente Segretario Inquisitor a stabilire il pubblico credito per le 5 per cento per l'Eredita sudette dal quondam Antonio Canal e sarà da' ministri a' qualli spetta apportate il Debito, intanto ecc.

Datta dell'Inquisitorato all'Acque li 27 Maggio 1768
(firmato) Alvise Contarini Primo Cavalier Aggiunto Inquisitor

R. Archivio di Stato—Venezia
Inquisitorato alle Acque—Busta 167
Calcoli intestati—Fascicolo 71

II

Adi 14 Maggio 1768—Venezia

Inventario di quanto ha lasciato il quondam Antonio Canal quondam Bernardo di sua proprietà.

Quadretti Mezzanelli, e Picoli n° 28
Letto Picolo da una Persona con due Stramazzi, Pagliazzo, tavole e Cavaletti
 d'albeo, due Coperte, una Imbotida, altra filsada tutto Vecchio . . n° 1
Giridon al Letto Sudetto di Noghera n° 1

–Biancheria–

Pera Linzoli canevina n° 4
Camise Vecchie n° 8
Comesso Fustagno n° 1
Calce vecchie bianche di Bombazo, e acce pera n° 6
Dette di Stame coloride, pera n° 2
Barette da notte bianche n° 5

Intimelle n° 4
Fasciolli n° 5
Crovatte n° 6

–Drappi–

Codegugno retento vecchio n° 1
Velada Pano scuro e Camisiola Scarlato vecchio n° 2
Bragoni veludo vecchio nero n° 2
Roclor Scarlato Vecchio n° 2
Velada Pano mischio vecchia n° 1
Camisiola Carè con Gallonsin d'oro antica n° 1
Roclor cambeloto d'ingiltera vecchio n° 1
Detto altro vecchio n° 1
Tabaro vecchissimo Scarlato n° 1
Giamberluco Pano Verde vecchio n° 1
Codegugno e Bragon di Telle vecchia n° 1
Capelli vecchi n° 2

–Argenti e Soldi–

Possade n° 4 il tutto stimato
Annelli n° 3 come da stime in
Scatola d'argento . . . n° 1 effettivi . . . Ducati 105 grossi 11
Più Zecchini . . . n° 103 in oro, argento e
 monetta, in effettivi Ducati 283 grossi 6
Più Capitale in Zecca di Ducati effettivi „ 1666 grossi 6
 Ducati 2054 grossi 23

Adi 27 Maggio 1768

Attesto con mio Giuramento Io Sottoscritta Sorella e Coerede della quondam Antonio Canal, contener le presenti notte, ed Inventarii la Facoltà tutta lasciata dalla quondam Sudetta nè oltre altro esservi, nè saper che altro vi sia.
Io Francesca Canal Afermo

Riprodotto per la Sudetta e giurò giusto le Leggi
(firmato) Alvise Contarini Primo Cavalier Aggiunto Inquisitor
R. Archivio di Stato—Venezia
Inquisitorato alla Acque—Busta 167
Calcoli intestati—Fascicolo 71

SELECT BIBLIOGRAPHY

THE following list gives the more important sources of information consulted. Additional references concerned with particular episodes and places or with individual paintings, drawings, and engravings are given in the text. A separate bibliography is included in the section on the etchings. Many of the titles are abbreviated in the text.

I. CONTEMPORARY DOCUMENTS

For those consulted in the Archivio di Stato, Venice, and in Rome, see Chapter I. Others are contained in

ALGAROTTI, FRANCESCO, *Opere*, 17 vols. Venice, 1791–4. Vol. viii. 89.

BOTTARI, G., and TICOZZI, S., *Raccolta di Lettere sulla pittura*, vii. 427. Milan, 1822–5.

GRADENIGO, PIETRO, *Notatori*. See Livan.

LIVAN, LINA (Ed.), *Notizie d'Arte tratte dei Notatori e dagli Annali del N. H. Pietro Gradenigo*. Venice, 1942. (Review by F. J. B. Watson, *Burl. Mag.*, July 1948.)

McSWINEY, OWEN, *Letters to the second Duke of Richmond*. Goodwood Archives. Published in part by Mrs. Finberg, Walpole Society ix (1920–1).

MOSCHINI, GIANNANTONIO, *Elenco di nomi di Artisti ascritti alle Fraglie dei Pittori*. MS. in library of Museo Correr, copied from originals which have disappeared (cf. Nicoletti, *Per la Storia dell'Arte Venezia*, in Ateneo Veneto, Nov.–Dec. 1890).

VERTUE, GEORGE, *Notebooks*. Original MSS. in British Museum. Published Walpole Society, London, 1929–30 to 1948–50. Six volumes, with index. (Refs. to Canaletto in vol. iii, 1933–4.)

See also below under Chaloner and Constable (*Some Unpublished Canalettos*). For documents relating to Joseph Smith see below under Parker and Blunt and Croft-Murray.

II. WRITINGS BY CONTEMPORARIES

MARIETTE, PIERRE JEAN, *Abécédario*. Ed. Ph. de Chennevières et A. de Montaiglon in *Archives de l'Art Français*, Paris, 1851–60.

ORLANDI, PELLEGRINO ANTONIO, *Abecedario Pittorico* (with additions by G. P. Guarienti). Venice, 1753.

ZANETTI, ANTONIO MARIA, *Della Pittura Veneziana e delle Opere Pubbliche dei Veneziani Maestri*. Venice, 1771. (1st edit.: 2nd edit. 1792).

III. LATER WRITINGS

ASHBY, THOMAS and CONSTABLE, W. G., 'Canaletto and Bellotto in Rome', *Burl. Mag.*, May, 207, and June, 288, 1925.

BERENSON, BERNHARD, *Venetian Painters of the Renaissance*. New York and London, 1894. (Editions of 1932 and 1936 omit lists of eighteenth-century painters.)

BLUNT, ANTHONY, and CROFT-MURRAY, EDWARD, *Venetian Drawings of the XVII & XVIII Centuries in the collection of Her Majesty the Queen*. London, 1957. (Contains much original material.)

CHALONER, W. H., 'The Egertons in Italy and the Netherlands, 1729–1734', *Bulletin of the John Rylands Library*, Mar. 1950, 157. (Previously unpublished letters from Joseph Smith concerning Canaletto.)

CICOGNA, E. A., *Delle Iscrizioni Veneziane*, Vol. v. Venice, 1842. (Biography, list of works, bibliography. Compilation from other sources, and not always reliable.)

CONSTABLE, W. G., 'Canaletto and Guardi', *Burl. Mag.*, Dec. 1921, 298.

—— 'Some Unpublished Canalettos', *Burl. Mag.*, June 1923, 278 (includes transcriptions of documents in Canaletto's hand describing paintings in the Pillow collection).

—— 'Canaletto in England: some further work', *Burl. Mag.*, Jan. 1927, 17.

—— 'Canaletto at the Magnasco Society, *Burl. Mag.*, July 1929, 46.

—— 'Four Paintings by Antonio Canal in the Gymnasium zum Grauen Kloster, Berlin', in *Scritti di Storia dell' Arte in onore di Lionello Venturi*. Rome, 1956.

CUST, LIONEL, 'Notes on Pictures in the Royal Collections', *Burl. Mag.*, June 1913, 150, Aug. 267 (includes Joseph Smith's catalogue of his paintings bought by George III).

DAMERINI, G., *I Pittori Veneziani in 1700*. Bologna, 1928.

DONZELLI, CARLO, *I Pittori Veneti del Settecento*. Florence, 1957. (Systematic: good bibliographies.)

FEDERICI, DOMENICO MARIA, *Memorie Trevigiane*, 2 vols. Venice, 1803. (Vol. ii has references to Canaletto.)

FERRARI, GIULIO, *I due Canaletto*. Turin, 1914. (Mainly reproductions. Bibliography.)

FINBERG, HILDA F., *Canaletto in England*. Walpole Society, London, ix (1920–1), 21; ibid. x (1921–2), Supplement.

—— 'Joseph Baudin, imitator of Canaletto', *Burl. Mag.*, April 1932, 204.

—— 'The Lovelace Canalettos,' *Burl. Mag.*, Feb. 1939, 69.

FIOCCO, GIUSEPPE, *Venetian Painting of the Seicento and Settecento*. Florence and Paris, 1929.

—— 'Giovanni Richter', *L'Arte*, Jan. 1932, 3.

FOGOLARI, GINO, 'L'Accademia Veneziana di Pittura e Scoltura del Settecento', *L'Arte*, 1913, 241–72, 364–94. (References to Canaletto few but important.)

FRITZSCHE, H. A., *Bernardo Belotto genannt Canaletto*. Burg b. Magdeburg, 1936.

GALLO, RODOLFO, *L'Incisione nel '700 a Venezia e a Bassano*. Venice, 1941.

—— 'Canaletto, Guardi, Brustolon', in *Atti dell'Istituto Veneto di Scienze, Lettere ed Arti*, Venice, 1956–7.

HADELN, BARON DETLEV VON, 'Some Drawings by Canaletto', *Burl. Mag.*, Dec. 1926, 310.

—— *Die Zeichnungen von Antonio Canal genannt Canaletto*. Vienna, 1930. Eng. trans. by Campbell Dodgson, London, 1939. (Pioneer work.)

HASKELL, FRANCIS, 'Stefano Conti, Patron of Canaletto and others', *Burl. Mag.*, Sept. 1956, 296. (Previously unpublished letters to Conti from A. Marchesini.)

HAYES, JOHN, 'Parliament Street and Canaletto's Views of Whitehall', *Burl. Mag.*, Oct. 1958, 341.

LEVEY, MICHAEL, 'Canaletto's Regatta Paintings', *Burl. Mag.*, Nov. 1953, 365.

LORENZETTI, C., *Gaspare Vanvitelli*. Milan, 1934.

LORENZETTI, GIULIO, *Venezia e il suo Estuario*. Venice, 1926. 2nd ed., Rome, 1956.

MAIER, JOHANN CHRISTOPH, *Beschreibung von Venedig*. Leipzig, 1795.

MAURONER, FABIO, 'Michiel Marieschi', *Print Collectors' Quarterly*, Apr. 1940.

—— *Luca Carlevaris*. Padua, 1945 (expansion, with many added illustrations of the 1931 edition).

MEYER, RUDOLF, *Die beiden Canaletto*, Dresden, 1878 (etched and engraved work).

MODIGLIANI, ETTORE, 'Settecento Veneziano nelle Raccolte Private Milanese', in *Strenna dell'Illustrazione Italiana*, 1924–5.

MOLMENTI, POMPEO, *La Storia di Venezia nella vita privata*, 3 vols. Bergamo, 1905–8. Vol. iii. Trans. H. F. Brown, London, 1906–8.

MORASSI, ANTONIO, 'Problems of Chronology and Perspective in the work of Canaletto', *Burl. Mag.*, Nov. 1955, 349.

MOSCHINI, GIANNANTONIO, *Della Letteratura Veneziana del Secolo XVIII*, 4 vols. Venice, 1806–8. (Vol. iii has many references to art and artists, often inaccurate.)

—— *Dell'Incisione in Venezia*. Venice, 1924 (from a MS. in the Correr Museum).

MOSCHINI, VITTORIO, *Canaletto*. Milan, 1954. (Very fully illustrated, with excellent bibliography.)

MOUREAU, ADRIEN, *Antonio Canal dit le Canaletto*. Paris, 1894. (Slight and ill-informed.)

NICOLETTI, G., 'Lista di nomi d'artisti tolta dei libri di tanse o liminarie delle Fraglie dei Pittori', in *Ateneo Veneto*, 1890.

PALLUCCHINI, RODOLFO, *Canaletto e Guardi*. Novara, 1941 (also in *Primato*, 1941).

—— and GUARNATI, G. F., *Le Acqueforti del Canaletto*. Venice, 1945. (The most complete treatment.)

—— *La Pittura Veneziana del Settecento*. (Lectures given at the University of Bologna.) Part II. Bologna, 1952.

PARKER, K. T., *Drawings of Antonio Canaletto in the Collection of His Majesty the King at Windsor Castle*. Oxford and London, 1948. (Detailed catalogue, with every drawing illustrated. Introduction contains the best account of Joseph Smith.)

PIGNATTI, TERISIO, *Il Quaderno di disegni del Canaletto alle Gallerie di Venezia*, Milan, 1958. (Facsimile of the sketch book in the Accademia, with catalogue and commentary.)

PITTALUGA, MARIA, 'Le Acqueforti del Canaletto', *L'Arte*, July 1934.

—— *Acquefortisti Veneziani del Settecento*. Florence, 1953.

SEIDLITZ, W. VON, 'Canal, Antonio', in Thieme-Becker, *Künstler-Lexikon*, v, 1911.

SIMONSON, GEORGE A., 'Antonio Canal', *Burl. Mag.*, Jan. 1922, p. 36.

SIREN, OSVALD, *Dessins et Tableaux de la renaissance italienne dans les collections de Suède*. Stockholm, 1902 (includes letters from Count Tessin referring to Canaletto).

UZANNE, OCTAVE, *Les Deux Canaletto*. Paris, 1906. (Superficial and inaccurate.)

VESME, ALEXANDRE DE, *Le Peintre-Graveur Italien*. Milan, 1906. (Standard work.)

Voss, Hermann, 'Studien zur Venezianischen Vedutenmalerei des 18. Jahrhunderts', *Rep. für Kunstwissenschaft*, Bd. 47, 1926, Heft i, 1–44 (a pioneer article).

Watson, F. J. B., 'Notes on Canaletto and his engravers', *Burl. Mag.* 1950, i: Oct., 291; ii: Dec. 351.

—— 'Some Unpublished Canaletto Drawings of London', *Burl. Mag.*, Nov. 1950, 315.

—— 'G. B. Cimaroli: A Collaborator of Canaletto', *Burl. Mag.*, June 1953, 205.

—— 'A Group of Views of Lucca by Bellotto', *Burl. Mag.*, May 1953, 166.

—— 'An Allegorical Painting by Canaletto, Piazzetta, and Cimaroli', *Burl. Mag.*, Nov. 1953, 362.

—— *Canaletto*. London and New York, 1949. 2nd (revised) edition, 1954 (authoritative brief account with bibliography).

Whitley, William T., *Artists and their Friends in England, 1700–1799*. London, 1928. Vol. i (references to Canaletto in England).

Zimmermann, Heinrich, 'Über einige Bilder der Sammlung Streit im Grauen Kloster zu Berlin', *Zeitschrift für Kunstwissenschaft*, VIII, Berlin, 1954 (gives detailed contemporary accounts of four paintings by Canaletto).

IV. CATALOGUES OF EXHIBITIONS AND OF PUBLIC AND PRIVATE COLLECTIONS

(limited to those giving substantial information about important groups of work)

Baker, C. H. Collins, *Catalogue of the Principal Pictures in the Royal Collection at Windsor Castle*. London, 1937.

Benesch, Otto, *Venetian Drawings of the Eighteenth Century in America*. New York, 1947. (Reviews by Palluchini, *Arte Veneta*, 1948, 157; F. J. B. Watson, *Burl. Mag.*, June 1948, p. 182.)

Burlington Fine Arts Club, *Catalogue of a Collection of Early Drawings and Pictures of London*. Illus. ed., London, 1920.

Fiocco, Giuseppe, 'La Pittura Veneziana alla Mostra del Settecento', in *Rivista della Città di Venezia*, Aug.–Sept. 1929.

Levey, Michael, *National Gallery Catalogues: Eighteenth Century Italian Schools*. London, 1956.

Lorenzetti, Giulio, *Feste e Maschere Veneziane*. (Catalogue of exhibition at Ca Rezzonico, Venice, 1937.)

Magnasco Society, Sixth Loan Exhibition, *Catalogue of Oil Paintings and Drawings by Antonio Canal*. London, 1929.

Mostra del Paesaggio Veneziano del Settecento. At Palazzo Massimo alle Colonna, Rome, 1940.

Pallucchini, Rodolfo, *Mostra degli Incisioni Veneti del '700*. Venice, 1941 (with bibliography).

Petit Palais, *Exposition de l'Art Italien de Cimabue à Tiepolo*. Paris, 1935.

Popham, A. E., *Italian Drawings exhibited at the Royal Academy, Burlington House*. Oxford, 1931.

Posse, Hans, *Die Staatliche Gemäldegalerie zu Dresden: Die Romanischen Länder*. Dresden and Berlin, 1929.

Royal Academy, *The King's Pictures*. Catalogue of exhibition, London, 1946–7 (includes a large number of works by Canaletto from the Royal collection).

Royal Academy, *European Masters of the Eighteenth Century*. Catalogue of exhibition, London, 1954–5.

Scharf, George, *A Descriptive and Historical Catalogue of the Collection of Pictures at Woburn Abbey*. Privately printed, 1890.

Waagen, H., *Treasures of Art in Great Britain*. 3 vols. London, 1854.

—— *Galleries and Cabinets of Art in Great Britain*. London, 1857. (Supplement to *Treasures of Art*.)

Wallace Collection Catalogues, *Pictures and Drawings*. 15th ed. London, 1928.

(Watson, F. J. B.) *Eighteenth Century Venice*. Catalogue of an exhibition at the Whitechapel Art Gallery and the City Museum and Art Gallery, Birmingham, 1951.

The following is a list of exhibitions since 1960 together with abbreviations used in the text to refer to them.

A.C. 1968	Italian Drawings from the collection of Janos Scholz, Arts Council, 1968.
Canada, 1964/5	*Canaletto*. The Art Gallery of Toronto, 1964, The National Gallery of Canada and the Museum of Fine Arts, Montreal, 1965.
Guildhall, 1971	*London and the Greater Painters*, Guildhall Art Gallery, May–June 1971.
Heim, London, 1972	*Venetian Drawings of the Eighteenth Century*, Heim Gallery, London, Jan.–Feb. 1972.
Kenwood, 1966	*Life in XVIII Century Venice*, The Iveagh Bequest, Kenwood, London, 1966.
Marble Hill, 1968	*Views of the Thames from Greenwich to Windsor*, Marble Hill, Twickenham, 1968.
Mellon, New York, 1972	*English Drawings and Watercolours in the Mellon Collection*, Pierpoint Morgan Library, New York, 1972.
New York, 1971	*The Eighteenth Century in Italy*, Metropolitan Museum of Art (organized with the Pierpoint Morgan Library), 1971.
Paris, 1960	*La Peinture italienne au XVIIIᵉ siècle*, Petit Palais, Paris, 1960–1.
Paris, 1971	*Venise au dix-huitième siècle*, Orangerie des Tuileries, 1971.
Q.G. 1964	*Italian Art*, The Queen's Gallery, Buckingham Palace, 1964.
Q.G. 1974	*George III, Collector and Patron*, The Queen's Gallery, Buckingham Palace, 1974.
Venice, 1962	*Canaletto e Guardi*, Fondazione Giorgio Cini, San Giorgio Maggiore, Venice, 1962.
Venice, 1967	*I vedutisti veneziani del Settecento*, Venice, 1967.

APPENDIX: WORKS PUBLISHED SINCE 1958

BROMBERG, RUTH, *Canaletto's Etchings*, London, 1974.

Canaletto, The Masters series (no. 3), Purnell, London, 1965; Italian edition: I maestri del colore (no. 28), Milan, 1963.

CHIARELLI, RENZO, *I vedutisti veneziani*, Forma e Colore series, Florence, 1965 (for colour reproductions).

CONSTABLE, W. G., 'Canaletto as a Figure Painter', *Apollo*, Feb. 1964, p. 108.

CORBOZ, ANDRÉ, 'Sur la prétendue objectivité de Canaletto', *Arte Veneta* XXVIII, 1974, pp. 206–18 (also private communication).

FLEMING, JOHN, 'Art Dealing and the Risorgimento—I', *Burlington Magazine*, Jan. 1973.

GIOSEFI, DECIO, *Il quaderno delle gallerie veneziane e l'impiego della camera ottica*, Trieste, 1959.

HASKELL, FRANCIS, *Patrons and Painters*, London, 1963. (See, especially, Appendix 5, 'Consul Smith and the Royal Collection'.)

HAYES, JOHN, 'A Panorama of the City and South London by Robert Griffier', *Burlington Magazine*, 1965, p. 458.

KAINEN, JACOB, *The Etchings of Canaletto*, Washington, 1967.

KOZAKIEWICZ, STEFAN, *Bernardo Bellotto*, English edition translated by Mary Whittall, London, 1972, 2 vols.

LEVEY, MICHAEL, The Eighteenth-century Italian Painting Exhibition at Paris: some corrections and suggestions', *Burlington Magazine*, Apr. 1961, p. 139.

—— *Pictures in the Royal Collection, Later Italian Pictures*, London, 1964.

—— *National Gallery Catalogues: The Seventeenth and Eighteenth Century Italian Schools*, London, 1971. (References in the first edition of the present work were to the 1956 edition.)

LINKS, J. G., 'A Missing Canaletto Found', *Burlington Magazine*, Aug. 1967, p. 405.

—— 'Secrets of Venetian Topography (The Wrightsman Collection Canalettos)', *Apollo*, Sept. 1969, p. 222.

—— 'Some Notes on Visentini's Drawings for Prospectus Magni Canalis Venetiarum in the Correr Library', *Bollettino dei Musei Civici Veneziani*, 1969, no. 4, p. 3.

—— *Townscape Painting and Drawing*, London, 1972.

—— 'Bellotto Problems', *Apollo*, Jan. 1973, p. 107.

—— 'Canaletto at Home', *Burlington Magazine*, June, 1973, p. 390.

MARTIN, GREGORY, *Canaletto: Paintings, Drawings and Etchings*, London, Folio Society, 1967.

MARTINI, EGIDIO, *La pittura veneziana del Settecento*, Venice, 1964.

MIOTTI, TITO, 'Tre disegni inediti del Canaletto', *Arte Veneta*, 1966, p. 275.

MORASSI, ANTONIO, 'Francesco Guardi as a Pupil of Canaletto', *The Connoisseur*, 1963, p. 150; 'Settecento inedito', *Arte Veneta*, 1963, p. 145.

—— 'La giovinezza del Canaletto', *Arte Veneta*, 1966, p. 207.

MOSCHINI, VITTORIO, *Drawings by Canaletto*, New York, 1963.

PALLUCCHINI, RODOLFO, *La pittura veneziana del Settecento*, Venice/Rome, 1960. (Book form of the lectures referred to on p. 182 to which references in the text and index apply.)

—— 'Per gli Esordi del Canaletto', *Arte Veneta*, XXVII, 1973 (published 1974).

PIGNATTI, TERISIO, 'Bernardo Bellotto's Venetian Period (1738–1743)', *National Gallery of Canada Bulletin*, 1967 (no. 1), p. 1 (first published in *Arte Veneta*, 1966, p. 218).

—— *Canaletto, Selected Drawings*, Pennsylvania, 1970. Italian edition: Florence, 1970. (64 drawings reproduced in six colours with annotations.)

PUPPI, LIONELLO, and BERTO, GIUSEPPE, *L'opera completa del Canaletto*, Classici dell'Arte series, Milan, 1968. English edition: *The Complete Paintings of Canaletto*, introduction by David Bindman, London, 1970 (omitting the concordance to the present catalogue which the original edition contains). Only the colour reproductions are referred to in the catalogue.

VIVIAN, FRANCES, *Il Console Smith*, Vicenza, 1971

WATSON, SIR FRANCIS (F. J. B.), 'Joseph Baudin again', *Burlington Magazine*, Aug. 1967, p. 410.

PLATE I

Canaletto's handwriting (*see also Pls.* 223–4)

(Document concerning a painting made for Stefano Conti. Appendix I, p. 171)

PLATE 2

a. Heintzius—The Canal at Murano on Ascension Day (*p.* 55)

b. Heintzius—Procession to the Redentore over the bridge of boats (*p.* 55)

c. Heintzius—Fight between the Nicolotti and the Castellani (*p.* 55)

PLATE 3

a. Heintzius—Piazza S. Marco, Venice,
looking East (*p.* 55)

b. Marco Ricci—Landscape (*p.* 59 n.)

c. Eismann—Landscape and Ruins (*p.* 58)

PLATE 4

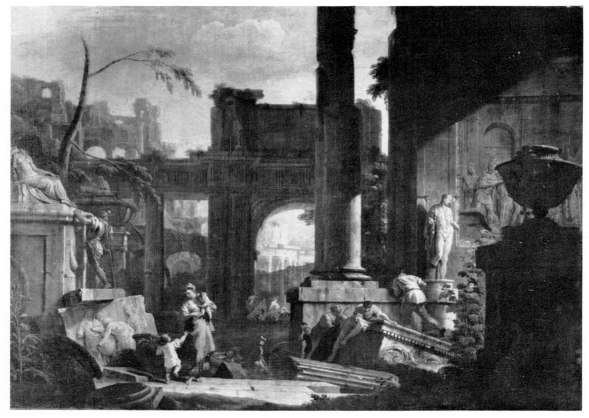

a. Marco Ricci—Roman ruins (*p.* 59)

b. Bibbiena School—Architectural
sketch (*p.* 60)

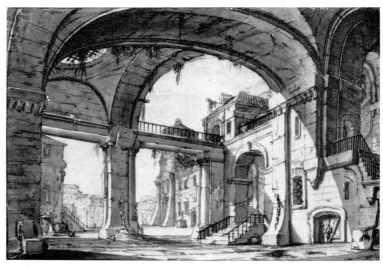

c. Bibbiena School—Architectural Capriccio
(*p.* 60)

PLATE 5

a. Vanvitelli—Molo and Piazzetta, Venice
(*p.* 61)

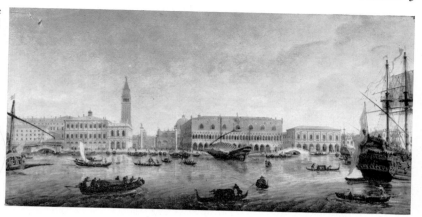

b. Vanvitelli—Bacino di S. Marco, Venice,
looking West (*p.* 62)

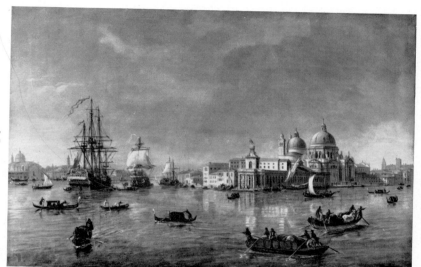

c. Vanvitelli—Ruins by lake (*p.* 63)

PLATE 6

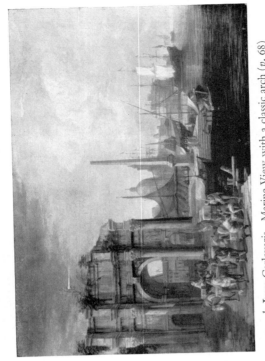

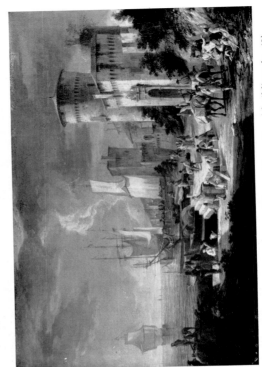

b. Luca Carlevaris—Marine View with a classic arch (p. 68)

d. Luca Carlevaris—Marine View with medieval buildings (p. 68)

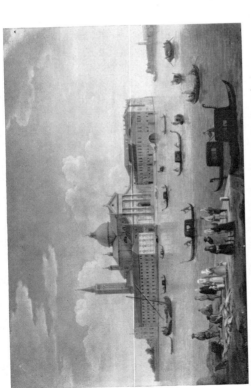

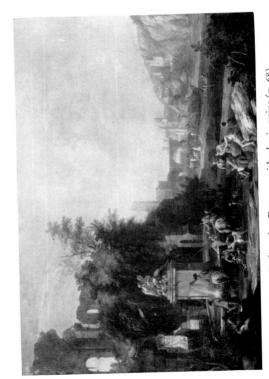

a. Van Lint—S. Giorgio Maggiore, Venice (p. 65)

c. Luca Carlevaris—Estuary with classic ruins (p. 68)

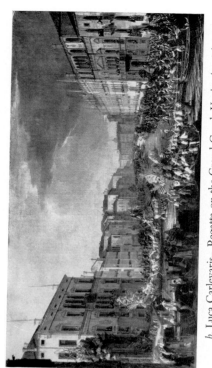

a. Luca Carlevaris—Entry of the Earl of Manchester into the Ducal Palace, Venice (*p.* 69)

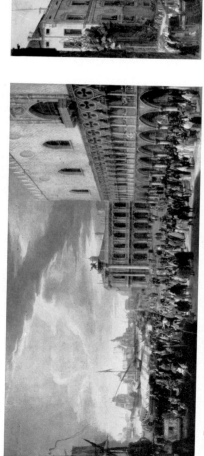

b. Luca Carlevaris—Regatta on the Grand Canal, Venice (*p.* 69)

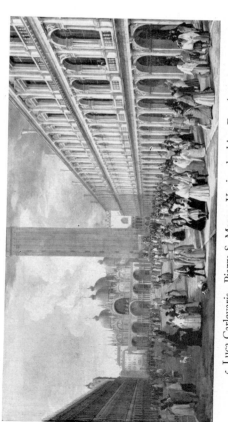

c. Luca Carlevaris—Piazza S. Marco, Venice, looking East (*p.* 70)

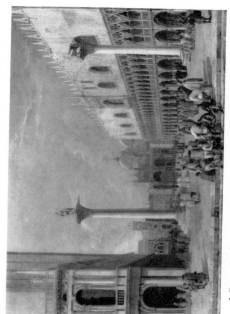

d. Luca Carlevaris—Piazzetta, Venice, looking North (*p.* 70)

PLATE 7

PLATE 8

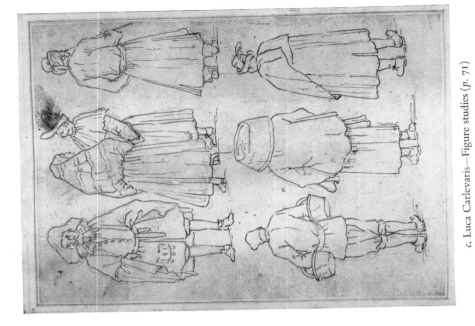

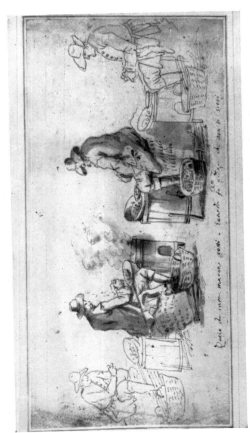

a. Luca Carlevaris—Riva degli Schiavoni, Venice (p. 70)

b. Luca Carlevaris—Roasting chestnuts (p. 71)

c. Luca Carlevaris—Figure studies (p. 71)

PLATE 9

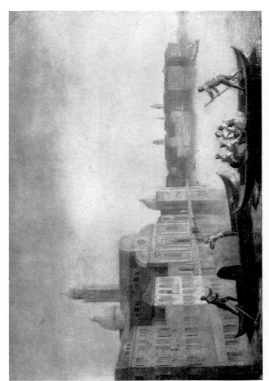

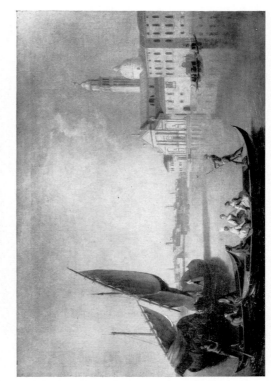

c. Richter—I Carmini, in a fanciful setting (*p.* 75)

d. Richter—S. Giorgio Maggiore, in a fanciful setting (*p.* 75)

a

b

Luca Carlevaris—Figure studies (*p.* 71)

PLATE 10

d. Richter—Sta Lucia and the Scalzi, in a fanciful setting (*p.* 75)

b. Richter—The Spirito Santo and the Zattere, in a fanciful setting (*p.* 75)

PLATE II

1. Piazza S. Marco: looking East along the central line (in or before 1723)

1. (Detail)

1. (Note)

2. Piazza S. Marco: looking East along the central line

PLATE 12

7. Piazza S. Marco: looking East along the central line

8. Piazza S. Marco: looking East along the central line

PLATE 13

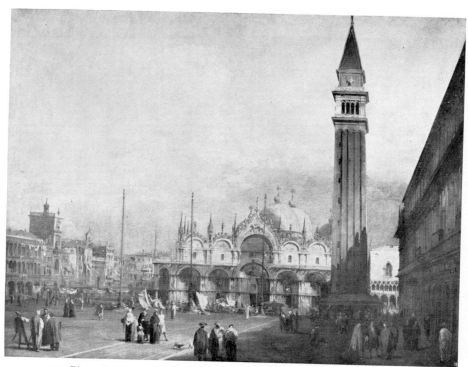

12. Piazza S. Marco: looking East from South of the central line (1726–8)

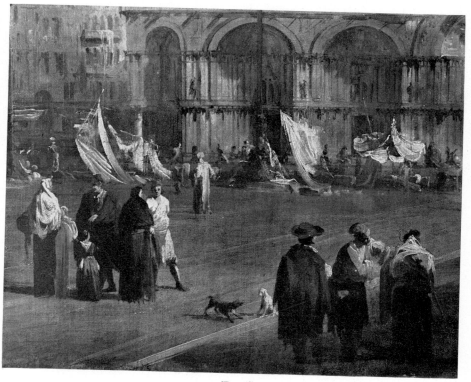

12. (Detail)

PLATE 14

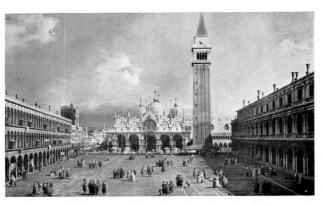

13. Piazza S. Marco: looking East from South of the central line

14. Piazza S. Marco: looking East from South of the central line

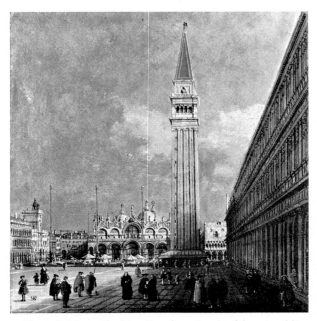

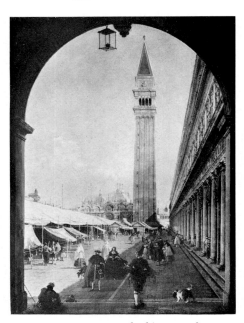

15. Piazza S. Marco: looking East from South of the central line

19. Piazza S. Marco: looking East from the South-West Corner

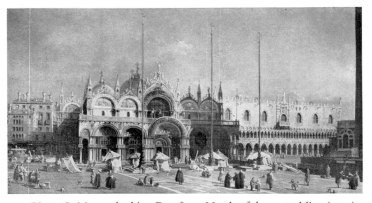

17. Piazza S. Marco: looking East from North of the central line (1744)

PLATE 15

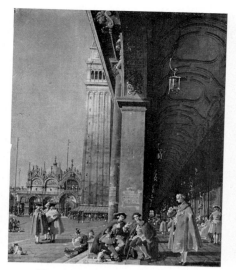

20. Piazza S. Marco: looking East from
the South-West Corner

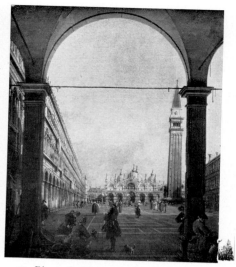

21. Piazza S. Marco: looking East from
the North-West Corner

23. Piazza S. Marco: looking West along the central line

24. Piazza S. Marco: looking West along the central line

27. Piazza S. Marco: looking West from South of the central line

PLATE 16

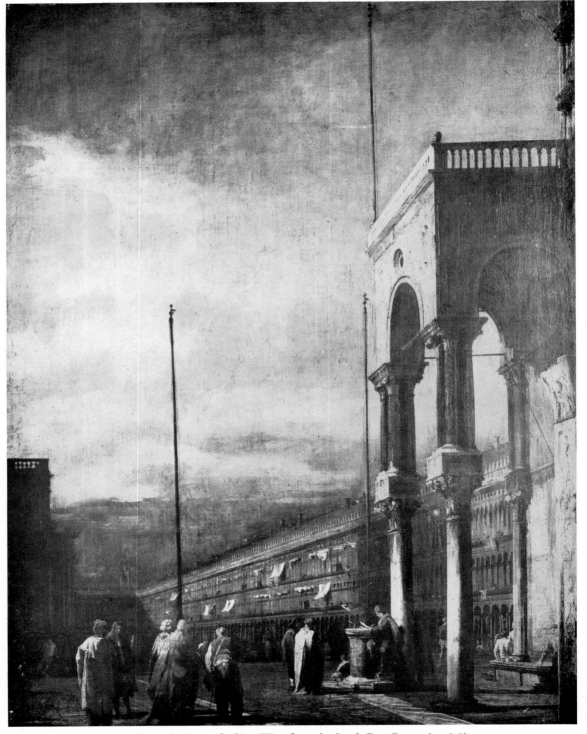

33. Piazza S. Marco: looking West from the South-East Corner (1726–8)

PLATE 17

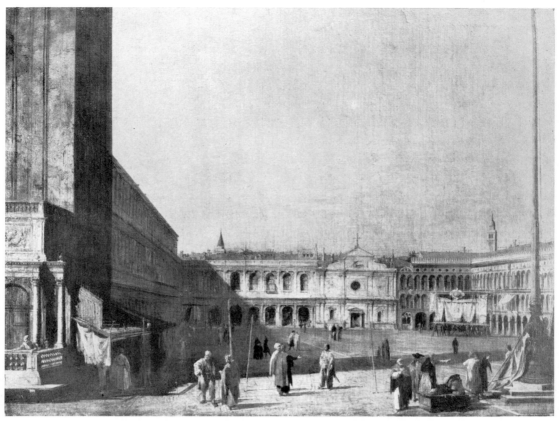

32. Piazza S. Marco: looking West from the North End of the Piazzetta (1726–8)

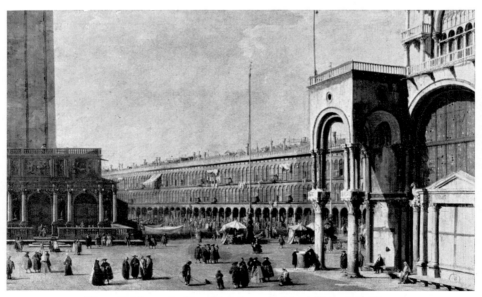

35. Piazza S. Marco: looking West from the North End of the Piazzetta

PLATE 18

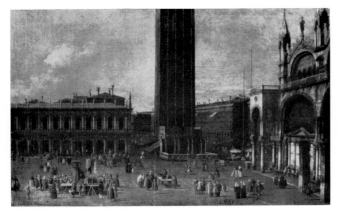

37. Piazza S. Marco: looking West from the North End of the Piazzetta (1744)

38. Piazza S. Marco: looking West from the North End of the Piazzetta

39. Piazza S. Marco: looking West, with the Loggetta of Sansovino

36. Piazza S. Marco: looking West from the North End of the Piazzetta

40. Piazza S. Marco: looking West from the Campo di S. Basso

PLATE 19

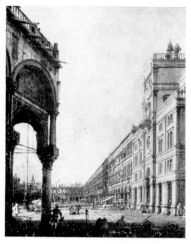

41. Piazza S. Marco: looking West from
the Campo di S. Basso (after 1755)

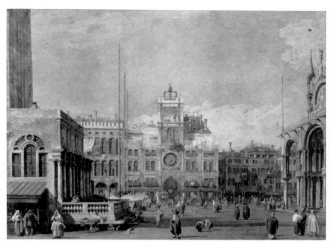

43. Piazza S. Marco: looking North

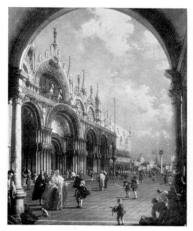

47 (note). Piazza S. Marco: looking
South

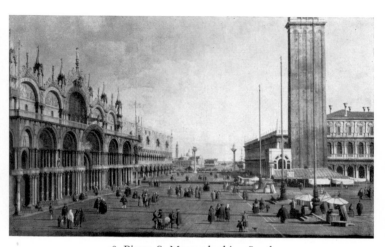

48. Piazza S. Marco: looking South

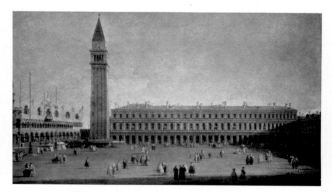

49. Piazza S. Marco: looking South (after 1755)

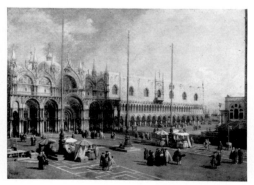

50. Piazza S. Marco: looking South-East

PLATE 20

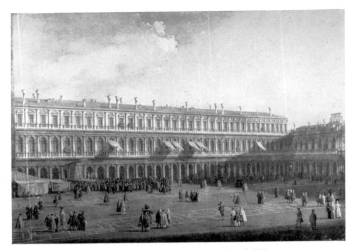

52. Piazza S. Marco: looking South-West

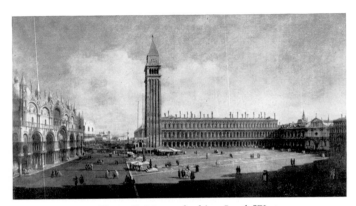

53. Piazza S. Marco: looking South-West

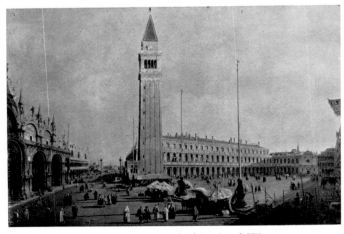

54. Piazza S. Marco: looking South-West

PLATE 21

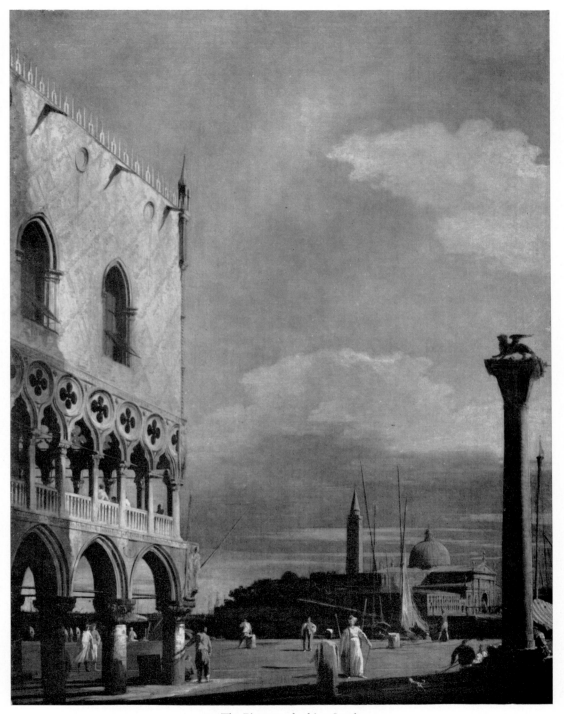

55. The Piazzetta: looking South

PLATE 22

56. The Piazzetta: looking South

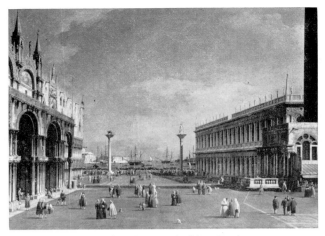

57. The Piazzetta: looking South

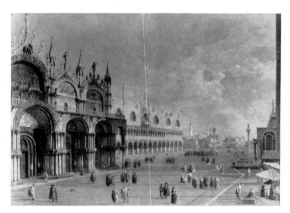

57. (Note)

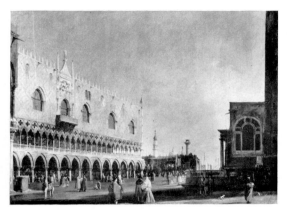

58. The Piazzetta: looking South

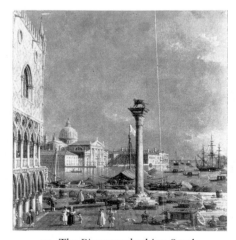

59. The Piazzetta: looking South

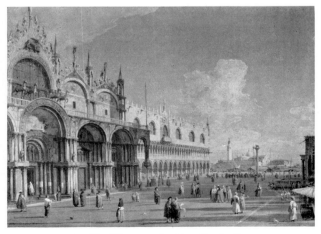

60. The Piazzetta: looking South-East

PLATE 23

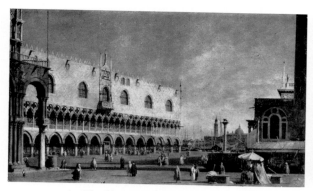

61. The Piazzetta: looking South-East

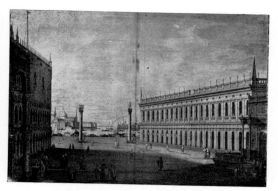

62 (a). The Piazzetta: looking South

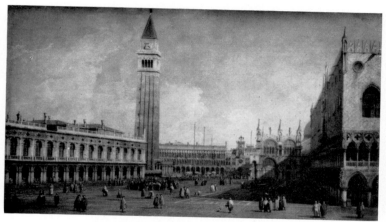

64. The Piazzetta: looking North

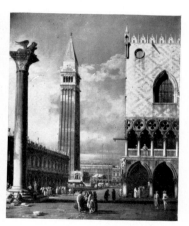

67. The Piazzetta: looking North

68. The Piazzetta: looking North (1743)

69. The Piazzetta: looking West, with the Library

PLATE 24

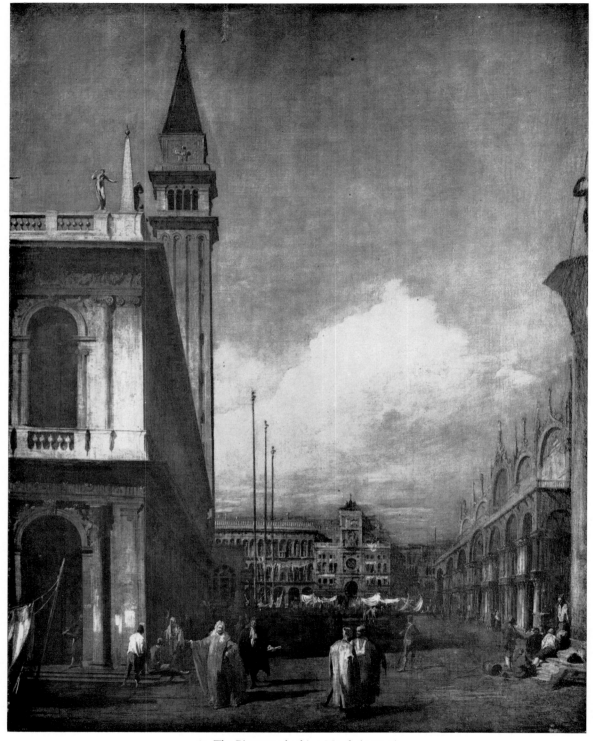

63. The Piazzetta: looking North (1726–8)

PLATE 25

71. The Piazzetta: looking West, with the Library

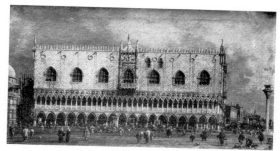

74. The Piazzetta: looking East, with the Ducal Palace

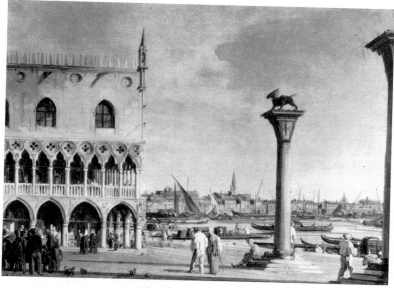

75. The Piazzetta: looking East

77. S. Marco: An Evening Service

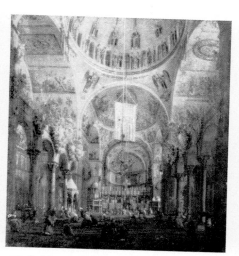

78. S. Marco: A Service on Good Friday (?)

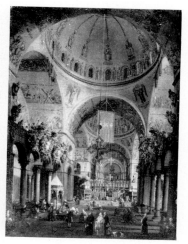

79. S. Marco: the Interior

PLATE 26

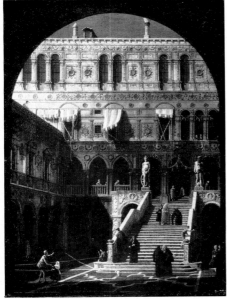

81. The Ducal Palace: the Scala dei Giganti

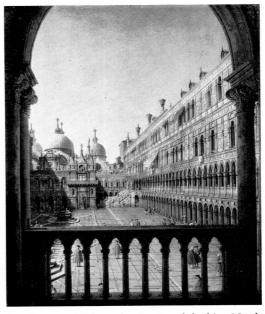

82. The Ducal Palace: the Courtyard, looking North

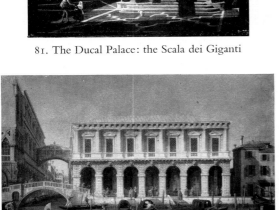

84. The Prison

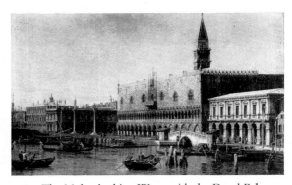

85. The Molo: looking West, with the Ducal Palace
and the Prison (1743)

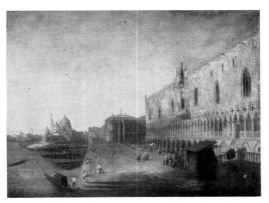

86. The Molo: looking West, with the Ducal Palace
and the Ponte della Paglia

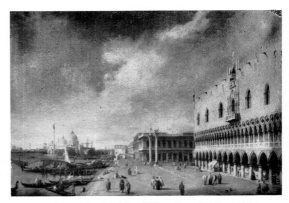

88. The Molo: looking West, Ducal Palace Right

PLATE 27

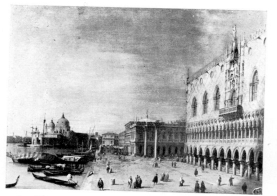

89. The Molo: looking West, Ducal Palace Right

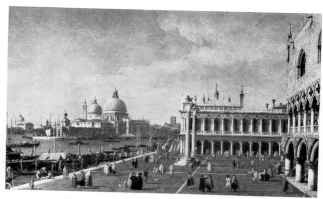

90. The Molo: looking West, Ducal Palace Right

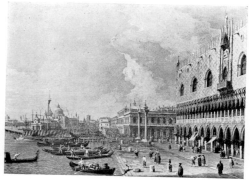

91. The Molo: looking West, Ducal Palace Right

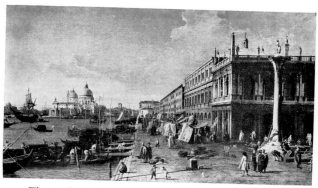

95. The Molo: looking West, Column of St. Theodore Right

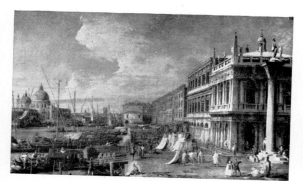

96. The Molo: looking West, Column of St. Theodore Right

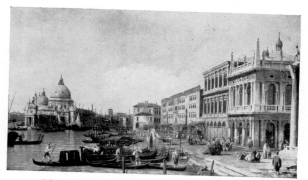

97. The Molo: looking West, Library to Right (1730)

PLATE 28

100. The Molo, looking West: the
Fonteghetto della Farina

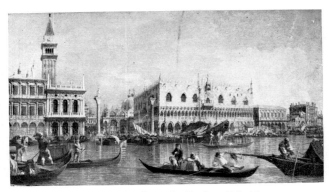

101. The Molo: from the Bacino di S. Marco

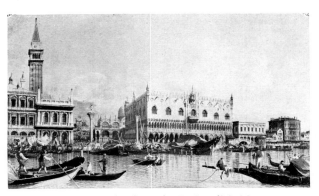

105. The Molo: from the Bacino di S. Marco

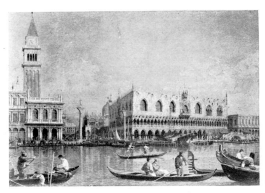

107. The Molo: from the Bacino di S. Marco

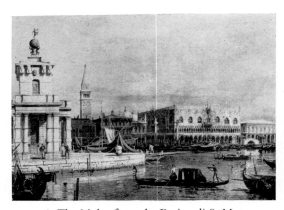

108. The Molo: from the Bacino di S. Marco

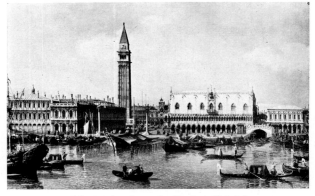

109. The Molo: from the Bacino di S. Marco

PLATE 29

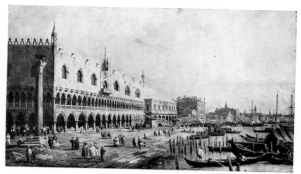

111. Riva degli Schiavoni: looking East (1730)

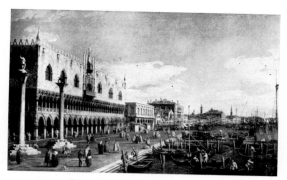

112. Riva degli Schiavoni: looking East

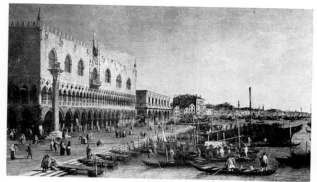

113. Riva degli Schiavoni: looking East

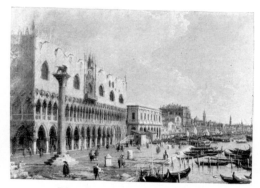

115. Riva degli Schiavoni: looking East

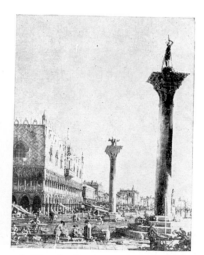

116. Riva degli Schiavoni: looking East

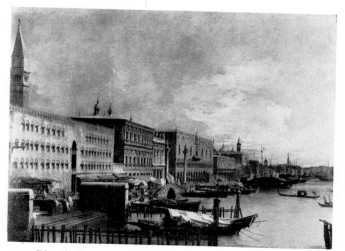

117. Riva degli Schiavoni: looking East from near the Mouth of the Grand Canal

PLATE 30

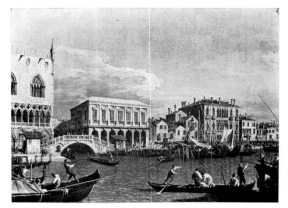

118. Molo and Riva degli Schiavoni: looking East from
the Bacino di S. Marco

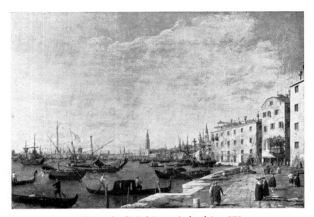

121. Riva degli Schiavoni: looking West

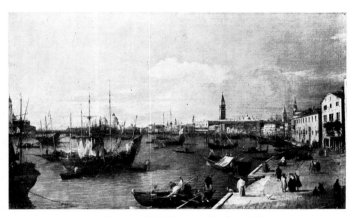

122. Riva degli Schiavoni: looking West

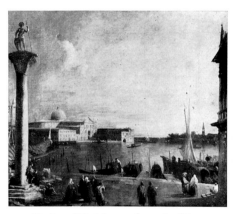

124. Bacino di S. Marco: from the Piazzetta

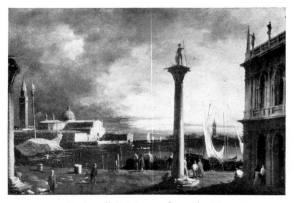

125. Bacino di S. Marco: from the Piazzetta

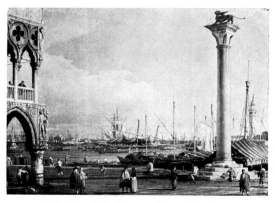

126. Bacino di S. Marco: from the Piazzetta

PLATE 31

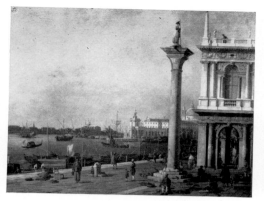

128. Bacino di S. Marco: from the Piazzetta

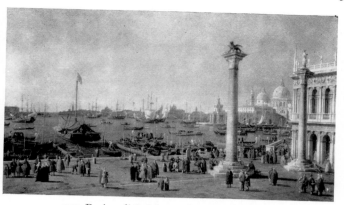

129. Bacino di S. Marco: from the Piazzetta

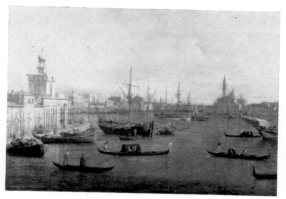

132. Bacino di S. Marco: looking Eest

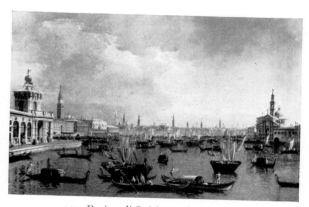

133. Bacino di S. Marco: looking East

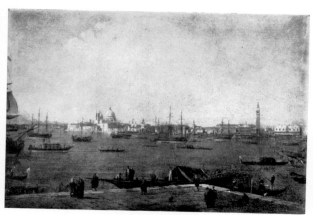

137. Bacino di S. Marco: from
S. Giorgio Maggiore

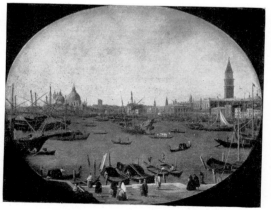

138. Bacino di S. Marco: looking West from
the Riva degli Schiavoni

PLATE 32

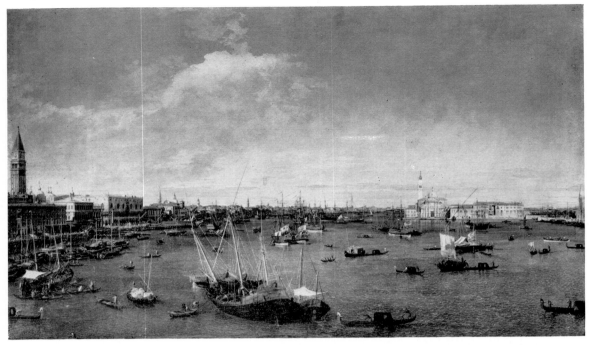

131. Bacino di S. Marco: looking East

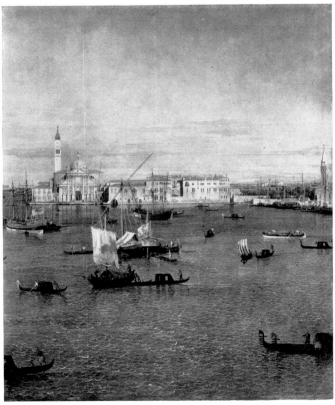

131. (Detail)

PLATE 33

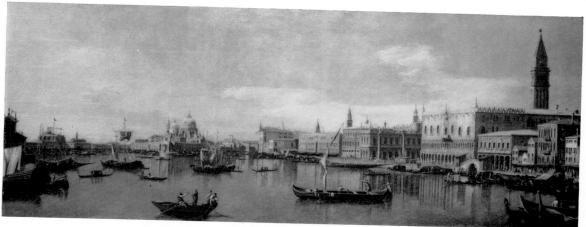

140. Bacino di S. Marco: looking West

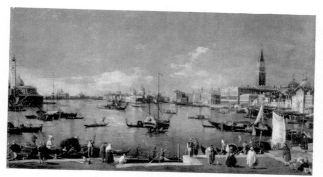

139. Bacino di S. Marco: looking West from
the Riva degli Schiavoni

141. Bacino di S Marco: looking West

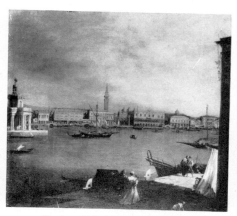

143. Bacino di S. Marco: looking North

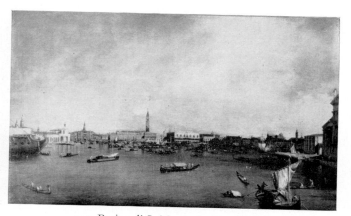

144. Bacino di S. Marco: looking North

PLATE 34

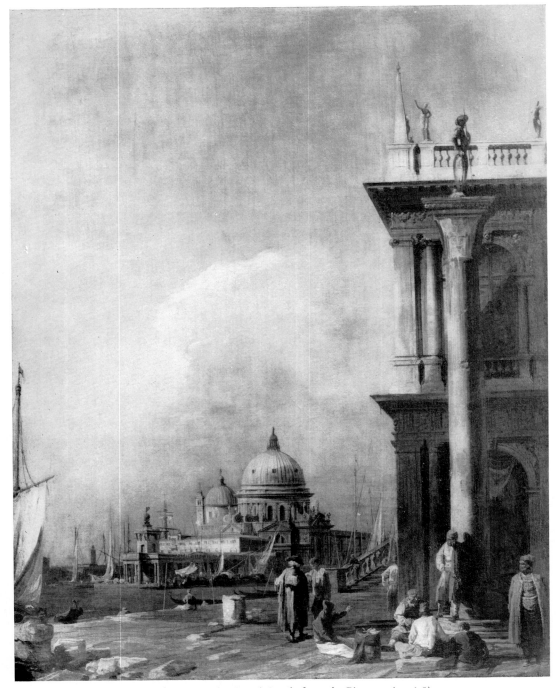

146. Entrance to the Grand Canal: from the Piazzetta (1726–8)

PLATE 35

148. Entrance to the Grand Canal: from the Piazzetta

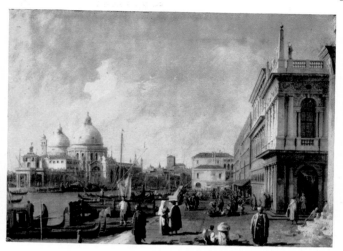

149. Entrance to the Grand Canal: from the Piazzetta

151. Entrance to the Grand Canal: from
the West End of the Molo

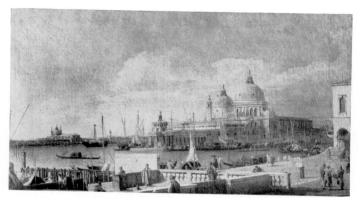

153. Entrance to the Grand Canal: from the West End of the Molo

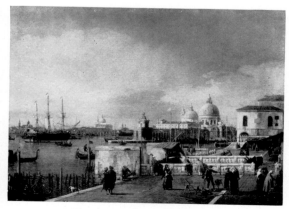

154. Entrance to the Grand Canal: from
the West End of the Molo

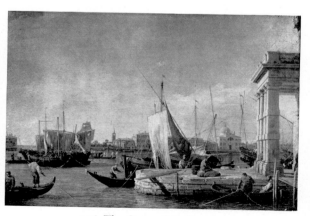

156. The Quay of the Dogana

PLATE 36

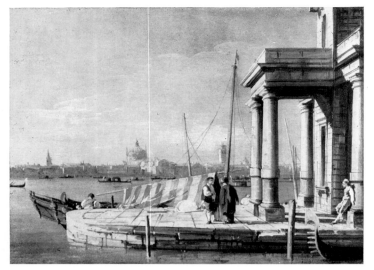

157. The Quay of the Dogana

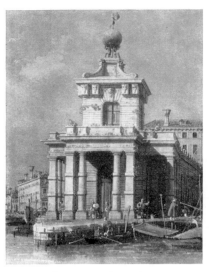

158. The Dogana from the Bacino
di S. Marco

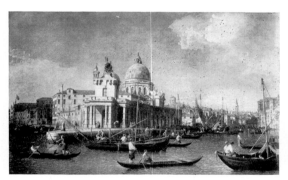

160. Entrance to the Grand Canal: looking West

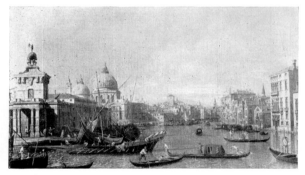

161. Entrance to the Grand Canal: looking West

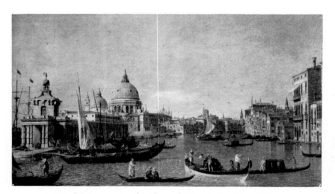

163. Entrance to the Grand Canal: looking West

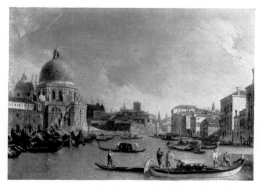

165. Entrance to the Grand Canal: looking West

PLATE 37

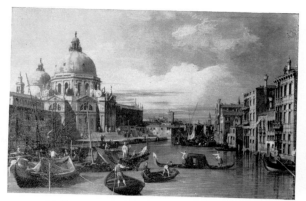

166. Entrance to the Grand Canal: looking West
(in or before 1730)

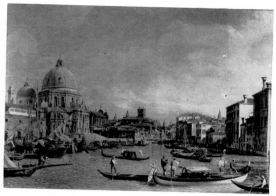

167. Entrance to the Grand Canal: looking West

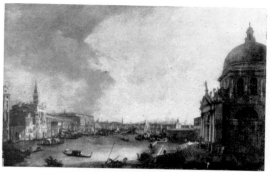

168. Entrance to the Grand Canal: looking East

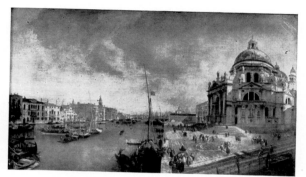

169. Entrance to the Grand Canal: looking East

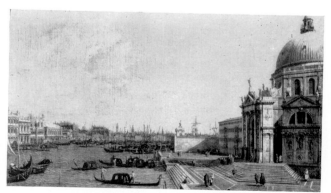

170. Entrance to the Grand Canal: looking East

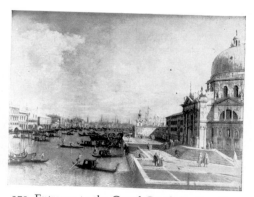

171. Entrance to the Grand Canal: looking East

PLATE 38

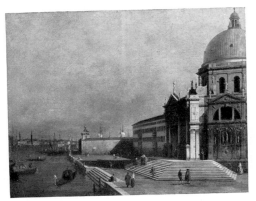

173. Entrance to the Grand Canal: looking East

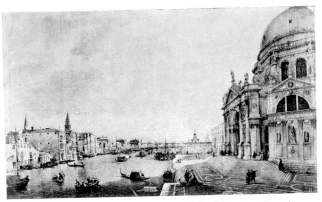

174. Entrance to the Grand Canal: looking East (1744)

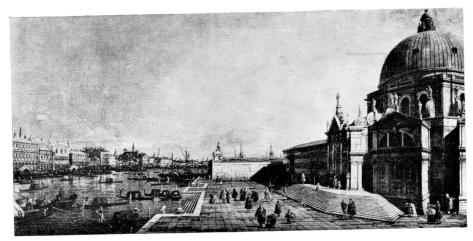

176. Entrance to the Grand Canal: looking East

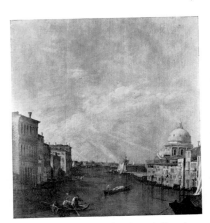

177. Entrance to the Grand Canal:
looking East

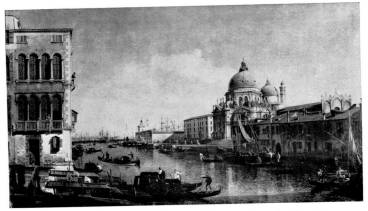

180. Grand Canal: the Salute and Dogana from the Campo
Sta Maria Zobenigo

PLATE 39

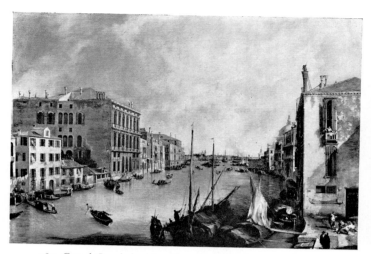

182. Grand Canal: looking East, from the Campo di S. Vio

182. (Detail)

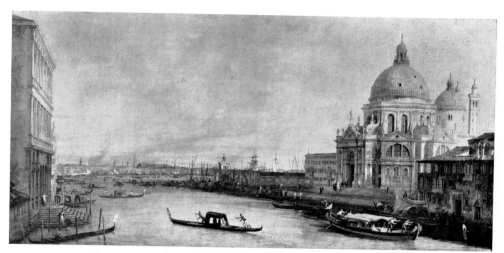

181. Grand Canal: the Salute and the Dogana, from near the Palazzo Corner

183. Grand Canal: looking East, from the Campo di S. Vio

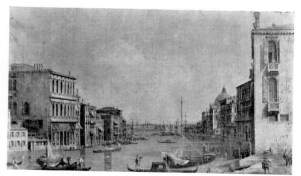

184. Grand Canal: looking East, from the Campo di S. Vio

PLATE 40

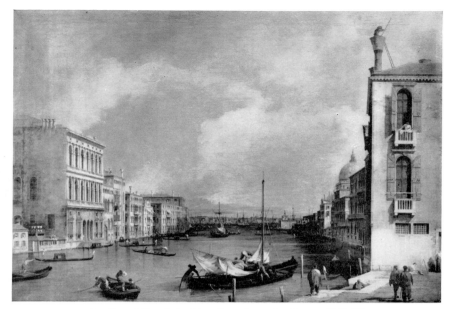

187. Grand Canal: looking East, from the Campo di S. Vio

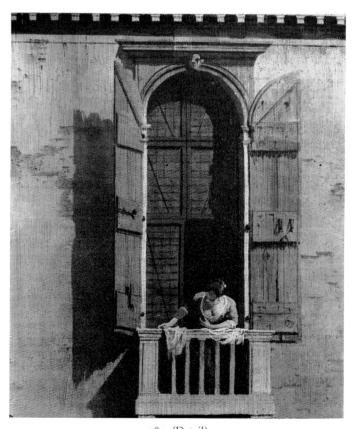

187. (Detail)

PLATE 41

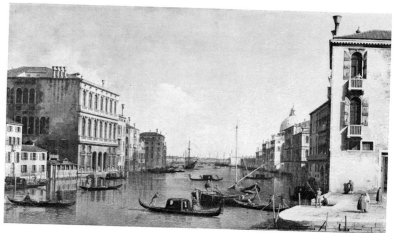

188. Grand Canal: looking East, from the Campo di S. Vio

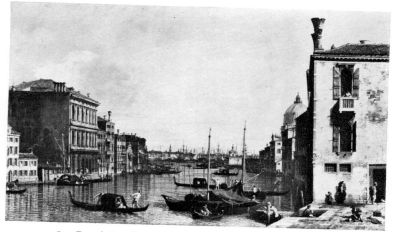

189. Grand Canal: looking East, from the Campo di S. Vio

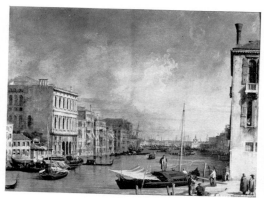

192. Grand Canal: looking East, from the Campo di S. Vio (1727–9)

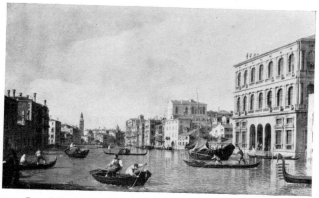

193. Grand Canal: looking North-West, from the Palazzo Corner to the Palazzo Contarini dagli Scrigni

PLATE 42

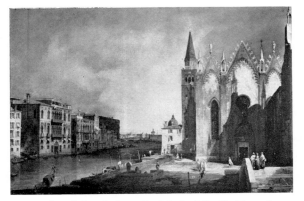

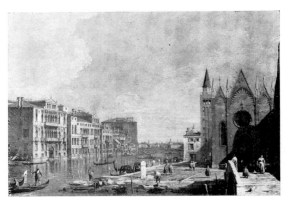

194. Grand Canal: from Sta Maria della Carità to the
Bacino di S. Marco (1725–6)

195. Grand Canal: from Sta Maria della Carità to the
Bacino di S. Marco

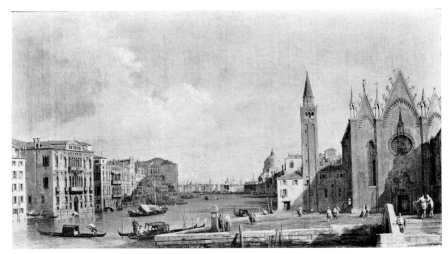

196. Grand Canal: from Sta Maria della Carità to the Bacino di S. Marco

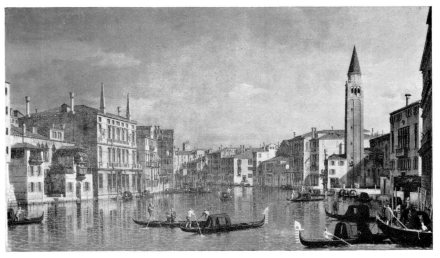

198. Grand Canal: looking South-East, from the Campo della Carità to the Palazzo Venier della Torresella

PLATE 43

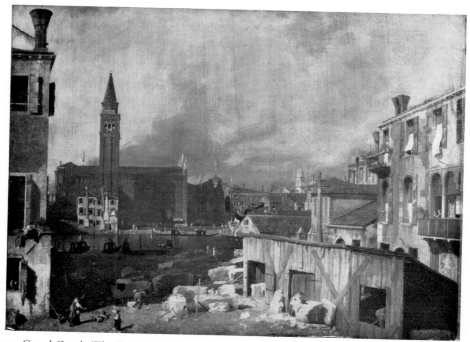

199. Grand Canal: 'The Stonemason's Yard'; Sta Maria della Carità from across the Grand Canal

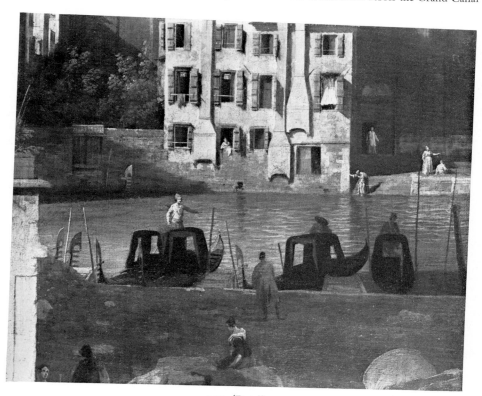

199. (Detail)

PLATE 44

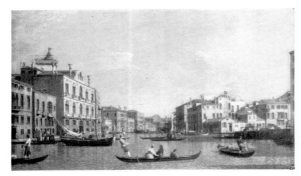

200. Grand Canal: looking North from the Palazzo
Contarini dagli Scrigni to the Palazzo Rezzonico

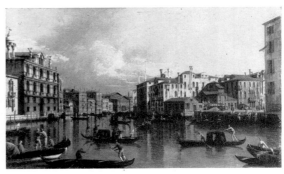

201. Grand Canal: looking North from the Palazzo
Contarini dagli Scrigni to the Palazzo Rezzonico

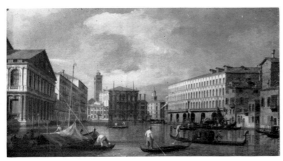

202. Grand Canal: looking North from the Palazzo
Rezzonico to the Palazzo Balbi

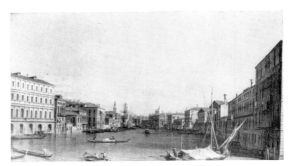

203. Grand Canal: looking South from the Palazzi
Foscari and Moro-Lin to Sta Maria della Carità

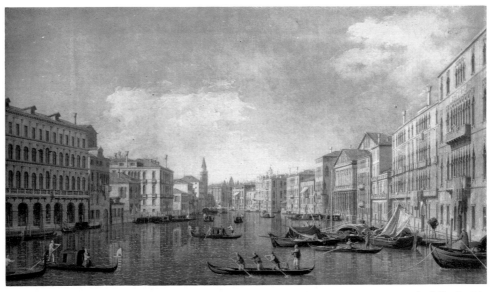

205. Grand Canal: looking South from the Palazzi Foscari and Moro-Lin to Sta Maria della Carità

PLATE 45

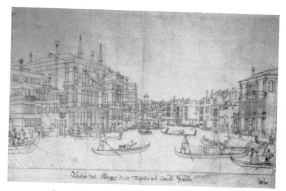

207. Grand Canal: looking North-East from the
Palazzo Tiepolo towards the Rialto Bridge

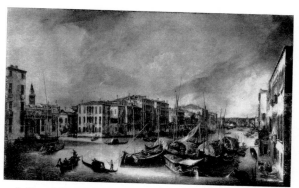

208. Grand Canal: looking North-East from near the Palazzo
Corner-Spinelli to the Rialto Bridge

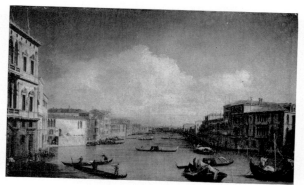

209. Grand Canal: looking North-East from the Palazzo
Corner-Spinelli to the Rialto Bridge

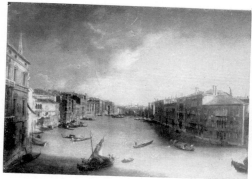

210. Grand Canal: looking North-East from the
Palazzo Balbi to the Rialto Bridge

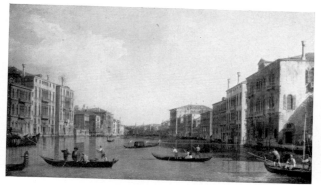

212. Grand Canal: looking North-East from the
Palazzo Balbi to the Rialto Bridge

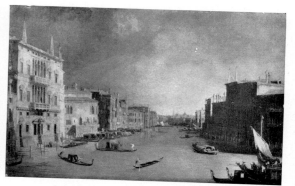

214. Grand Canal: looking North-East from the
Palazzo Balbi to the Rialto Bridge

PLATE 46

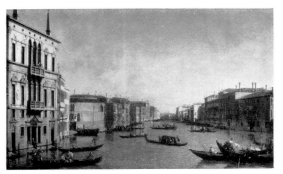

216. Grand Canal: looking North-East from the
Palazzo Balbi to the Rialto Bridge

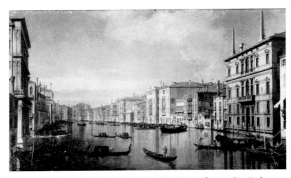

217. Grand Canal: looking South-West from the Palazzo
Coccina-Tiepolo to the Palazzo Foscari

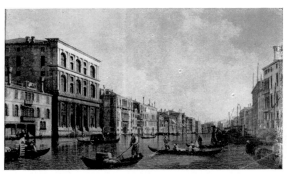

218. Grand Canal: looking South-West from the Palazzo
Grimani to the Palazzo Foscari

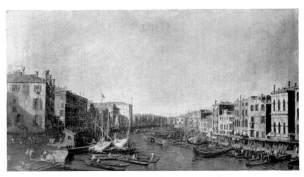

219. Grand Canal: looking South-West from the Rialto Bridge
to the Palazzo Foscari

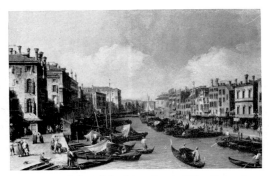

220. Grand Canal: looking South-West from the
Rialto Bridge to the Palazzo Foscari (in or before
1730)

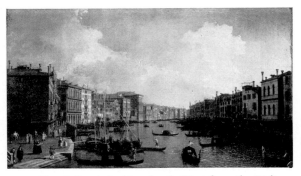

221. Grand Canal: looking South-West from the Rialto
Bridge to the Palazzo Foscari

PLATE 47

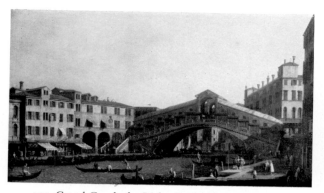

225. Grand Canal: the Rialto Bridge from the South

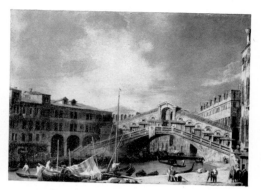

226. Grand Canal: the Rialto Bridge from
the South (1727–9)

227 (*a*). Grand Canal: the Rialto Bridge from the South (detail)

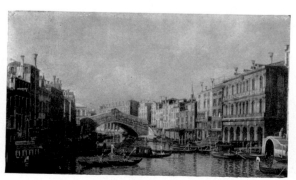

228. Grand Canal: the Rialto Bridge from the South (1744)

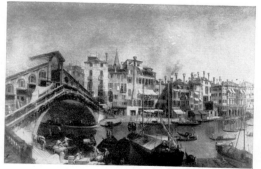

229. Grand Canal: the Rialto Bridge from the
Fondamenta del Vin

PLATE 48

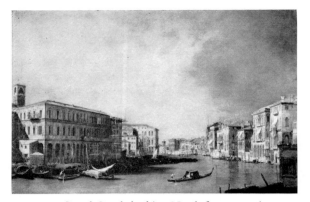

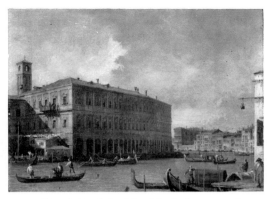

230. Grand Canal: looking North from near the
Rialto Bridge (1725)

232. Grand Canal: looking North from near the
Rialto Bridge (1727)

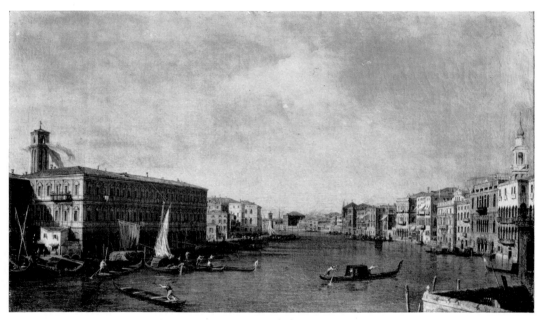

233. Grand Canal: looking North from near the Rialto Bridge

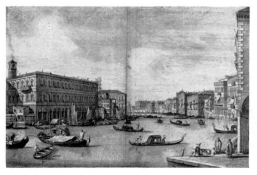

233 (h) 1

233 (h) 2

PLATE 49

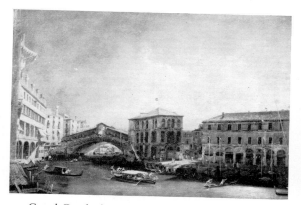

234. Grand Canal: the Rialto Bridge from the North (1725)

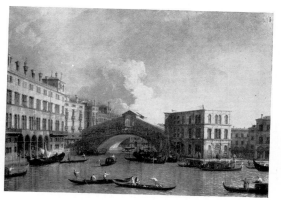

235. Grand Canal: the Rialto Bridge from
the North (1727–9)

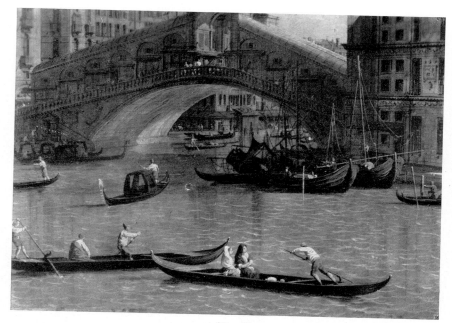

235. (Detail)

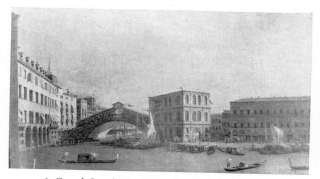

236. Grand Canal: the Rialto Bridge from the North

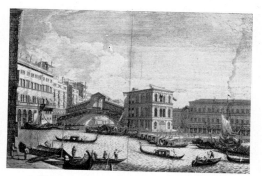

238 (b). Grand Canal: the Rialto Bridge from
the North

PLATE 50

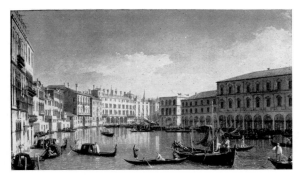

240. Grand Canal: looking South from the Cà da Mosto
to the Rialto Bridge

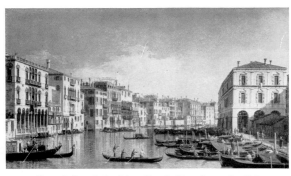

241. Grand Canal: looking South-East from the Palazzo
Michiel dalle Colonne to the Fondaco dei Tedeschi

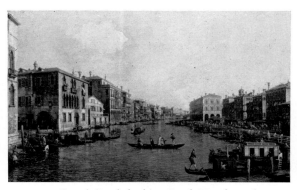

242. Grand Canal: looking South-East from the
Campo Sta Sofia to the Rialto Bridge

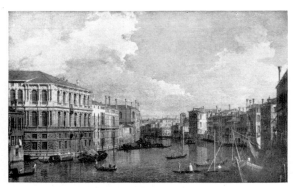

244. Grand Canal: looking North-West from the
Palazzo Pesaro to S. Marcuola

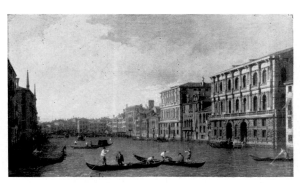

245. Grand Canal: looking South-East from the Palazzo
Pesaro to the Fondaco dei Tedeschi

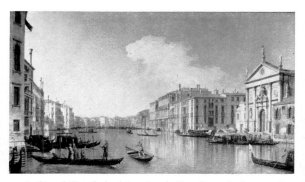

246. Grand Canal: looking South-East from S. Stae to the
Fabbriche Nuove di Rialto

PLATE 51

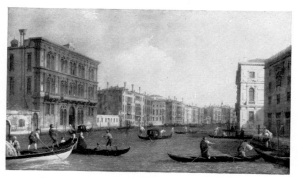

247. Grand Canal: looking South-East from the Palazzo Vendramin-Calergi to the Palazzo Fontana

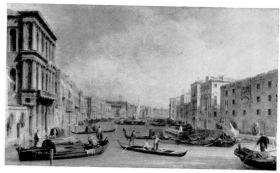

248. Grand Canal: looking South-East from the Palazzo Vendramin-Calergi to the Palazzo Michiel dalle Colonne

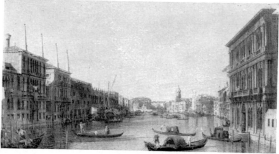

250. Grand Canal: looking North-West from the Palazzo Vendramin-Calergi to S. Geremia and the Palazzo Flangini

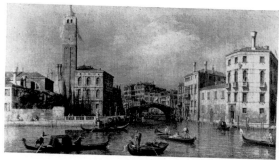

251. Grand Canal: S. Geremia and the Entrance to the Cannaregio

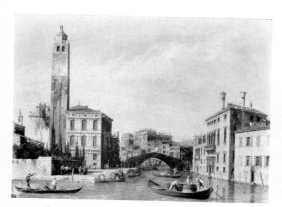

252. Grand Canal: S. Geremia and the Entrance to the Cannaregio

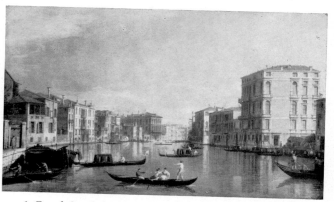

256. Grand Canal: looking East from the Palazzo Bembo to the Palazzo Vendramin-Calergi

PLATE 52

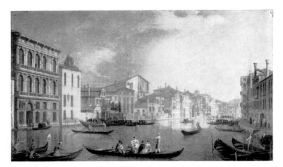

257. Grand Canal: looking East from the Palazzo
Flangini to S. Marcuola

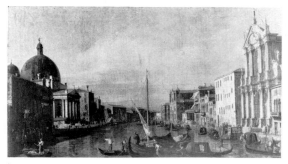

258. Grand Canal: looking South-West from the
Chiesa degli Scalzi to the Fondamenta della Croce,
with S. Simeone Piccolo

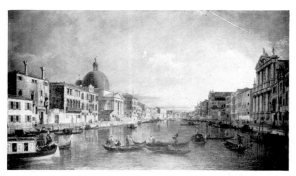

259. Grand Canal: looking South-West from the Chiesa degli
Scalzi to the Fondamenta della Croce, with S. Simeone Piccolo

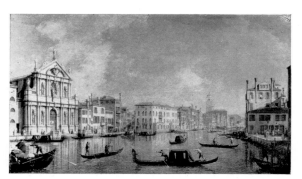

260. Grand Canal: looking North-East from the Chiesa
degli Scalzi to the Cannaregio

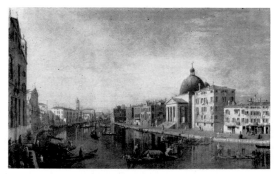

261. Grand Canal: looking North-East from
S. Simeone Piccolo to the Cannaregio

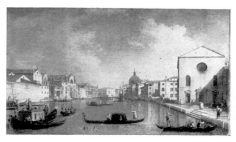

262. Grand Canal: looking North-East from
Sta Croce to S. Geremia

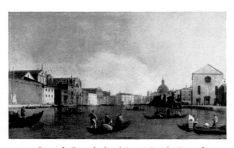

263. Grand Canal: looking North-East from
Sta Croce to S. Geremia

PLATE 53

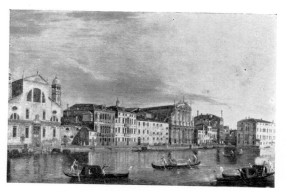

265. Grand Canal: Sta Lucia and the
Church of the Scalzi

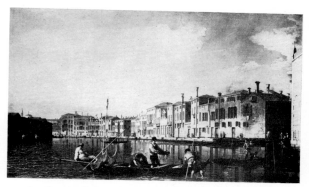

267. Canale di Sta Chiara: looking South-East along the
Fondamenta della Croce

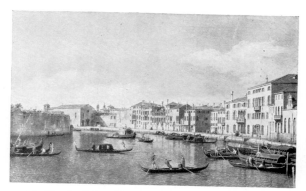

268. Canale di Sta Chiara: looking South-East along the
Fondamenta della Croce

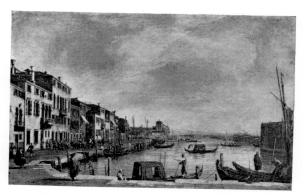

269. Canale di Sta Chiara: looking North-West from the
Fondamenta della Croce to the Lagoon

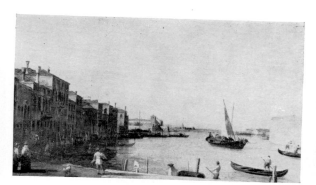

270. Canale di Sta Chiara: looking North-West from
the Fondamenta della Croce to the Lagoon

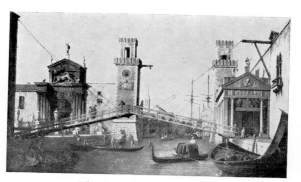

271. The Arsenal: the Water Entrance

PLATE 54

272. The Arsenal and the Campo
di Arsenale

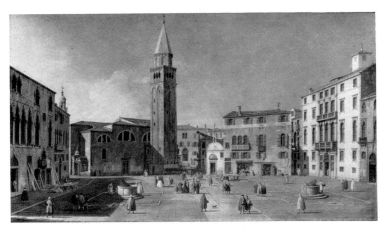

274. Campo S. Angelo

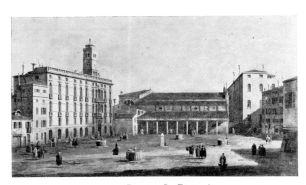

275. Campo S. Geremia

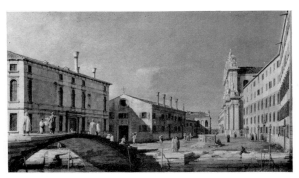

276. Campo dei Gesuiti

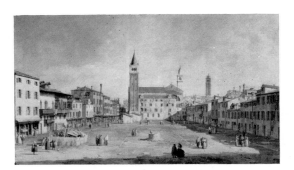

277. Campo Sta Margherita

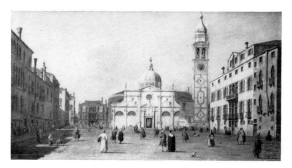

278. Campo Sta Maria Formosa

PLATE 55

279. Campo Sta Maria Formosa

281. Campo S. Polo

282. Campo di Rialto

283. Campo S. Salvatore

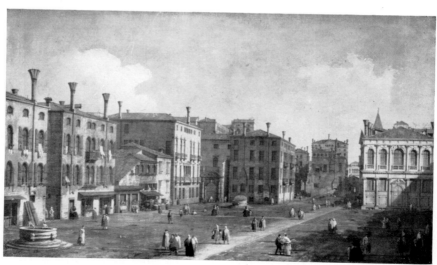

284. Campo S. Stefano (now Francesco Morosini)

PLATE 56

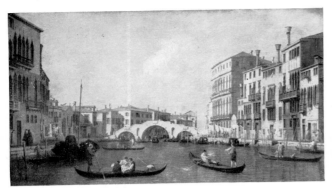

287. The Cannaregio

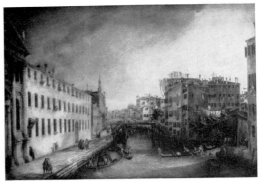

290. Rio dei Mendicanti: looking South

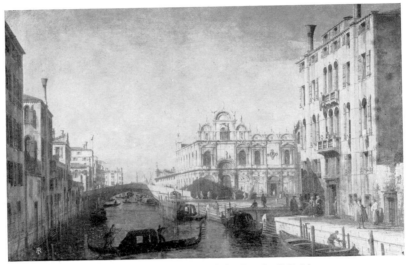

291. Rio dei Mendicanti and the Scuola di S. Marco

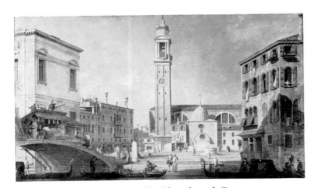

294. SS. Apostoli: Church and Campo

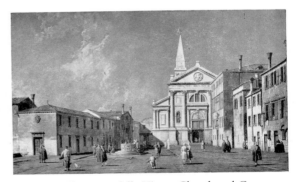

295. S. Francesco della Vigna: Church and Campo

PLATE 57

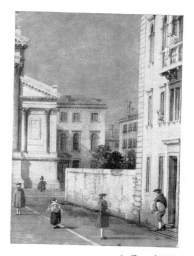

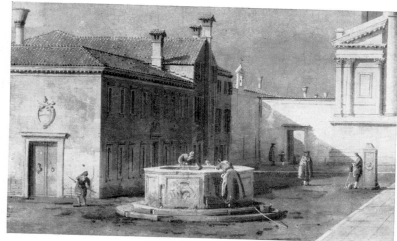

296. (I and III) S. Francesco della Vigna: Church and Campo (see Pl. 201 for whole)

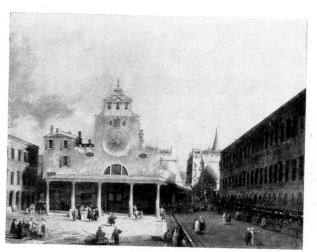

297. S. Giacomo di Rialto

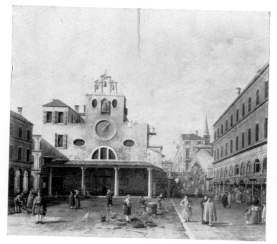

298. S. Giacomo di Rialto

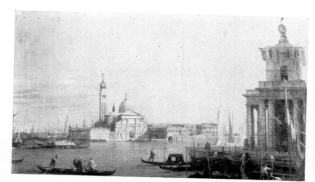

299. S. Giorgio Maggiore: from the Entrance to the Grand Canal

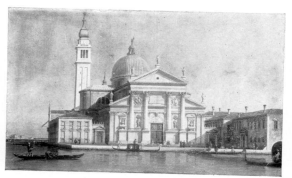

301. S. Giorgio Maggiore: from the Bacino di S. Marco

PLATE 58

304. SS. Giovanni e Paolo and the Scuola di S. Marco
(1725–6)

305. SS. Giovanni e Paolo and the Scuola di S. Marco

308. SS. Giovanni the Paolo and e Monument to Bartolommeo Colleoni

309. The Monument to Colleoni and the
Church of SS. Giovanni e Paolo

310. The Monument to Colleoni and
the Church of SS. Giovanni e Paolo

PLATE 59

313. Sta Maria Zobenigo

314. S. Nicolò di Castello

315. S. Pietro di Castello

316. Il Redentore

317. Il Redentore

319. S. Salvatore

PLATE 60

321. The Fondamenta Nuove and Sta Maria del Pianto

323. Palazzo Corner della Cà Grande

324. Palazzo Grimani

325. Palazzo Pesaro

327. Scuola di S. Rocco

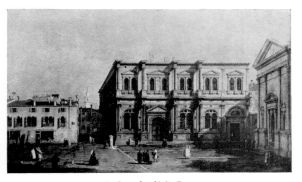

328. Scuola di S. Rocco

PLATE 61

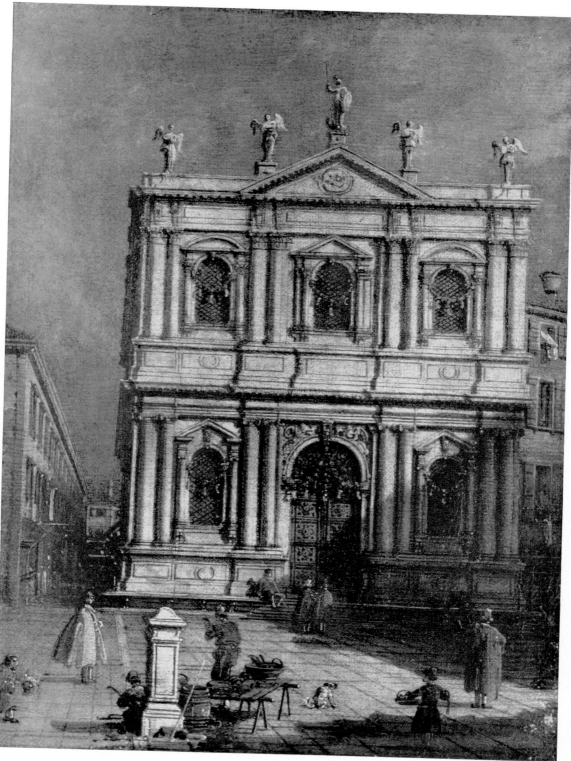

329. Scuola di S. Teodoro

PLATE 62

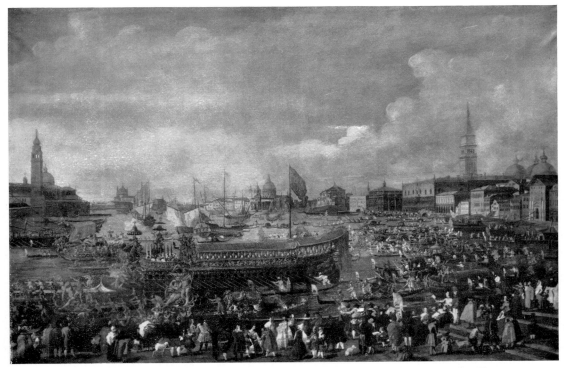

330. (V. I) The Doge in the Bucintoro departing for the Porto di Lido on Ascension Day

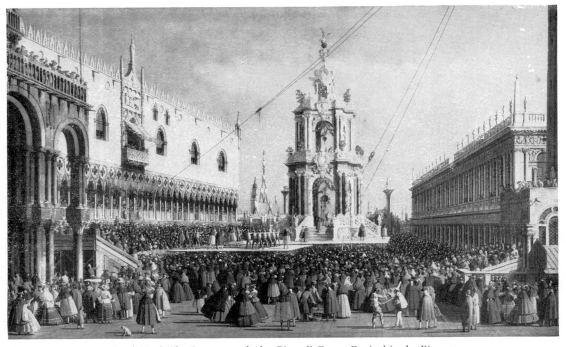

330. (VII. I) The Doge attends the Giovedì Grasso Festival in the Piazzetta

PLATE 63

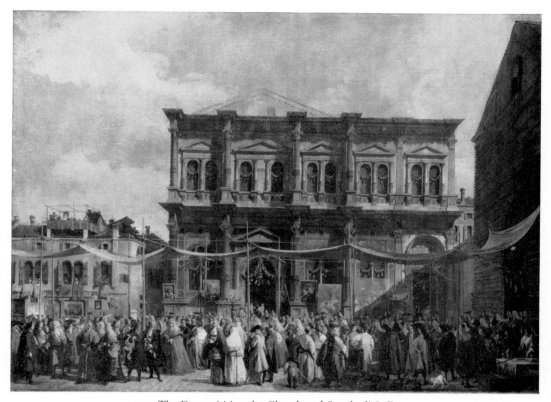

331. The Doge visiting the Church and Scuola di S. Rocco

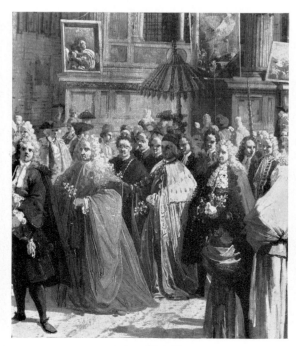

331. (Detail)

331. (Detail)

PLATE 64

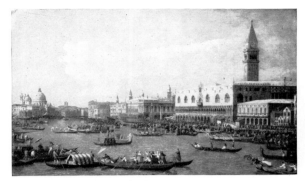

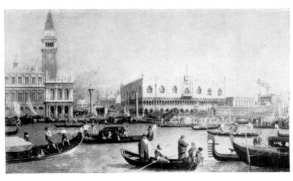

332. The Bucintoro preparing to leave the Molo on
Ascension Day

335. The Bucintoro returning to the Molo on Ascension Day

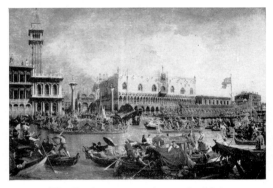

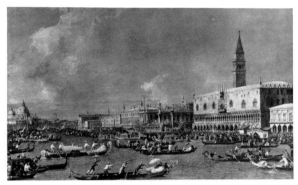

336. The Bucintoro returning to the Molo on
Ascension Day

340. The Bucintoro returning to the Molo on Ascension Day

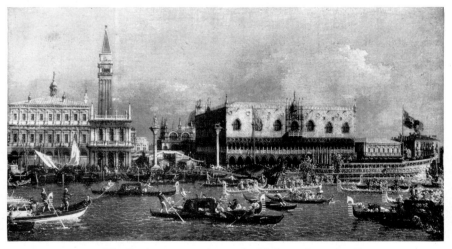

339. Detail

339. The Bucintoro returning to the Molo on Ascension Day

PLATE 65

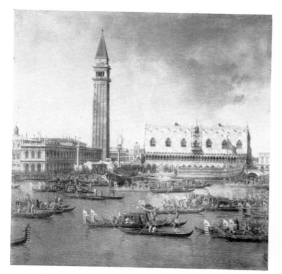

342. The Bucintoro at the Molo on Ascension Day

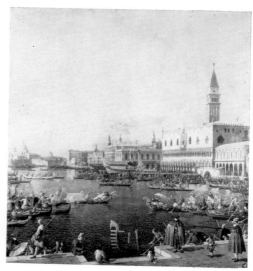

343. The Bucintoro at the Molo on Ascension Day

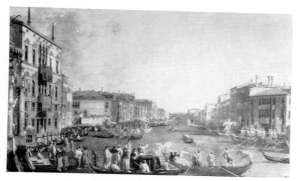

347. A Regatta on the Grand Canal

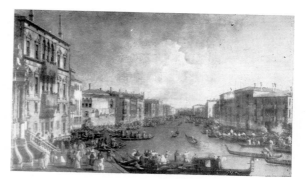

348. A Regatta on the Grand Canal

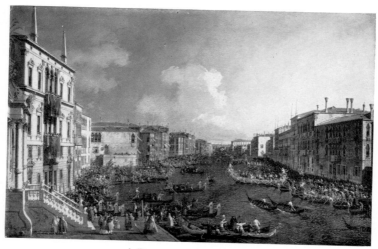

350. A Regatta on the Grand Canal

PLATE 66

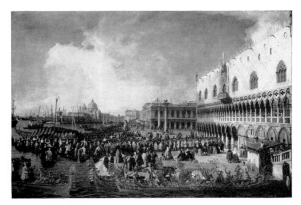

355. Reception of the Imperial Ambassador, Count
Giuseppe di Bolagno, at the Doge's Palace

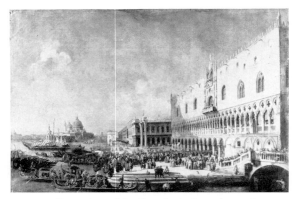

356. Reception of the French Ambassador at the
Doge's Palace

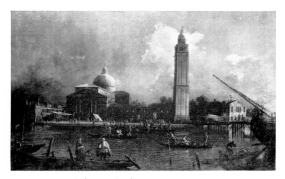

359. Night Festival at S. Pietro di Castello

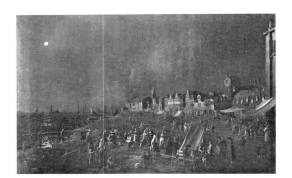

360. Festival on the Eve of St. Martha

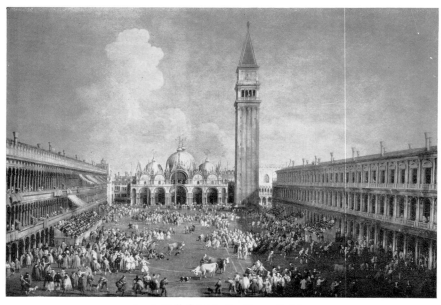

361. A Bull-fight in the Piazza S. Marco

PLATE 67

365. S. Cristoforo, S. Michele, and Murano from the Fondamenta Nuove, Venice

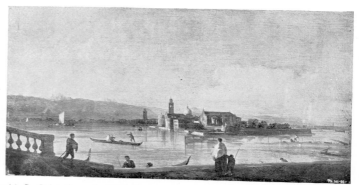

366. S. Cristoforo, S. Michele, and Murano from the Fondamenta Nuove, Venice

367. The Island of S. Michele, with Venice in the distance

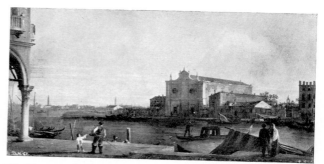

368. Murano: S. Giovanni dei Battuti, with Venice in the distance

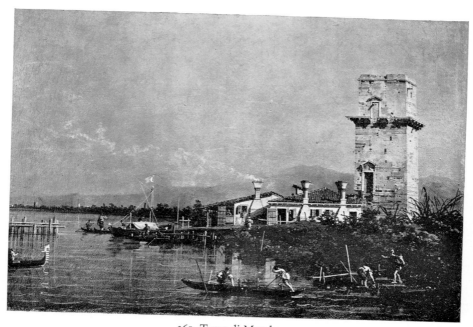

369. Torre di Marghera

PLATE 68

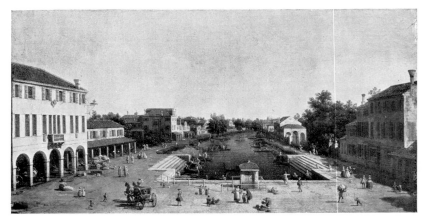

370. Mestre

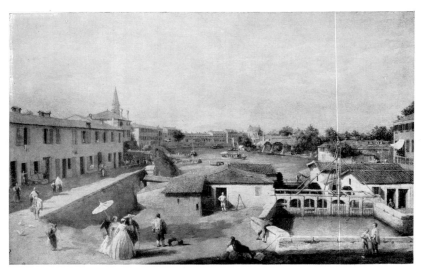

371. Dolo on the Brenta

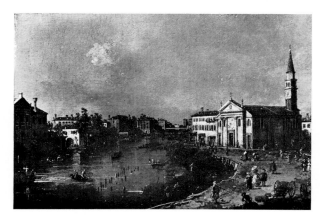

372. Dolo on the Brenta

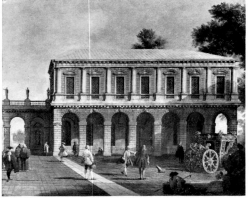

374. Capriccio of the Public Prison at St. Mark's

PLATE 69

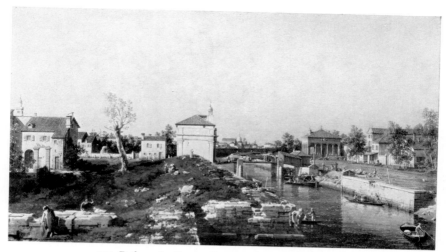

375. Padua: the Brenta Canal and the Porta Portello

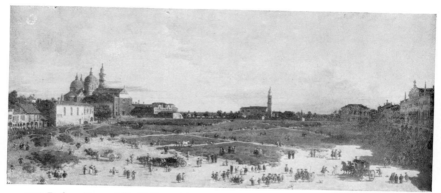

376. Padua: Prato della Valle, with Sta Giustina and the Chiesa della Misericordia

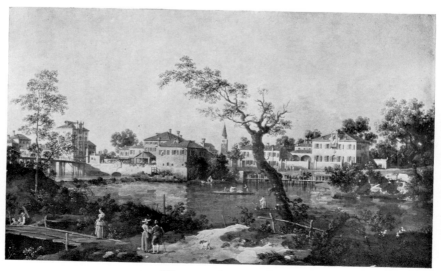

377. View on a river at Padua (?)

PLATE 70

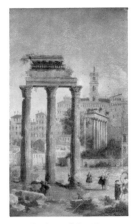

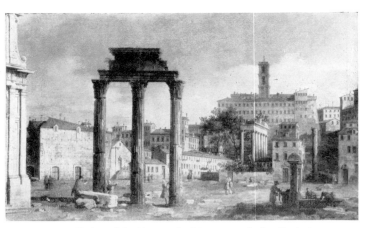

378. Ruins of the Forum,
looking towards the Capitol (1742)

379. Ruins of the Forum, looking towards the Capitol

380. The Forum, with the Basilica
of Constantine and Sta Francesca
Romana

380. (Note)

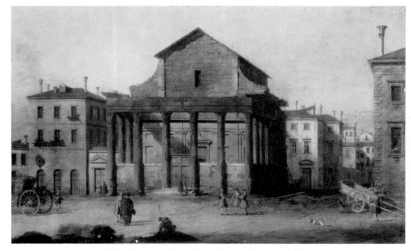

381. The Forum: Temple of Antoninus and Faustina

382. The Arch of Constantine
(1742)

PLATE 71

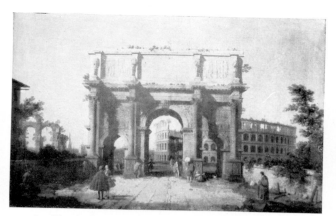

383. The Arch of Constantine and the Colosseum, Rome

384. The Arch of Septimius Severus, Rome (1742)

386. The Arch of Titus, Rome (1742)

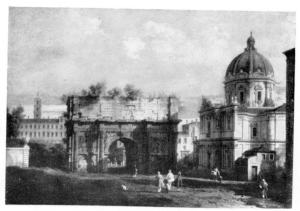

385. The Arch of Septimius Severus, with SS. Martina e Luca

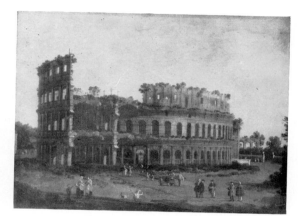

388. The Colosseum, Rome

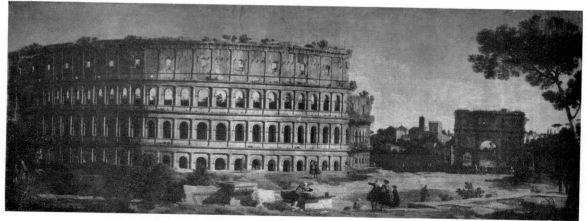

387. The Colosseum and the Arch of Constantine, Rome (1743)

PLATE 72

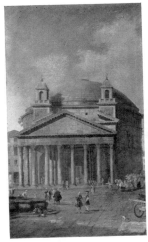

390. The Pantheon (1742)

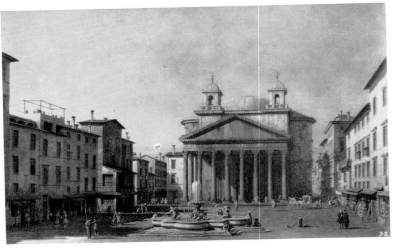

392. The Pantheon

393. St. Peter's: the façade by moonlight

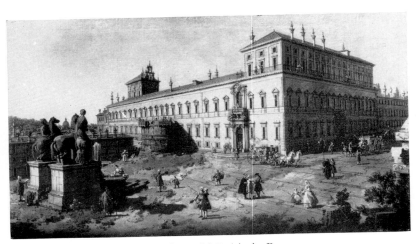

394. Palazzo del Quirinale, Rome

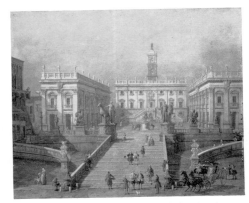

396. Piazza del Campidoglio and the Cordonata
(1755)

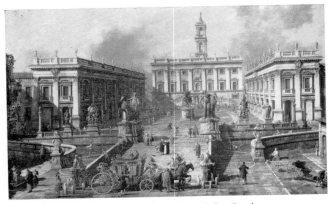

397. Piazza del Campidoglio and the Cordonata

PLATE 73

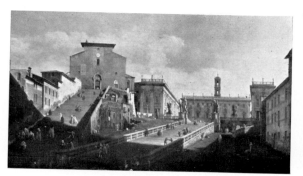

398. Piazza del Campidoglio, Sta Maria d'Aracoeli and
the Cordonata

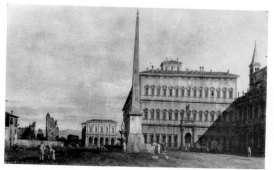

400. Piazza of S. Giovanni in Laterano, Rome

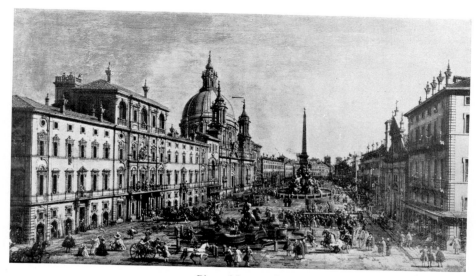

401. Piazza Navona, Rome

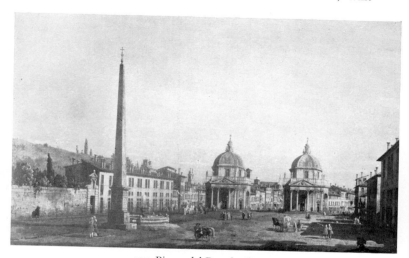

402. Piazza del Popolo, Rome

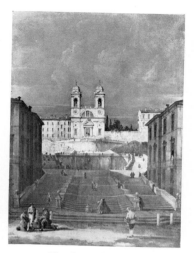

404. The Spanish Steps and
Sta Trinità dei Monti

PLATE 74

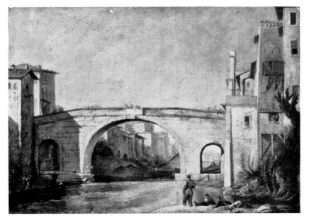

406. The Tiber and the Ponte Cestio

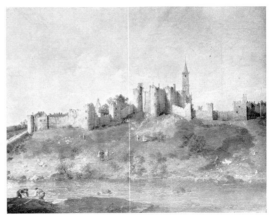

408. Alnwick Castle, Northumberland
(in or before 1751)

409. Badminton House, Gloucestershire, from the park
(1748–9)

410. Badminton Park, from the house (1748–9)

411. Cambridge: interior of King's
College Chapel

412. London: seen through an arch of Westminster Bridge (1746–7)

PLATE 75

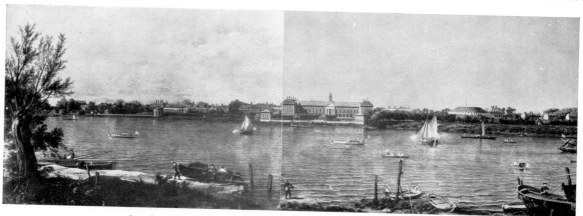

413. London: Chelsea College with Ranelagh House and the Rotunda (1751)

413. (Detail)

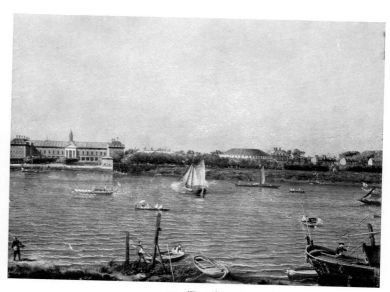

413. (Detail)

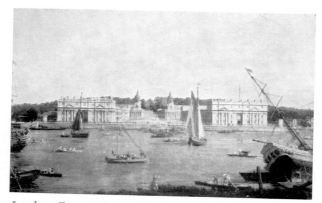

414. London: Greenwich Hospital from the North bank of the Thames

PLATE 76

415. London: the Old Horse Guards from St. James's Park

417. London: the New Horse Guards from St. James's Park

416. London: the Old Horse Guards and the Banqueting Hall,
from St. James's Park

419. London: Northumberland House (1752–3)

PLATE 77

420. London: Ranelagh, interior of the Rotunda (1754)

421. London: Ranelagh, interior of the Rotunda

423. London: old Somerset House from the River Thames

424. London: the Thames and the City of London from
Richmond House (1746–7)

424. (Detail)

PLATE 78

425. London: the Thames on Lord Mayor's Day, looking towards the City

426. London: the Thames, with Westminster Bridge in the distance

427. London: the Thames, looking towards Westminster from near York
Water Gate

PLATE 79

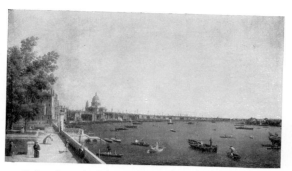

428. London: the Thames from the terrace of Somerset House, the City in the distance

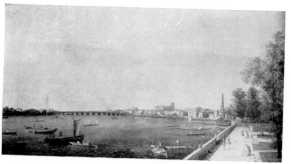

429. London: the Thames from the terrace of Somerset House, Westminster Bridge in the distance

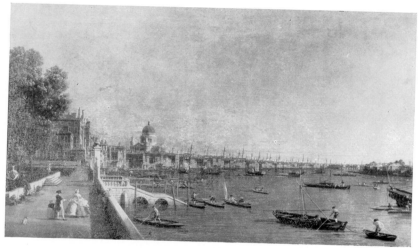

428 (a)

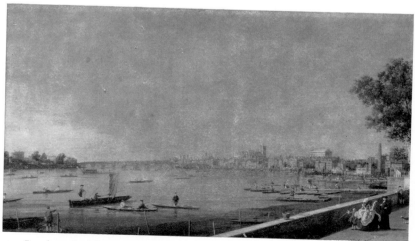

430. London: the Thames from the terrace of Somerset House, Westminster Bridge in the distance

PLATE 80

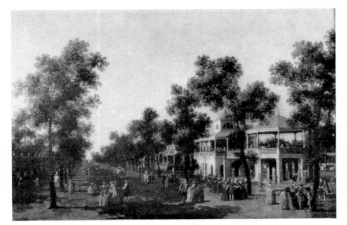

431. London: Vauxhall Gardens; the Grand Walk

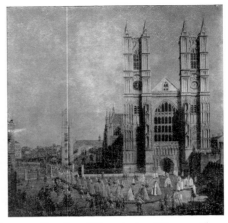

432. London: Westminster Abbey, with
a procession of Knights of the Bath

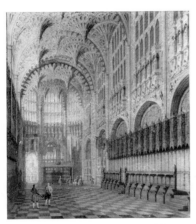

433. London: Westminster Abbey,
interior of Henry VII's Chapel

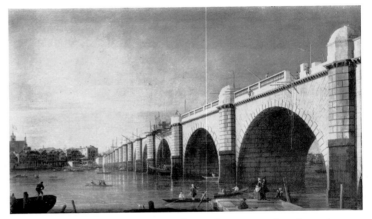

434. London: Westminster Bridge under construction, from the
South-East

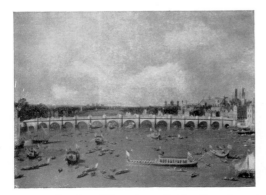

435. London: Westminster Bridge from the
North on Lord Mayor's Day

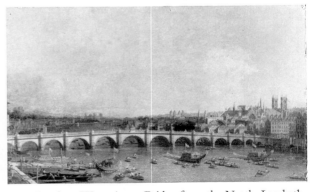

436. London: Westminster Bridge from the North, Lambeth
Palace in the distance

PLATE 81

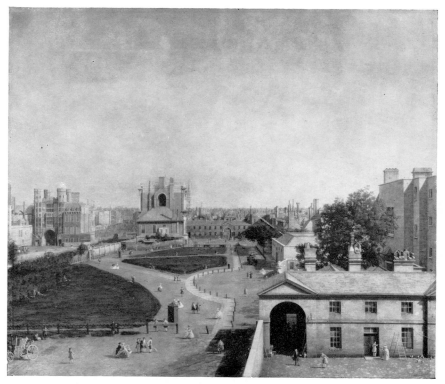

438. London: Whitehall and the Privy Garden from Richmond House (1746–7)

438. (Detail)

438. (Detail)

PLATE 82

439. London: Whitehall and the Privy Garden looking North (1751–2)

439. (Detail)

PLATE 83

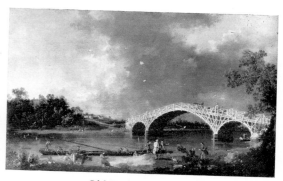

440. Syon House, Middlesex (1749)

441. Old Walton Bridge (1754)

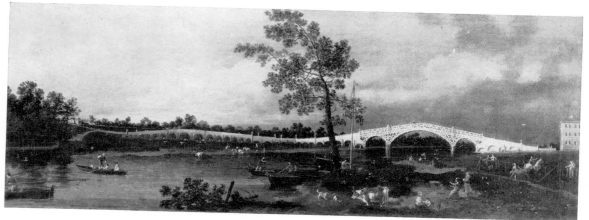

442. Old Walton Bridge (1755)

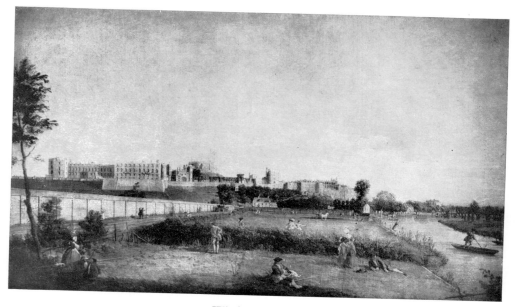

449. Windsor Castle (1747)

PLATE 84

444. Warwick Castle: the South front

445. Warwick Castle: the South front

446. Warwick Castle: the East front

447. Warwick Castle: the East front from the courtyard

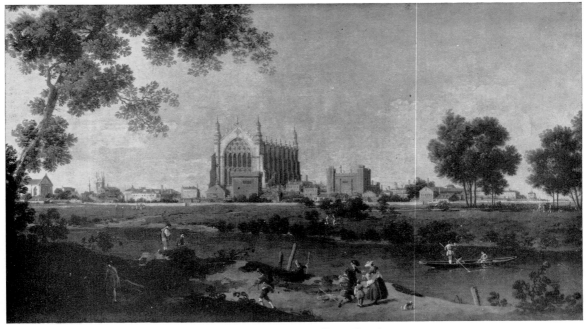

450. Windsor: Eton College Chapel

PLATE 85

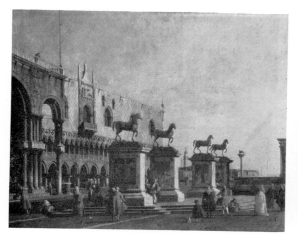

451. Capriccio: the Horses of S. Marco in the Piazzetta (1743)

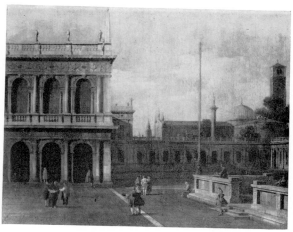

452. Capriccio: the Library of St. Mark and other buildings in Venice (1744)

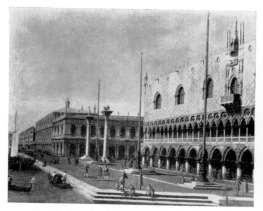

453. Capriccio: the Molo with the flagstaffs from the Piazza di S. Marco

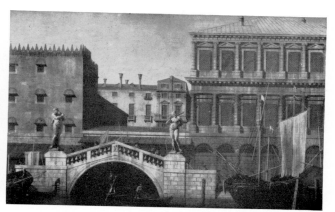

454. Capriccio: the Ponte della Pescaria and buildings on the quay

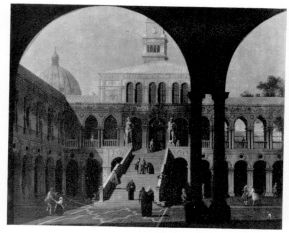

455. Capriccio: the Scala dei Giganti (1744)

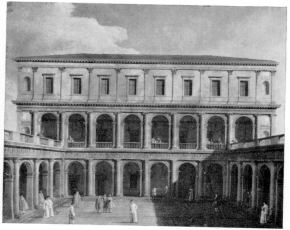

456. Capriccio: the monastery of the Lateran Canons, Venice

PLATE 86

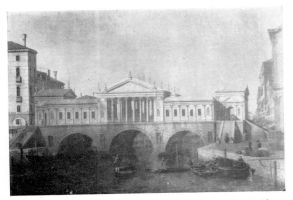

457. Capriccio: a Palladian design for the Rialto Bridge

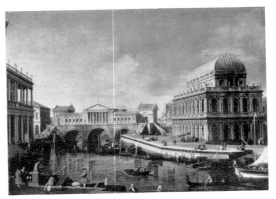

458. Capriccio: a Palladian design for the Rialto Bridge, with buildings at Vicenza

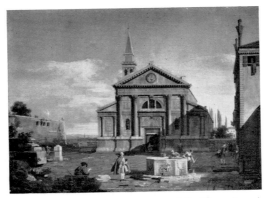

460. Capriccio: with S. Francesco della Vigna (1744)

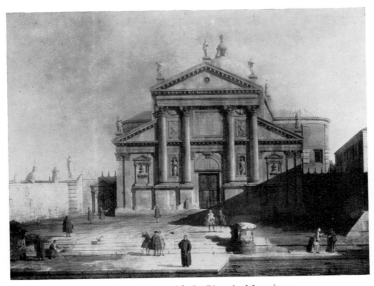

462. Capriccio: with S. Giorgio Maggiore

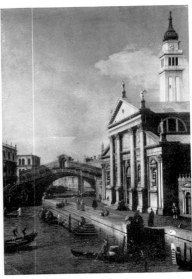

463. Capriccio: with S. Giorgio Maggiore and the Bridge of the Rialto

PLATE 87

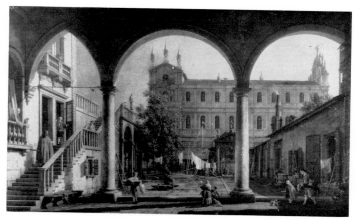

467. Capriccio: with reminiscences of the Scuola di S. Marco

473. Capriccio: river landscape with a ruin and reminiscences of England

474. Capriccio: river landscape with a column, a ruined Roman arch, and reminiscences of England

472. Capriccio: buildings in Whitehall, London

475. Capriccio: a sluice on a river, with a reminiscence of Eton College Chapel (1754)

PLATE 88

477. Capriccio: Roman ruins, with a Renaissance church and the
Colleoni Monument

476. Capriccio: the Colleoni Monument, Venice, set
among ruins (1744)

478. Capriccio: ruins with a domed church
and the Colleoni Monument

479. Capriccio: with reminiscences of Rome and Vienna

PLATE 89

481. Capriccio: a castle on a bridge by the Lagoon

482. Capriccio: a classical triumphal arch by the Lagoon

483. Capriccio: classical ruins and a statue by the Lagoon

484. Capriccio: a classic triumphal arch and a Gothic
building by the Lagoon

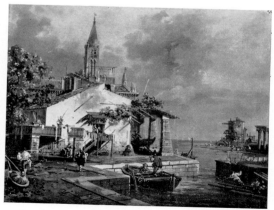

485. Capriccio: a house, a church, and a tower on
the Lagoon

PLATE 90

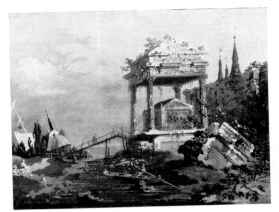

486 (*a*). Capriccio: a tomb by the Lagoon

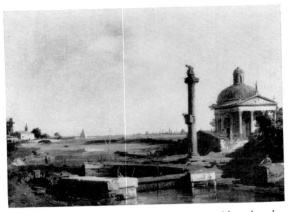

487. Capriccio: an island in the Lagoon, with a church
and a column

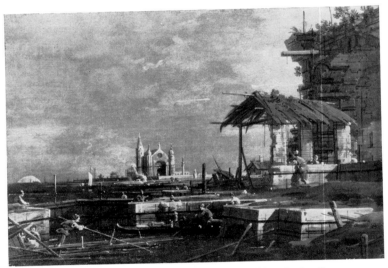

493. Capriccio: ruins by a lock, a Gothic building in the distance

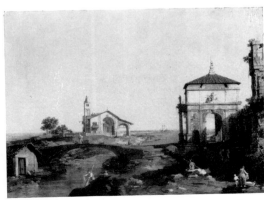

488. Capriccio: an island in the Lagoon, with
a pavilion and a church

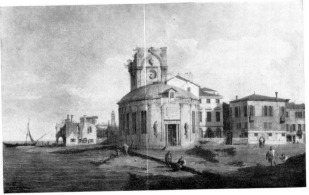

489. Capriccio: an oval church by the Lagoon

PLATE 91

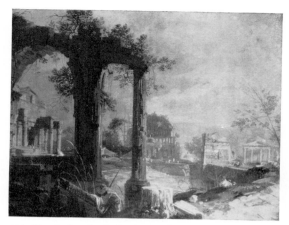

494. Capriccio: classical ruins, with Paduan reminiscences

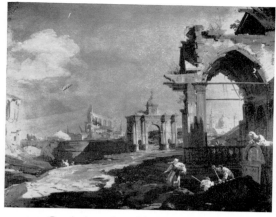

495. Capriccio: ruins with Paduan reminiscences

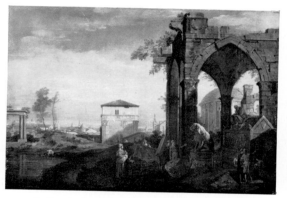

496. Capriccio: ruins with Paduan reminiscences

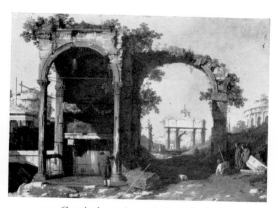

497. Capriccio: ruins and classic buildings

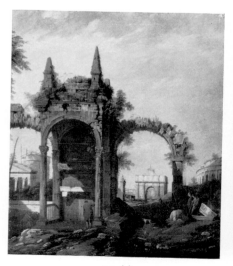

497 (a)

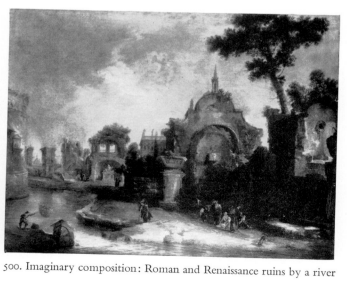

500. Imaginary composition: Roman and Renaissance ruins by a river

PLATE 92

502. Capriccio: with a palace, an obelisk, and a church tower

503. Capriccio: a castellated villa, with a column and a church

504. Capriccio: with a palace, a bridge, and an obelisk

505. Capriccio: a palace with clock tower and a Roman arch

506. Capriccio: a triumphal arch seen from the portico of a palace

507. Capriccio: a round church, with Renaissance and Gothic buildings

PLATE 93

508. Capriccio: a domed circular church

509. Capriccio: a colonnade
opening on to the courtyard
of a palace (1765)

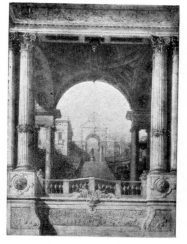

510. Capriccio: a stairway and
triumphal arch seen through
a loggia

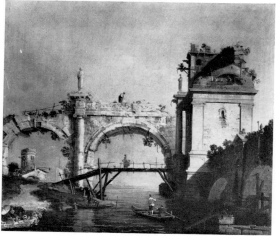

511. Capriccio: a pavilion and a ruined arcade by
the Lagoon

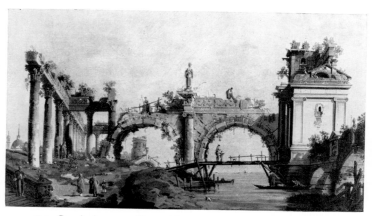

512. Capriccio: a pavilion with a ruined arcade and colonnade,
on the Lagoon (1754)

PLATE 94

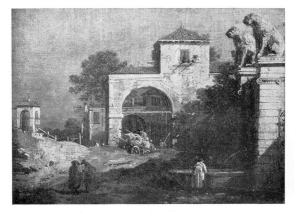

513. A farmhouse on the Venetian mainland

514. A villa and ruins by a river

516. Capriccio: tomb of Lord Somers, with ruins and landscape

517. Capriccio: tomb of Archbishop Tillotson, with ruins and landscape

518. A seaport with a volcano in eruption

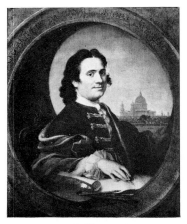

519. Self-portrait

PLATE 95

522. Venice from the Punta della Motta

523. View on the outskirts of Venice

524. Piazza S. Marco: looking East

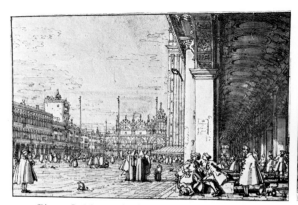

525. Piazza S. Marco: looking East from the South-West Corner

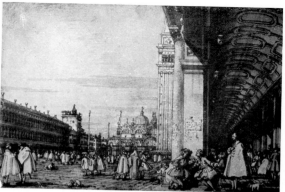

526. Piazza S. Marco: looking East from the South-West Corner

PLATE 96

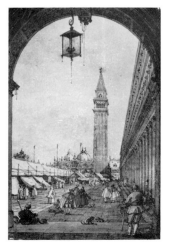

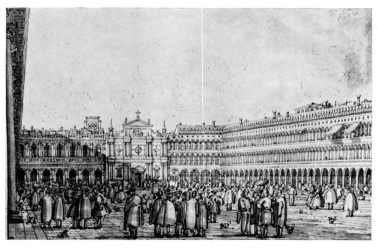

527. Piazza S. Marco: looking
East

529. Piazza S. Marco: looking West

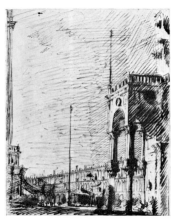

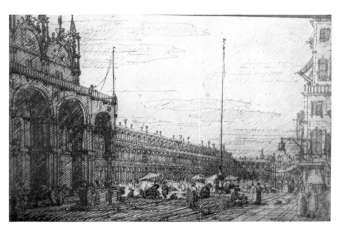

532. Piazza S. Marco: looking
West from the North end of
the Piazzetta

533. Piazza S. Marco: looking West from the Campo di
S. Basso

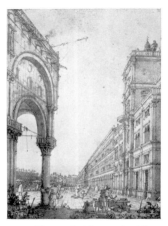

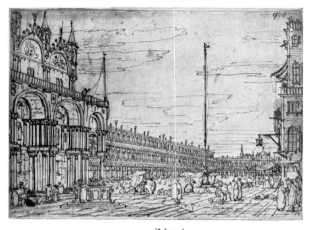

534. Piazza S. Marco: looking
West from the Campo di
S. Basso

533. (Note)

PLATE 97

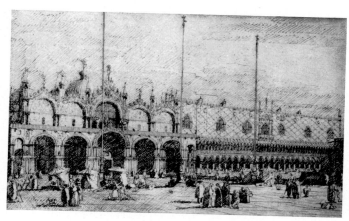

535. Piazza S. Marco:
looking South-East

536. Piazza S. Marco:
looking South-East

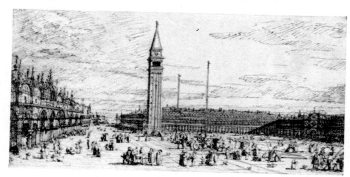

537. Piazza S. Marco:
looking South

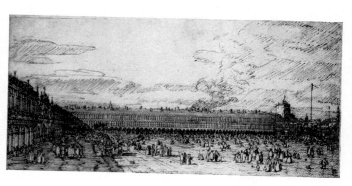

538. Piazza S. Marco:
looking North

PLATE 98

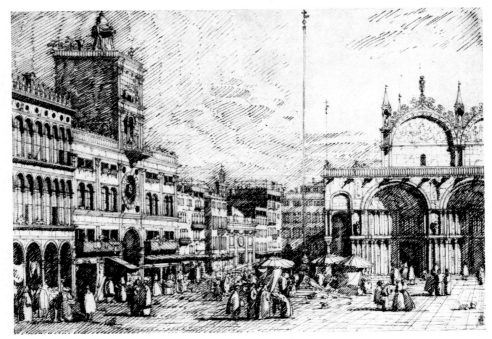

539. Piazza S. Marco: the North-East Corner

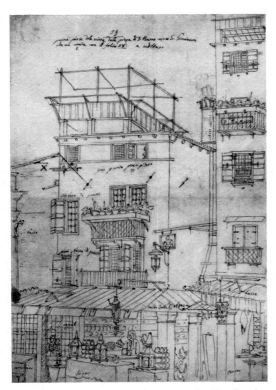

540. Campo di S. Basso: houses on the North side

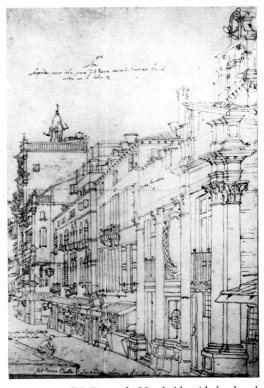

541. Campo di S. Basso: the North side with the church

PLATE 99

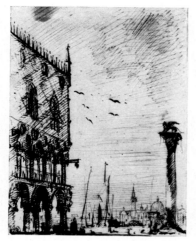

542. The Piazzetta: looking South

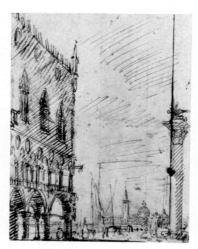

543. The Piazzetta: looking South

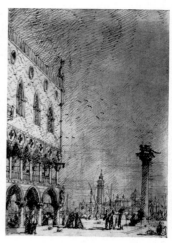

544. The Piazzetta: looking South

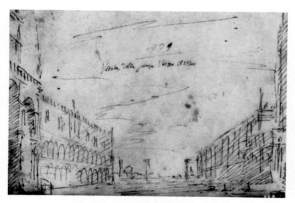

545. The Piazzetta: looking South (1729)

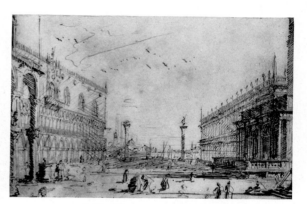

546. The Piazzetta: looking South

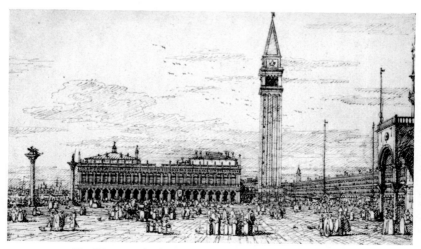

547. The Piazzetta: looking West, with the Library and Campanile

PLATE 100

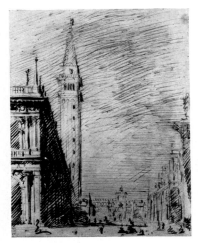

548. The Piazzetta: looking North

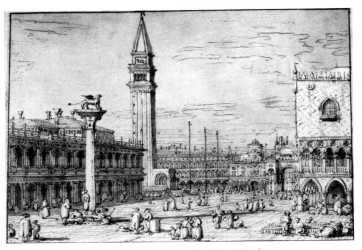

549. The Piazzetta: looking North

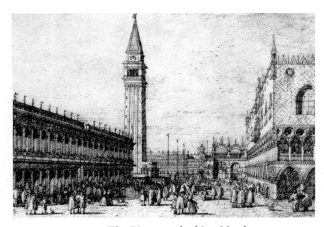

550. The Piazzetta: looking North

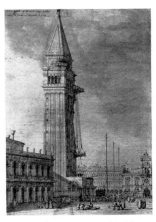

552. The Piazzetta: looking
North, the Campanile under repair

551. The Piazzetta: looking North (1732)

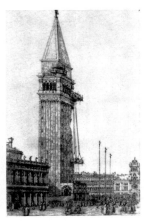

553. The Piazzetta: looking
North, the Campanile under repair

PLATE 101

554. S. Marco: the West front

555. S. Marco: the North front

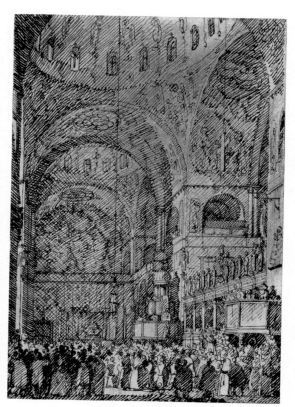

556. S. Marco: the Crossing and North Transept

557. S. Marco: a sarcophagus

PLATE 102

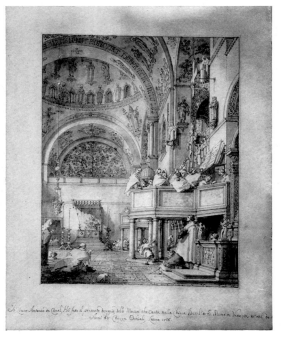

558. S. Marco: the Crossing and North Transept, with musicians singing (1766)

559. S. Marco: interior

560. S. Marco: the South Pulpit

561. S. Marco: the Crossing and Choir

PLATE 103

562. The Molo: looking West, from the Bacino di S. Marco

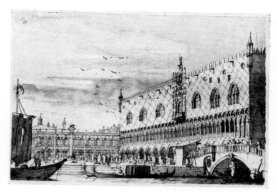

564. The Molo: looking West, from the Bacino di S. Marco

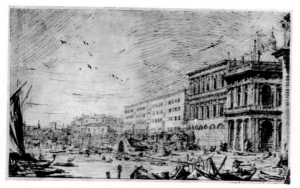

565. The Molo: looking West, the Library Right

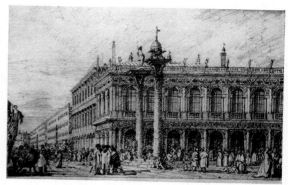

566. The Molo: looking West, the Library Right

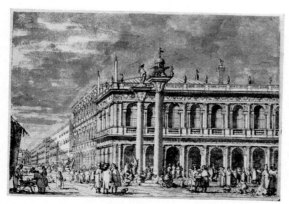

567. The Molo: looking West, the Library Right

568. The Molo: looking West, with the old Fish Market

PLATE 104

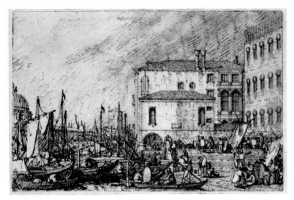

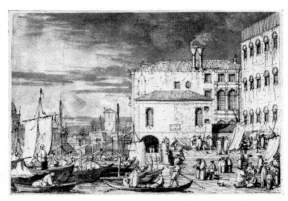

569. The Molo: looking West, with the Fonteghetto
della Farina

570. The Molo: looking West, with the Fonteghetto
della Farina

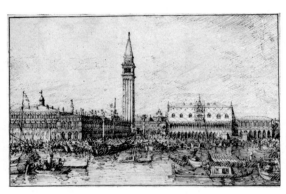

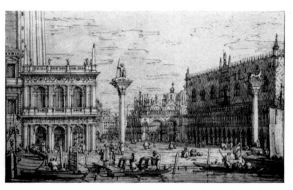

571. The Molo, from the Bacino di S. Marco

572. The Molo and Piazzetta, from the Bacino di S. Marco

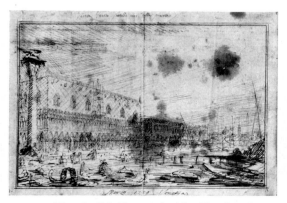

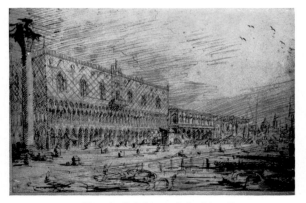

573. Riva degli Schiavoni: looking East (1729)

574. Riva degli Schiavoni: looking East

PLATE 105

575. Riva degli Schiavoni: looking West

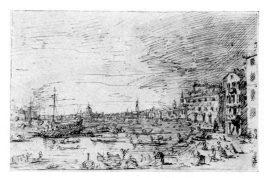

577. Riva degli Schiavoni: looking West

578. Bacino di S. Marco: from the Piazzetta

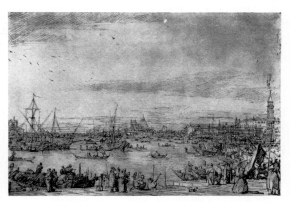

579. Bacino di S. Marco: looking West from the
Riva degli Schiavoni

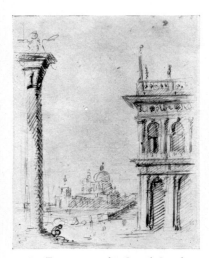

580. Entrance to the Grand Canal:
from the Piazzetta

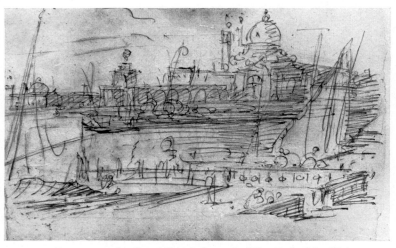

581. Entrance to the Grand Canal: from the West End of the Molo

PLATE 106

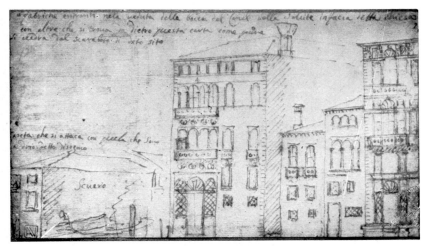

582. Grand Canal: buildings opposite the Salute

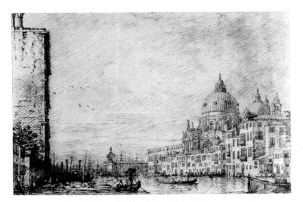

583. Grand Canal: looking East, from near the
Palazzo Corner

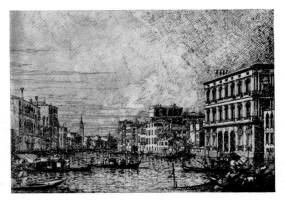

584. Grand Canal: looking North-West from the Palazzo
Corner to the Palazzo Contarini dagli Scrigni

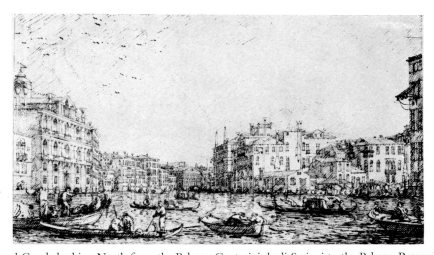

586. Grand Canal: looking North from the Palazzo Contarini dagli Scrigni to the Palazzo Rezzonico

PLATE 107

587. Grand Canal: looking South from the Palazzo Rezzonico to Sta Maria della Carità

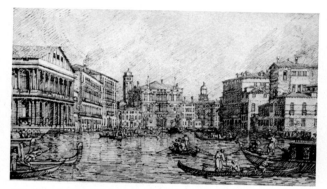

588. Grand Canal: looking North from the Palazzo Rezzonico to the Palazzo Balbi

589. Grand Canal: the Palazzi dei Mocenigo and others

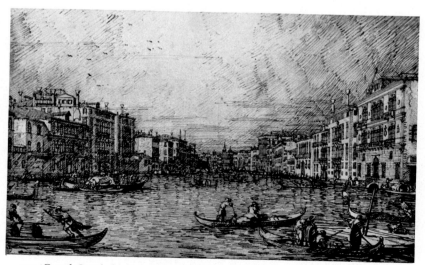

590. Grand Canal: looking North-East from the Palazzo Corner-Spinelli to the Rialto Bridge

PLATE 108

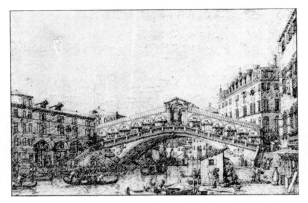

591. Grand Canal: the Rialto Bridge from the South

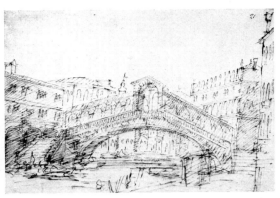

592. Grand Canal: the Rialto Bridge from the South

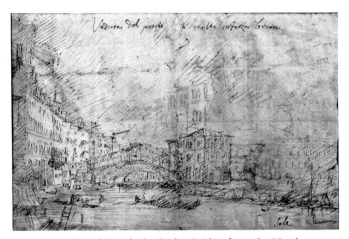

593. Grand Canal: the Rialto Bridge from the North

594. Grand Canal: buildings opposite the Vegetable Market

595. Grand Canal: buildings behind the house of Consul Smith and the Leon Bianco

PLATE 109

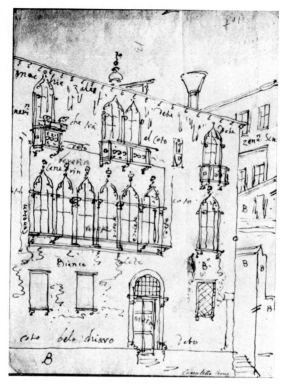

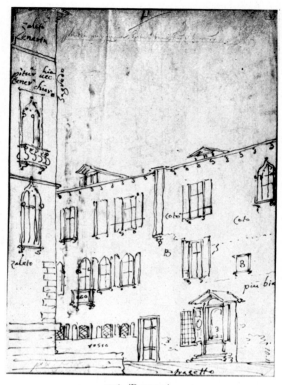

596. Grand Canal: the Palazzo Foscari and the Campo
S. Sofia (Obverse)

596. (Reverse)

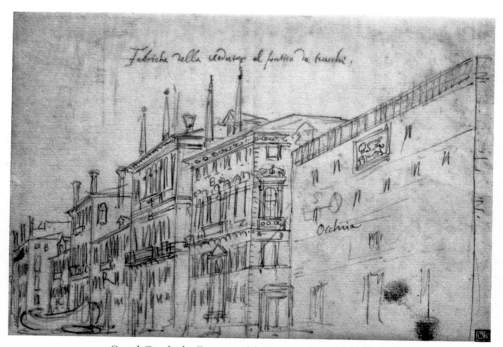

597. Grand Canal: the Deposito del Megio and neighbouring palaces

PLATE 110

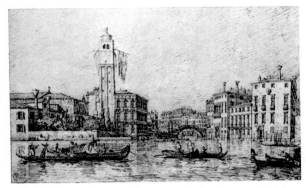

598. Grand Canal: S. Geremia and the entrance to the
Cannaregio

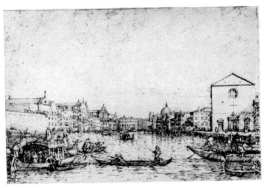

599. Grand Canal: looking North-East from Sta
Croce to S. Geremia

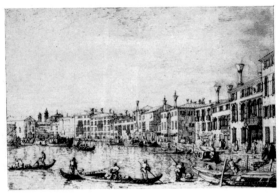

600. Canale di Sta Chiara: looking South-East along the
Fondamenta della Croce (I)

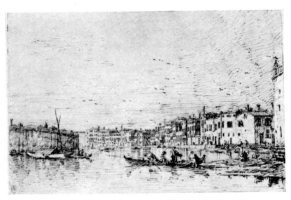

602. Canale di Sta Chiara: looking South-East along the
Fondamenta della Croce (III)

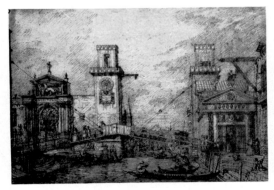

603. The Arsenal: the Water Entrance

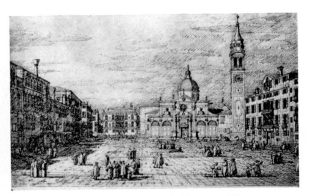

605. Campo Sta Maria Formosa (II)

PLATE III

607. Campo S. Stefano (now
Francesco Morosini)

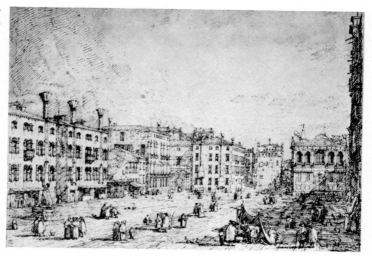

608. A canal in Venice
(Rio S. Barnaba?)

609. S. Francesco della Vigna:
Church and Campo

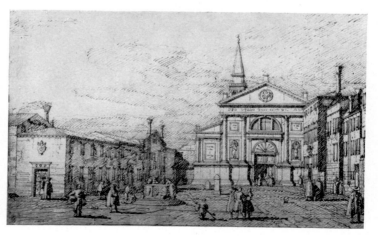

PLATE 112

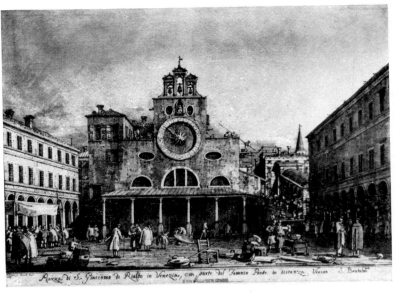

610. Church of the Gesuati
(Sta Maria del Rosario)

611. S. Giacomo di Rialto

612. S. Giorgio Maggiore from the Canale di Giudecca

613. SS. Giovanni e Paolo and the Scuola di S. Marco

614. S. Giuseppe

615. Sta Maria della Pietà

PLATE 113

617. Sta Marta and houses adjoining (Recto)

617. (Verso)

616. Sta Maria della Salute

618. Sta Marta and the shore of the Lagoon (Recto)

619. S. Nicolò da Tolentino, with houses and gardens

PLATE 114

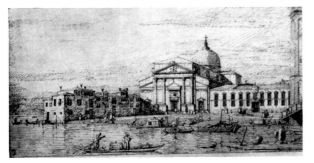

620. S. Pietro in Castello

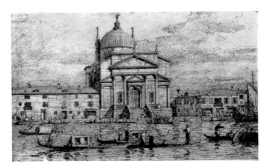

621. Il Redentore

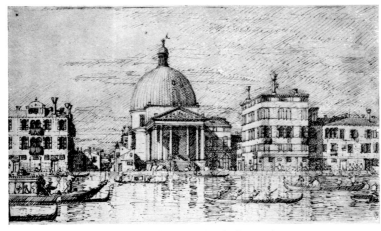

622. S. Simeone Piccolo (*c.* 1738)

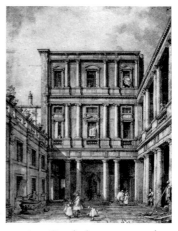

623. Capriccio: a courtyard

624 (*a*). Scuola di S. Marco

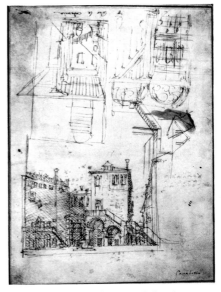

626. Four architectural sketches

PLATE 115

627. Houses and a campanile, Venice

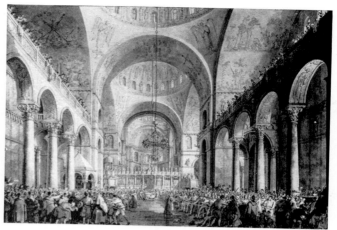

630. The newly elected Doge presented to the people in S. Marco

628. A palace on a canal

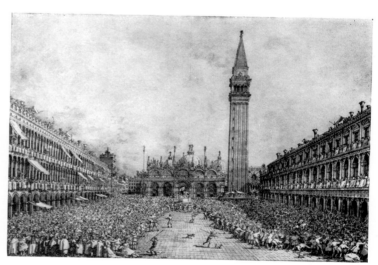

631. The Doge carried round the Piazza di S. Marco

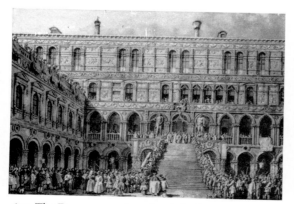

632. The Doge crowned on the Scala dei Giganti of the Ducal Palace

633. The Doge returns thanks in the Sala del Consiglio Maggior

PLATE 116

634. The Doge in the Bucintoro departing for
the Porto di Lido on Ascension Day

635. The Doge in the Bucintoro leaving S. Nicolò
di Lido

636. The Doge attends the Giovedi Grasso Festival in
the Piazzetta

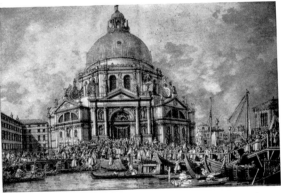

637. Annual visit of the Doge to Sta Maria della Salute

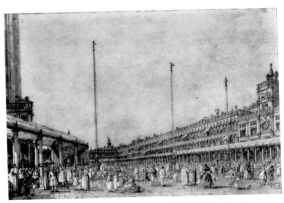

638. Procession on Corpus Christi Day in the
Piazza S. Marco

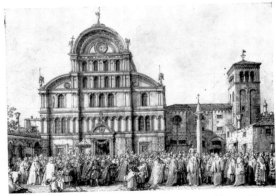

639. Visit of the Doge to S. Zaccaria on Easter Day

PLATE 117

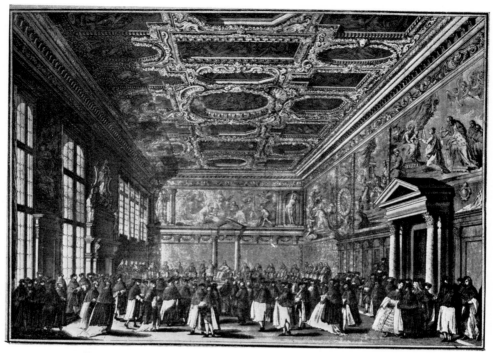

640. Reception by the Doge of foreign ambassadors on the Sala del Collegio

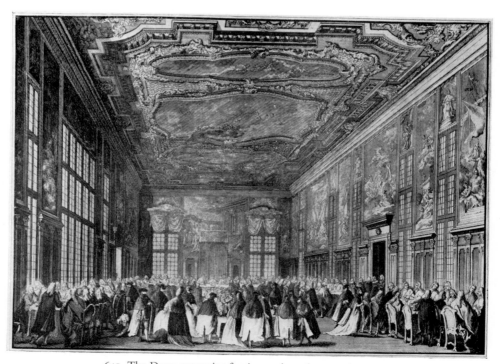

641. The Doge entertains foreign ambassadors at a banquet

PLATE 118

642. The Bucintoro at the Molo

643. The Bacino di S. Marco, with the Bucintoro at
the Molo

644. Bridge of Boats leading to the Redentore across the
Giudecca Canal

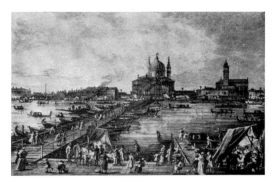

644. (Note)

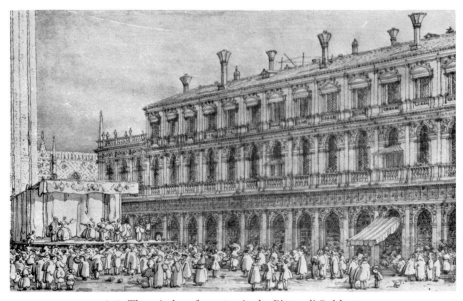

646. Theatrical performance in the Piazza di S. Marco

PLATE 119

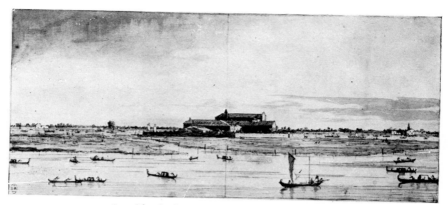

649. Island of S. Elena, the Lido in the distance

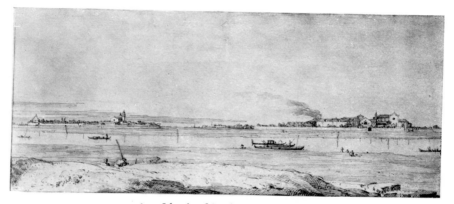

650. Islands of S. Elena and S. Pietro

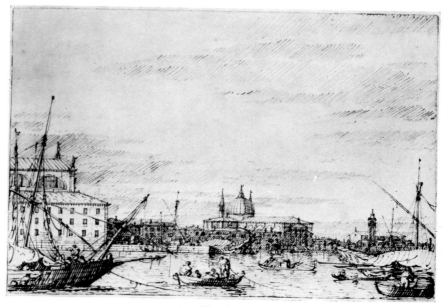

651. The Giudecca

PLATE 120

652 (a) and (b). The Lido: the waterfront

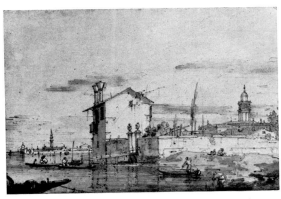

653. The island of S. Michele, with Venice in the distance 654. The island of S. Michele, with Venice in the distance

655. Murano: S. Giovanni dei Battuti, with Venice in
the distance

655 (a)

PLATE 121

655 (b)

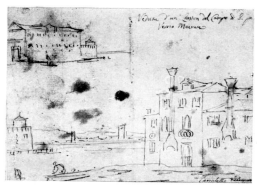

656. Island of S. Pietro: looking towards Murano

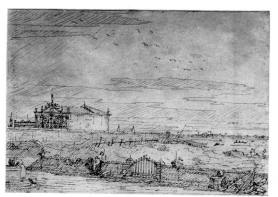

657. A church (?) by the Venetian Lagoon

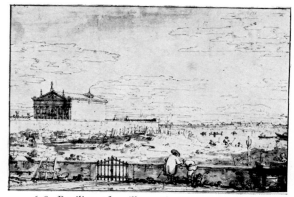

658. Pavilion of a villa on the Venetian Lagoon

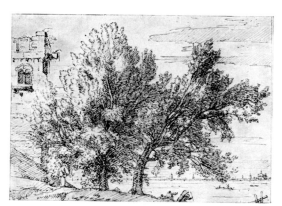

659. Trees and a tower on an island in the Lagoon

661. A bridge with a glimpse of the Lagoon

PLATE 122

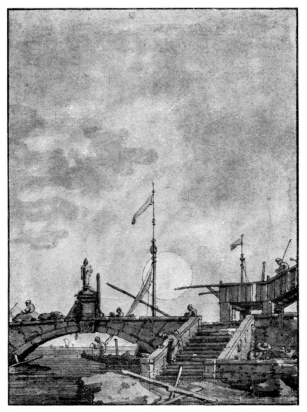

662. A bridge at the opening of a canal into the Lagoon

663. A house on the Lagoon

664. The Lagoon, looking towards the Mainland

665. Roofs and houses near the Lagoon

PLATE 123

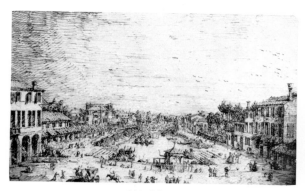

666. Mestre

667. Dolo (?): entrance to the Brenta Canal

668. 'Le Porte del Dolo'

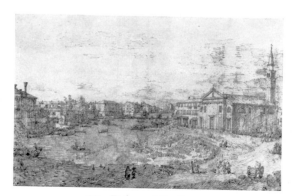

669. Dolo and the Brenta

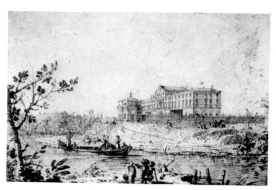

671. Villa Tron, on the Brenta (I)

PLATE 124

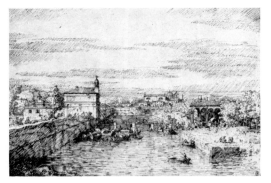

675. Padua: the Brenta Canal and the Porta Portello (I)

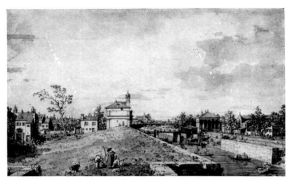

676. Padua: the Brenta Canal and the Porta Portello (II)

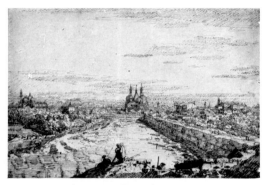

677. Padua: view from the ramparts with
S. Antonio (I)

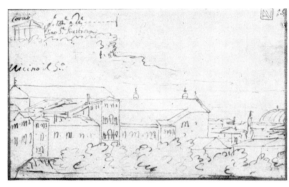

679. Padua: sketches of buildings, with S. Francesco and
the Salone

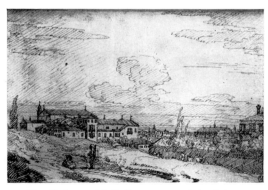

680. Padua: with S. Francesco and the Salone

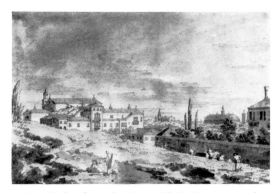

681. Padua from the East, with S. Francesco and
the Salone

PLATE 125

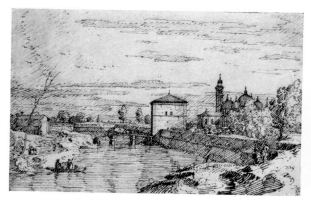

682. Padua: the ramparts and Sta Giustina

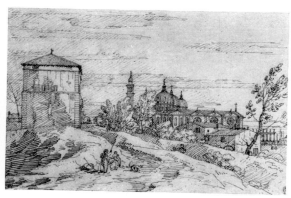

683. Padua: view from the ramparts with Sta Giustina

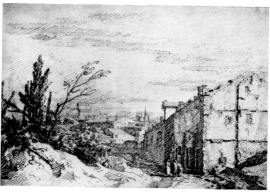

684. Outskirts of Padua: the tower of Ezzelino and
S. Antonio in the distance (I)

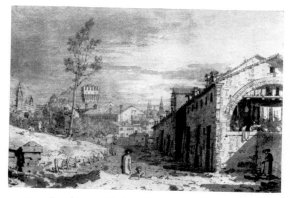

685. Outskirts of Padua: the tower of Ezzelina and
S. Antonio in the distance (II)

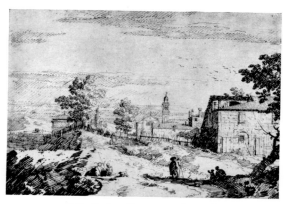

686. Padua, from near the walls

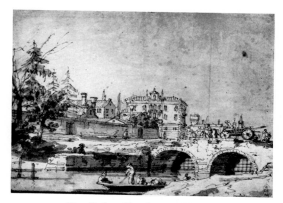

687. Padua (?): river and bridge

PLATE 126

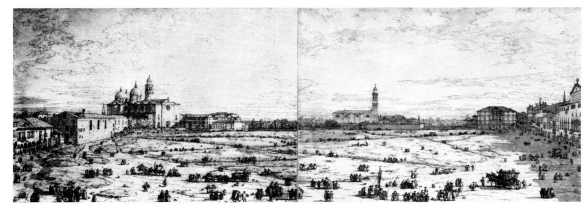

689. Padua: the Prato della Valle, with S. Giustina 690. Padua: the Prato della Valle, with the Chiesa della Misericordia

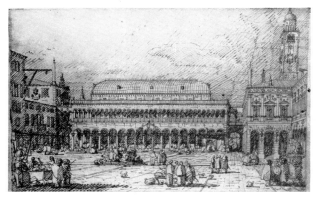

688. Padua: Piazza delle Erbe, with the Palazzo della Ragione

692. Paduan Capriccio: the terrace

693. Padua: the ramparts and a city gate

694. A farm on the outskirts of Padua

PLATE 127

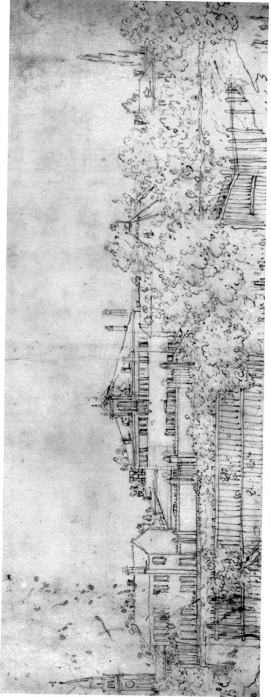

695 (*a*) and (*b*). Panoramic view of houses and gardens by a river at Padua (?) (1742)

PLATE 128

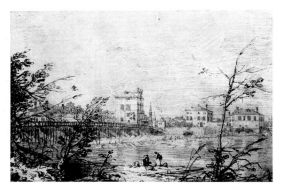

696. Footbridge over a river at Padua (?)

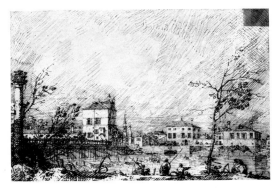

697. A footbridge over a river at Padua (?)

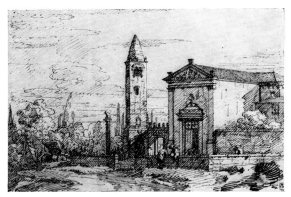

698. A church by a roadside

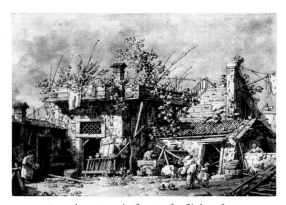

699. A cottage in front of a flight of steps

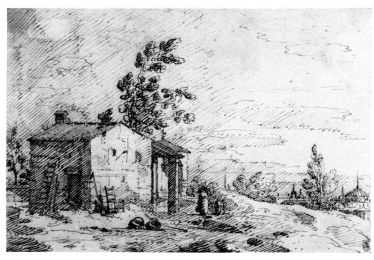

700. Rustic cottage, and distant view of a city

PLATE 129

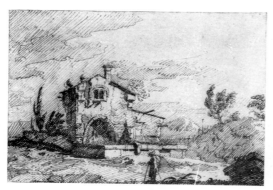

701. A cottage with arched windows and a fountain

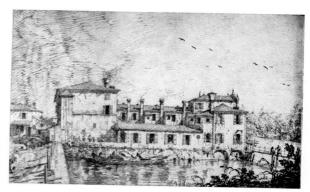

703. House on a river

704. Houses and a walled garden by a stream (Note)

706. House with an arched doorway, by a country
road (II)

707. Courtyard and pavilion of a villa

PLATE 130

708. A villa with a statue in the foreground

710. Statues in the grounds of a villa (II)

711. A water-wheel

713 (221). The Tiber and Rome, from the Basilica of
S. Valentino on the Via Flaminia

713 (222). Arch of Constantine

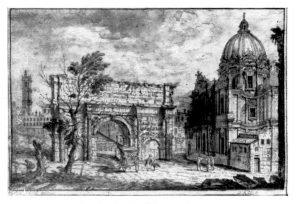

713 (223). Arch of Septimius Severus

PLATE 131

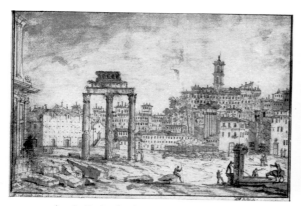

713 (224). Ruins in the Forum, looking towards
the Capitol

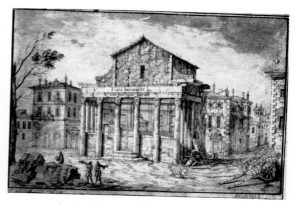

713 (225). Temple of Antoninus and Faustina

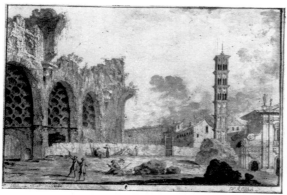

713 (226). The Basilica of Constantine, left, and
S. Francesca Romana, right

713 (230). Pyramid of Cestius, centre, and the Porta
S. Paolo, right

713 (232). A half-domed ruin (Caldarium, Baths of
Caracalla?)

713 (234). Church of SS. Domenico e Sisto

PLATE 132

713 (235). The Colosseum

713 (237). The Temple of Venus and Rome, with
S. Francesca Romana

713 (238 (19)). The Cordonata and the Buildings of the
Piazza del Campidoglio, with Sta Maria d'Aracoeli

713 (240). The Tiber from the Ponte Fabricius

713 (241). Piazza of S. Giovanni in Laterano

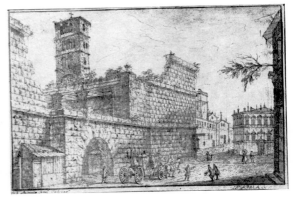

713 (242). Temple of Mars Ultor, and the Arco
dei Pantani

PLATE 133

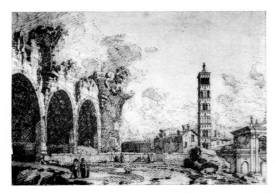

714. The Forum, with the Basilica of Constantine and
S. Francesca Romana

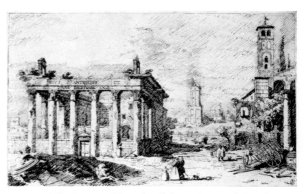

715. The Forum: Temple of Antoninus and Faustina

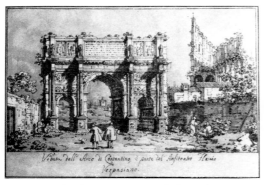

716. Arch of Constantine, with the Colosseum

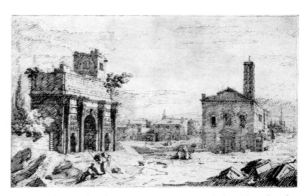

717. The Arch of Septimius Severus and the Church of
S. Adriano

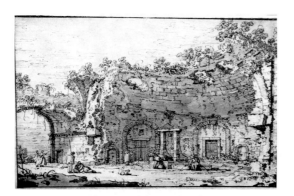

718. The Caldarium of the Baths of Caracalla (?)

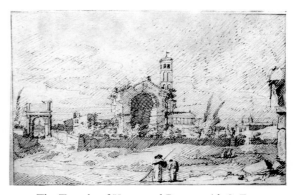

720. The Temple of Venus and Rome, with S. Francesca
Romana and the Arch of Titus

PLATE 134

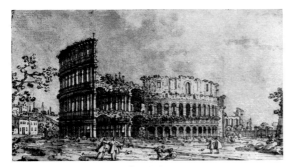

721. The Colosseum

722. Pyramid of Cestius and the Porto S. Paolo, Rome

724. SS. Domenico and Sisto

727. Piazza di S. Giovanni in Laterano

728. The Tiber, with the Ponte Rotto and Sta Maria in Cosmedin (I)

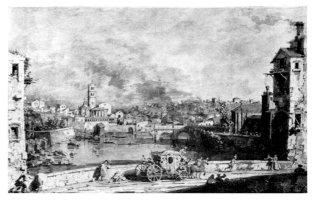

729. The Tiber, with the Ponte Rotto and Sta Maria in Cosmedin (II)

PLATE 135

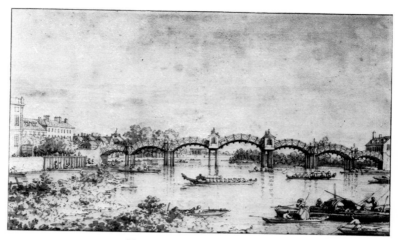

730. Hampton Court Bridge, Middlesex

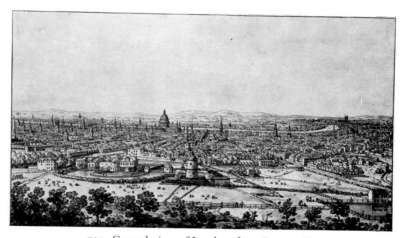

731. General view of London, from Pentonville

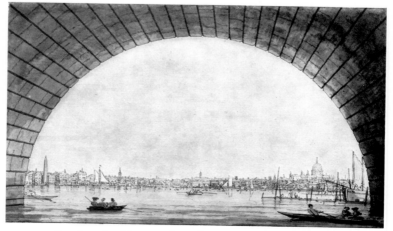

732. London: the City seen through an arch of Westminster Bridge

PLATE 136

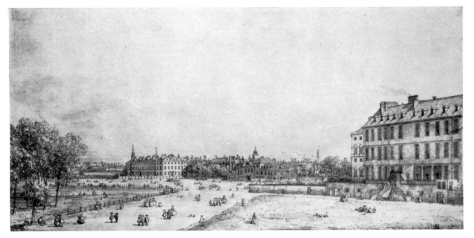

734. London: the Old Horse Guards, from St. James's Park

735. London: the Old Horse Guards and the Banqueting Hall,
Whitehall

736. London: Little Walsingham House,
Whitehall

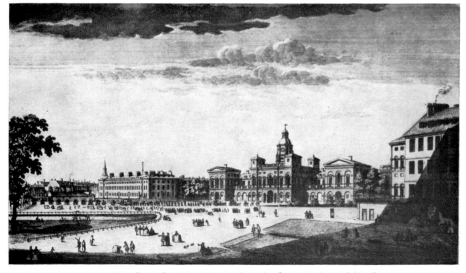

737. London: the New Horse Guards, from St. James's Park

PLATE 137

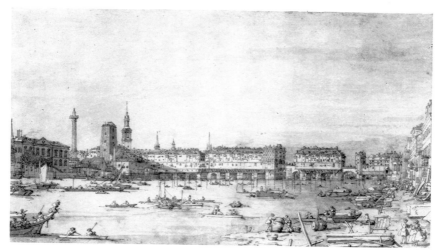

738. London: Old London Bridge

739. London: the Monument

740. London: Northumberland House

741. I (*a*)

741. I (*b*)

London: Ranelagh, Exterior of the Rotunda

PLATE 138

743. London: Old Somerset House from the River Thames

744. London: the Thames and the City of London from the terrace of
Richmond House

745. London: the Thames from the terrace of Somerset House
the City in the distance

PLATE 139

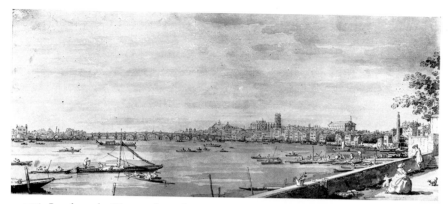

746. London: the Thames from the terrace of Somerset House, Westminster Bridge
in the distance

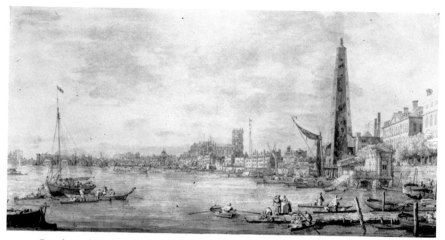

747. London: the Thames, looking towards Westminster from near York Water-Gate

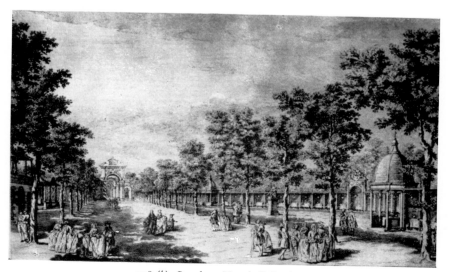

748 (b). London: Vauxhall Gardens

PLATE 140

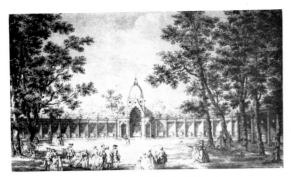

748 (*c*). London: Vauxhall Gardens

748 (*d*). Vauxhall Gardens, Centre Cross Walk

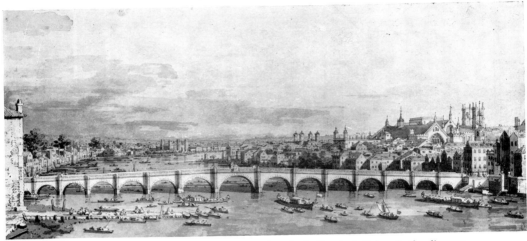

749. London: Westminster Bridge from the North, Lambeth Palace in the distance

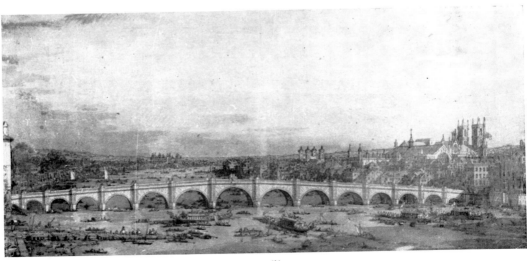

749 (*b*)

PLATE 141

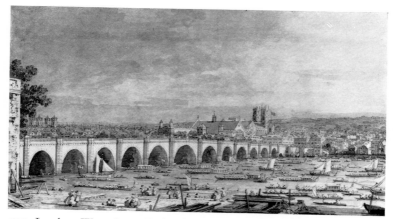

750. London: Westminster Bridge from the North-East, with a procession of civic barges

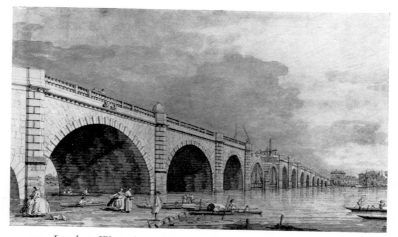

751. London: Westminster Bridge under repair: from the South-West

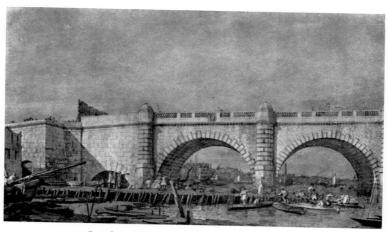

752. London: Westminster Bridge, the western arches

PLATE 142

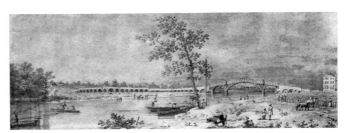

753. London: Westminster Bridge, the western arch
with adjacent buildings

755. Old Walton Bridge

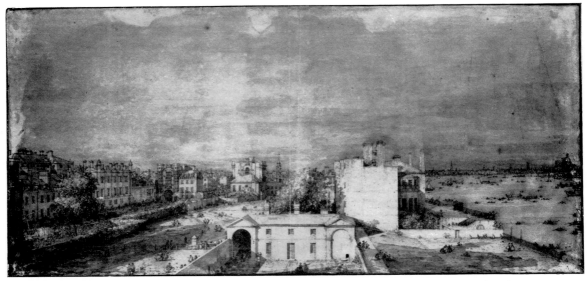

754. London: Whitehall and the Privy Garden looking North with Montagu House and the Thames

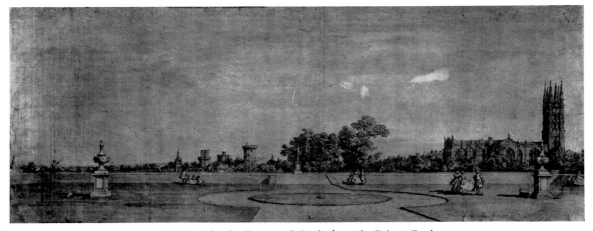

756. Warwick: the Town and Castle from the Priory Gardens

PLATE 143

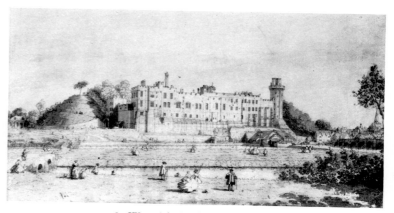

757. Warwick: St. Mary's Church

758. Warwick Castle: the South Front

759. Warwick Castle: the East Front

760. Warwick Castle: the East Front from the courtyard

PLATE 144

761. Capriccio: the Loggetta of Sansovino as portico of an imaginary church

762. Capriccio: a church with a porch based on the Loggetta of Sansovino

763. Capriccio: the Zecca and the Ponte della Pescaria

764. Capriccio: with the Fonteghetto della Farina (I)

766. Capriccio: with the Rialto Bridge

PLATE 145

767. Capriccio: with the Convent of the Corpus Domini set in the Lagoon (I)

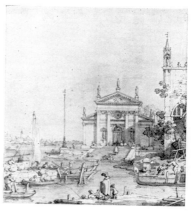

771. Capriccio: with S. Giorgio Maggiore (?)

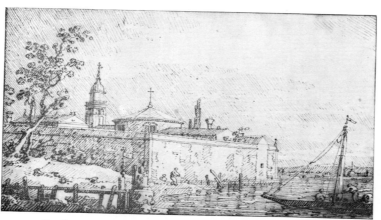

768. Capriccio: with the Convent of the Corpus Domini set in the Lagoon (II)

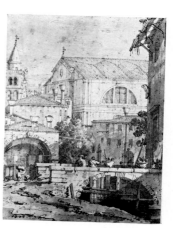

772. Capriccio: with S. Lorenzo and other Venetian buildings

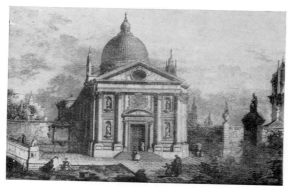

769. Capriccio: with the Chiesa dei Gesuati (Sta Maria del Rosario)

770. Capriccio: with S. Giorgio Maggiore

PLATE 146

773. Capriccio: S. Marco set upon an island

774. Capriccio: S. Pietro di Castello in fanciful surroundings

775. Capriccio: with the Redentore

776. Capriccio: with S. Salvatore

777. Capriccio: with S. Simeone Piccolo

777. (Note)

PLATE 147

778. Capriccio: with reminiscences of S. Donato, Murano (I)

779. Capriccio: with reminiscences of S. Donato, Murano (II)

780. Capriccio: with a distant view of Padua

781. Capriccio: with river and bridge at Padua (?)

782. Capriccio: based on reminiscences of Palladio and Padua (?)

783. Capriccio: with the Arco dei Pantani, and the Temple of Mars Ultor

PLATE 148

784. Capriccio: the Temple of Saturn, in imaginary
surroundings

785. Capriccio: the Temple of Vespasian, in imaginary
surroundings

786. Capriccio: with reminiscences of Westminster
Bridge and Old Montagu House

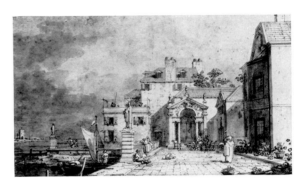

786 (a)

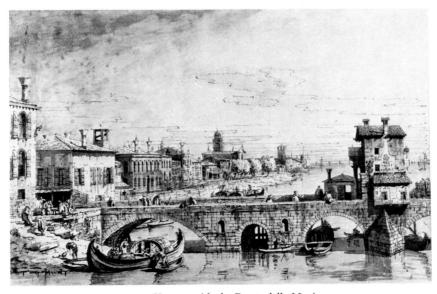

792. Verona with the Ponte delle Navi

PLATE 149

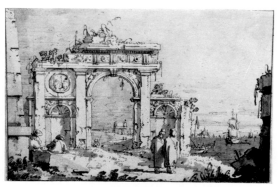

789. Capriccio: a classic triumphal arch by the Lagoon

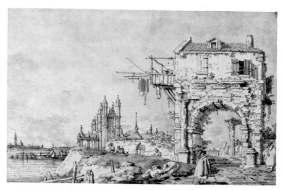

790. Capriccio: a ruined arch and a Gothic building by the Lagoon

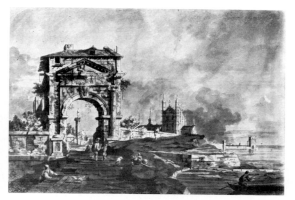

791. Capriccio: an arch and a Gothic building by the Lagoon

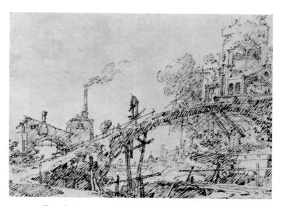

793. Capriccio: a castle and a bridge on the Lagoon

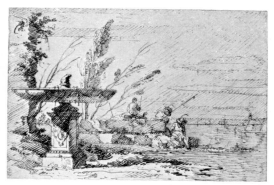

794. Capriccio: a fountain and ruins by the Lagoon

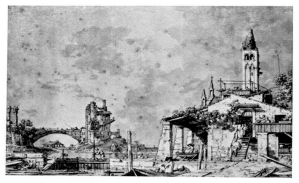

797. Capriccio: house, church, tower, and bridge by the Lagoon

PLATE 150

795 (b). Capriccio: a house and tower on the Lagoon (I)

796. Capriccio: a house and tower on the Lagoon (II)

798. Capriccio: an island in the Lagoon with a Gothic church

799. Capriccio: an island in the Lagoon, with a Gothic church and monastery

PLATE 151

800. Capriccio: classic ruins by the Lagoon

801. Capriccio: classic ruins on a quay, mountains in the background

802. Imaginary composition: ruins and a bridge by the Lagoon

803. Imaginary composition: ruined mill and houses by the Lagoon

804. Imaginary composition: ruins of a church by the Lagoon

PLATE 152

805. Imaginary composition: a church on a hill,
the Lagoon in the distance

805. (Note)

806. Imaginary composition: a round tower and ruins
by the Lagoon

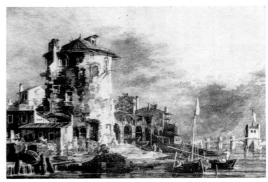

806. (Note)

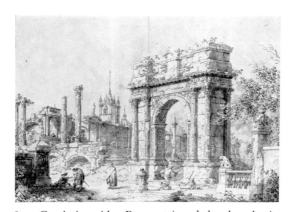

807. Capriccio, with a Roman triumphal arch and ruins

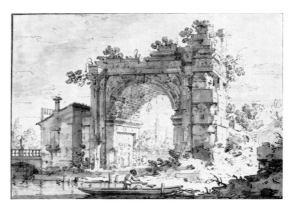

808. Capriccio: a ruined Roman arch in a rustic setting

PLATE 153

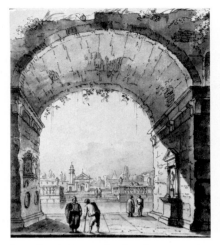

809. Capriccio: a ruined archway opening
on a canal, and a terrace with a church

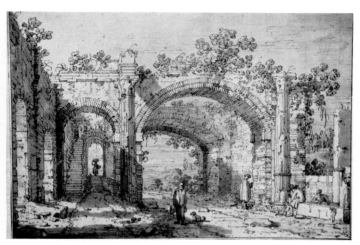

811. Capriccio: with a ruined Roman portico (II)

812. Capriccio: a ruined classical temple

813. Capriccio: a ruined colonnade with a tomb

814. Capriccio: a canopied Gothic tomb with Roman ruins

815. Capriccio: with ruins of a domed building and
a triumphal arch

PLATE 154

816. Ruins and houses

817. Imaginary composition: a house and column adjoining
a ruined arch

818. Imaginary composition: design for a title-page

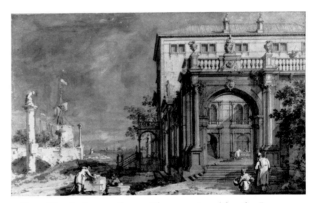

819. Capriccio: a palace with a courtyard by the Lagoon

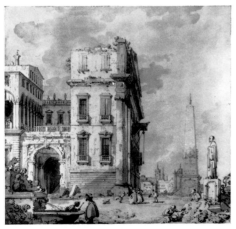

820. Capriccio: a palace with an obelisk and
a statue

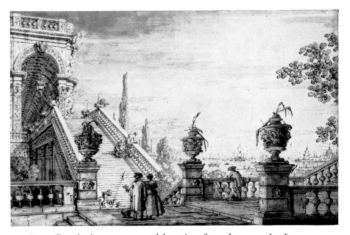

821. Capriccio: terrace and loggia of a palace on the Lagoon

PLATE 155

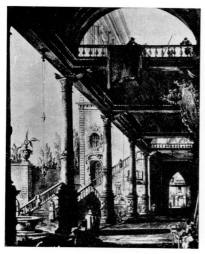

822. Capriccio: a colonnade opening on
to the courtyard of a palace

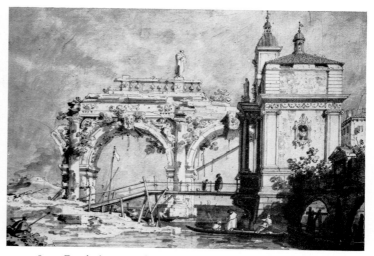

823. Capriccio: a pavilion and a ruined arcade by the Lagoon

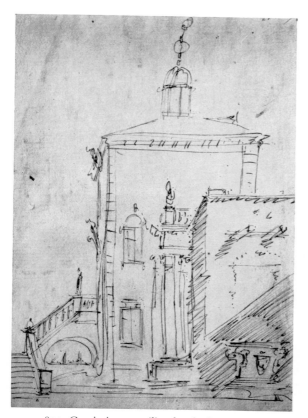

824. Capriccio: a pavilion by the Lagoon (I)

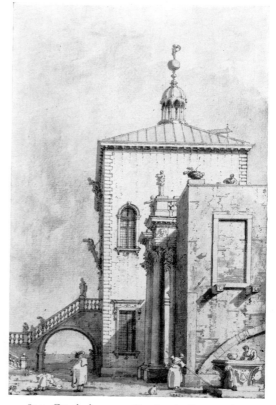

824. Capriccio: a pavilion by the Lagoon (II)

PLATE 156

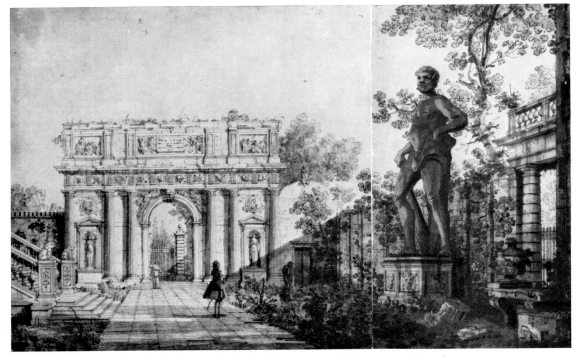

827. Capriccio: a classical arch in a garden with a statue of Hercules

826. Capriccio: a courtyard with a portico

828. Capriccio: a garden seen from a baroque vestibule

PLATE 157

830. Capriccio: a domed church by the Lagoon

831. Capriccio: a sluice-gate on a river, with a church

832. Capriccio: church, pavilion, and walled garden by the Lagoon

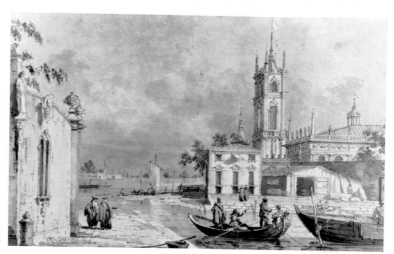

PLATE 158

833. Five men

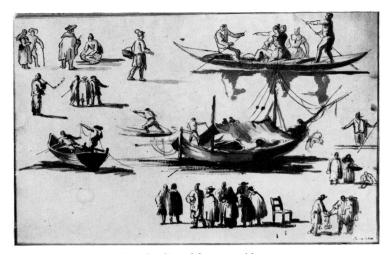

836. Studies of figures and boats

837 (1). Two sheets of figure studies

837 (2)

838. Three groups of figures: market scenes

PLATE 159

839 (Obverse and Reverse). Two studies of men, standing

840 (Obverse and Reverse). Two studies of men, standing

841. Two seated men, and a third standing

842. Two groups of men, and woman

843. Studies of men and a gondola

PLATE 160

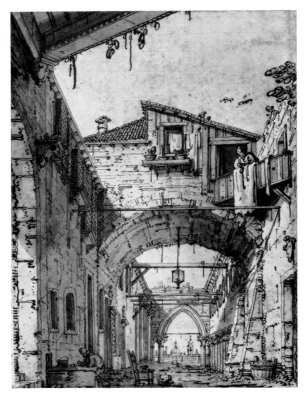

845. A street crossed by arches

846. A bridge and adjacent buildings

847. Houses and other buildings

848. A church by a canal crossed by a wooden bridge

(See also Pl. 223)

PLATE 161

849. A domed church, with a statue

850. Two churches and a palatial
gateway

852. A masted war galley

PLATE 162

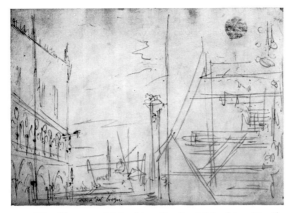

2*v*. The Piazzetta (1) looking South, (2) looking North

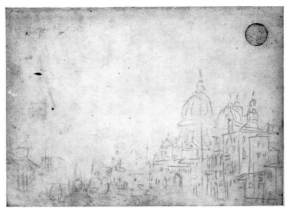

3*r*. The Grand Canal: Entrance, looking East

4*r*. The Molo looking West

7*v*. Man in a turban

6*r*. The Molo, the two columns and the Library

PLATE 163

13v
Houses on site of Palazzo
Venier dei Leone

14r
Palazzi da Mula and
Barbarigo

12v
Palazzi Loredan and
Contarini dal Zaffo

13r
Campanile of Carità and
houses

11v
Palazzi Barbaro and
Franchetti

12r
Palazzo Foscolo

10v
Traghetto S. Maurizio and
Palazzo Pisani

11r
Palazzi Pisani and Corner

7r
The Fondeghetto della Farina,
the Palazzo Giustiniani behind

8r
Piazza S. Marco and the
Piazzetta

PLATE 164

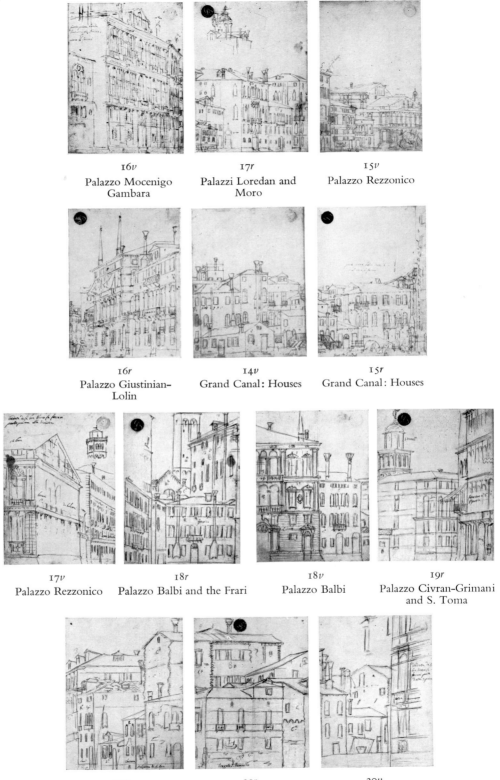

16*v*
Palazzo Mocenigo
Gambara

17*r*
Palazzi Loredan and
Moro

15*v*
Palazzo Rezzonico

16*r*
Palazzo Giustinian-
Lolin

14*v*
Grand Canal: Houses

15*r*
Grand Canal: Houses

17*v*
Palazzo Rezzonico

18*r*
Palazzo Balbi and the Frari

18*v*
Palazzo Balbi

19*r*
Palazzo Civran-Grimani
and S. Toma

19*v*
Palazzo Moro-Lin and
houses

20*r*
Traghetto of S. Samuele

20*v*
Campo S. Samuele

PLATE 165

24v
Palazzi Capello-Layard and Grimani

25r
Palazzo Querini-Dubois

23v
Palazzi Bernardo and Dona

24r
Palazzo Dona

22v
Palazzi and Rialto Bridge

23r
Traghetto di S. Benedetto

21v
Palazzi Curti and Benzon

22r
Palazzo Corner-Spinelli

28v
Convent and Church of Corpus Domini

29r

27v
Church of Sta Lucia

28r
Church of the Scalzi

26v
Palazzo Calbo-Crotta

27r
S. Simeone Piccolo and houses

25v
Fondamenta di S. Simeone Piccolo

26r
Church of Sta Croce

PLATE 166

33r
Wall of Convent of
Corpus Domini

32v
Fondamenta di Sta Chiara:
houses

32r 31v
Fondamenta di Sta Chiara: houses

31r 30v
Fondamenta di Sta Chiara: houses and shops

30r 29v
Fondamenta di Sta Chiara: houses and church

35v
Arsenal wall: house

36r
Gate of Arsenal

34v
Tower of Arsenal

35r
Madonna dell'Arsenale

PLATE 167

39r
Campo Sta Maria Forimosa: East side

37v

38r
Sta Maria Formosa

36v
Sta Maria Formosa

37r
Campo Sta Maria For-
mosa: West side

45v

46r
S. Giorgio Maggiore and the Redentore

44v
The Giudecca

45r

43v

44r
Sta Maria della Salute and the Dogana

42v
Grand Canal: Entrance looking West

43r

41v
The Molo: West

42r

40v
The Molo: East and Centre

41r

PLATE 168

47r
Palazzi Giovanelli and Bembo

46v
Palazzo Bembo

49v
Grand Canal: houses

49r
Palazzo Correr-
Contarini

48v
Palazzo Gritti and
Campo S. Marcuolo

48r
Palazzo Vendramin-
Calergi

47v
Palazzo Marcello and
others

52r
SS. Giovanni e Paolo: façade

51v

51r
SS. Giovanni e Paolo

50v
Campo SS. Giovanni e Paolo

PLATE 169

52v
53r
53v
54r

S. Simeone Piccolo and the Fondamenta

54v
55r
55v

Palazzo Grimani
Palazzo Tron and others

56r
56v
57r

Palazzi Martinengo and
Benzon
Palazzi Curti and Corner-
Spinelli
Palazzo Garzoni and others

PLATE 170

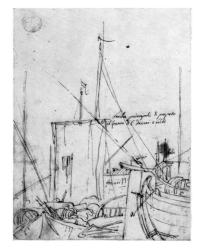

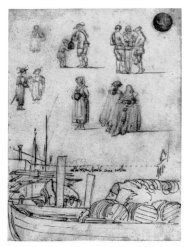

57v
Boats and barges

58r
Barges and figure studies

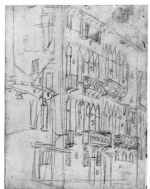

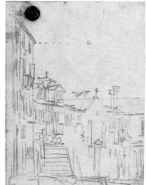

63v
Palazzo Testa

63r
Houses on the Fondamenta di S. Giobbe

62v

62r

61v

Ponte dei Tre Archi

61r
Palazzo Surian-Bellotto

60v
Houses on the Fondamenta
di Cannaregio

PLATE 171

64r
64v
Palazzo Loredan-Vendramin-Calergi

65r
Palazzo Marcello and others

65v
Palazzi Molin and Barbarigo

66r
Palazzo Barbarigo and others

66v
Palazzo Boldù

67r
Palazzo Contarini-Pisani

67v
Palazzo Belloni-Battagia

72r
Palazzo Fontana

70v
Palazzo Civran and houses

71r
Pescharia and Fabbriche Nuove di Rialto

69v
Fondamenta dell'Olio

70r
Casa Favretto and Palazzo dei Brandolin

68v
Palazzi Dona and Correggio

69r
Palazzo Pesaro

PLATE 172

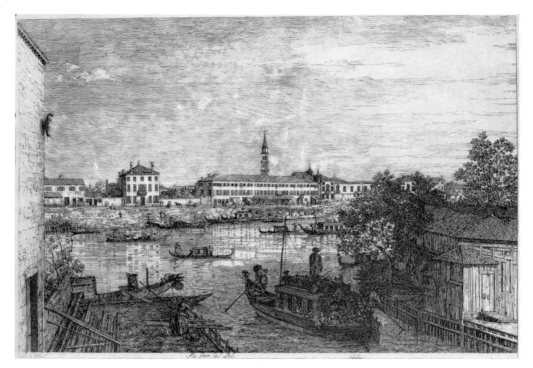

No. 2
'Ale Porte del Dolo'

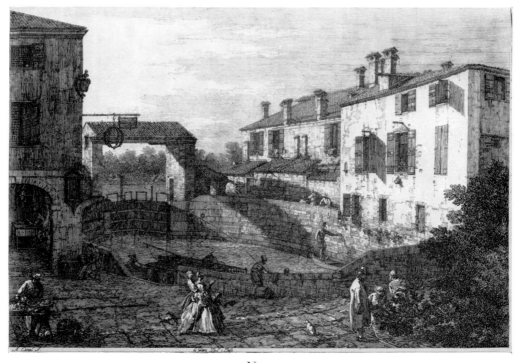

No. 3
'Le Porte del Dolo'

PLATE 173

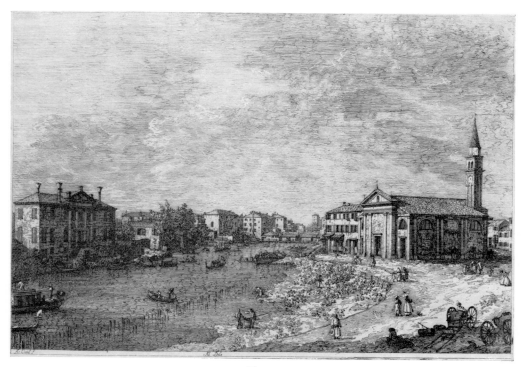

No. 4
'Al Dolo'

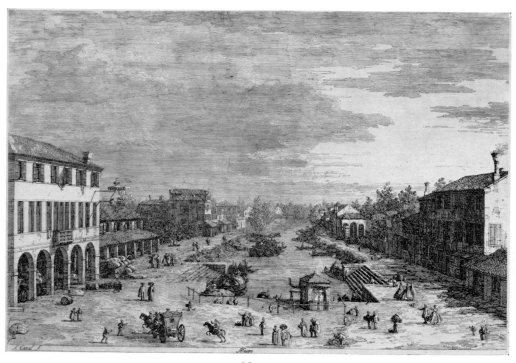

No. 5
'Mestre'

PLATE 174

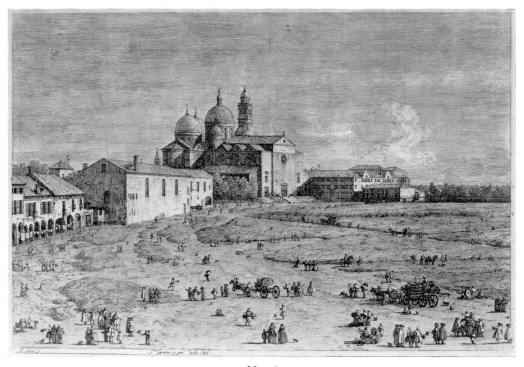

No. 6
'S. Giustina in Pra della Valle'

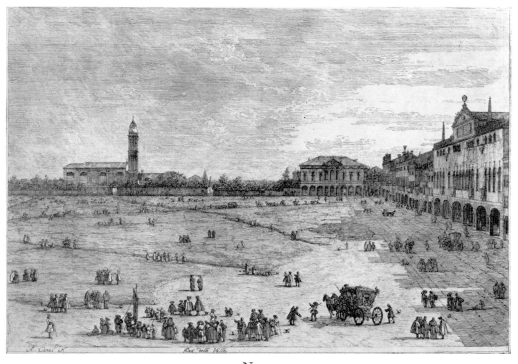

No. 7
'Pra della Valle'

PLATE 175

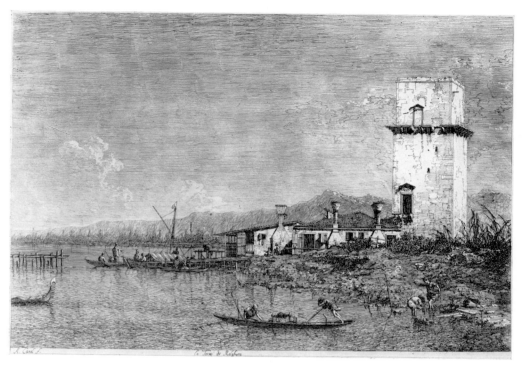

No. 8

'La Torre del Malghera'

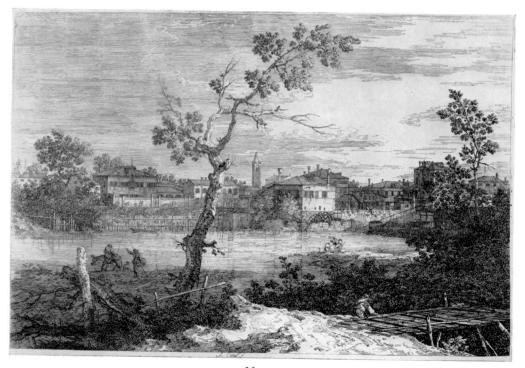

No. 9

A town on a river bank

PLATE 176

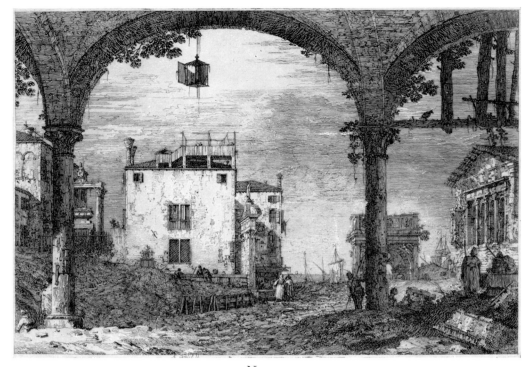

No. 11
The portico with a lantern

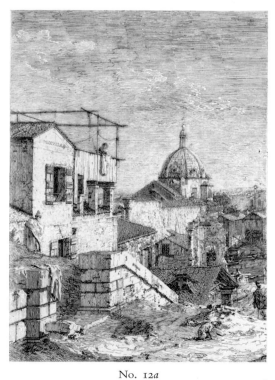

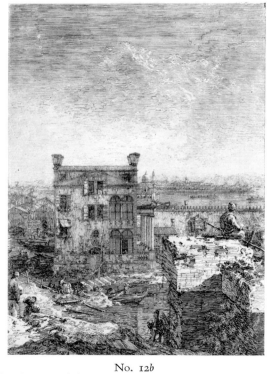

No. 12a

No. 12b

Imaginary view of Venice (after division of plate)

PLATE 177

13a

13c

13b

A town with a bishop's tomb

PLATE 178

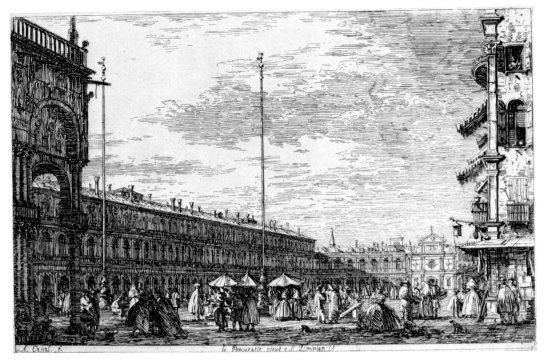

No. 16
'Le Procuratie Niove e S. Ziminian V.'

No. 18
The terrace

PLATE 179

No. 22
Landscape with a pilgrim at prayer

No. 23
The equestrian monument

No. 25
Mountain landscape with five bridges

PLATE 180

No. 28
Landscape with church, houses, and mill

No. 30
Mountain landscape with a church, houses, and two columns

PLATE 181

PAINTED BY CANALETTI

ENGRAVED BY W.H.FELLOWS

VIEW OF WESTMINSTER, TAKEN UPON THE THAMES, AT THE PERIOD OF THE BUILDING OF THE BRIDGE.

From a Picture in the Collection of

THE HON.ᴮᴸᴱ PERCY WYNDHAM, F.A.S.

Who in the most liberal manner permitted this Copy to be made for the benefit of the Publisher.

London, Published as the Act directs 11 Jan.ᵞ 1809, by John Thomas Smith, N.º 4. Polygon, Somers Town.

Fellows (1)
Westminster Bridge from the North

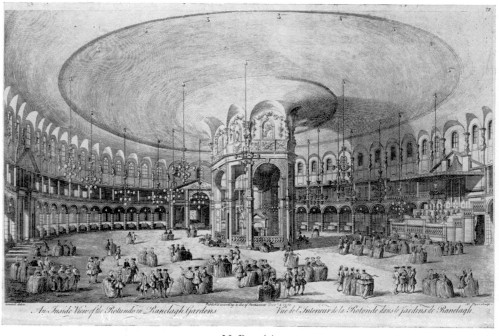

An Inside View of the Rotunda in Ranelagh Gardens

Vue de l'Intérieur de la Rotonde dans le jardins de Ranelagh.

N. Parr (3)
Ranelagh: Interior of the Rotunda

PLATE 182

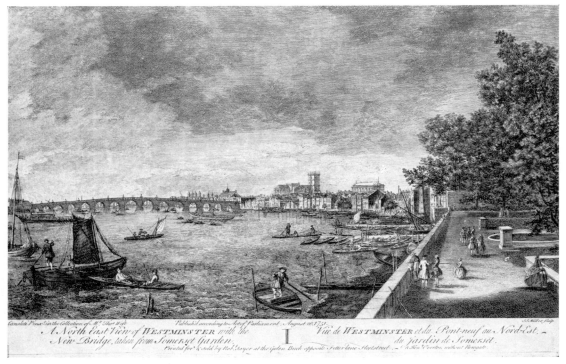

Müller (3)
The Thames from the terrace of Somerset House, Westminster Bridge in the distance

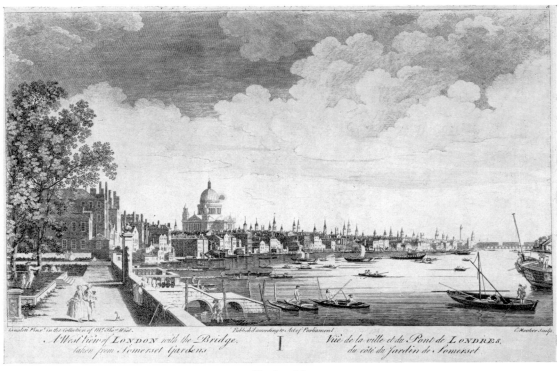

Rooker (1)
The Thames from the terrace of Somerset House, the City in the distance

PLATE 183

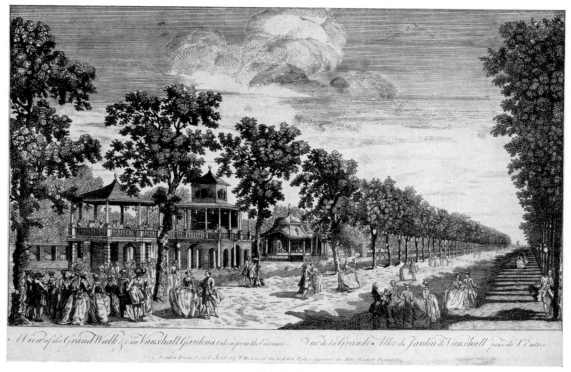

Rooker (2)
Vauxhall Gardens: the Grand Walk

Rooker (3)
Vauxhall Gardens: the Centre Cross Walk

PLATE 184

A View of the Canal in St James's Park, Buckingham House &c: taken from the Parade. | Vue du Canal et de la Maison de Buckingham dans le Parc de St James.

Stevens (2)
St. James's Park: the Canal, looking West

Veduta del Prospetto della Chiesa di S. Francesco della Vigna così alcune aggiunte d'invenzione

Wagner (57.6)
Cappriccio: with S. Francesco della Vigna

PLATE 185

541. (Detail)

ILLUSTRATIONS
TO
SECOND EDITION

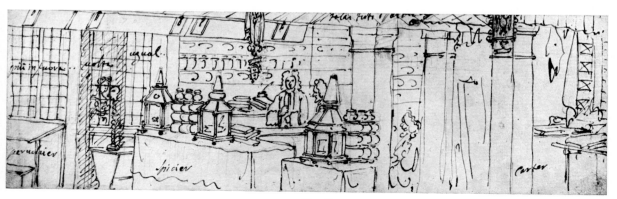

540. (Detail)

PLATE 186

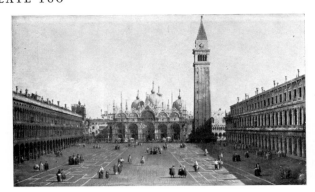

4. Piazza S. Marco: looking East
along the central line

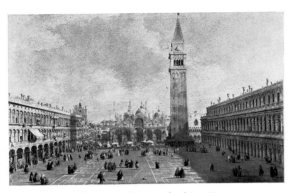

9. Piazza S. Marco: looking East
along the central line

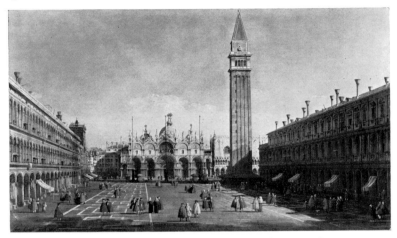

16.★ Piazza S. Marco: looking East from North
of the central line (1744)

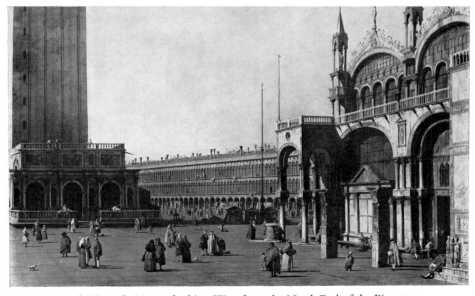

35.★ Piazza S. Marco: looking West from the North End of the Piazzetta

PLATE 187

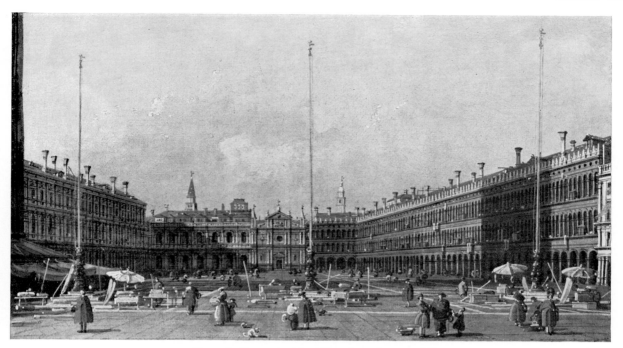

25. Piazza S. Marco: looking West along the central line

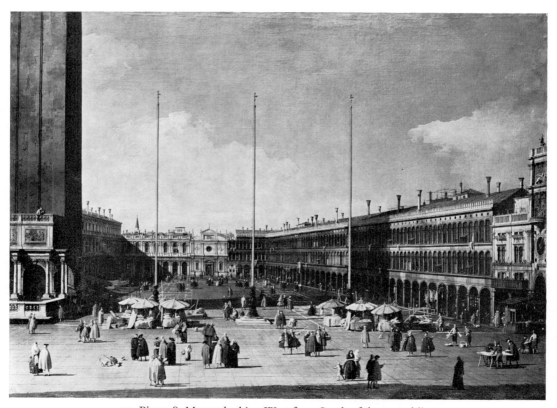

29. Piazza S. Marco: looking West from South of the central line

PLATE 188

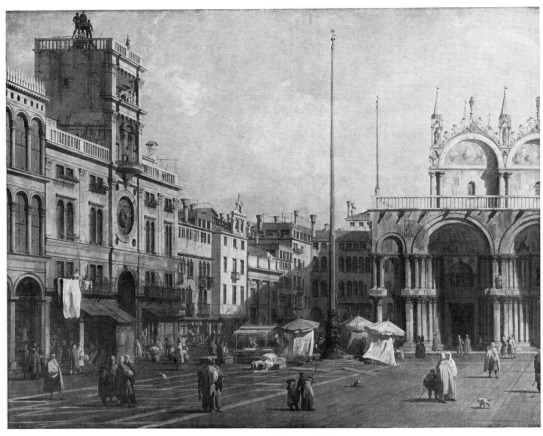

45. Piazza S. Marco: the North-East corner

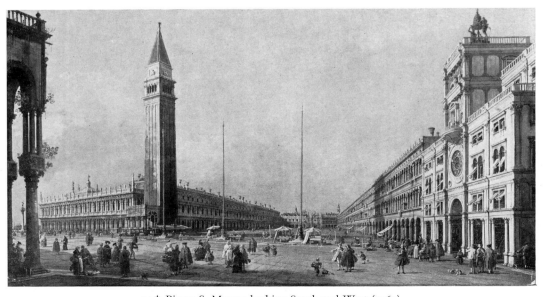

54.★ Piazza S. Marco: looking South and West (1763)

PLATE 189

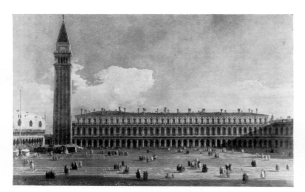

49.* Piazza S. Marco: looking South

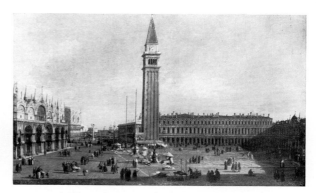

53.* Piazza S. Marco: looking South and West

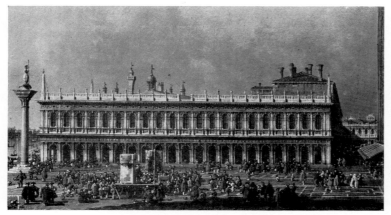

72. The Piazzetta: looking West with the Library

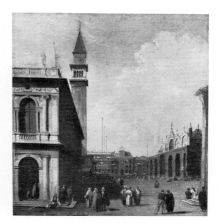

63(a). The Piazzetta:
looking North

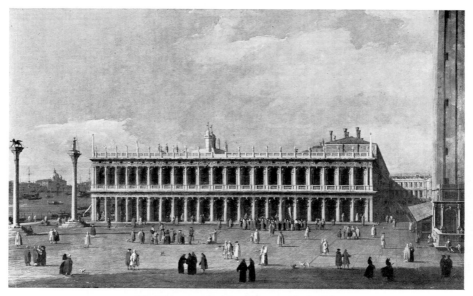

70. The Piazzetta: looking West, with the Library

PLATE 190

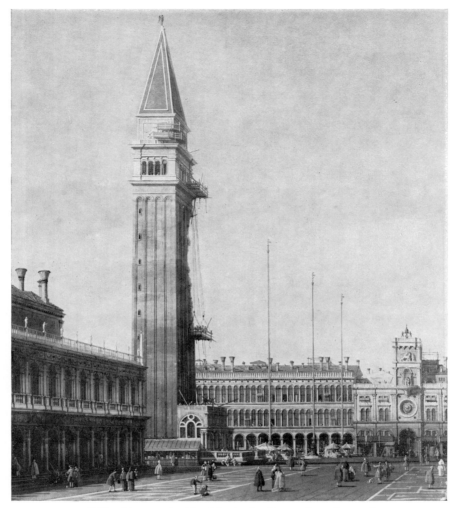

67.★ The Piazzetta: looking North, the Campanile under repair

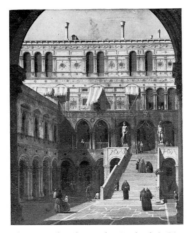

80. The Ducal Palace: the Scala dei Giganti

PLATE 191

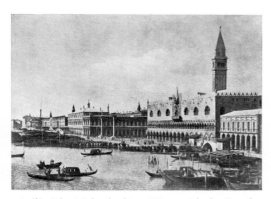

85(b). The Molo: looking West, with the Ducal
Palace and the Prison

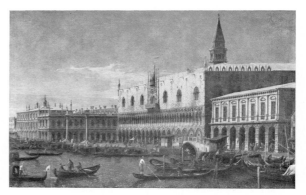

85.★ The Molo: looking West, with the Ducal Palace and
the Prison

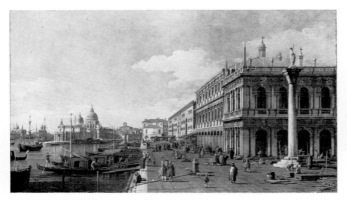

95(aa). The Molo: looking West, Column of St. Theodore right

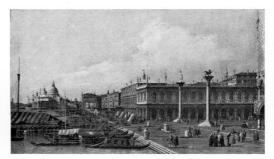

98.★ The Molo: looking West, corner of Ducal
Palace right

87. The Molo: looking West, Ducal Palace right

88(a). The Molo: looking West, Ducal Palace right

PLATE 192

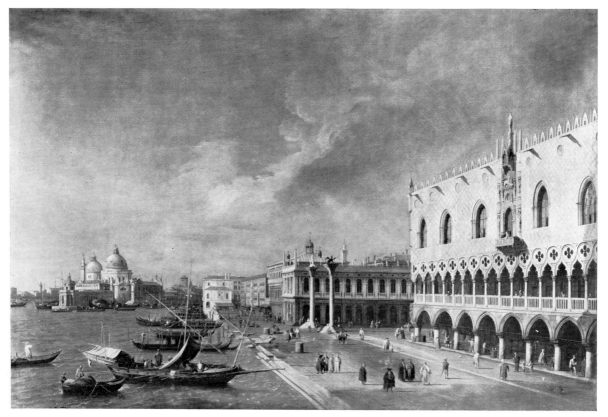

94. The Molo: looking West, Ducal Palace right

99. The Molo, looking West: the Fonteghetto della Farina

PLATE 193

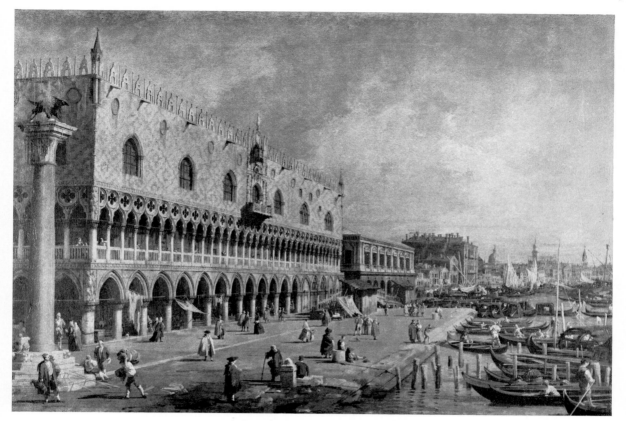

111.* Riva degli Schiavoni: looking East

115.* Riva degli Schiavoni: looking East

Detail of 111*

PLATE 194

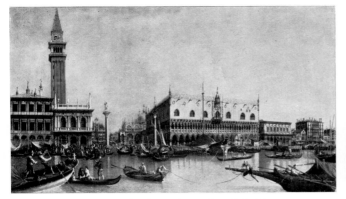

105.★ The Molo: from the Bacino di S. Marco

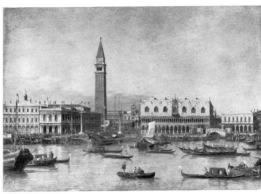

109(a). The Molo: from the Bacino di S. Marco

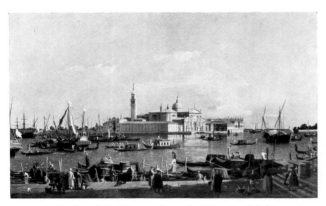

124.★ Bacino di S. Marco: from the Riva degli Schiavoni

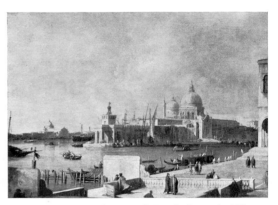

152. Entrance to the Grand Canal: from the West end of the Molo

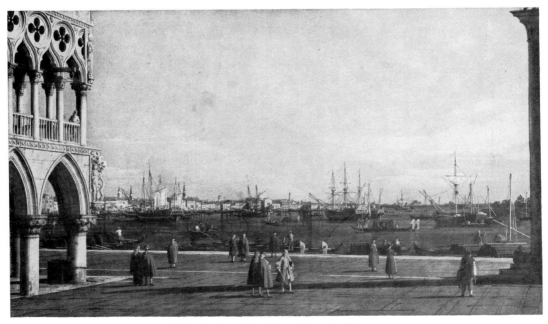

127. The Bacino di S. Marco, from the Piazzetta

PLATE 195

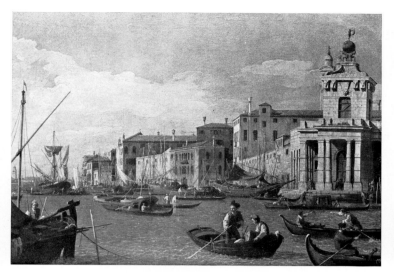

159. The Dogana and the Giudecca Canal

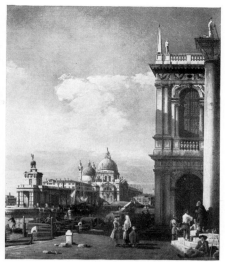

147. Entrance to the Grand Canal: from
the Piazzetta

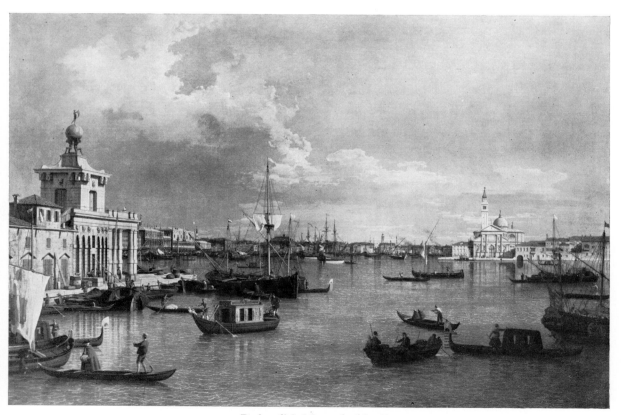

134. Bacino di S. Marco: looking East

PLATE 196

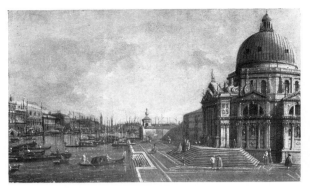

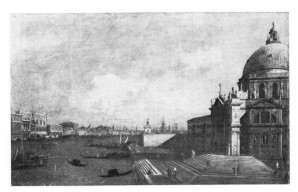

170(*a*) 2. Entrance to the Grand Canal: looking East

170(*b*) 1. Entrance to the Grand Canal: looking East

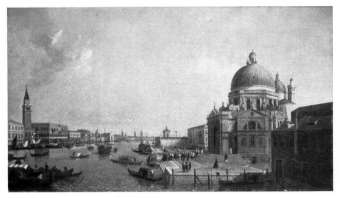

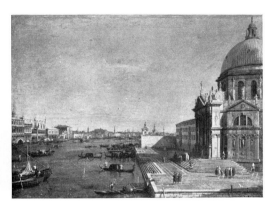

170(*a*) 3. Entrance to the Grand Canal: looking East

171(*a*). Entrance to the Grand Canal: looking East

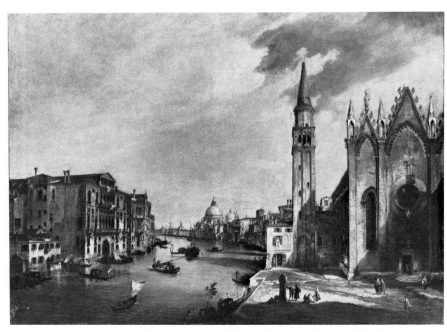

196.★ Grand Canal: from Sta Maria della Carità to the Bacino di S. Marco

PLATE 197

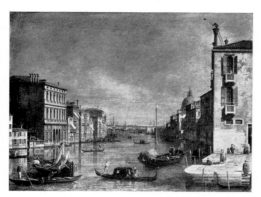

190(a). Grand Canal: looking East, from the
Campo di S. Vio

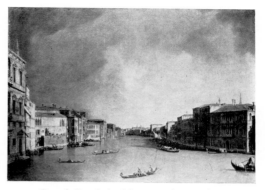

211. Grand Canal: looking North-East from the
Palazzo Balbi to the Rialto Bridge

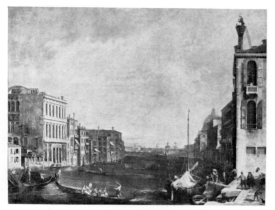

187(a). Grand Canal: looking East, from the
Campo di S. Vio

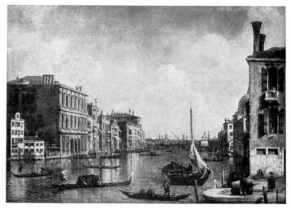

191. Grand Canal: looking East, from the Campo di S. Vio

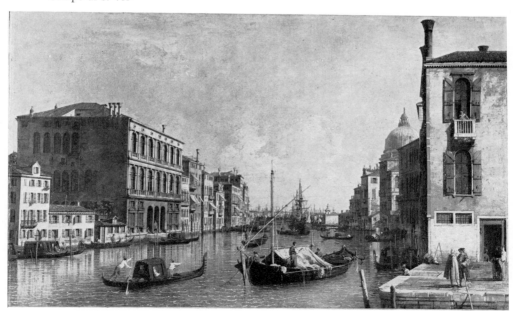

190. Grand Canal: looking East, from the Campo di S. Vio

PLATE 198

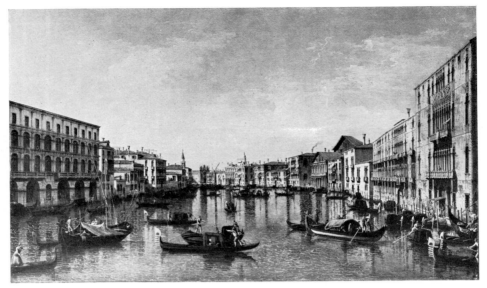

204. Grand Canal: looking South from the Palazzi Foscari and Moro-Lin to Sta Maria della Carità

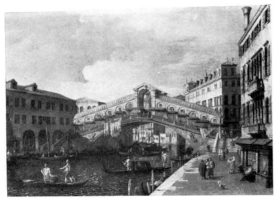

227. Grand Canal: the Rialto Bridge from the South

227(c) (detail)

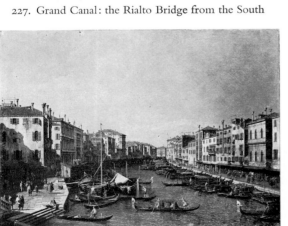

223. Grand Canal: looking South-West from the Rialto Bridge to the Palazzo Foscari

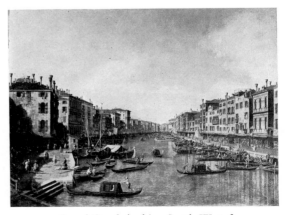

224. Grand Canal: looking South-West from the Rialto Bridge

PLATE 199

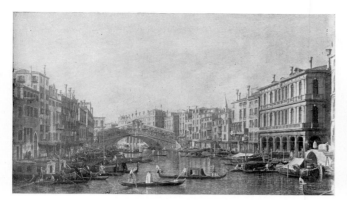

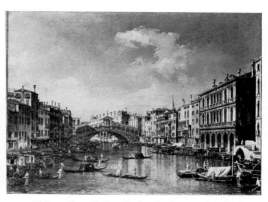

228(*a*) 1. Grand Canal: the Rialto Bridge from the South

228(*a*) 4. Grand Canal: the Rialto Bridge from the South

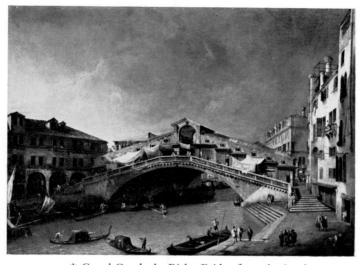

227.★ Grand Canal: the Rialto Bridge from the South

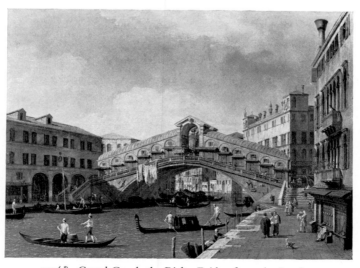

227(*d*). Grand Canal: the Rialto Bridge from the South

PLATE 200

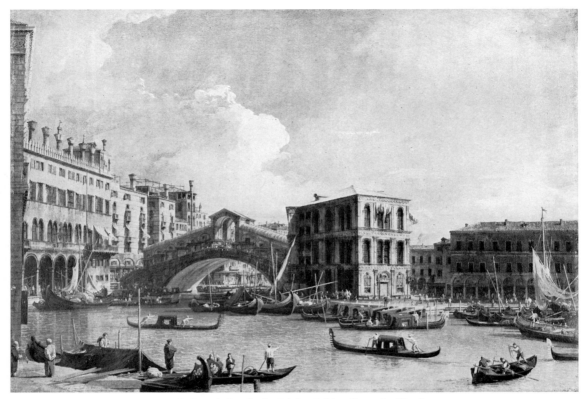

238.★ Grand Canal: the Rialto Bridge from the North

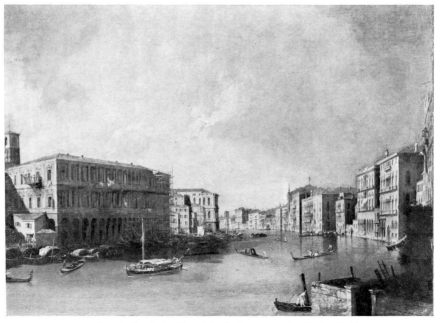

231. Grand Canal: looking North from near the Rialto Bridge

PLATE 201

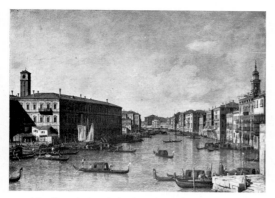

233(c). Grand Canal: looking North from near the
Rialto Bridge

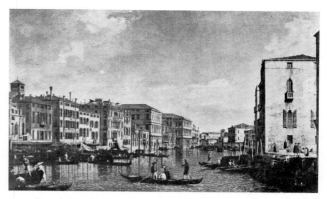

243. Grand Canal: looking North-West from the Campo di Sta
Sofia to S. Marcuola

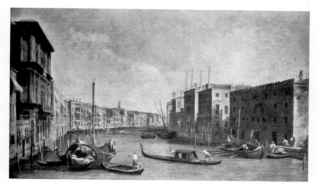

249. Grand Canal: looking South-East from the Palazzo
Vendramin-Calergi

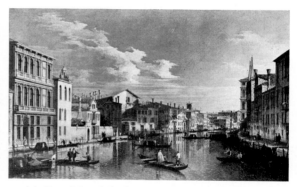

257(a). Grand Canal: looking East from the Palazzo Flangini
to S. Marcuola

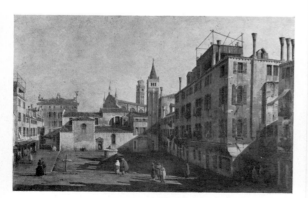

286. Campo S. Stefanin (S. Stin)

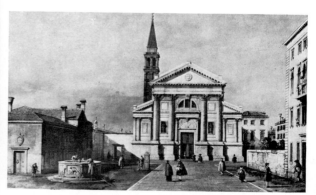

296. S. Francesco della Vigna: Church and Campo
(see also Pl. 57)

PLATE 202

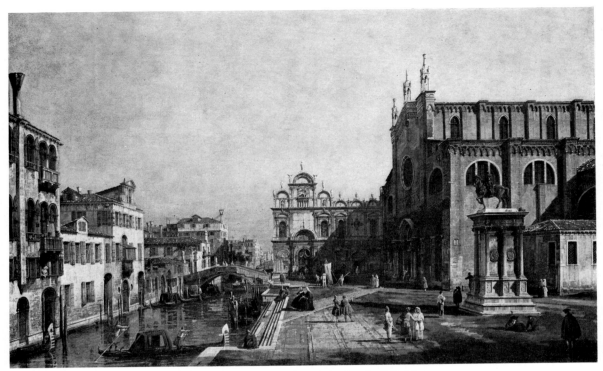

307. SS. Giovanni e Paolo and the Scuola di S. Marco

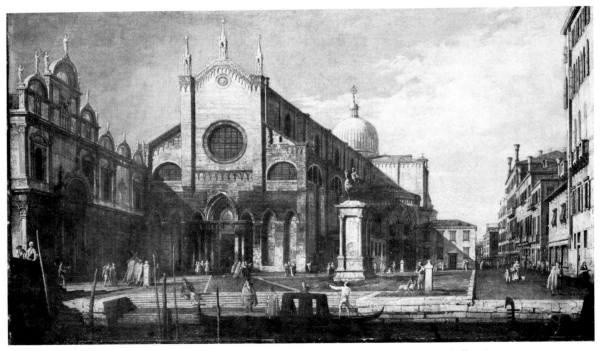

308(*aa*). SS. Giovanni e Paolo and the Monument to Bartolommeo Colleoni

PLATE 203

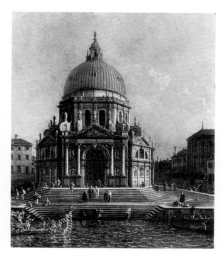

312.★ Sta Maria della Salute

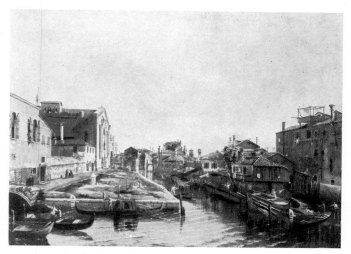

312.★★ Sta Maria dei Servi and surrounding buildings

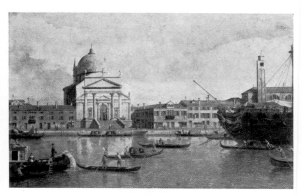

318.★ Il Redentore

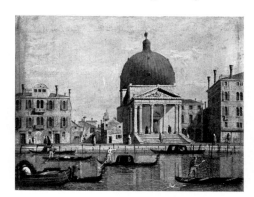

320. S. Simeone Piccolo

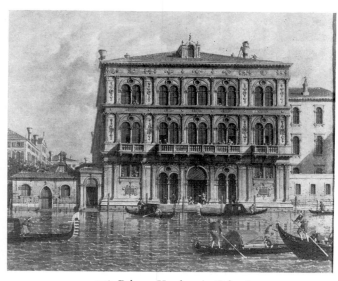

326. Palazzo Vendramin-Calergi

PLATE 204

337. The Bucintoro returning to the Molo on Ascension Day

349. A Regatta on the Grand Canal

340(*aa*). The Bucintoro at the Molo on Ascension Day

344. The Bucintoro at the Molo: the Campanile
damaged (1745–6)

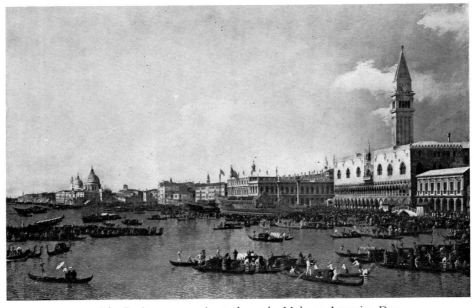

333. The Bucintoro preparing to leave the Molo on Ascension Day

PLATE 205

366.★ View towards S. Michele and Murano from S. Pietro

368.★ View of Murano

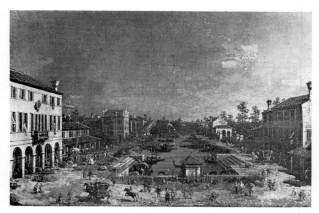

370.★ Mestre

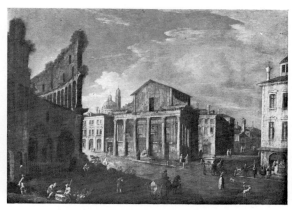

381.★ Temple of Antoninus and Faustus, Rome

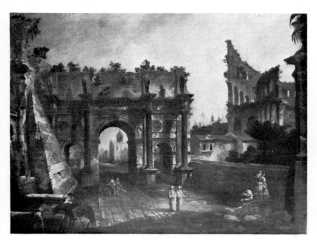

382.★ The Arch of Constantine, Rome

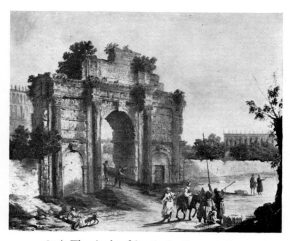

385.★ The Arch of Septimius Severus, Rome

PLATE 206

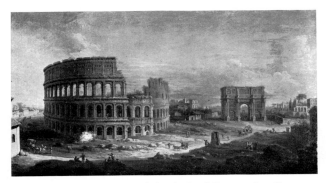

387.★ The Colosseum and the Arch of Constantine, Rome

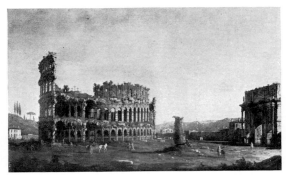

388.★ The Colosseum and the Arch of Constantine, Rome, from the West

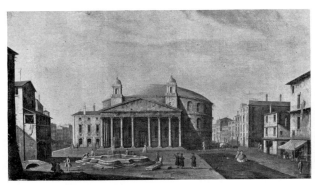

391. The Pantheon

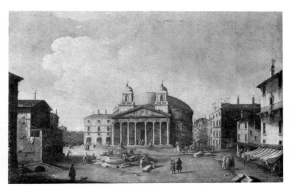

391(*aa*) The Pantheon

398.★ The Piazza del Campidoglio, Rome

402(*aa*) Piazza del Popolo, Rome

PLATE 207

418. London: the New Horse Guards from St. James's Park

422. London: St. Paul's Cathedral

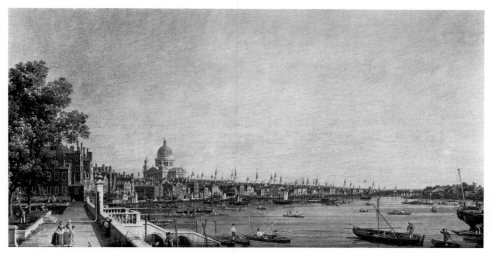

428(*b*). London: the Thames from the terrace of Somerset House, the City in the distance

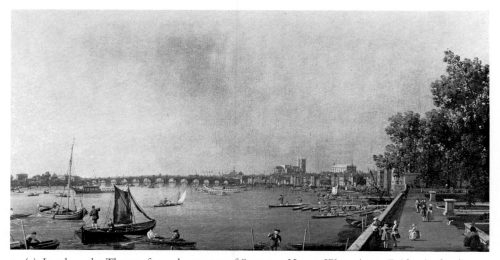

429(*a*) London: the Thames from the terrace of Somerset House, Westminster Bridge in the distance

PLATE 208

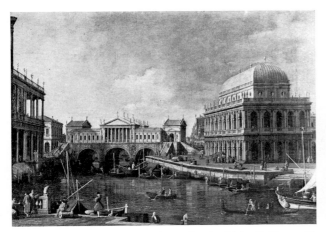

458(a). Capriccio: a Palladian design for the Rialto Bridge, with buildings at Vicenza

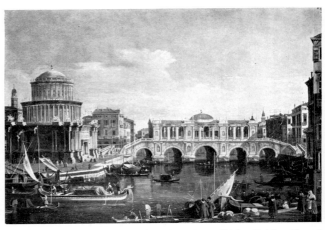

459(a) Capriccio: a canal with an imaginary Rialto Bridge (?) and other buildings

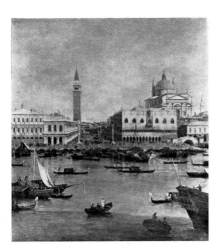

459.★ A Capriccio View of the Piazzetta with the Church of Il Redentore

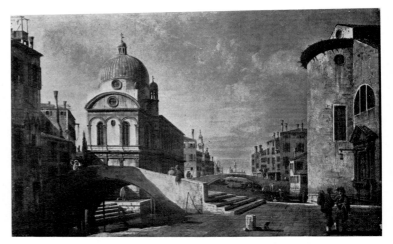

464. Capriccio (?): Sta Maria dei Miracoli, Venice

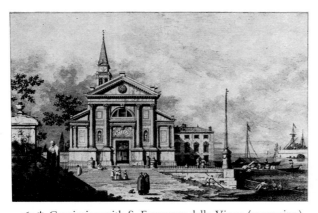

460.★ Capriccio: with S. Francesco della Vigna (engraving)

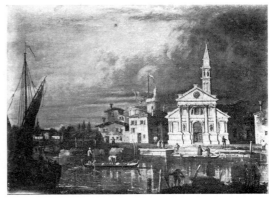

461. Capriccio: an island in the Lagoon with motives from S. Francesco della Vigna

PLATE 209

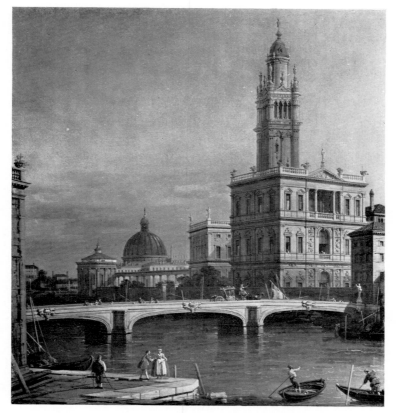

472.★ Capriccio: a river crossed by the Ponte Santa Trinità with buildings

469. Capriccio: houses in Padua

PLATE 210

479.★ Rome: a Caprice View with ruins based on the Forum

479.★★★★ Capriccio with ruins and a
Renaissance building in the distance

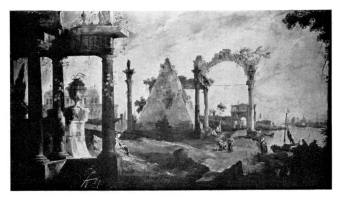

479.★★ Capriccio with ruins, the Basilica at Vicenza and the Arch
of Constantine

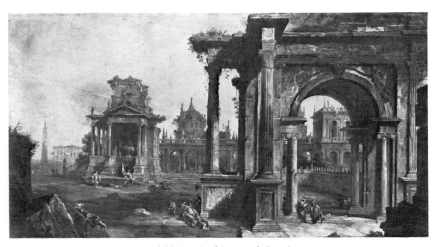

479.★★★ An Architectural Caprice

PLATE 211

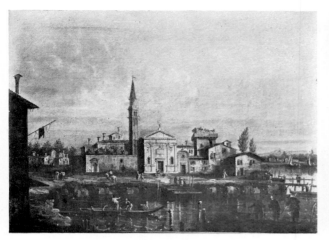

480. Capriccio: an island with a church in the Lagoon

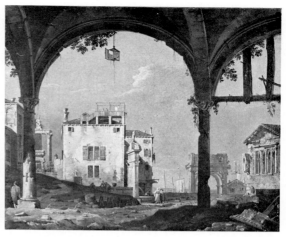

492. Capriccio: a portico, houses, and classic ruins
by the Lagoon

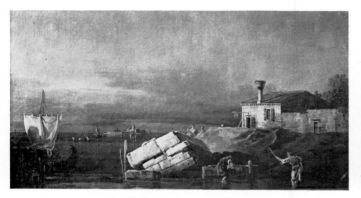

491. Capriccio: a cottage on the Lagoon

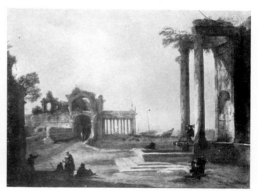

501. Imaginary composition: Roman ruins
by the sea

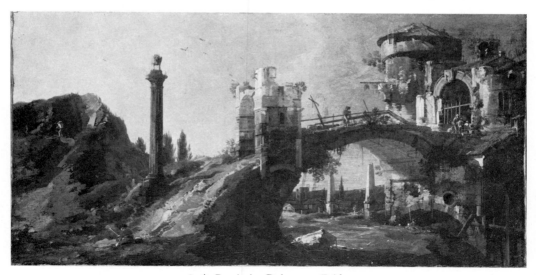

481.★ Capriccio: Ruins on a Bridge

PLATE 212

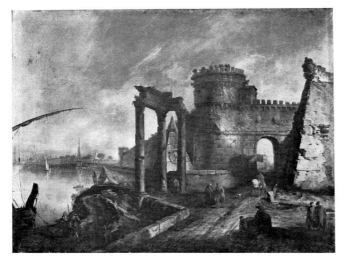

501.★ Imaginary View of Rome

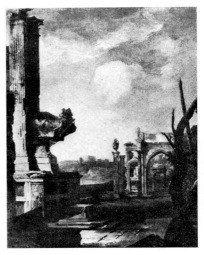

501.★ Imaginary View of Rome

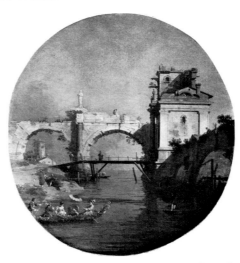

511(a) Capriccio: a pavilion and a ruined arcade
by the Lagoon

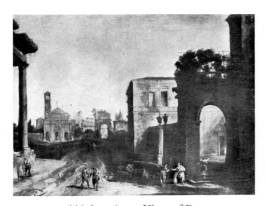

501.★★★ Imaginary View of Rome

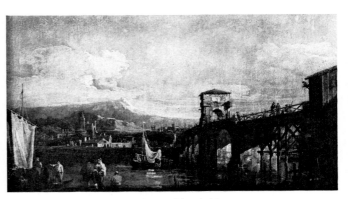

515. River with a bridge

PLATE 213

517.★ Figure studies

517.★ Figure studies

517.★ Figure studies

517.★★ Study of six figures

PLATE 214

528. Piazza S. Marco: looking East

540 (reverse). Upper part of the Torre dell'Orologio

537.★ Piazza S. Marco: looking South (1731)

PLATE 215

530. Piazza S. Marco: looking West

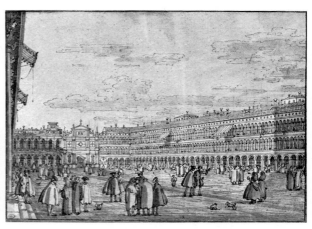

531. Piazza S. Marco: looking West

777(*b*) (reverse). Piazza S. Marco with part of the Procuratie
Vecchie (?)

582 (reverse). Grand Canal: buildings opposite the
Salute

587 (reverse). Inscription

595 (reverse). Grand Canal: Fabbriche Nuove and corner of the
Fondaco dei Tedeschi (?)

PLATE 216

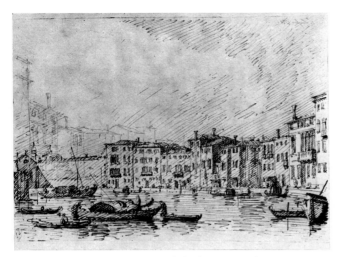

601. Canale di Sta Chiara (with buildings and date, 1734, on reverse)

624.★ Façade of a Palace near S. Girolamo

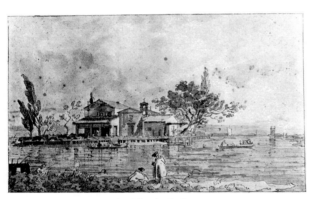

648. The island of L'Anconetta

674. A villa on the Brenta

663.★ The Lagoon with the Torre di Malghera (?)

PLATE 217

691. Padua: houses

691.★ Paduan (?) capriccio: a bridge over an undercroft

PLATE 218

625.★ View from Canaletto's window with Sta Maria della Fava

625. Roofs and chimneys in Venice (from Canaletto's window)

PLATE 219

713 (227). Rome: the Baths of Caracalla

713 (228). Rome: the Baths of Caracalla

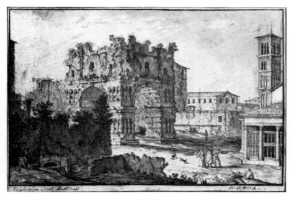

713 (229). Rome: Arch of Janus and S. Giorgio in Velabro

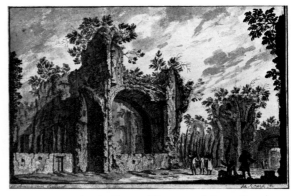

713 (231). Rome: Thermae of Caracalla

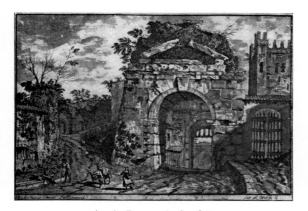

713 (233). Rome: Arch of Drusus

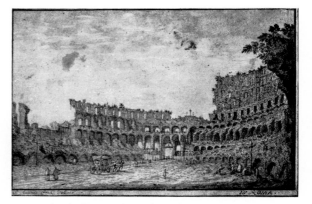

713 (236). Rome: the Colosseum, interior from the
South-East

PLATE 220

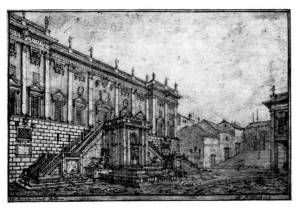

713 (239). Rome: Piazza del Campidoglio, looking South

709. Statues in the grounds of a villa (1)

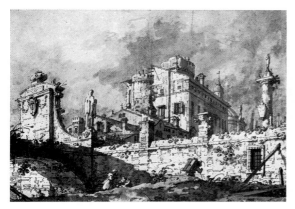

832.★ Architectural Capriccio

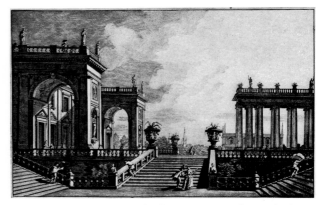

828.★ Capriccio: steps leading to a terrace (engraving)

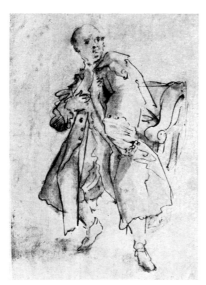

842.★ A Gentleman seated in an
Armchair

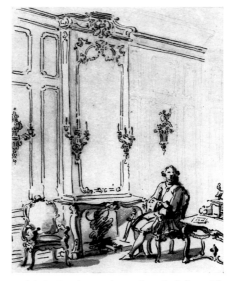

842.★★ A Gentleman in an Armchair by a Fire

PLATE 221

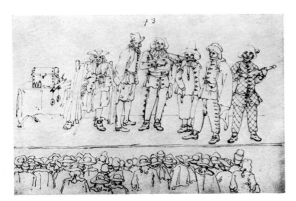

840.* A Charlatan and five masquers

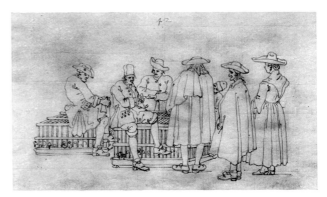

840.** Six figures and bird-coops

840.*** Cloth merchants

840.**** (1). Study of two figures

840.**** (2). Study of three figures with masks

PLATE 222

840.***** A crowd watching a tumbler

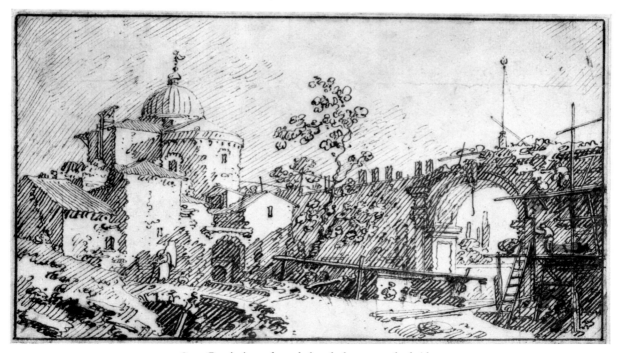

854. Capriccio: a domed church, houses, and a bridge

PLATE 223

848 II. A church (or amphitheatre) by a canal

852 (note) A masted fishing-vessel

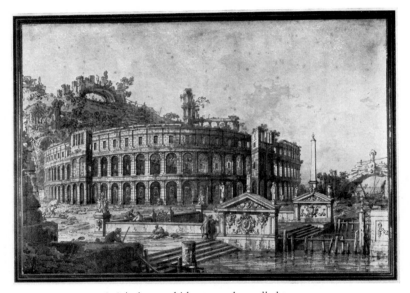

848.* An amphitheatre and a walled terrace

855. A rural cottage with figures at a garden table

PLATE 224

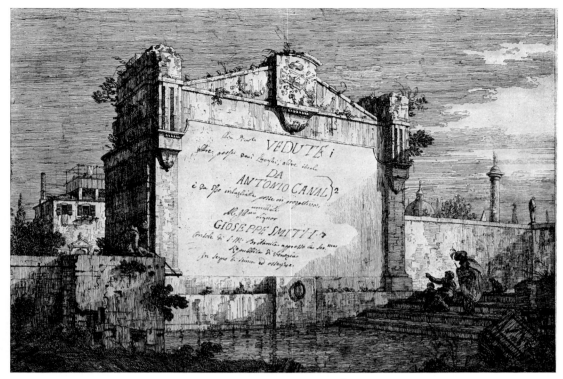

No. 1 Frontispiece, proof

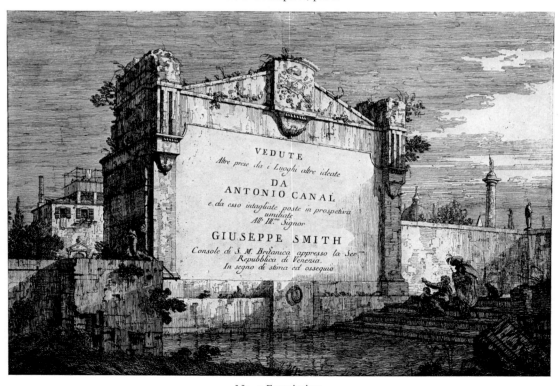

No. 1 Frontispiece

PLATE 225

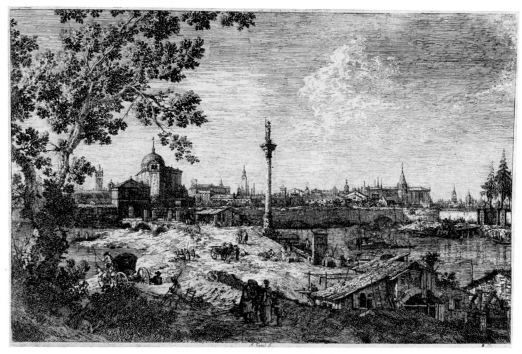

No. 10 Imaginary view of Padua

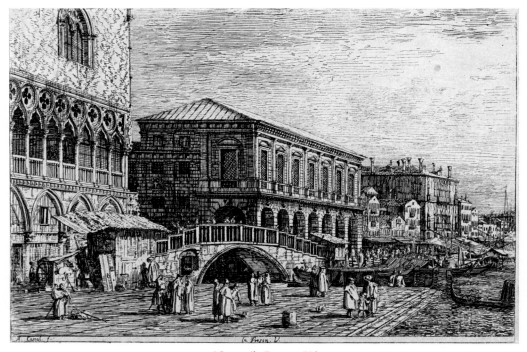

No. 14 'le Preson. V.'

PLATE 226

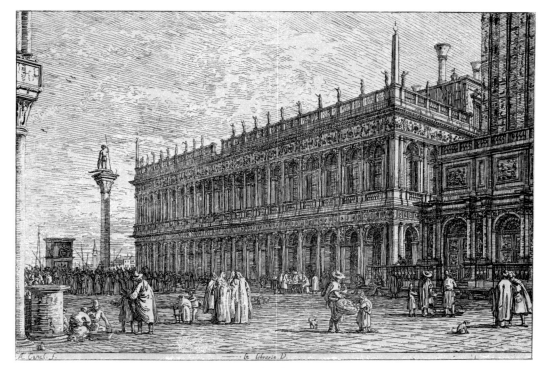

No. 15 'la Libreria. V.'

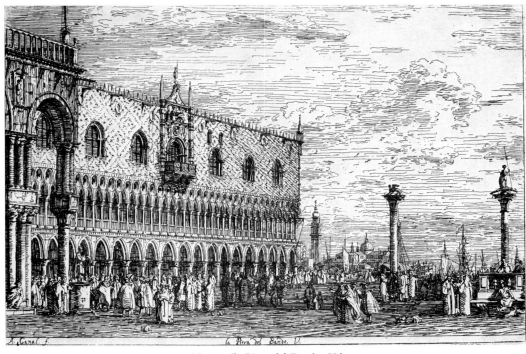

No. 17 'la Piera del Bando. V.'

PLATE 227

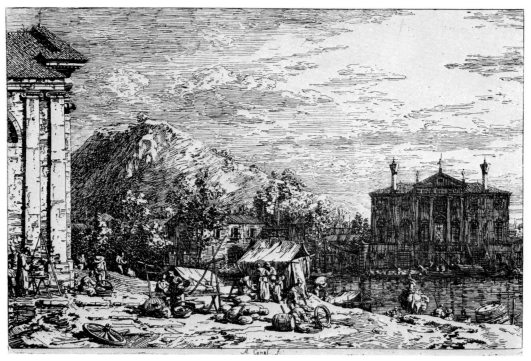

No. 19 Market at Dolo

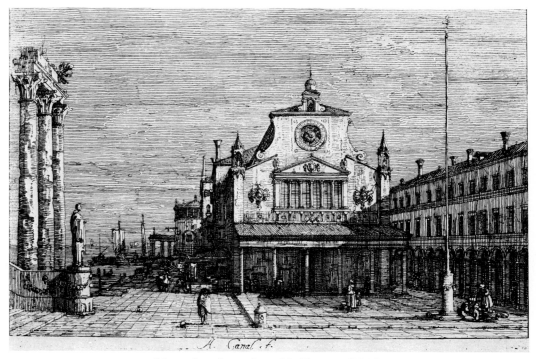

No. 20 Imaginary view of S. Giacomo di Rialto

PLATE 228

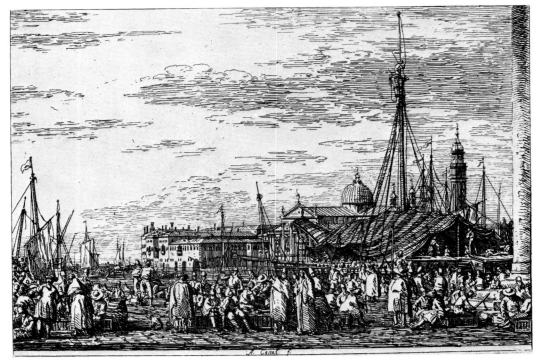

No. 21 Market on the Molo

No. 24 Landscape with a woman at a well

PLATE 229

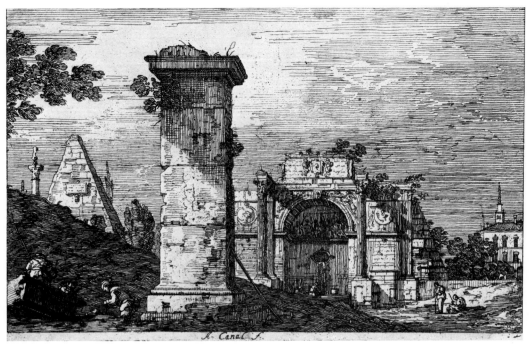

No. 26 Landscape with ruined monuments

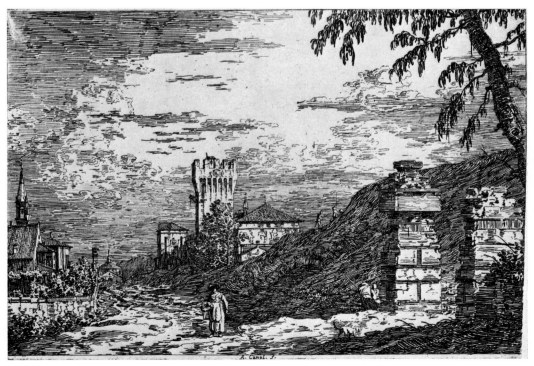

No. 27 Landscape with tower and two ruined pillars

PLATE 230

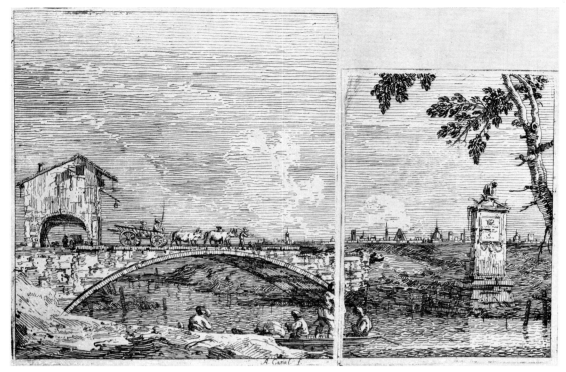

No. 29(a) The waggon passing over a bridge. No. 29(b) The little monument
under a tree

582 (top)

552 (top)

540 (top)

PLATE 231

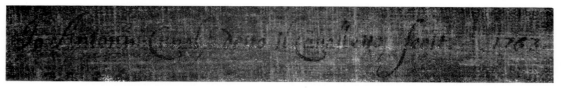

54.* (back)

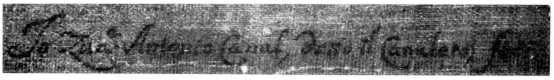

321 (back)

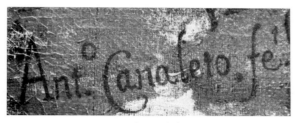

383 (lower left)

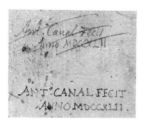

695(*b*) back

Io Zuane Antonio da Canal, Hò fatto il presente disegnio delli Musici che Canta nella Chiesa Ducal di S. Marco in Venezia in' età de Anni 68 Cenzza Ochiali, L'anno 1766.

558 (lower margin)

Piazza di S. Giaccomo di Rialto in Venezia, con parte del Famoso Ponte in distanza, Versso S. Bartolmⁱⁿ

611 (lower margin)

Io Zuane Antonio da Canal, deto il Canaleto
Iò Dissegnià è
fatto.

691 (attached)

Disegnato da me Antonio Canal detto il Canaleto appresso il Mio Quadro Dippinto in Londra. 1755
Per il Signore Cavaliere diKert.

755 (below)

Io Zuane Antonio da Canal, detto il Canaleto, feci il detto Dissegnio.

786 (back)

PLATE 232

DETAILS

S. Marco

Shipping

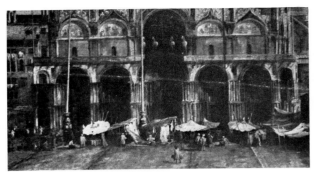

Pl. 11, 1. *c.* 1723

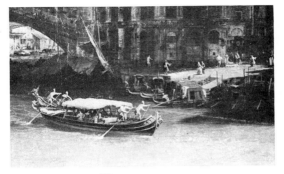

Pl. 49, 234. 1725

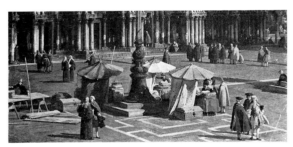

Pl. 19, 50. *c.* 1735

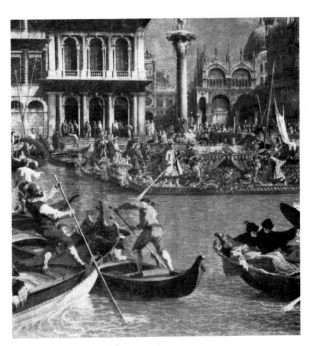

Pl. 64, 336. *c.* 1730

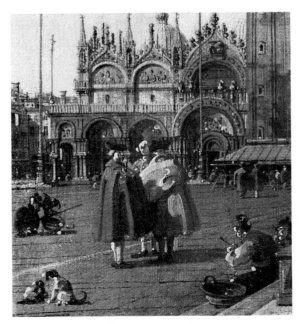

Pl. 15, 20. *c.* 1760

Pl. 77, 424. *c.* 1747